Beyond the Lines

Beyond the Lines

Pictorial Reporting, Everyday Life,
and the Crisis of Gilded Age America

Joshua Brown

UNIVERSITY OF CALIFORNIA PRESS
Berkeley · Los Angeles · London

University of California Press
Berkeley and Los Angeles, California

University of California Press, Ltd.
London, England

© 2002 by
The Regents of the University of California

Library of Congress Cataloging-in-Publication Data
Brown, Joshua, 1949–
 Beyond the lines : pictorial reporting, everyday life, and the crisis of Gilded Age America /
Joshua Brown.
 p. cm.
 Includes bibliographical references and index.
 ISBN 0-520-23103-1 (cloth : alk. paper)
 1. Illustrated periodicals. 2. Frank Leslie's illustrated newspaper. 3. Illustrated
periodicals—United States—History—19th century. I. Title.

PN4834.B76 2002
071′.3′09034—dc21 2002000714

Manufactured in the United States of America
10 09 08 07 06 05 04 03 02
10 9 8 7 6 5 4 3 2 1

To my mother and father

Contents

Illustrations

Acknowledgments

This book has been a long time in coming. Despite the lengthy gestation period from its original conception to its first incarnation as a dissertation to the present work, *Beyond the Lines* reflects the successful coalescence of previously distinct parts of my life. Throughout my graduate training, artwork and historical inquiry remained separate and competing endeavors, the former largely a means to finance the pursuit of the latter. It was only after several years' research on a very different dissertation topic that I began to contemplate an intellectual course that incorporated my otherwise alienated visual labor. Work on the editorial collective of the *Radical History Review* and then on the staff of the City University of New York's American Social History Project demonstrated to me that my work in art and interest in history could be integrated in critical commentary and presentations about the past. And, while attempting to accomplish such work for ASHP, I began to investigate and grew to appreciate the form and content of wood engravings in the nineteenth-century illustrated press.

Moving along such a long and circuitous path I have accumulated many intellectual and personal debts, all of which I now may happily acknowledge. Several friends served as persistent co-conspirators in this project. Peter Buckley assumed the role of primary *provocateur;* it was he who coerced me into finally collecting my fractured thoughts and research, always punctuating his harassment with provocative insights and unbounded enthusiasm. Like Peter, Jeanie Attie read the manuscript

both in its dissertation phase and during its transmutation; she was always there with her comradeship and incisive criticisms. This project would never have been accomplished without Betsy Blackmar, who supplied me with infusions of wise commentary as I worked my way through the first draft. Steve Brier applied his historical insight and editorial skills to the first draft of this work and also graciously authorized additions to the American Social History Project's pictorial archive, which served as its primary source. Daniel Czitrom and Richard Stott read the dissertation manuscript and provided sound advice about the thesis and organization of the study. And David Jaffee carefully examined the revised manuscript with a sharp eye for imprecise thinking.

Many other friends and colleagues played crucial roles in seeing this thing through. Barbara Balliet, Susan Davis, Ian Gordon, Elliott Gorn, Kirsten Silva Gruesz, Ed Hatton, Marvin Jeter, Rob Kennedy, Kevin Kenny, Michael Leja, Niamh O'Sullivan, Nicholas Salvatore, Dan Schiller, Paul Semonim, and Bob Stepno generously shared their research and writing. For suggesting avenues of inquiry and commenting on proposals, papers, and draft chapters, I wish to thank John Adler, Jean-Christophe Agnew, Marc Aronson, Pennee Bender, Carol Berkin, Daniel Bluestone, Michele Bogart, Daniel Czitrom, Stuart Ewen, Bret Eynon, Eric Foner, Joshua Freeman, Tracy Gottlieb, Steven Jaffe, David Jaffee, Bruce Laurie, Kenneth Myers, Edward O'Donnell, Roy Rosenzweig, Harry Rubenstein, Herbert Sloan, Madeleine Stern, and Rebecca Zurier. John Kolp played a pivotal role early in this venture by helping me obtain the necessary machinery to carry out my research. Mark Hurley assisted in locating supplementary *Frank Leslie's* material at the Library of Congress. The many illustrations in this book were obtained over eighteen years through the ingenious efforts of past and present ASHP colleagues, including Kate Pfordresher, Bret Eynon, Andrea Ades Vásquez, David Osborn, and Mario Frieson. I also received valuable assistance in locating pictures and documents from the staff of the New York Public Library Print Room and especially from Stewart Bodnar, the Helen Bernstein Chief Librarian for Periodicals. Perhaps the most gratifying aspect of this project was that its extended length allowed me to turn, in its latter stages, to my sons for help: Gideon Joslyn Brown repeatedly embarked on quests for obscure materials in the New York Public Library for both the dissertation and book, and Daniel Joslyn Brown patiently acceded to my endless entreaties for books and articles in Columbia University's research libraries. The Bowery Seminar, formerly of the New York Institute for the Humanities and then Cooper

Union, was a reliable source of intellectual inspiration as I wended my way through this book's various incarnations.

Three senior scholars made significant contributions. Jim Shenton was my mentor and protector at Columbia for eighteen years, my undaunted sponsor and friend. William Taylor provided support at a decisive moment in the completion of this project. Although this book was researched and written after Herb Gutman's untimely death, I feel it in no small part reveals my exposure to his excitement about history, whatever form the inquiry might take, and his passion for unlocking America's many pasts.

I will always be in Ann Fabian's debt for introducing me to Monica McCormick and the University of California Press. Monica's enthusiasm and clear vision helped me unknot parts of my argument in the final revision of the manuscript. The arduous task of editing and designing this complicated book was lightened under Senior Editor Suzanne Knott's graceful guidance. If *Beyond the Lines* is a sound, not to mention readable, scholarly work it is very much due to Alice Falk's copyediting prowess and sensitivity to the materials. Nola Burger and Janet Villanueva are responsible for the elegant design of this book and the clarity of its many illustrations. Margie Towery constructed a precise and useful index. Previous to the book's finding a home at the University of California Press, Nancy Stauffer supplied contractual advice during early negotiations with publishers. And I cannot forget Roy Rosenzweig and Wendy Wolf, who helped me get through some unexpected twists and turns in the route toward publication.

At critical junctures during this project, my work was sustained by financial assistance from several organizations and institutions. I received crucial support for the dissertation from a 1992–93 Henry Luce Foundation/American Council of Learned Societies Dissertation Fellowship in American Art, and an in-kind fellowship from the Columbia University History Department. Columbia University's Bancroft Dissertation Award supplied subvention funds that assisted the publication of this book. A National Endowment for the Humanities Research Fellowship allowed me to devote my full time to this study in 1997. I wish to thank Alan Gartner, former dean of Research and University Programs at the City University of New York's Graduate Center, as well as Yosette Jones Johnson, executive director, and Lora T. Williams of The Graduate Center's Office of Human Resources for their help in securing official sanction for my leave.

Finally, I want to acknowledge the inspiration and support of my

family. I could never have undertaken this project, let alone finished it, without the love, allegiance, patience, and fortitude of my wife Julie and my sons Gideon and Daniel. The first years of graduate school so long ago would have been a financial impossibility without the aid of my grandmother Helen Rotman. In so many ways this book represents the confluence of the talents and interests of my late parents, Eleanor and Ben Brown; it is to them that I dedicate this work.

Note on Terms

Note on terms: "Del." in some citations is an abbreviation of the Latin *delineavit,* meaning "drawn by"; it indicates the office artist who was occasionally credited on engravings for rendering artist-correspondent sketches on the woodblock. "Sc." in some citations is an abbreviation of the Latin *sculpsit* or *scalpsit,* meaning "sculpted by" ("sculptor" being an archaic term for engraver); it indicates the engraver.

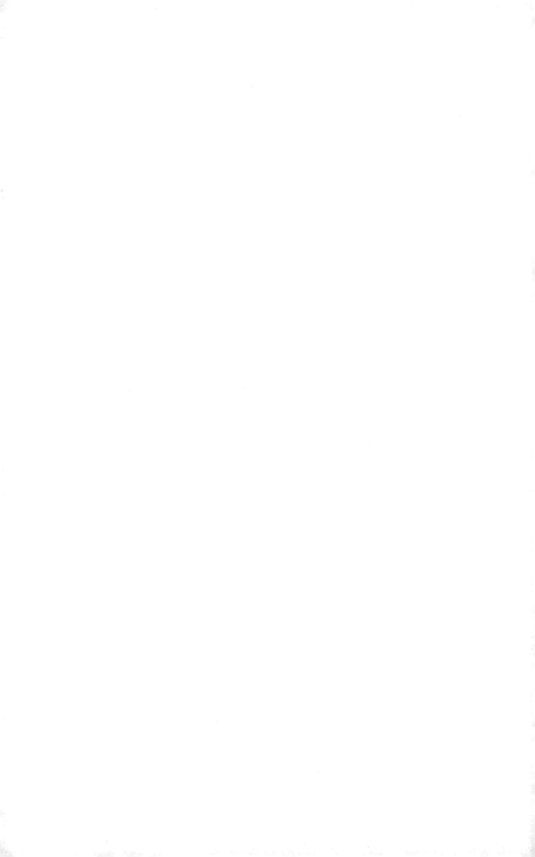

Introduction

With the perfection of the wood-engraved block at the close of the eighteenth century, for the first time pictures could be placed alongside movable type, and the scope of American print culture expanded to include a veritable universe of visual information. To be sure, the pace was at the start tentative, but by the middle of the next century the popular pictorial landscape had changed utterly. And nowhere was this change more evident than in the proliferation of topical imagery, from political cartoons to pictures depicting contemporary events, published in the nineteenth-century weekly illustrated press.

In the canon of the visual, the wood-engraved graphics published in *Frank Leslie's Illustrated Newspaper, Harper's Weekly,* and other pictorial papers are ephemeral products—quotidian materials apparently disposable in their time, easily overlooked and certainly underestimated in ours. This book takes these news images on their own terms to decipher the conventional wisdom and unconventional debates embedded in their seemingly dull, linear visual codes. Whatever their aesthetic strengths or weaknesses, the illustrated weeklies were an arena for contending representations of Gilded Age life, their wood-engraved pictures constituted by a complicated social negotiation among artists, editors, engravers, and readers. They were as changeable and volatile as the times they depicted, their meanings buffeted by crisis and shaped by ways of producing and viewing far different from those of the present.

Beyond the Lines emerged out of my efforts as a social historian and

filmmaker to reconcile the apparent disjuncture between the sensibilities of popular pictorial media of the past with the conventions of late-twentieth-century documentary programs. My first encounter with wood engravings published in the nineteenth-century weekly illustrated press occurred in the early 1980s when I set about producing documentaries for the City University of New York's American Social History Project. I initially confronted the vast pictorial archive offered by periodicals such as *Frank Leslie's Illustrated Newspaper* and *Harper's Weekly* with a mixture of anticipation and dread. The engravings of people, places, and events afforded the sorts of details and compact narratives that were perfect for the alternately roving and intrusive camera eye of video and film. But the opportunities these pictures afforded for presenting the past were countered by their very pastness. Their dense linework and theatrical compositions were alien to late-twentieth-century sensibilities acclimated to the tones and captured motion of photography, not to mention the movement and peripatetic editing of commercial programming. Perhaps more significant than their disjointed aesthetic, many of these illustrations treated "ordinary" people in a manner that was particularly problematic for the purposes of ASHP's "Who Built America?" programs, which were meant to relate the experiences of nineteenth-century American working-class men and women: while news pictures depicted working-class living conditions, labor, pastimes, and collective actions, these subjects were often sifted through a representational filter that reduced the historical actors to caricatured types bearing invidious somatic signs.

In short, the visual information about the working-class past provided by the illustrated press was offset by its representational purpose, which seemed to convey one particular "way of seeing"—the perceptions of the papers' self-regarding middle-class and elite readers. These problems notwithstanding, the availability of and extensive coverage provided by this resource (depicting people, places, and events that mid-nineteenth-century photographs only partially addressed) justified its use. But as I worked with these news images I eventually discovered unexpected variations. A visual medium that at first glance had appeared superficial and reliant on transparent class, ethnic, and racial stereotypes, that seemed to preserve dominant expressions of power, turned out to encompass differing interpretations and to change over time.[1]

Perhaps because of its mix of the ephemeral, irresolute, commercial, and mass-produced, American illustrated journalism tends to give rise to scholarship located in the interstices between the fields of art, photog-

raphy, and journalism history. Studies of nineteenth-century American popular imagery that favor technological and formalist approaches usually pose photographic realism as the standard for pictorial representation; in this view, the rapid acceptance of and demand for photography after its introduction in the early 1840s relegated the engraved news image to a holding action, frustrating readers who awaited the technology of photomechanical reproduction.[2] This perspective is complemented by approaches in art history that emphasize authorship and artistic intention, viewing most engraved news imagery as the commercial "hackwork," reflecting dominant beliefs, executed by recognized artists on the road to their later mature expression.[3] The historiography of nineteenth-century journalism provides only glimpses of its illustrated weekly practitioners (with the notable exception of Thomas Nast, studies of whom constitute an industry unto itself), usually beginning to consider news illustration only in the late 1880s, when pictures appeared in daily newspapers.[4] Finally, the scholarship of nineteenth-century popular culture places the illustrated press on one side of what has been perceived as an increasingly rigid dichotomy of "high" and "low" practices. Focusing on the illustrated monthlies, such studies render a social map of cultural pursuits in which all pictorial magazines are comparable as purveyors of a genteel, elite ethos: *Harper's Weekly* was *Frank Leslie's* was *Harper's Monthly* was *Scribner's Monthly* . . . with the mischievous exception of the *National Police Gazette*.[5]

The illustrated press has had its outstanding histories, as exemplified in the pioneering work of Budd L. Gambee Jr., Madeleine B. Stern, Robert Taft, W. Fletcher Thompson, and, of course, Frank Luther Mott.[6] But, for the most part, the fate of this medium—both so preponderant in the nineteenth century and, despite the encroaching march of decay, still extensively available in archives, as well as many attics[7]—is as a scholarly form of decoration. The ubiquitous appearance of images from *Frank Leslie's* and *Harper's Weekly* as illustrations in contemporary history books and articles merely serves to corroborate the nineteenth-century lives, events, and conditions discussed in the surrounding text; their use for largely illustrative purposes ignores news images as evidence of a social practice in its own right.[8]

Recent trends in historical inquiry have diminished the isolation of the illustrated press and have blazed an intellectual pathway for the present study. Acknowledging cultural studies' transgression of boundaries of discipline and genre, some art history scholarship has moved beyond the cloistered studio and salon to draw attention to the "vernacular," com-

mercial pictorial realm—from magazine illustration to advertising—
that first emerged out of the milieu of the nineteenth-century city.[9] Some
histories of documentary photography and pictorial genres have revealed
their respective forms' reliance on and resistance to the representational
codes and practices of news engravings.[10] "Cultural materialist" schol-
arship on the British illustrated press has demonstrated how historians
might locate the practice of American pictorial journalism in a broader
cultural and social framework.[11] This approach has resonated in studies
of public art that expand their purview beyond the intentions of the art-
ist to uncover the socially constructed meanings and debates embedded
in the opaque stolidity of commemorative monuments and sculpture.[12]
And the burgeoning historiography of American print culture, which
has particularly emphasized the turn of the century's mass-market mag-
azines (the successors to the nineteenth-century illustrated press), has
applied the insights of social and cultural history to delineate the peri-
odicals' role in the development of consumer society as well as the trans-
action between producers and readers that constituted the form and con-
tent of these publications.[13]

With such exemplary works as a guide, I endeavor in *Beyond the
Lines* to situate the illustrated press, and especially its representations,
firmly within the social context of Gilded Age America. Focusing on
Frank Leslie's Illustrated Newspaper, the publication that set the pattern
for nineteenth-century illustrated journalism, with comparative forays
into the coverage of the competing pictorial press (especially *Leslie's* more
stable and genteel contemporary, *Harper's Weekly*), this study demon-
strates that neither the papers nor their readerships were interchange-
able. Moreover, rather than being a rigid representational form, illus-
trated journalism was constituted by a complex interaction between the
creation and viewing of images that changed over the course of the late
nineteenth century. The change was not the result of the intentions of
sketch artists laboring at the scene of events or of their colleagues in the
newspaper office (engraving's mass production and division of labor un-
dermined any singular vision); nor was it a consequence of photogra-
phy's hegemony. On the contrary, the cause was located in the eminently
social nature of illustrated journalism and its vulnerability to the exigen-
cies of American life after the Civil War. Over the thirty-four years cov-
ered in this study, *Frank Leslie's* pictorial coverage of the news was driven
by a continuous and largely unsuccessful effort to find equilibrium amid
rapid social change, a persistent attempt to encompass the demands of
a broad and diverse "middle" readership that was increasingly charac-

terized by different experiences and perceptions in Gilded Age America. *Frank Leslie's* did not simply reflect in its pages the crises of the Gilded Age; rather, its varying representations *enacted* those crises. In the shifting narratives and social types of its news engravings provoked by the era's volatile class, ethnic, racial, and gender relations, *Frank Leslie's* epitomized the social history of the late nineteenth century.

As a social history of news representation, *Beyond the Lines* is not a detailed chronicle of *Frank Leslie's Illustrated Newspaper* as a publishing enterprise or business, nor is it a biography of the two extraordinary characters named Leslie who ran the publishing house until the last decade of the nineteenth century. Those tasks have been ably accomplished by the likes of Madeleine Stern and Budd Gambee.[14] My emphasis, instead, is on the history of the images that were the paper's most prominent attribute, as I reach beyond the immediate facets of entrepreneurship and personal caprice (influential though they were) to ascertain how the social milieu shaped the practice of illustrated journalism. Having said that, I must add that I have not attempted to conduct a comprehensive survey of *Frank Leslie's* illustrations: news about events abroad, for example, receive only brief attention—in part because many of these images were "derived" from European sources that fell outside the medium's defining relationships of production and viewing.

The method of my inquiry arose from problems of evidence that other scholars of nineteenth-century popular imagery will surely recognize. In contrast to twentieth-century commercial publications, the illustrated press, and *Frank Leslie's* in particular, offer records documenting their day-to-day operations only sporadically. As a result, we are confronted by extensive gaps in our ability to answer elementary questions, such as who composed the papers' personnel, who was responsible for selecting subjects to be illustrated, and how that selection process was structured. And though we must speculate on many aspects of the production of pictorial news, information about the papers' readership is even more tortuously impressionistic. With no extant correspondence files and only the occasional letter published in *Frank Leslie's,* we must turn to the illustrations themselves to locate the weekly's audience and its perspectives. While this strategy may not enjoy the reassuring precision of text (which, as the poststructuralists chide, may serve only to veil its own illusion), it does acknowledge that images are not the antithesis of print culture but an intrinsic part of its nineteenth-century practice: the wood engraving, with its innovative capacity to be set with movable type, was predicated on a popular reading culture even as it relied on a unique

visual language to enunciate views in a different manner than does the word.[15] Moreover, *Frank Leslie's* illustrations provide us with an unusual entrée to deciphering the nineteenth century's pictorial "lexicography," for unlike reproductions of fine art, their primary purpose was informational: they were intended for immediate social use, conveying to the American reading public the people, places, and events that composed the news of the day.[16]

Finally, I should address the question of "authenticity." To be sure, *Leslie's* illustrations were not the direct product of its varied readership. It would not be until the twentieth century, for example, that labor, immigrant, suffrage, and African American papers could afford to include illustrations (or, at least, more than the occasional cartoon). But breaking down visual expression into a Manichaean split between "essentialism" and "appropriation" assumes some "golden mean" of authentic objective representation that commercial visual forms are believed only to obscure. We must await future scholarship on the work—limited as it may have been—of immigrant, working-class, and African American art in the period before we can make any definitive claims. But preliminary studies suggest that "indigenous" expressions (such as cartoons in the immigrant press) relied on similar codes and conventions categorizing subjects into social types.[17] Instead it may be more instructive to heed the art historian Timothy J. Clark's observations about the ways social classes, whether dominant or subordinate, seek meaning in the forms of visual expression available to them:

> [T]here are always *other* meanings in any given social space—counter-meanings, alternative orders of meaning, produced by the culture itself, in the clash of classes, ideologies and forms of control. . . . [A]ny critique of the established, dominant systems of meaning will degenerate into a mere refusal to signify unless it seeks to found its meanings—discover its contrary meaning—not in some magic re-presentation, on the other side of negation and refusal, but in signs which are already present, fighting for room—meanings rooted in actual forms of life.[18]

The contingencies of visual expression in Gilded Age America notwithstanding, artists, engravers, publishers, and readers cooperated and contended in the practice of illustrated journalism. I offer *Beyond the Lines* as one contribution in a collective scholarly effort to recapture the complexity and richness of the popular nineteenth-century pictorial realm.

Pictorial Journalism in Antebellum America

Illustrated papers have become a feature. Every newspaper
stand is covered with them. Every railroad train is filled with
them. They are "object-teaching" to the multitude. They
make the battlefields, the coronations, the corruptions of
politicians, the balls, the race-course, the yacht race, the mili-
tary and naval heroes, Napoleon and William, Bismarck and
Von Beust, Farragut and Porter, Grant and Sherman, familiar
to every one. They are, in brief, the art gallery of the world.
Single admission, ten cents.

Frederic Hudson

With this paragraph, Frederic Hudson embarked on a survey of "the il-
lustrated newspapers" in his 1873 *Journalism in the United States.*[1] In
this first comprehensive history of American journalism, written by the
former managing editor of the *New York Herald,* the illustrated publi-
cations of the Harper Brothers received the most extended consideration.
Yet while Hudson lavished attention on *Harper's Weekly,* he reserved
pride of place and precedence for the decidedly less refined publish-
ing house of Frank Leslie. Hudson could hardly ignore the fact that this
immigrant wood engraver had produced the first successful pictorial
weekly in the United States. Despite the Harpers' subsequent commer-
cial supremacy and emphasis on gentility and literature, it was *Frank
Leslie's Illustrated Newspaper,* first published in 1855, that set the stan-
dard for representing the news in nineteenth-century America.[2]

"The 'illustration' mania is upon our people," the *Cosmopolitan Art
Journal* had warned in 1857. "Nothing but 'illustrated' works are prof-

itable to publishers; while the illustrated magazines and newspapers are vastly popular."[3] By the time Hudson wrote his account fifteen years later, the fruits of Leslie's antebellum innovation in pictorial reportage were readily apparent. To many observers, 1870s America seemed obsessed with printed imagery; the range and breadth of illustrated periodicals had become excessive, threatening to engulf the printed word in (as one historian has put it) a "frenzy of the visible."[4] Newsstands and shops were filled with engraved books and weekly and monthly magazines; building exteriors were obscured by lithographed posters and advertisements; and homes were cluttered with chromolithographed prints, stereograph collections, and photographs. Every event, individual, and product seemed to be represented in the burgeoning marketplace of published images. Speaking for other genteel critics, the *Nation* editor E. L. Godkin equated the vast dissemination of imagery (along with other forms of "pseudo-culture") with the deterioration of a hierarchical moral and social order. Such media, he wrote in 1874, "diffused through the community a kind of smattering of all sorts of knowledge, a taste for 'art'—that is, a desire to see and own pictures—which, taken together, pass with a large body of slenderly-equipped persons as 'culture,' and give them an unprecedented self-confidence in dealing with all the problems of life, and raise them in their own minds to a plane on which they see nothing higher, greater, or better than themselves." America was fast becoming "a chromo-civilization," "a society of ignoramuses each of whom thinks he is a Solon. . . . The result is a kind of mental and moral chaos." Although Godkin settled on the chromolithograph—the popular colored print so ubiquitously visible in household parlors and on postered walls—as his metaphor for the dilution of culture, his fears were in no small part a reaction to Frank Leslie's efforts.[5]

The vast expansion of the pictorial marketplace in the 1870s—most particularly the plethora of illustrated magazines—was perhaps most remarkable because twenty-five years earlier such magazines were almost unknown. In the generation before the Civil War, the nature and number of published images were severely limited; topical news images depicting the events of the day were, for all intents and purposes, nonexistent. When Frank Leslie arrived in New York City in 1848, having spent the previous six years running the engraving department of the weekly *Illustrated London News,* he discovered no comparable news publication in the United States that might require his services.

NEWS IMAGERY IN THE UNITED STATES:
AN UNDERDEVELOPED ENTERPRISE

Pictures, whether original or reproduced, were scarce items in colonial America. But by the mid–eighteenth century, northern colonists had managed to overcome their forebears' puritanical aversion to images, at least to the extent of recognizing the utility of topical pictures in furthering political ends. As the revolutionary crisis intensified, woodcuts and copperplates appeared on Patriot broadsides, almanacs, and newspapers published in northern seaboard cities. However, with the exception of such celebrated and widely copied prints as Paul Revere's 1770 etching of the Boston Massacre, most political imagery—whether Patriot or Loyalist—was imported from Europe and England, where printers engaged in more active pictorial political practice.[6]

In the first decades of the new republic, Americans' appetite for pictures grew. Itinerant portrait painters and limners followed the expanding network of roads into the New England countryside, prompting and feeding rural Americans' interest in decorating their homes with commercial products that denoted affluence and respectability. The favored form of visual consumption was the individual or family portrait, rendered speedily through simplified and conventionalized techniques, that memorialized the ideal domestic matrix. With the perfection of the daguerreotype in 1839, portraitists traded in brushes and boards for cameras and copperplates (and were joined by journeymen looking for a new trade to replace their deteriorating crafts). Fast becoming the de rigueur representation of self and family, the photographic likeness quickly dominated one wing of the pictorial marketplace; traveling daguerreotypists captured the visages of rural Americans while daguerrean studios multiplied along commercial thoroughfares in the cities.[7]

Another wing of the pictorial market catered to the belief that images should instruct the household and sanctify the home. Chromolithographs, produced in commercial shops in northeastern cities and purveyed by traveling peddlers and agents for as little as twenty cents and as much as three dollars, flooded the pictorial marketplace from the 1840s onward. Unlike customized portraits, chromolithographs could be reproduced in the thousands, printed from limestone blocks upon whose surface images had been drawn with greasy crayons, pens, or pencils. The process provided respectable homes with colorful pictures that complemented prescriptions for the domestic cultivation of moral character.[8] According to *The American Woman's Home,* Catharine Esther Beecher

and Harriet Beecher Stowe's popular manual instructing women on how to maintain the middle-class household, children reared amid "such suggestions of the beautiful, and such reminders of history and art, . . . are constantly trained to correctness of taste and refinement of thought, and stimulated—sometimes to efforts at artistic imitation, always to the eager and intelligent inquiry about the scenes, the places, the incidents represented." The scenes, places, and incidents represented were carefully chosen to provide "moral scope and bearing" against the increasing depredations of the "industrial and commercial spirit." Subject matter was meant to promote therapeutic as much as informational ends. "[T]he great value of pictures for the home would be, after all, in their sentiment," Beecher and Stowe instructed. "They should express the sincere ideas and taste of the household and not the tyrannical dicta of some art critic or neighbor." [9] Landscapes, allegorical prints bearing homely mottoes, sentimental rural and urban genre scenes, and still lifes abounding with fruit, fish, and fowl hung in appropriate rooms (each decorated according to its specific theme). Imagery that threatened to overpower the senses, offering visions of life that might upset the equilibrium of sentiment, were unsuitable (a ban extending to the robust works of the Renaissance).

Beecher and Stowe's precepts notwithstanding, topical lithography in the form of portraiture invaded many a parlor. Portraits copied from paintings or daguerreotypes of revered statesmen, soldiers, businessmen, authors, and artists were standard fare in every lithography shop. This business in famous faces, often published in large editions, was supplemented by smaller runs of portraits commissioned by congregations, companies, associations, and sects to commemorate their own local luminaries. But the alliance of moral guardianship and lithography was not necessarily disrupted by the parlor mounting of inexpensive likenesses of illustrious Americans: their careers, if not their glowering visages, emanated instruction down upon impressionable youth.[10]

The exact place where Americans hung "journalistic" prints is harder to discern. The 1846–48 Mexican War bolstered this more dogged sector of the lithography trade: the New York firm of Nathaniel Currier printed some seventy lithographic scenes of the war, most quickly generated to capitalize on public interest in the events and sold in front of the shop or hawked by pushcart salesmen in the city streets. Ranging from crude monochromatic sketches to sumptuous tableaux (many based on eyewitness drawings or paintings), the war prints' appeal was topical and yet—steeped in heroism, nationalism, and romance—not necessar-

ily unfit for the respectable home.[11] The same could not be said, however, for the works produced by lithograph firms that catered to Americans' increasing political partisanship. In the heated political debates of the Jacksonian era, local and national electoral campaigns bristled with pictorial propaganda, principally in abrasive and derisive cartoons and caricatures. These lithographs, apparently produced for the most part by Whig artists such as Henry R. Robinson in New York and David Claypool Johnston in Philadelphia and Boston, may not have hung in genteel parlors, but there was room for them in artisanal workshops, saloons, and party headquarters (and perhaps even kitchens). When not contributing to the exuberant rancor of Jacksonian politics, Robinson, Johnston, and their colleagues produced prints depicting urban scenes and theatrical and sporting events, as well as portraits of popular thespians and sportsmen. The exact audience for such prints is hard to determine, at least as evidenced in the historiography of lithography. But judging from the subjects and style of their work, which at times celebrated the world of cheap amusements and "rough" sports, the market for these urban lithographers included the plebeian population of young male mechanics and laboring women.[12]

Wars and political campaigns might call forth a host of topical prints, but news and contemporary events remained inconsistently covered. It would be left to another medium of reproduction to depict the news. Unlike lithographs, which could not be produced in the same press as text printed from movable type, wood engravings could be locked into forms with hand-set type and printed in the same operation. When the penny press appeared in New York City during the 1830s, wood engraving's compatibility with type prompted its use in illustrating the pages of these innovative newspapers addressed to the "common men" of the Jacksonian era.

Beginning with Benjamin Day's one-cent *New York Sun* in 1833, the daily penny press broke with the structure and practice of the established six-cent papers. Whereas older newspapers such as the *Commercial Advertiser* and *Morning Chronicle* largely ignored daily events and instead served up a steady fare of partisan editorials, advertisements, and commercial notices to their subscription list of elite mercantile readers, the new penny papers enthusiastically embraced everyday news. Paid reporters covered national and local politics, investigated crimes and covered trials, conveyed the gossip of the streets, and pried open household secrets. Reporting the news was defined by many of the editors of the penny press as a mission of democratic education. "[T]he penny press,"

ran a *Sun* editorial, "by diffusing useful knowledge among the operative classes of society, is effecting the march of intelligence to a greater degree than any other mode of instruction." Although Day's *Sun* aimed for readers from the artisan and journeyman ranks and its later rival, James Gordon Bennett's *Herald* (1835) addressed a larger, middle readership, both editors saw their purpose as conveying information to the broad, changing population of the expanding city.[13]

The *New York Herald,* more than any other of the penny newspapers, published news pictures. Beginning with an engraving showing the smoldering ruins of the 1835 fire that devastated lower Manhattan, the paper published occasional news cuts on its front page depicting processions and meetings, crimes and trials, riots and wars, receptions and balls, and, a sign of the times, more fires. Maps and portraits of people in the news—particularly people involved in sensational scandals and crimes—regularly graced the *Herald*'s cover page. More ambitious images appeared infrequently, and when they did—for example, the publication of several cuts illustrating the 1844 lynching of the Mormon Joseph Smith in Nauvoo, Illinois—their provenance was not an eyewitness artist but probably an already-published commercial lithograph of the event.[14]

Competition among the penny papers for readership and advertising revenues increasingly fueled their reporters' pursuit of exclusive news stories. Despite their paeans to "the facts," editors quickly found that to expand circulation, making news could be more effective than merely reporting it. The "sensation" was born, a term coined by Edgar Allan Poe after the *Sun* ran a two-week series of articles during the summer of 1835 delineating an astronomer's discovery of a civilization of winged creatures on the moon. The hoax displayed all the required reportorial conventions of detailed description, demonstrating that the seemingly reliable components of textual reportage could easily be transmogrified into fabrication. The visual codes used to depict news events were equally suspect. When the *Herald* published five detailed cuts on its cover showing New York's 1845 funeral procession honoring Andrew Jackson—the first full-page cover devoted to pictures ever to appear in a daily newspaper—the authenticity of its depiction was immediately challenged (figure 1.1). Rival newspapers claimed that the same engravings had been used to illustrate Queen Victoria's coronation, William Henry Harrison's funeral, and the celebration of the opening of the Croton reservoir. In this case, the *Herald* engraver Thomas W. Strong vehemently maintained authorship of his work, presenting a convincing defense.

Figure 1.1. "Grand funeral procession in memory of Andrew Jackson." Wood engraving, *New York Herald*, June 25, 1845, cover. Prints and Photographs Division, Library of Congress.

Nevertheless, though the penny papers claimed (in the words of the *Herald* admirer) to be "the daily daguerreotype of the heart and soul of a modern republic" casting a democratic light on monopolized news, realism hardly characterized the practice of either textual or pictorial journalism. Or perhaps it is more accurate to say that the realism seemingly inspired by the invention and dissemination of photography may have led to the production of deceptively authentic forms of representation and reportage. While this "operational aesthetic," as such hoaxes and humbugs have been characterized by Neil Harris, may have operated in part as a challenge to the public, actively testing their ability to decipher illusion and reality, the net effect at the very least was general skepticism toward both written and engraved journalistic accounts.[15]

Whatever the verdict about the veracity of their depiction of the news, wood-engraved images of topical events would soon leave the pages of the daily press. Wood engraving presented newspaper publishers with the means to reproduce detailed news imagery but, as we will see below, the process of inscribing the image on the woodblock was lengthy and complicated, and printing large quantities of images proved to be extremely slow and expensive. Faced with such technical limitations, editors like James Gordon Bennett soon opted to reserve the already cramped space of antebellum papers for news in letterpress and paid advertising. Around 1850, the *Herald* dropped illustrations as part of its news format. It was not alone; for the next thirty years, few pictures would appear in the pages of the American daily press.[16]

PIONEERING PICTURES IN THE PAPERS:
THE BRITISH ILLUSTRATED PRESS

The model for what would subsequently become the American illustrated press was to be found not within the borders of the United States but across the Atlantic. At the same time as American newspapers were relinquishing the task of publishing news pictures, the *Illustrated London News* was systematically illustrating events of the day. The engravings that filled the pages of the British weekly were distinctly different from earlier American and British efforts: in their size, detail, placement, and number, these pictures rendered the text secondary.

In the *Illustrated London News*'s first edition on May 14, 1842, comprising sixteen pages with thirty-two engravings, publisher Henry Ingram pronounced a representational mission that was as lofty as it was ambitious:

We know that the advent of an Illustrated Newspaper in this country *must* mark an epoch—give wealth to Literature and stores to History, and put, as it were mile-stones upon the traveled road of time. . . . The life of the times—the signs of its taste and intelligence—its public monuments and public men—its festivals—institutions—amusements—discoveries—and the very reflection of its living manners and costumes—the variegated dresses of its mind and body—what are—what *must* be all these but treasures of truth that would have lain hid in Time's tomb, or perished amid the sand of his hour-glass but for the enduring and resuscitating powers of art—the eternal register of the pencil giving life and vigour and palpability to the confirming details of the pen.[17]

The promotional hyperbole notwithstanding, this declaration of the *Illustrated London News*'s intent to become the recorder of the age fit comfortably within the reigning ideology of representation in Victorian England. First articulated by Sir Joshua Reynolds in his *Discourses on Art* published between 1769 and 1790, this reinterpretation of seventeenth-century Franco-Italian theory erected a hierarchy that placed academic history painting at the summit of the arts. The cultivation of such art, in Reynolds's schema, would bestow moral benefits on the nation through the "contemplation of universal rectitude and harmony." Commercial ventures like the *Illustrated London News* took the next logical step, linking representations of contemporary events to the canonical pictorial chronicle of British history. As popular publications the illustrated press might not be the exact embodiment of the ideal, but by making art accessible to the public via wood engravings—which had been perfected as a practical method of visual reproduction by the English craftsman Thomas Bewick in the last decades of the eighteenth century—they conveniently conflated the laudatory goals of moral education with leisure pursuits.[18]

The pictures representing the news published in the *Illustrated London News* tended to support its lofty aims. Impressive panoramic views of London, the architectural detail of each building exquisitely rendered, alternated with views of exotic foreign locales and colonial holdings. The pursuit of knowledge was upheld in cuts of scientific expeditions and archaeological digs, and the cultivation of culture in the depiction of theatrical events and exhibitions. The doings of the royal family (including the repeated attempts on Victoria's life) received the paper's rapt attention, and there was a constant flow of portraits of leading statesmen and men of letters. Spectacular fires were complemented by equally fascinating battles; coverage of the Crimean War would raise the circulation of the *Illustrated London News* to more than 100,000.[19]

But the *Illustrated London News*'s mission tended to restrict its vision of British society. In its formulation of pictorial reportage, anything that did not contribute to the elevation of morals and sentimental education failed to constitute news. The *Illustrated London News* lovingly recorded the progress of London's urban development, cluttering its engravings with exhibition halls, churches, and asylums; the activity in the surrounding streets was equally well-ordered and curiously devoid of the chaos and diversity of urban life in the 1840s. The crowds of the busy capital contained a sprinkling of stock types, including fashionably dressed women, itinerant tradesmen, and the requisite town criers.[20] What these engravings failed to convey was readily apparent to critics like Charles Knight, publisher of the *Penny Magazine,* the pioneering illustrated reform weekly dedicated to the popular dissemination of knowledge:

> The staple materials for the steady-going illustrator to work most attractively upon are, Court and Fashion; Civic Processions and Banquets; Political and Religious Demonstrations in crowded halls; Theatrical Novelties; Musical Meetings; Races; Reviews; Ship Launches—every scene, in short, where a crowd of great people and respectable people can be got together, but never, if possible any exhibition of vulgar poverty.[21]

It was permissible to portray the less laudable fruits of industrialization as long as those scenes were set on the Continent. Readers might observe the poverty of the laboring poor or class warfare in France and Germany in 1848; but England remained tranquil and prosperous. There were a few occasions when social turmoil was depicted—such as an attack on a Stockport workhouse or a Chartist riot in Halifax in August 1842— but these engravings served only to support the overall vision of a largely ordered society.

This idealized, restricted view was grounded on a canny consideration of what would attract a readership sizable enough to support the expensive operation of a pictorial paper. The *Illustrated London News* perceived its primary patrons to be the "respectable families of England" who would prefer "the purity of our columns inviolate and supreme."[22] Ingram and his colleagues could not have failed to notice the prosperity of British publishing houses that catered to a bourgeois readership hankering for genteel "family" books and magazines. The *Illustrated London News*'s adherence to the wishes of such a market quickly proved commercially justified. By the end of its first year, it had attracted 66,000 readers. The numbers reached 130,000 in 1851, when the paper devoted excessive coverage to the Great Exhibition, chronicling every stage in the construction of the Crystal Palace. Although readers would enthusias-

tically purchase the weekly during the subsequent Crimean War campaign, circulation failed to reach the heights achieved during the Great Exhibition. Soothing, uplifting images of current events seemed to be what the *Illustrated London News*'s respectable readership preferred. Circulation had reached 300,000 by 1863—a time when the readership of the country's foremost daily newspaper, the *London Times*, totaled 70,000. Within a year of its first edition, the *Illustrated London News*'s success prompted the inauguration of similar publications on the European continent, principally *L'Illustration* in Paris and *Illustrirte Zeitung* in Leipzig.[23]

An alternative Hogarthian tradition challenged the Reynoldsian vision, but in commercial practice its social reportage was largely restricted to comic magazines, notably *Punch* (1841), where humor and the use of caricature and social typing mitigated the sting of depiction.[24] More direct graphic reportage existed in small-circulation magazines with committed reform readers. However, one illustrated paper briefly challenged the *Illustrated London News*'s dominance of representation: frustrated by the blinkered and pious view of the periodical he had helped co-found, Henry Vizetelly joined forces with Andrew Spotiswoode in 1843 to publish the *Pictorial Times*. With an eye on reform goals, the paper strove to depict the conditions of working-class life in England and Ireland in the hopes of prodding its readers into action. Explaining the intent behind publishing engravings that showed the effects of tenant oppression and famine in Ireland in 1846, the *Pictorial Times* stated: "We wish, so far as possible, to annihilate distance, to bring our readers into contact with the peasantry of the sister isle, and to contribute our part to the urging of appropriate means for the amelioration of their wretched condition." Laudatory as its aims were, the *Pictorial Times* was unable to attract enough readers to maintain its operations and collapsed in 1848 under a debt of £20,000.[25]

At least one member of the London weekly's staff was as much impressed by his employer's continuing popularity and profits as he was by the grinding work schedule required each week to get the periodical out on time. Looking at the *Illustrated London News*'s commercial success, the young employee could imagine what might be accomplished in the potentially even more lucrative market of the United States.

The ambitious artist-engraver in question was a portly young man in his mid-twenties named Henry Carter. Born in Ipswich, Suffolk, in 1821, in early adolescence Carter distressed his father by displaying a predilection for the marginality of the arts. As far as Joseph Leslie Carter

was concerned, young Harry spent entirely too much time drawing pictures and haunting Ipswich wood-turning and silversmith shops. Instead of attending to his father's glove manufacturing business (the largest of a number of small factory enterprises run by the family), by thirteen Henry Carter had settled into an intensive pursuit of wood engraving. When Carter reached seventeen, his father sent him off to London to sit behind the glove counter at his uncle's wholesale dry goods firm. Unsurprisingly, London provided the youth with a golden opportunity to defy his father's wishes and follow his own. Brashly borrowing his father's middle name, Carter adopted the *nom de crayon* of "Frank Leslie" and began hawking drawings and engravings to cheap London printers and publishers. Carter endured three years behind the glove counter, but in 1841 he decided to break with his family and take up engraving full-time. He seemed to compound his risky decision by marrying Sarah Ann Welham that same year, but whatever financial problems the young couple may have experienced were short-lived, due to the fortuitous appearance of the *Illustrated London News.*[26]

Carter was hired to work in the *Illustrated London News*'s engraving department. With little experience, he probably received a fraction of the salary paid to older staff engravers; though they were subordinate to artists in status, the expanding pictorial market netted engravers high pay and a measure of independence. Still, he distinguished himself by displaying, in his youthful zeal, the kind of speed, dexterity, inventiveness, and self-exploitation that were indispensable in running an illustrated newspaper. Within a short time Carter was in charge of the engraving department. For six years he learned all of the tricks and pitfalls of producing news imagery on wood—also noting how the *Illustrated London News* continued to garner more readers and make greater profits. Carter began to form an ambition to run his own illustrated newspaper. But the prospects for an independent venture in England seemed unpromising; Carter possessed little capital and the pictorial market was glutted with illustrated papers. The fate of the *Pictorial Times,* the *Illustrated London News*'s scrappy competitor, undoubtedly suggested to Carter that if he was setting his sights higher it was perhaps best to do so across the Atlantic.[27]

FRANK LESLIE MEETS THE AMERICAN PICTORIAL PRESS

Having secured his reputation as an engraver with the name "Frank Leslie," on his arrival in New York in 1848 Henry Carter adopted the

pseudonym as his American identity. The engraving shop he opened at
98 Broadway under his new name immediately attracted the attention of
aficionados of the craft. One of his early admirers was Phineas T. Bar-
num, who may have been less concerned with the aesthetics of Leslie's
work than with its potential for publicity. In fact, it was probably Leslie
who approached Barnum in 1849, just as the showman was beginning
to promote the upcoming Jenny Lind tour. Leslie convinced Barnum
that he was the man to produce a lavishly illustrated program to be sold
at the Swedish Nightingale's concerts, a scheme that no doubt contrib-
uted to the $500,000 in profits Barnum garnered from the overall ven-
ture. After producing the contracted engravings, Leslie joined the whirl-
wind 1850–51 tour, gaining in his travels a vivid impression of the
potential public for an American illustrated newspaper as he also mas-
tered the fine art of promotion.[28]

While Leslie traveled about the United States, the first American pic-
torial weekly was inaugurated in Boston in May 1851. Produced by story-
paper publisher Frederick Gleason and sold by subscription for three
dollars a year, fully half of the sixteen pages composing *Gleason's Pic-
torial Drawing-Room Companion* contained engravings. Appearing on
alternate page-spreads, the cuts presented a "faithful delineation of men
and manners, all over the world, its perfect transcript of ancient and
modern cities, its likenesses of eminent characters, its geographical illus-
trations of scenery and localities, and, in short, its illustrations of every
notable current event[.]"[29] However, *Gleason's* endeavor to pictorially
represent "every notable current event" was mediated by a definition of
news that must have seemed familiar to Frank Leslie. Bracketed by edi-
torials, essays, short stories, and serialized novels laden with religious
and moral themes—appropriate to the family drawing room—*Glea-
son's* engraved record of American events sharply curtailed its vision in
a manner that replicated both the format and the conventions of the *Il-
lustrated London News*. To be sure, the occasional riot appeared and
there was always the requisite cut of a disastrous fire, but newsworthy
coverage was largely limited to events such as Commodore Perry's de-
parture for "the Orient" or Hungarian patriot Louis Kossuth's reception
in the United States.

One of the most striking indications of *Gleason's* blinkered view was
a December 1852 engraving of an "Irish Harvest Scene, in Kilkenny, Ire-
land," depicting "a group of laborers in the harvest field partaking of re-
freshments after the labors of the day" (figure 1.2). This rendition of a
bucolic idyll, occurring during the Irish famine, was peculiar enough to

Figure 1.2. "Irish harvest scene, in Kilkenny, Ireland." Wood engraving, *Gleason's Pictorial Drawing-Room Companion*, December 11, 1852, 380. American Social History Project, New York.

force a begrudging editorial concession: "It is true that many parts of Ireland have become very nearly deserted by reason of the extensive emigration to this country; but," *Gleason's* hastily added, "there are still, as our picture represents, smiling harvest fields and happy laborers there, still rich fields of ripened grain, and richly laden storehouses of prolific yields." [30]

By the time *Gleason's* engravings, so emulatory of academic history painting, reached readers, the events they depicted were indeed securely anchored in the past. The process of engraving a single four-column boxwood block from which an image was printed was lengthy and costly: it took from three to four days for an artist to render a drawing in reverse on the boxwood surface, and then a single engraver labored ten to fourteen days to prepare the block for printing, all at a cost of forty to fifty dollars for each engraving. To make matters worse, skilled engravers were not readily available and the final result was not always successful. "We really owe our readers an apology for the miserable character of the picture on the first page of the last number of our paper," *Gleason's* lamented to its readers in one August 1851 edition. "It was miserably engraved, and we shall take care to print no more so deficient in this respect." In January 1852, a notice "To Wood Engravers" appeared on the editorial page, calling for "a few more experienced hands well acquainted with the business of fine wood engraving, who can find constant em-

ployment, by applying at our office." [31] Returned from his sojourn with Barnum, Frank Leslie was one of a number of skilled engravers who answered the call. "Leslie Sc" would appear regularly at the bottom of some of the more ambitious engravings (with "sc" an abbreviation of the Latin *sculpsit* or *scalpsit,* meaning "sculpted by"—"sculptor" being an archaic term for engraver). By the next volume, *Gleason's Pictorial* could announce a decided improvement in the appearance of its engravings and the commensurate increase of its circulation to 100,000. Frederick Gleason was now realizing $25,000 in profits, but by then one of his more valued employees had moved on.[32]

In the fall of 1852 Leslie was back in New York and was once again engaged in a Barnum project. This time it was a pictorial weekly called the *Illustrated News,* published by Barnum in partnership with Henry D. and Alfred E. Beach, the sons of the *New York Sun*'s publisher, Moses Y. Beach. Inaugurating a New York paper seemed like a sound business proposition to Barnum and his partners even though another pictorial weekly had collapsed earlier in the year. That ill-fated venture was the *Illustrated American News,* founded by the former *Herald* engraver T. W. Strong, which had appeared in June 1851, close on the heels of *Gleason's Pictorial.* Though Strong was more inclined than his Boston contemporary to cover current news, his ambitions were nevertheless thwarted by the same lengthy engraving process. Within ten months, the field was again open for another adventurous or unwary entrepreneur. Barnum probably hoped that his publication could surmount the problems of its predecessor under the sure hand of an *Illustrated London News* veteran, but when he proposed Leslie for the post of general manager of the New York weekly, offering in return to double his investment of $20,000, his partners demurred.[33]

The *Illustrated News* began publication on January 1, 1853, with Leslie as its chief engraver. In the ensuing months its circulation reached 70,000. The numbers were satisfactory (apparently forty to fifty thousand readers were enough to ensure a profit), but operating a weekly pictorial newspaper proved to be a frustrating experience for the investors. There never seemed to be enough suitable boxwood, artists experienced in pictorial production always seemed wanting, and by the time the *Illustrated News* published its engravings the news they depicted was stale. "Numerous and almost insurmountable difficulties, for novices in the business, continued . . . to arise," Barnum would later recall, "and my partners becoming weary and disheartened with constant over-exertion, were anxious to wind up the enterprise at the end of the first year."

Eleven months after its first appearance, Barnum and his partners re-couped their investment; they sold their store of engravings to *Gleason's Pictorial* and ceased publication of the *Illustrated News*.[34]

Frank Leslie was not about to return to Boston. With the limited cap-ital he had managed to accumulate during his six years in the United States, he embarked on his own publication. Recent experience and the limits of his income dictated a less risky venture than an illustrated weekly; casting an eye toward the continuing success of women's maga-zines, he managed to persuade the novelist Ann S. Stephens to leave her longtime editorship of *Peterson's Ladies' National Magazine,* and in Jan-uary 1854 *Frank Leslie's Ladies' Gazette of Fashion and Fancy Needle-work* was inaugurated. The illustrated twenty-five-cent monthly, bal-ancing cosmopolitan gossip and sentimental instruction, quickly gained a dedicated readership. At the end of the year, Leslie was able to pur-chase a foundering story paper, the *New York Journal of Romance,* to which he added his name and more lavish engravings. By January 1855, Leslie could savor his rapid ascent as a publisher of two prospering women's magazines; yet his primary goal remained unattained. Try as he might, he could not attract investors to such a seemingly foolhardy scheme as a weekly illustrated newspaper. Displaying the blend of im-petuousness, incaution, and canniness that would characterize his entire career in publishing, as he seesawed between financial success and dis-aster, Leslie decided to establish a paper using his own meager stock of capital. On December 15, 1855, he published the first issue of *Frank Leslie's Illustrated Newspaper*.[35]

NEW CONDITIONS FOR AN ILLUSTRATED PRESS

On first reflection, one might conclude (borrowing the parlance of his time) that Leslie's impetuousness and incaution had overwhelmed the other traits in his character. The history of the illustrated press in Amer-ica, as he must have been aware, was marked by discontinuity and eva-nescence. But in fact, the time was ripe for pictorial journalism: by the mid-1850s the transportation revolution, innovations in printing tech-nology, and an expanded literary and pictorial market came together to provide almost all the conditions necessary for a commercially viable il-lustrated press.

The American population quadrupled during the first half of the nineteenth century through a combination of natural increase, immigra-

tion, and the acquisition of new territories. Over three-quarters of the 23 million people living in the nation in 1850 could read and write. The spread of literacy occurred in tandem with profound changes wrought by the transportation revolution and the rise of industrial capitalism, altering social relations from the family to the workshop. Americans endeavored to position themselves in this shifting social landscape; whether heeding evangelical calls for the improvement of self and scion or wishing to defend themselves against the exigencies of the industrial capitalist economy, a broad "middle" public grew thirsty for knowledge. By the fourth decade of the century, books, magazines, and newspapers were traveling via road, canal, and rail to an unprecedented national reading public.[36]

The 1850s also marked a decisive realignment in the structure of American publishing. The balance shifted from a localized, undercapitalized printing industry to centralized manufacturing by large publishers located in New York, Philadelphia, and Boston for a national audience. As publishing restructured into a culture industry of large, heavily capitalized firms, it became like other trades. Along with books, new magazines marked out specific reader territories across the nation. Their dissemination was aided by improved transportation and new postal regulations that lowered the costs of distribution; moreover, technological innovations, such as steam printing presses and new paper-making machinery, lowered costs and sped up production. Innovations in paper technology were particularly important: the substitution of wood pulp for rag in 1843 gave publishers an unlimited supply of cheap paper for the new popularly priced periodicals. Two other advances benefited the daily press and purveyors of weekly news like Leslie: by the early 1850s, the telegraph linked more than five hundred American cities in a vast system of wires that hurtled information across the nation; the completion of the transatlantic cable in August 1858 made international news equally accessible and immediate.[37]

By the end of the decade, Frank Leslie would become one of the most prominent of the new magazine publishers that supplanted the earlier periodicals and publishers of the Jacksonian era. But the Harper Brothers' New York book publishing firm was the first to industrialize the printing process and exploit the new technology, enabling it to reach a national reading public.[38] Perhaps most important, Harper Brothers demonstrated the crucial role of pictorial representation in the success of a new generation of periodicals.

At its inception in 1850 *Harper's Monthly Magazine* was viewed by the publishing house as a convenient vehicle for its literary business, which had been built on the reprinting of popular English novels; the magazine would draw material from its books and, in turn, would serve as a source for future publications. Each 144-page issue of the new magazine presented a literary miscellany of serialized and short fiction, poetry, biography, travel accounts, historical essays, humorous sketches, and scientific articles by established Harper authors. But the engravings that supplemented these writings, illustrating stories as well as famous people, places, and events, soon proved to be as important as the text in drawing readers to the magazine. Starting with a meager offering of eight engravings in the first issue, the number of illustrations grew in subsequent issues along with *Harper's Monthly*'s circulation. In 1853, with a readership of more than 100,000, Harper Brothers decided to increase significantly the number of engravings. The outlay of $24,000 for the 356 pictures that appeared during that year was offset by the economies of scale enjoyed by a publishing house that could reuse illustrations in other publications—and by the 35,000 new readers that they attracted. "Probably no magazine in the world was ever so popular or so profitable," grumbled the rival *Putnam's Monthly* in 1857.[39]

Harper's Monthly—and Harper Brothers' publishing house—seemed to set the standard for the publication, appearance, and contents of the illustrated magazine in the United States. Aimed at a broad literate public, the Harpers assiduously kept the contents of their magazine above reproach and thus away from the news. Appearing in 1850, *Harper's Monthly* embodied the conciliation attempted by the political compromise of that year that maintained the balance of power between North and South, averting a national crisis.[40]

When he entered the fray five years after the appearance of *Harper's Monthly*, Leslie aspired to something less rarefied, less aloof from the events of the day. His decision to publish a pictorial newsweekly would prove prescient, but his immediate prospects remained hazardous. *Frank Leslie's Illustrated Newspaper* appeared at a critical if still not fully defined moment: all of the conditions for perpetuating an illustrated press were not yet in place. The first years of the paper's existence were marked by instability. During that time Leslie devised his approach to addressing the reading public and overcame major technical problems. But it would be the final phase of the struggle over slavery, a national crisis drawing large numbers of readers to the pictorial representation of the news, that would firmly establish pictorial journalism in America.

FRANK LESLIE'S ILLUSTRATED NEWSPAPER:
THE FIRST FIVE YEARS

Operating in its first year out of cramped offices on Spruce Street, *Frank Leslie's Illustrated Newspaper* managed to be a convincing pictorial version of a weekly newspaper. What it may have lacked in depth of coverage *Frank Leslie's* made up for in breadth: the engravings that appeared on the cover and alternating spreads of its sixteen quarto pages included enthusiastic depictions of William Walker's marauding filibusters in Nicaragua and of the retributive actions of the Vigilance Committee in San Francisco. News of a less illicitly political nature (if one excludes Preston Brooks's physical assault on Charles Sumner on the floor of the Senate) included the congressional turmoil over Kansas and, later in 1856, the first extended pictorial narrative of a presidential campaign (with a decided bent, despite *Frank Leslie's* claims to political neutrality, toward the Democrats). European reportage focused primarily on the Crimean War; the engravings' subject matter, dashing soldiers and romantic war scenes, indicated their provenance in the *Illustrated London News*—a source to which *Frank Leslie's* would regularly resort, without acknowledgment, in its early years. In addition to national and international news, *Frank Leslie's* also regularly covered the New York theater; in the first year, portraits of popular actors and engravings of scenes from plays were balanced with a pictorial series on the city's Protestant churches and clergy (although articles sympathetic to the Catholic Church also appeared).[41]

Leslie's boldly claimed to be attracting readers, but the decision at the end of its first year to lower its price from ten to six cents, and its annual subscription rate from four to three dollars, suggested that circulation was insufficient to maintain the paper's operation. At that time Leslie also began to drastically rearrange the contents and design of the weekly; by February 1857, with serialized fiction, short stories, miscellaneous columns, and "borrowed" pictures filling three-quarters of each issue, *Frank Leslie's* was threatening to become a slightly less pristine version of *Gleason's Pictorial*. Leslie would later relate his desperate search for funds to buy paper for an issue or to pay his staff's weekly salary, resorting on more than one occasion to the largesse of an unnamed friend (who, on Leslie's third successive loan request, remarked, "Don't you think you had better give it up?").[42] This romantic portrayal of the publisher, often repeated after Leslie's death in official biographies, conveys his determination but glosses over his monomaniacal obliviousness. On

one occasion, after a three-week hiatus in pay—Leslie having spent the funds instead, according to Thomas Nast's biographer Albert Bigelow Paine, on the purchase of a yacht—the art staff went out on strike. The outcome of that particular confrontation remains unrecorded, but Leslie's flamboyance and exploitation continually exhausted the patience and goodwill of his employees. Beginning with the British essayist and poet Thomas Powell, he ran through a succession of chief editors and young artists, accumulating a host of former associates who would later express deep respect for Leslie's talent along with an equal measure of ambivalence about his disregard for the consequences of his actions.[43]

Frank Leslie's fortunes changed dramatically in mid-February of 1857. As Leslie later recalled, he awoke one morning to hear

> the newsboys crying a shocking murder. It was that of Dr. Burdell, the Bond-Street dentist, which, as you know, stirred all New York, and which, by the mystery surrounding it and the proceedings which followed, became a *cause célèbre*. . . . I seized upon this incident. I caused exact illustrations to be made of the minutest detail, and to be published immediately. The sales of the *Newspaper* rose enormously, and when the excitement subsided, enough new purchasers stuck by it to put the paper beyond any fear of failure.[44]

Joining the other city papers' feverish coverage, *Leslie's* devoted most of its illustrated pages in February to depicting the principals in the case and the scene of the grisly crime as well as one particularly gruesome engraving of the victim's slashed heart and four re-creations of the murder itself. A month later *Frank Leslie's* lavished equal attention on James Buchanan's inauguration; the first illustrated coverage of the ritual of presidential office, though a less sensational subject, garnered increased sales.[45]

Leslie chose to remember 1857 as a turning point. Indeed, as sales improved, news once more became dominant in *Frank Leslie's* pages; much of the fiction it had been publishing found a home in *Frank Leslie's New Family Magazine* (which absorbed the *Gazette of Fashion*, Leslie's first publication). In August Leslie also instituted *Frank Leslie's Illustrirte Zeitung*, a German-language edition of his illustrated newspaper; Leslie claimed that within a year it was reaching 50,000 readers. But 1857 also saw two new obstacles drop in the path of Leslie's fortunes. The first and more long-lasting problem was the Harper Brothers' new illustrated newspaper, *Harper's Weekly*, which began publication in January. By the end of the year, the *Weekly* was publishing as many engravings as *Frank Leslie's* (if depicting fewer news events) at five cents an issue. Leslie resorted to vituperative attacks on his rival, vaunting his paper's de-

votion to news over the *Weekly*'s more literary and genteel content. "We forgive them their feeble assault on us," a comparatively mild December *Frank Leslie's* notice ran, "and only ask that they will continue on in the way they have begun, and their journal . . . may serve . . . as a foil in its old-fogyishness to our energy and enterprise."[46] Leslie endeavored to cover the news more assiduously, but competition from *Harper's Weekly* was soon exacerbated by the economic panic that swept the country in the fall.

The panic of 1857 ruined many of the periodicals that had been published in the United States during the previous decade. Among its victims was *Ballou's Pictorial Drawing-Room Companion,* the successor to Frederick Gleason's Boston weekly, which had been purchased in 1854 by its editor, Martin Ballou. As circulation fell in the wake of the panic Ballou progressively cut back the number of engravings until his publication's final issue, dated December 24, 1859. To the last, *Ballou's Pictorial* ignored "sordid" news, failing to illustrate, let alone mention, John Brown's execution on December 2. In contrast, *Frank Leslie's Illustrated Newspaper* continued to prosper during the hard times.[47] According to its own figures (an admittedly dubious source), circulation rose to 90,000 during 1858, with special editions reaching as high as 130,000. Circulation was probably helped by *Leslie's* increased news coverage, which included pictorial reports of the effects of the depression in New York. But it was the "swill milk" campaign that attracted readers during 1858 to 1859 and signaled a turn to a new activist policy in pictorial reporting.

The unhealthy condition of New York dairies, where cows were fed on distillery mash that stimulated milk production as it inexorably destroyed the animals, had long been the target of ineffective newspaper criticism and complaints of sanitary reformers. Leslie embarked on a concerted pictorial campaign, depicting sore-ridden, dying beasts in befouled barns; it detailed not just the deterioration of animals and the unsanitary conditions of milk production but also the stalwart artist-reporter at work—joined in one cut by his indomitable employer (figure 1.3). Aroused by these images, which appeared month after month, public pressure eventually overcame the sloth of city officials (who, to their consternation, soon found themselves pictorial subjects in *Frank Leslie's*) and led to the passage of an 1861 New York state law regulating dairy production. The swill milk campaign demonstrated the effectiveness of images in stimulating public outrage and reform. Pursuing a policy that departed utterly from the example set by the *Illustrated Lon-*

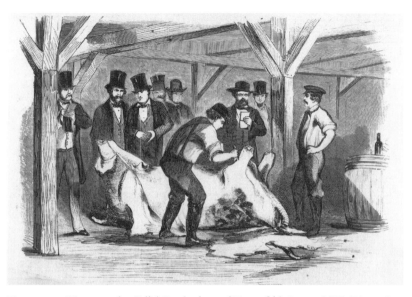

Figure 1.3. "Scene at the Offal Dock, foot of Forty-fifth Street, N.Y. Dissecting the cow brought from the 16th St. Swill Cow Stables." Wood engraving, *Frank Leslie's Illustrated Newspaper,* May 22, 1858, 385. Prints and Photographs Division, Library of Congress.

don News, Leslie also discovered that combining self-promotion and reform drew readers.[48]

During the next two years *Frank Leslie's* would energetically pursue sensation and revelation. While its pictorial coverage of the lurid murder case involving New York congressman Daniel Sickles was predictable (momentarily raising circulation to 200,000), *Leslie's* depictions of the Pemberton mill collapse in Lawrence, Massachusetts, and the 1860 Lynn shoemakers' strike staked out new territory for illustrated journalism (figure 1.4). In the latter two cases, the weekly focused attention on industrialization, its abuses and disruptions; it added a new visual dimension to a growing debate that, in the realm of publishing, had largely been carried out in text.[49] *Leslie's* greatest promotional feat, however, occurred in April 1860 when chief artist Albert Berghaus was dispatched to England to cover the eagerly anticipated bare-knuckle bout between the British champion, Tom Sayers, and his American challenger, John C. "Benecia Boy" Heenan. *Leslie's* exhibited its superior organizational, if not reportorial, skills by publishing a special London edition one day after the fight. While *Leslie's* pictorial competitors were still reeling (in-

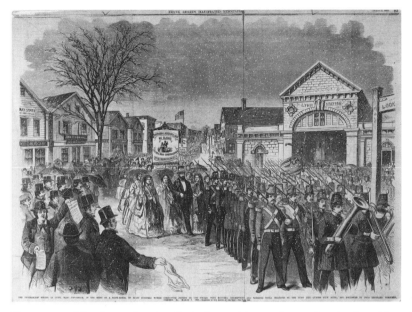

Figure 1.4. "The shoemakers' strike in Lynn, Mass.—Procession, in the midst of a snow-storm, of eight hundred women operatives joining in the strike, with banners, inscriptions, and working tools, preceded by the Lynn City Guards with music, and followed by four thousand workmen, firemen, &c., March 7, 1860." Wood engraving, *Frank Leslie's Illustrated Newspaper,* March 17, 1860, 242, 251. Prints and Photographs Division, Library of Congress.

cluding the five-month-old New York *Illustrated News,* which had sent the former *Leslie's* employee Thomas Nast to draw the match), the engravings of the gory forty-two-round fight were rushed across the Atlantic; *Leslie's* New York edition sold 347,000 copies. Although the *Illustrated News* cried foul, and later testimony would reveal that the pictures had been sketched in New York and largely engraved beforehand in London, the fact that *Frank Leslie's* had delivered timely pictures seemed to reinforce its claim of dominance in the field.[50]

Leslie had learned that pictorial calls for reform and reportorial stunts attracted readers. Circulation grew—142,000 by the beginning of 1860, *Frank Leslie's* fifth year—yet readership remained undependable, a fibrillating heartbeat strengthened by steady infusions of promotion and revelation. As *Leslie's* constantly pursued readers and news that would attract them, its publication schedule grew erratic, provoking the ire of a prominent wholesale newsdealer. In a March 1860 circular letter to its customers, the firm of Ross and Tousey complained that

we find it utterly impossible to get our supplies of that paper with any satis-
faction to ourselves, or justice to our customers. Since the establishment of
The New York Illustrated News, Mr. Leslie has published his paper very ir-
regular, sometimes on Saturday, sometimes on Sunday, Monday, Tuesday,
&c., his old publication day having been changed to keep up with the news.
In his anxiety to get out his paper as soon as the other, he now publishes it
as soon as he gets a few hundred printed, and then commences a struggle
among the dealers for their supplies, many of us keeping two or three hands
at his press watching and fighting for the papers. We, as well as the other
dealers, are sick and tired of this kind of work, and shall submit to it no
longer.[51]

It would be *Frank Leslie's* coverage of the growing sectional conflict,
however, that would finally secure a public for the pictorial press.

As soon as news of John Brown's raid on Harpers Ferry reached New
York in October 1859, Leslie dispatched staff artists and writers to Vir-
ginia. Steeping its pictorial reportage in the crisis, the paper was careful
to eschew any hint of partisanship as it attempted to avoid alienating
any of its readers. Its strategy, in the ensuing weeks, was predicated on
an unprecedented flow of imagery, supplemented by detailed descrip-
tions of how the paper was serving the public's hunger for pictorial news
of the raid and of John Brown's subsequent capture. *Leslie's* focus on the
developing events in Virginia outstripped its competitors in the sheer
quantity of engravings that depicted, week after week, the trial and, ul-
timately, John Brown's execution. Although the Virginia-born artist for
Harper's Weekly, David Strother (better known by his *nom de plume*
"Porte Crayon"), was the first reporter on the scene at Harpers Ferry
and gained unequaled access to the trial, his drawings of the execution
were never published in the paper, which had grown wary of the vitu-
peration provoked by its pictorial coverage. The New York *Illustrated
News,* established by John King in November 1859, covered only the
grim climax of the story. *Leslie's* John Brown coverage inevitably aroused
the anger of southern sympathizers who saw such extensive reporting as
serving abolitionist ends; nonetheless, the pictorial representation of the
escalating national crisis helped *Leslie's* attain a consistent readership.
By the 1860 presidential campaign, *Leslie's* was devoting all of its illus-
trated pages to news, though the weekly neglected Abraham Lincoln's
rise to prominence. The dominance of engravings depicting the Demo-
cratic campaign seemingly had no effect on *Leslie's* circulation, which in
1860 stood at 164,000.[52]

In February 1860 Leslie moved his operations from his second lo-
cation (on Frankfort Street) to a more resplendent site at 19 City Hall

Square, along Chatham Street. Within the new five-story building (shared with the *Daily News*), *Frank Leslie's Illustrated Newspaper* stood at the heart of a thriving publishing concern that kept 130 editors, artists, engravers, and writers constantly busy, yielding a yearly income of $500,000.[53] Now both in name and substance a pictorial chronicle of contemporary American events, *Frank Leslie's Illustrated Newspaper* was established as the leading source of pictorial news in the nation.[54]

Illustrating the News

Then, there comes the artist of a picture newspaper, with a foreground and figures ready drawn for anything, from a wreck on the Cornish coast to a review in Hyde Park, or a meeting in Manchester,—and in Mrs. Perkins' own room, memorable evermore, he then and there throws in upon the block, Mr. Krook's house, as large as life; in fact, considerably larger, making a very Temple of it. Similarly, being permitted to look in at the door of the fatal chamber, he depicts that apartment as three-quarters of a mile long, by fifty yards high[.]

Charles Dickens

Describing the pictorial coverage of the singular demise (via spontaneous combustion) of the loathsome Krook in his 1853 novel *Bleak House,* Charles Dickens cast an eye on the accuracy and skill of the new profession of the artist-reporter that was almost as jaundiced as the one he aimed at the British legal profession.[1] His derision was no doubt fueled by the speed with which such news images moved from, in Dickens's view, the fallible hand of the artist to the credulous eye of the public. With an impressive dependability, the sixteen-page weekly *Frank Leslie's Illustrated Newspaper* (often accompanied by supplements and special editions) arrived on newsstands and through the mails with its collection of engravings depicting the events and personages of the previous week.[2] Supplementing daily press coverage, the pictures in *Frank Leslie's* added palpability to the news, displaying the faces of noted individuals, the contexts and content of events. The paper's contribution to reporting lay in its rapid visualization of the topical and in its transformation

of news into a detailed pictorial narrative provided by a new type of journalist, the artist-reporter or "special artist." In its first years, *Leslie's* drew on the talents of a number of young artists, many of whom gained experience in a new trade while enduring an incessant work schedule and low pay. For the most part, after a short time both established artists like the painter Jacob Dallas and newly seasoned "amateurs" like the precocious Thomas Nast moved on to other publications, though several returned occasionally for brief assignments.[3]

Although *Leslie's,* like other illustrated papers, proclaimed—and, as we will see, defended—the authenticity of its images as "eye-witness" recordings of events, the significance of the special artist's work was, in fact, not predicated on direct observation. Rather, much like the "traditional" print journalist, the artist-reporter usually formulated his report (at this time, all the special artists were men) after diligently collecting information. To be sure, artists were dispatched to cover "predictable" events such as receptions, rallies, and other public and private ceremonials;[4] sudden local incidents such as fires, floods, and other disasters usually lasted long enough to permit the hasty dispatch of an on-the-spot recorder. But it is safe to say that most of the artist-reporters' work—including that of the broad network of corresponding artists who mailed in their sketches of distant news[5]—occurred after the event, requiring them to reconstruct the news through verbal testimonials and visual transcriptions of the details of place and circumstance. "Most of these scenes so pictured," *Leslie's* commented regarding its coverage of an 1873 Atlantic shipwreck, "are real: others are pictorial reprints of authentic statements and descriptions, whereby our artists have caught and transfixed the reports of the telegraph."[6]

The special artist's sketch often took the form of visual notes composed of hastily articulated lines supplemented by written comments supplying information that the artist didn't have the time or inclination to render. "A line made out of doors means as much as a dozen in the studio," commented *Harper's Weekly* artist Charles Stanley Reinhart,[7] and it was in the offices of an illustrated newspaper that the concerted work took place of converting the complexity implied in hasty slashes and shadings into a comprehensible picture. There, the special artist returned to work up his rough sketches into a finished drawing, or to hand his visual notes over to one or more staff draftsmen who specialized in specific subjects. The distinction between the artist in the field and the office draftsman was not always that marked, since roles were constantly exchanged depending on assignments and availability. In either case, the

in-house artwork was based on more than eyewitness sketches; office draftsmen often turned to *Leslie's* forever-expanding photographic file as a resource for elaborating on and verifying the observations of the "outside" artists.[8]

The on-the-spot artist's scanty representation was shaped by the limitations of time and the chaos of circumstance, but there could be little motivation for comprehensive sketching in the field when every artist knew that his work served as only the first step in an extended process of pictorial reproduction that would progressively reconfigure his interpretation. Art historians have emphasized what they see as the pure part of the process—the "accurate" or, at the very least, "expressive" artist-reporter's sketch—focusing on the more glamorous figure of the artist in the field while bemoaning the ensuing work of office artists and engravers as dilutions, misrepresentations, and outright infringements on the favored realm of artistic intention. Similarly, historians of photography have made invidious comparisons between the presumed documentary veracity of the photograph and the abuses and unreliability of graphic news imagery.[9] But perhaps the essence of the original sketch is found less in its authenticity than in its place within a larger practice. Like it or not, it was the *engravings* that appeared in *Frank Leslie's Illustrated Newspaper,* as well as in its competitors, that represented the news for readers; the engravings were the images the public viewed and it was their representation of events to which readers responded. In subsequent chapters we will consider how these reproduced images conveyed information and ideas to readers and how they succeeded and failed in conforming to their expectations—how the engravings operated as part of a complex social practice constituted by production methods and audience response. To start such a consideration, however, we must investigate the method of pictorial reproduction, which requires placing the work of the special artist in its proper context as the beginning of the process through which *Frank Leslie's* delivered the representation of the news to the public.

MASS-PRODUCED NEWS

To ensure the survival of an ambitious enterprise like an illustrated newspaper, Frank Leslie had to overcome the obstacles that had doomed earlier endeavors. The public wanted images of the events of the day, pictures that conveyed detailed visual information about the people involved, the

nature of the location featured, and the quality of the experience cap-
tured. Moreover, the public wanted pictures while the events were still
topical, as an adjunct to the news they read in their newspapers every
day. With these demands in mind, Leslie adopted the methods of mass
production that were changing the labor process in mid-nineteenth-
century America. Copying many of the processes inaugurated by the
British illustrated press, Leslie added his own innovations in centraliz-
ing, subdividing, and speeding up production. And, as in so many other
trades, this industrialization undermined the autonomy and status of
craftworkers who saw what had been their signature and intention me-
diated and transformed into a new, mass-produced form of imagery.

After the art superintendent chose a sketch to be worked up into an
engraving—an editorial procedure whose criteria of selection, beyond
"newsworthiness," unfortunately remain murky—an artist drew a new
version on paper. Rendered in outlines, the new drawing sometimes was
merely a tracing of the original sketch; more often the original sketch
was reworked with greater detail and consistent perspective, altering its
composition to fit the proportions of *Frank Leslie's* page. The outlined
drawing was then rubbed down in reverse upon a plank of Turkish box-
wood, the surface of which had been polished and lightly whitewashed
so that the transferred lines would be easily demarcated.[10]

Wood for engraving had to be cut across the grain so that the resulting
plank could provide the proper surface for flexible incisions. As the New-
castle copperplate engraver Thomas Bewick discovered at the end of the
eighteenth century, planks cut across the grain, where the wood fibers
ran perpendicular rather than horizontal to the surface, provided a hard,
nonsplintering plane into which one could etch fine lines.[11] The durable
Turkish boxwood tree, however, rarely reached a diameter beyond six
inches. That size was useful for smaller engravings, but the full-page and
double-page engravings featured in the illustrated press exceeded the di-
mensions of the otherwise reliable boxwood. The straightforward solu-
tion to the problem, as indicated by the appearance of "oversized" en-
gravings in *Gleason's Pictorial,* was to construct large planks by gluing
together smaller blocks. Leslie has been credited with introducing an
innovation: rather than gluing component pieces, he composed a large
block of smaller sections—ranging between ten and twenty pieces, each
approximately two inches square by one inch thick—secured by a sys-
tem of sunken nuts and bolts (figure 2.1). The new jointed block not
only allowed flexible sizing of engravings (and *Frank Leslie's* had more

Figure 2.1. "Back of block, showing how it is fastened together." Wood engraving, *Frank Leslie's Illustrated Newspaper*, August 2, 1856, 124. Prints and Photographs Division, Library of Congress.

than its share of special supplemental four-page cuts, measuring twenty by thirty inches); it also was the key to a new process of mass reproduction of engraved images that could deliver pictures of news events to readers only one week after those events had occurred.[12]

With the transfer of the outlined drawing to the composite wood block, the subdivision of labor began in earnest. After one artist used brush and India ink to indicate the broad lights and shadows, the team of artists designated to work on the block gathered together briefly to discuss the overall tone of the composition, a critical consultation since it was for many of these artists the only time they would glimpse the full image. Then the block—sometimes complete, sometimes unbolted and in component parts—followed a harried, if systematic, course from one draftsman to another. Consulting stock drawings and photographs, each artist specialized in one area of drawing (e.g., figures, animals, architecture, landscape, sky, water, and machinery) and was responsible for delineating that detail in washes and pencil line upon the block's surface.[13] Because drawing on the block was just the start of the process of reproduction, artists worked intensively, devising conventionalized styles to meet short deadlines.

The block, rebolted together, now went to the engraving department. The supervising engraver first surveyed the wash- and pencil-covered surface and proceeded to carve out all the lines that traversed across adjacent constituent blocks, creating guidelines for the engravers who would work on the individual sections. Then the composite block was unbolted again and distributed to between ten and fifteen engravers, once more according to their specific skills. A four-page engraving could involve the work of as many as forty engravers.

According to one reminiscence, the subdivided specialties had their distinctive nicknames: sky and foliage were cut by "pruners"; drapery and cloth went to "tailors"; the youngest and least skilled artisans who were designated to incise the plane geometry of machinery were dubbed

Figure 2.2. "Jonathan's Engraver." Wood engraving, *Yankee Notions* 1.9 (September 1852): 259. American Social History Project, New York.

"mechanics"; and on the more skilled engravers assigned to depict features was bestowed the fading compliment of "butchers." Perched beside a window by day and a lamp or gaslight by night (the illumination focused through a glass globe filled with water), the engravers bent over their work (figure 2.2). Each wearing eyeshades, they peered through watchmaker's lenses down on the block propped upon a small sandbag or leather cushion. Equipped with a number of tools, each with a handle designed to fit snugly in the palm of the hand, they maneuvered the

block to carve out spaces between the drawn lines, or translated shades of gray into analogous incisions. In effect, they thought and worked in what we might term the "negative," cutting out what would later appear as white in the finished engraving and leaving the lines in relief to print black.[14]

This specialized and subdivided process, perhaps introduced by Leslie but quickly adopted by all publications that required large, rapidly produced illustrations, marked the decline of wood engraving as a skilled craft. William J. Linton, the radical British engraver who would briefly work for *Frank Leslie's* in the late 1860s, excoriated the industrializing trend that transformed artisans into "two-legged, cheap machines for engraving,—scarcely mechanics, machines, badly geared and ineffective."[15] Engravers were now trained to transcribe the drawn lines and washes into (in the phrase of the print historian William Ivins) "a predetermined system or network of engrained lines."[16] Individual style and expression were suppressed to ensure that the constituent blocks presented a uniform effect. "A certain kind of line, it was held, should be used to represent ground," later remarked John P. Davis, who worked for *Leslie's* in its first years of publication, "another kind to represent foliage; another to represent sky; another, flesh; another drapery, and so on. Each sort of line was the orthodox symbol for a certain form." *Frank Leslie's* engravings, in contrast to the cuts that had been published in *Gleason's Pictorial,* no longer bore engravers' signatures, an absence that symbolized their subordination in the overall process.[17] The decline of engravers' status was also denoted by the increasing feminization of the trade. Women did not invade the male enclave of the newspaper publishing house but worked freelance at home or in the few woman-run engraving shops. In New York, the Ladies School of Design, which opened in 1852 and then affiliated with Cooper Union in 1859, became a crucial if uncredited locus for the employment of women engravers. Assuming guardianship over women trained under its auspices, Cooper Union's engraving school (at which both Linton and Davis taught) commissioned jobs for its advanced students and alumnae and provided facilities for carrying out the work.[18] The rise of a "New School" of wood engraving in the 1880s, inspired by the process of photoxylography in which photographs of artwork were directly transferred to the woodblock surface, would further diminish the engraver's task.[19] Heralding a new era of art engraving with engravers inventing new codes that mimicked brush strokes and other painterly techniques, the New School ac-

tually marked the last phase of a dying craft; within a generation the half-tone would lead to engravers' virtual obsolescence.

Through the innovation of the divisible boxwood block, the time to engrave a full-page illustration was reduced from more than a week to approximately eight hours. As described by Hiram Merrill, who engraved for *Harper's Weekly* in the 1890s, even at that late date stringent deadlines dictated marathon bouts of engraving, often performed overnight:

> . . . Mr. Smithwick (the director) would come around about three o'clock and whisper: "We're going to be busy tonight, Merrill, so you had better go out and get the air. Be back by 6 o'clock!"
>
> I would promptly head for Dietz's Weinstube, which was crowded under the New York end of the Brooklyn Bridge, and soon another engraver would pop in, and another, until nearly all the eight engravers who were to work on the page were collected there. Some solid and liquid food was obtained, and then we usually started up Broadway to study art in the saloons along the way. . . . By 6 o'clock we had returned to the shop, rested and ready for the work. I cannot recall that the engraved work suffered noticeably in quality.[20]

After the individual engravers were finished, the constituent blocks were rebolted together. Here, the supervising engraver applied his finishing touches, ensuring that incised lines met across the sections. Even with his best efforts, however, the final completed engraving often betrayed the contours of the individual blocks, which appeared as ghostly white lines (called "block marks" by engravers). Flawed or not, the engraved jointed block was then sent to the composing room, where it was locked into place with handset type to create a *Frank Leslie's* page.[21]

The page, however, was not printed directly from the form containing the wood engravings and hot type. Each page was electrotyped, a process that involved making a beeswax mold of the entire page and then immersing it in an electrocharged bath containing copper particles. The final cardboard-thin copperplate took between thirty and forty-eight hours to produce; though the procedure was slow, multiple plates could be made from one page form, making possible extended print runs. Electrotyping was a significant advance over the earlier stereotype process using plaster molds and fragile metal casts. The new process was substantially shortened when the electrical source was changed from a battery to a dynamo, enabling a plate to be formed in thirty minutes; by the 1880s three sets of *Frank Leslie's,* comprising forty-eight pages, were being electrotyped in three hours.[22]

After the plates were secured to the cylinders of the printing press, one last step affected the appearance of the engravings. One impression of each engraving was made on a piece of thick paper; the white sections of each printed paper were then sliced away, leaving a reverse paper stencil. Printers then placed this "overlay," or parts of it, onto the cylinder, determining how its strategic placement would add to the pressure of the press in specific areas to strengthen and vary the blacks in each engraving (in contrast to the uniform tone of the type).[23]

The purchase of a new Taylor Perfecting Press in 1858 significantly increased the speed of printing *Frank Leslie's*. Whereas previously the paper had to be produced in two print runs—one for illustrated pages, one for type—the Taylor press printed the weekly's sixteen pages on two sides of one large sheet of paper at a rate of 1,200 copies an hour. The resulting printed sheet carried eight pages of illustrations and text on one side and eight pages containing solely text on the other. To achieve the folio magazine with its alternating illustrated and text spreads required careful folding of the sheet and the slicing of horizontal creases to release the pages—but where these latter finishing touches were applied depended on the destination of the weekly. From the press room, some of the printed sheets of *Frank Leslie's Illustrated Newspaper* were delivered to a packing room where individual copies were folded, placed in wrappers, and mailed to subscribers who, following enclosed instructions, slit apart the pages; other sheets were bound into rolls of one hundred and sent to newsagents who both folded the copies and cut the pages to create the folio edition sold to customers. Finally, folded issues were allotted to waiting squads of newsboys who went off to vociferously hawk *Leslie's* latest edition in the New York streets (often, no doubt, selling its competitors as well).[24]

APPEALING TO A NEW AUDIENCE

Frank Leslie's process of mass-producing images ensured that its readers would be furnished with visual representations of news events, often within days of their occurrence and at a relatively modest price. The adoption of an industrial model for producing visual news coverage represented one critical part in Leslie's strategy to construct a commercially viable illustrated paper. Another crucial factor, which complemented this technological and organizational transformation of production, involved Leslie's orientation toward his market. Leslie framed his publishing house, and particularly his capstone eponymous newsweekly, to re-

Figure 2.3. "The dog pit at Kit Burns' during a fight." Wood engraving, *Frank Leslie's Illustrated Newspaper,* December 8, 1866, 181. American Social History Project, New York.

semble the very public he required to sustain the expensive operation of publishing a pictorial paper.

Unlike the House of Harper, his staid rival, Frank Leslie teetered on the cusp of respectability. While *Harper's Weekly* demurred, *Frank Leslie's Illustrated Newspaper* delved into the realm of sensation: its engravings depicting the scenes, perpetrators, and victims of notorious crimes alternated with less topical but equally lurid glimpses of raucous, sexually charged cheap amusements and violent "rough" sports. At times, as contemporary critics charged, *Frank Leslie's* appeared to be an illustrated adjunct to the daily penny press, or yet one more addition to weekly illustrated publications directed at plebeian tastes, such as the *National Police Gazette* (started in 1845).[25]

Yet such representations of the lurid and profane were often accompanied or succeeded by images depicting differing perspectives: scenes of brawny bare-knuckle boxing matches were coupled with editorial plaints about the moral degradation engendered by such amusements, or with pictures portraying the intervention of authorities; the six engravings detailing the dogfights held in Kit Burns's Sportsmen's Hall included cuts showing the gruesome effect of the sport and, two weeks later, an engraving of the proprietor's arrest (figure 2.3).[26] A strong dose of moral reform lay embedded in the weekly's representations of the sensational, an aspect that Leslie consistently emphasized when confronted

with charges of pandering to popularity. "We take some pride," *Leslie's* declared after depicting Kit Burns's arrest,

> in knowing that the graphic illustration of the cruelties practiced in that place . . . was the means of directing the special attention of the police to the existence of such a den, and thus led to its suppression. And it is not unworthy of note, as showing the influence of such appeals to the sensibilities as only the pictorial art can give, that the written description of the scenes in Water Street, published by a daily contemporary, was read with indifference, if not with incredulity, by the public. . . . No more palpable instance can be given than this of the service an illustrated paper can render to the great cause of morals, and of the superiority we have in this respect over the daily journals, whose articles, however well written, must necessarily lack the striking appeal to the eye supplied by an illustrated newspaper like our own.[27]

Adding insult to injury, as far as *Leslie's* critics were concerned, *Frank Leslie's* also took aim at the inadequacies—and pomposity—of nonpictorial reform efforts. Its brash publication of two contrasting engravings, showing evangelical reformers momentarily possessing Kit Burns's turf only to be replaced one hour later by a rat-baiting match, served to promote the superiority of *Leslie's* efforts. Such pictures also presented another perspective, adding yet one more ball to an editorial juggling act designed to address all viewpoints (despite the publication's reform claims to the contrary). As a correspondent of the *New York Express* opined, "It is difficult to find out what Mr. Leslie's personal politics are, since his serials all seem to have a different way of thinking; but no one can doubt the ability he bestows in at least hitting all around."[28]

Frank Leslie's inclusive approach, its balancing of depictions of rough pastimes and reform, of the profane and the pompous, seems to substantiate contemporary and later charges of opportunism. However, while we should not ignore Leslie's bow to crass practicality, the simple reduction of the weekly's approach to "pandering to the masses" fails to consider how its inclusive, alternating coverage extended beyond the sensational to represent constituencies and popular pastimes that the more respectable *Harper's Weekly* steadfastly omitted. For example, the broad and varied world of the New York stage was a frequent subject in *Leslie's* pages. Theatrical audiences were increasingly bifurcating into class-defined spaces, but *Frank Leslie's* remained attentive to "blood and thunder" productions in the Bowery Theatre as well as to the more subdued theatricals performed in polite parlors.[29] And, whereas the pronounced

Protestant bias of *Harper's Weekly* was displayed in its treatment of Catholics as little more than subjects for the revelation of vice, *Leslie's* added coverage of the Catholic Church to its pictorial representation of religious pursuits. "While the Harpers are blackguarding us at every turn," one Catholic paper later commented, "it is pleasant to have this able journal animated by the spirit of even-handed justice and fair play toward our Church." [30]

Frank Leslie's Illustrated Newspaper endeavored to address the varied constituencies that constituted the vastly expanded reading public. In effect, Leslie constructed his weekly newspaper to mirror that diversified marketplace. His larger publishing house approached this readership differently, if consistently. "Frank Leslie deserves to be called the pioneer and founder of illustrated journalism in America," New York publisher J. C. Derby remarked in his 1884 memoir. "He understood what the great reading public in this country wanted, and provided it, so that all tastes were satisfied by one or another of his many publications." [31] Leslie's other periodicals were targeted at more specific audiences—fashion and story magazines for women, a newsweekly for German immigrants, a humor magazine for men, pristine story and instructional periodicals for the "family" (including didactic children's publications)—and overall, they embodied the range of the reading public. Leslie's book publishing ventures, begun in the 1860s, resembled his approach to periodicals. Frank Leslie's Publishing House printed expensive "souvenir" books (commemorating and reproducing *Frank Leslie's* pictorial coverage of the Civil War and, later, the 1876 Centennial Exposition), reprint editions of established nineteenth-century authors, and a series of cheap paper-cover "railroad" books (mostly reprints of stories and serialized novels published in one or another of Leslie's magazines), the latter available at newsstands, station kiosks, and on trains. [32] In time, Leslie would genuinely embrace the "profane" as well by founding *The Days' Doings* in 1868. "Illustrating Current Events of Romance, Police Reports, Important Trials, and Sporting News," *The Days' Doings* assumed some of the sensational features previously published in a regular department of *Frank Leslie's Illustrated Newspaper*. Begun in 1866, "Home Incidents, Accidents, &c." offered readers a weekly page full of small cuts and brief reports about the gruesome, scandalous, and strange, closely resembling a pocket edition of the *Police Gazette*. It disappeared from *Leslie's* pages when publication of *The Days' Doings* began. Directed to a male, "nonparlor" readership, Leslie's sensational weekly paid

some obeisance to respectability by bearing no direct indication of his proprietorship.[33]

In attempting to address the reading public, Frank Leslie's Publishing House, and especially *Frank Leslie's Illustrated Newspaper,* became a manifestation of that audience. Leslie's operation was rooted firmly in— if also in contradiction to—the material world of mid-nineteenth-century publishing as it began its transformation from small shop to culture industry. Leslie was certainly representative, and in some cases prototypical, of a new generation of periodical publishers whose firms were coalescing into centralized and heavily capitalized giants; for some of these publishers, one condition of that growth was the expansion of "legitimate" subject matter beyond the gentility harbored in older publications. While the established Harper Brothers firm relied on economies of scale to support a range of publications, it nonetheless consistently focused on a "politer" audience. Leslie's publishing company from the start was built on the more tenuous foundation of a broad and diverse readership. To survive, *Frank Leslie's Illustrated Newspaper* had to appeal beyond the localism of the daily press or the cloistered audiences for genteel publications to a public large enough to cover the exceptionally high production costs of an illustrated newspaper. In short, Leslie designed his illustrated newspaper for a "middle" readership, a vast and elastic range of readers that, in the miasma of class relations and formation in mid-nineteenth-century America, stretched across the nation and into the territories, and extended from mechanics to merchants. This public, composed of diverse constituencies, required an approach to pictorial news coverage that addressed differences and, more uneasily, attempted to encompass them.[34]

Who exactly read *Leslie's* remains difficult to determine, reader polls and research being inventions of a later magazine era. *Frank Leslie's* references to its readers tended toward self-serving paeans to the "more matured classes of our people, the active, the enterprising, educated, and refined." Whatever specificity might accrue to that remark was lost in other editorials that commented on how *Leslie's* "pictures appeal immediately and forcibly to the masses" or that, more ecumenically, touted its "pictorial illustration for everyday reading by all classes of the community."[35] Stepping back from *Leslie's* columns for a moment, we can safely say that as comparatively inexpensive as the weekly's price was, at six cents (or seven, or eight, or the final figure of ten cents) per copy, regular purchase of the weekly would severely tax the budgets of many working-class households. The penny press gained its readership, after

all, by its price as well as its reportage. However, evidence exists that *Leslie's* was read by working people: the weekly printed a few communications from miners regarding coverage as well as endorsements from other publications that indicated a readership extending not only across class but into comparatively isolated regions of the country. At the risk of further muddying the interpretive waters, we must keep in mind that *Leslie's* circulation figures, undependable as they are, do not reflect individual sales. Copies clearly circulated among populations, especially in the unions, associations, and organizations that were able to procure *Frank Leslie's* through the more economical club subscription rates.[36] Finally, the venues for viewing the pictorial press extended beyond the proverbial parlor. Observing the downtown Pittsburgh streets after the ironworks let out on a Saturday afternoon in the late 1860s, the journalist James Parton noted the public nature of plebeian culture in respect to reading the news: "They [working-class families] stroll about; they stand conversing in groups; they gather in semicircles, about every shop-window that has a picture in it, or any bright or curious object; especially do they haunt the news-stands, which provide a free picture-gallery for them of Illustrated News, Comic Monthlies, and Funny Fellows." And, as recent scholarship on late-nineteenth-century reading has indicated, public libraries served as a crucial location for many working-class readers.[37]

Frank Leslie's Illustrated Newspaper was hardly unique to the period, and it is helpful to consider another entrepreneur of the popular to better capture the essence of the weekly's appeal and approach to its readers. We can do so without taking any great conceptual or temporal leap. Leslie's introduction to the American audience, and particularly the increasingly varied urban crowd, took place under the auspices of Phineas T. Barnum. Accompanying the 1850–51 Jenny Lind tour, Leslie not only ascertained the nature of the public he wished to reach but also observed how Barnum successfully structured his amusements to fit the opportunities and strictures of that public.

If *Frank Leslie's* resembles any other cultural entity in the mid–nineteenth century it is Barnum's American Museum on Broadway. In purchasing the foundering Scudder Museum in 1843, Barnum took an institution that through its exhibits and classifications embodied rational education and transformed it into a venue that combined unrestricted entertainment with instruction and moral uplift. For a twenty-five-cent admission, visitors viewed peculiar "transient attractions," from the patchwork Feejee Mermaid to the diminutive and articulate Tom

Thumb. But the museum, festooned in Bowery bunting and glutted with oddities, also promulgated educational ends, including temperance and Shakespearean dramas in its "Lecture Room," or theater. Thus, in one site, Barnum not only gathered exhibitions and amusements that previously had been sequestered in separate locations; he also coalesced a new audience that ranged from the truculent Bowery denizens Mose and Lize to families in search of "respectable" edification. In an urban culture characterized by increasing difference—in taste, in subject, and in audience—Barnum constructed a middle institution where, in one place, diverse constituencies could gather if not merge.[38]

Like Barnum's American Museum, *Frank Leslie's Illustrated Newspaper* prospered because of its ability to both address and encompass difference. However, at least for the reading public, this inclusiveness could never successfully bridge oppositions. A middle periodical sooner or later would be confronted with the realization that its heady concoction of diversity also carried an explosive charge. As we will see in subsequent chapters, the broad public that *Frank Leslie's* attempted to address would at times fracture into opposing constituencies. Losing its footing on such tenuous turf, *Leslie's* would grapple for purchase by reconfiguring its pictorial coverage.

THE CIVIL WAR

We need not look far for such hazards in the history of *Frank Leslie's Illustrated Newspaper*—or, for that matter, in the history of the United States. The rapid secession of southern states following Abraham Lincoln's victory in November 1860 threw *Leslie's* and its rival illustrated papers into a quandary. Along with northern literary monthlies such as *Harper's Monthly* and *Godey's Lady's Book,* the pictorial weeklies had made vast inroads into the southern market (much to the consternation of cultural advocates below the Mason-Dixon line who saw these publications as part of a northern hegemony smothering regional literature and art). For *Leslie's,* war threatened to cut off a significant readership on whose patronage it had come to rely. In the years leading up to secession, the weekly had circumspectly ignored slavery to focus on travelers' accounts and scenic views of the South. Nevertheless, by simply covering the looming crisis, the illustrated paper made southern enemies: *Leslie's* editorials opposed abolition and denounced John Brown as a "maniac," but its extended coverage of the Harpers Ferry raid and Brown's ensu-

ing trial and execution fanned southern ire. "These Northern illustrated papers are all unworthy of respect," fumed the *Savannah News* in January 1861. "Frank Leslie's paper is as bad as the one before us and *Harper's Weekly* is not one whit better. Their sale at the South—and the *New York Ledger,* the *New York Mercury,* et id omne genus—should be interdicted. They are incendiary and pernicious, to say nothing of their demoralizing effect."[39] By conveying the news of growing sectional conflict—by reporting on the presidential campaign, transcribing speeches, and publishing engravings of turbulent rallies—the press in general served as a catalyst in the general deterioration leading to war. No matter how hard *Leslie's* tried to "balance" its coverage, the publication of pictures that portrayed sectional division undermined compromise. Its images unavoidably depicted a nation fracturing in two.[40]

In the first few months of 1861, as one southern state after another seceded from the Union, *Frank Leslie's* attempted to retain its southern readers. Its editorials criticizing Lincoln's new administration were in perfect harmony with the pro-southern Democratic press in the North. "The destruction of our Union, merely to rescue a runaway nigger," *Leslie's* concluded in February 1861, "would be as absurd as the Chinaman who set fire to his house merely to roast a little pig."[41] Later that month, it accepted the establishment of the Confederacy and called for compromise with the new southern nation (a position mirrored by the Republican *Harper's Weekly*). Meanwhile, preparing for the worst, *Leslie's* endeavored to position itself as a nonpartisan chronicler of events, "without bias and without feeling." As Fort Sumter lay under siege, the weekly published a call for artists on both sides of the barricades:

IMPORTANT NOTICE!

*To Officers and others Attached to the Armies of
the Federal and the Confederate States*

I shall be happy to receive from Officers and others attached to either Army, sketches of important events and striking incidents which may occur during the impending struggle which seems to threaten the country. For such sketches, forwarded promptly, I will pay liberally . . .

Any gentleman connected with either Army who will forward us a small sketch, as a specimen of his ability as a draughtsman, will receive, gratuitously, "Frank Leslie's Illustrated Newspaper," for the coming year . . .

The most convincing proof of the reliability and accuracy of our illustrations is, that ours is the only Illustrated Paper which is allowed to circulate freely in the South, and an additional proof is, that it stands a critical examination in those places where the scenes we illustrate occurred.[42]

Once Fort Sumter was bombarded, however, *Frank Leslie's* became a vigorous supporter of the Union. Forsaking its southern readers, *Leslie's* found a new, broader audience for its coverage in a North mobilized by war. Embracing partisanship, it soon proved, was an economically feasible choice for the illustrated press. Whereas the loss of southern subscribers would lead to the demise of many northern magazines that had managed to survive the depression of the late 1850s, *Leslie's, Harper's Weekly,* and the New York *Illustrated News,* in concert with the nation's daily press, discovered that civil war gave them a new stature and importance. Northerners were desperate for the latest news about the conflict; and in purveying information, the press became an indispensable part of most citizens' everyday life. Newspaper circulation soared as reporters, aided by the telegraph, presented news within a day of its occurrence. But in the years leading up to war, the reading public had grown used to observing pictorial representations of news events. While daily newspapers could provide only maps and occasional portraits, the weekly illustrated press offered pictures that conveyed stories and visual evidence about the progress of the war. Five months after the attack on Fort Sumter, the circulation of *Frank Leslie's Illustrated Newspaper* hovered at an exceedingly profitable 200,000.[43]

Historians of the Civil War have recognized its visualization as a unique feature of the conflict. Because the war coincided with technological innovations in pictorial recording and reproduction, it was perceived through new informational forms—engravings and photographs. Historians have emphasized the photograph over the engraving, retrospectively attributing significance to the former's representational detail, clarity, and "authenticity."[44] Observing the thousands of pictures taken by Mathew Brady, Alexander Gardner, Timothy O'Sullivan, and other photographers who accompanied the Union Army, scholars have judged the engravings published weekly in the illustrated press to be poor substitutes. Clearly, the celebrated photographs of mangled bodies and smoldering buildings presented the public with new, gruesome evidence of the effect of total war. But the extremely slow exposure time and precarious "wet plate" process of developing photographs limited their representations. "The photographer who follows in the wake of modern armies," observed the London *Times* in December 1862, "must be content with conditions of repose, and with the still life which remains when the fighting is over[.]"[45] Moreover, the limitations of pictorial reproduction made photographs largely exhibition pieces, which lined the walls of Broadway photographic salons or were "published" in albums and ste-

reograph cards. The photograph stands as an invaluable pictorial record for the historian; for the northern public during the Civil War, however, the engravings in the illustrated press—almost 6,000 cuts by one estimate—though they were at times based on photographs, outweighed in their accessibility and immediacy the comparatively expensive photographic albums and cards.[46]

Every week, the northern public examined new engravings depicting detailed panoramas of battles, specific incidents during combat, and the mundane and peculiar camp life of "Billy Yank." The home front also was a subject for news illustration, as the weeklies showed women sewing havelocks for the troops, resplendent Sanitary Commission fairs, and raucous recruitment rallies, as well as political dissension and social revolt (most conspicuously in the draft riots of July 1863). Such engravings, along with the ubiquitous portraits of Union officers and politicians, not only presented information but also served as a source of popular art: "All over the country," *Harper's Weekly* commented in 1865, "thousands and thousands of the faces and events which the war has made illustrious are tacked and pinned and pasted upon the humblest walls."[47] The pictorial papers' readership extended to the battlefront. Languishing in isolated encampments during the long intervals between combat, soldiers eagerly sought any form of reading matter. *Frank Leslie's, Harper's Weekly,* and the New York *Illustrated News* were particular favorites; unlike the literary magazines, their appeal extended across the ranks. Although the United States Sanitary Commission distributed illustrated papers as part of its support service, and some soldiers subscribed to the weeklies (usually receiving their copies weeks late), most soldiers bought copies directly from the sutlers and newsboys who followed the troops. Faced with a ravenous hunger for publications, these roving newsagents often raised their prices as much as 250 percent; and even at those rates, they usually sold out their stock. "A curious sight it was to see," remarked a British traveler who arrived at one camp on a mail boat carrying a consignment of illustrated papers, "a tearing up of envelopes . . . a general rustle of opening leaves, and in a moment every man as if it had been part of his drill, was down upon the ground with the same big picture before him." By the time each copy had been read, passed from one soldier to another, all that remained were tatters of newsprint.[48]

While Colonel Thomas Wentworth Higginson, commander of the African American First South Carolina Volunteers, would dismiss "Leslie's Pictorial" as one of the many newspapers used to blot up stains in the

officers' mess ("Every steamer brings us a clean table-cloth"), the illustrated papers found avid readers among black troops. In a report on freedmen's schools made to the commissioners of the Freedmen's Bureau in January 1866, an army surgeon noted the newly literate black soldiers stationed at Fort Livingston in New Orleans: "A short time since the commanding officer of the fort told the doctor that the soldiers, who were his A B C pupils one year ago, now took over forty copies of Harper's and Frank Leslie's weeklies, besides other papers."[49]

The thousands of engravings published in New York City by the three weekly illustrated newspapers and disseminated throughout the Union and on the warfront portrayed the Civil War from a decidedly northern perspective. Copies of the northern illustrated papers also managed to make their way into the Confederacy, where their resolute depiction of the northern side aroused equal measures of interest and venom. "The pictures in 'Harper's Weekly' and 'Frank Leslie's' tell more lies than Satan himself was ever the father of," wrote Georgia's Eliza Francis Andrews in her journal. "I get in such a rage when I look at them that sometimes I take off my slipper and beat the senseless paper with it."[50]

In comparison, only a handful of images were produced in the South representing the Civil War behind Confederate lines. In September 1862 the Richmond publishing firm of Ayers and Wade established the *Southern Illustrated News*, an eight-page weekly that aimed to present a pictorial record of the Confederacy at war. However, faced with the loss of materials previously supplied by northern industry and cut off by the naval blockade from an alternative European supply, the Confederacy lacked the resources necessary for publishing any pictorial paper comparable to *Frank Leslie's* or *Harper's Weekly*. From its inception, the *Southern Illustrated News* struggled with shortages of paper, ink, and printing presses. Most crucially, the southern weekly could not find competent engravers to produce its pictures. A July 1863 notice offering craftsmen "the *highest salaries* ever paid in this country for good engravers" ultimately failed to elicit any response.[51] As a result, the paper was largely composed of text with one portrait of a Confederate general or crudely engraved scene on its cover, and one cartoon on its back page. In November 1864 the *Southern Illustrated News* ceased publication. The scarcity of resources also undermined the operations of two other short-lived and barely illustrated periodicals, *Southern Punch* and the Raleigh *Illustrated Mercury*.[52]

Extensive pictorial coverage of the Confederacy was supplied by one

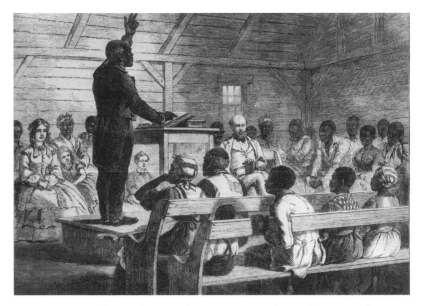

Figure 2.4. "Family worship in a plantation in North Carolina." Wood engraving based on a sketch by Frank Vizetelly, *Illustrated London News,* December 5, 1863, 561. American Social History Project, New York.

publication, but its provenance lay far from the American South and its engravings were viewed by only a small minority of southern readers. With the outbreak of war, the *Illustrated London News* dispatched Frank Vizetelly, the younger brother of the British weekly's co-founder (and himself co-founder of the Paris *Le Monde Illustré* in 1857), to cover the conflict. Fresh from reporting on Garibaldi's campaign, Vizetelly soon witnessed and recorded the Union rout at Bull Run. After the *Illustrated London News* published uncomplimentary engravings based on Vizetelly's sketches, Secretary of War Stanton turned down the British artist-correspondent's request to accompany McClellan's planned advance into Virginia. Frustrated, Vizetelly went South to depict the Confederacy at war from the Battle of Fredericksburg in 1862 to Jefferson Davis's ignominious departure from Richmond in 1865. Vizetelly's engravings depicted more than warfare or camp life from behind Confederate lines; an ardent supporter of the southern cause, he also sympathetically presented the "civilization" that was being defended (figure 2.4). While the *Illustrated London News* published 133 engravings based on his sketches, few of these images appeared on this side of

the Atlantic; those that did were published in *Harper's Weekly* after Vize-telly's sketches were commandeered en route to England by the Union naval blockade.[53]

Though Frank Vizetelly gained some fame in the South, it was the more numerous special artists of the northern illustrated press who won broad public recognition through their pictorial service and their (often self-proclaimed) exploits. A comparatively small part of the vast "Bo-hemian Brigade" of reporters who thronged the war front, the artist-correspondents were dashing, theatricalized figures, constructing them-selves as roving servants to the news positioned between the military and the public. "As you know," *Frank Leslie's* Henri Lovie reported to the weekly's readers in December 1861,

> I have travelled in all directions—from Western Maryland to the Indian Territories; made the acquaintance of a great many different divisions of the army, and so informed myself of their movements, so as to be at the *right* place at the *right* time. All this has kept me moving inces-santly . . . I have spent more than three months in the open air, sleeping in tents or bivouacs, and have ridden nearly 1,000 miles on horseback. A "Special Artist's" life is certainly not one of elegant leisure; but I like action, and have no objection to a spice of danger. I have several horses at various points, which have "come to me," and am prepared for what-ever may turn up.[54]

Representing themselves in their sketches as inevitably bearded, wear-ing knee-high boots and a rackishly angled broad-brimmed hat, and burdened by revolver, canteen, knife, binoculars, and, of course, draw-ing pad, the Civil War special artist inaugurated the romantic image of the wartime correspondent that, with minor variations, would persist through the twentieth century.

"We have had since the commencement of the present war," *Frank Leslie's* proudly announced in December 1864, "over eighty artists en-gaged in making sketches for our paper, and have published nearly three thousand pictures of battles, sieges, bombardments, and other scenes incidental to the war."[55] This number, if the claim was anywhere near true, was composed mainly of "amateurs" within the ranks of the mili-tary. During the first half of 1861, most of the engravings in *Leslie's, Harper's Weekly,* and the New York *Illustrated News* were based on contributions mailed to New York from military outposts. Once the war started, however, the pictorial papers quickly organized a coterie of art-ists: William Campbell has counted thirty special artists who each con-tributed more than ten drawings to the three illustrated weeklies. Alto-

gether, *Leslie's* employed sixteen, as many artists as the two other weeklies combined (occasionally losing one to its competitors).[56]

No doubt, for the purposes of copy, the life of the special artists was adventurous. But as the war continued, it also proved to be fraught with difficulties and danger. Their middle position, as neither civilians nor soldiers, provided opportunities but also hazards. When not being harassed by hostile officers—Henri Lovie presented his credentials to William T. Sherman in October 1861 and was immediately expelled from Louisville—they risked capture and injury: *Leslie's* John F. E. Hillen was briefly caught by Confederate troops at the Battle of Chickamauga, and later was severely wounded while accompanying the now more cooperative Sherman during his campaign against Atlanta.[57] Even when not confronting combat, artists had to endure lengthy bouts of discomfort and deprivation. Writing in a May 1862 issue of *Leslie's,* William Waud reported on the conditions under which he lived while accompanying Farragut's expedition against New Orleans: "Our diet . . . is simple, if not cheap, consisting of hard ship bisquit—which we beg of the marines opposite—harder salt tongue, and coffee without milk or sugar. Add to this . . . that our sleeping arrangements imply no blankets, which I neglected to bring and which I cannot buy; imagine all this and more, and you will form some notion of the delights of a 'Special Artist' off the mouth of the Mississippi."[58] Although all the special artists were young, with the oldest in his early thirties, most suffered repeated and debilitating bouts of illness.

But the greatest challenge that faced these artists was fulfilling the task of sketching combat. With the exception of Thomas Nast, who had covered Garibaldi in Italy (but who would do little battlefront work during the Civil War), none of the special artists had ever experienced warfare, let alone attempted to draw its particulars while under fire. "I fully expected when I started for the front," *Frank Leslie's* Edwin Forbes later recalled, "to accompany troops into the battle and seat myself complacently on a convenient hillside and sketch exciting incidents at my leisure."[59] Once faced with actual battle conditions, Forbes and his compatriots devised new strategies for recording the fighting. When possible, artists located an elevated position behind the lines from which they could sketch the events. From such a vantage point, they gained a more comprehensible panoramic view while, with the aid of binoculars, they also observed specific aspects of the fighting. Nevertheless, not all of the battles of the Civil War provided a conveniently detached ridge; and as the artist-correspondents would learn, actual warfare was

more chaotic and harder to grasp at a glance than the conventions of history painting that governed the pictorial representation of combat suggested.[60]

When the fighting was over, the job of sketching had only begun: artists spent hours doing follow-up drawings on the littered battlefield and interviewing soldiers to find order in the confusion. "I commenced on the extreme left wing," Henri Lovie wrote in a letter accompanying his packet of sketches depicting the Battle of Shiloh, "and visited every division, obtained guides, listened to all stories from all sides, and made upwards of 20 local sketches of positions and scenery, including all the battlegrounds—for there were many—and send them to you in something like their logical and chronological relation, a task of no little difficulty, where nobody knows what was done by anybody else."[61]

Based on observation and secondhand description, these sketches were rendered hurriedly in penciled shorthand with scribbled notations or, time permitting, organized and ordered into comprehensible compositions in washes and white on colored paper, and then were mailed back to New York. At the offices of *Frank Leslie's, Harper's Weekly,* and the New York *Illustrated News* the sketches were reconfigured for the boxwood block in the complicated reproduction process described above. Rough sketches were worked up into finished drawings, and compositions were often revised to fit the dimensions of the woodblock.[62] Although images were occasionally altered to spare readers "offensive" details, the one historian to methodically compare sketches to finished engravings has concluded that the alterations were minor.[63]

Nonetheless, inaccuracies abounded in the engravings; these errors often arose from the invention of the staff artist, but they could be found on the pages of the field sketchpad as well. *Leslie's* William Waud, in an 1864 letter to his brother Alfred, a special artist for *Harper's Weekly,* noted how officers' hostility to the artist-correspondents was mixed with a low regard for their abilities: "Gen Patrick told me he should have kicked the artist out of Camp but that Gen Meade to whom they [the artist's sketches] were shewn said they were so unlike the places they were intended for & so bad they could do no harm."[64]

The officers' irritation with the representations and representatives of the illustrated press was understandable insofar as *Frank Leslie's,* in particular, made it a point in its editorials to excoriate the upper ranks, not to mention the Lincoln administration, when battles were lost or their outcomes were indeterminate. As *Leslie's* saw it, the Union army was in-

domitable but for inept or corrupt officers and officials—a stance that undoubtedly endeared the weekly to its readers in the ranks. Yet these soldier-readers, these unmitigated pictorial-press enthusiasts, enjoyed pointing out the engravings' inaccuracies and fantasies as much as they enjoyed lavishing attention on the cuts' overall depiction of warfare. Negligible errors involving misplaced scabbards or uniforms drew constant comment. But it was the larger representation of combat that at times raised the greatest mirth, such as engravings that depicted officers valiantly leading their men into enemy fire, the troops marching in perfect shoulder-to-shoulder symmetry, or cuts showing cavalrymen charging forward, firing rifles and swinging sabers while exhibiting little concern for how they might stay atop their horses. "If all the terrific hand-to-hand encounters which we have seen for two or three years displayed in the pages of our popular weeklies had actually occurred," the *Army and Navy Journal* commented in 1864, "the combatants on each side would long ago have mutually annihilated each other[.]" [65]

Accuracy was important to the illustrated papers, which frequently published soldiers' testimonials to the "correctness" of the engravings' portrayals, but it seemed of less concern to *Frank Leslie's* and the other pictorial papers than "authenticity." Throughout the war, the papers constantly defended their illustrations as based on eyewitness observation while simultaneously and ceaselessly accusing their competitors of fabrication. The satirical weekly *Vanity Fair* persistently ragged the pictorial press in cartoons showing artists drawing toy soldiers "on the spot," or diligently recording a ship explosion (having clairvoyantly predicted its destruction).[66] As a consequence of the charges and countercharges, the papers increasingly ascribed authorship of their pictures to individual artists, a strategy simultaneously adopted by the daily press in the *Herald*'s innovation of reporters' "by lines" in 1863. *Frank Leslie's* adopted its own particular method to establish the "authenticity" of its representations: it issued prestamped drawing pads to its artists that bore in the lower left corner of each sheet the statement, "An actual sketch, made on the spot by one of the Special Artists of Frank Leslie's Illustrated Newspaper. Mr. Leslie holds the copyright and reserves the exclusive rights of publication."[67] As the second sentence suggests, *Frank Leslie's* was as concerned about preventing any other publication from using its artists' work—a realistic problem after the weekly donated 500 drawings for sale at the U.S. Sanitary Commission's 1864 New York Metropolitan Fair—as about authenticating the origin of its engravings.

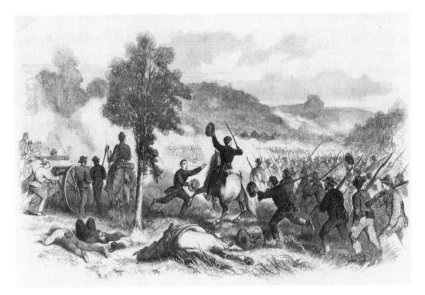

Figure 2.5. "The Charge of the First Iowa Regiment, with General Lyon at its head, at the Battle of Wilson's Creek, near Springfield, Missouri." Wood engraving based on a sketch by Henri Lovie, *Frank Leslie's Illustrated Newspaper,* August 31, 1861, 244. Prints and Photographs Division, Library of Congress.

The criticisms and defenses, the demands for accountability regarding the "truth" of the visualization of war, should not obscure the fact that the engravings in the illustrated press changed substantially over the course of the Civil War. As W. Fletcher Thompson Jr. has compellingly argued in *The Image of War: The Pictorial Reporting of the American Civil War,* the romanticism of early engravings, where combatants assumed the classic poses of academic painting, soon gave way to less lyrical compositions. Henri Lovie's depiction of General Nathaniel Lyon's death at the Battle of Wilson's Creek, published as an engraving in *Frank Leslie's* in August 1861, preserved the familiar heroic conventions of gesture and pose (figure 2.5). By October 1862 an engraving of "Maryland and Pennsylvania farmers visiting the battle-field of Antietam," based on a sketch by Frank H. Schell, portrayed the carnage after the battle—highlighting corpses that, while not dismembered, were twisted in the gruesome clutches of rigor mortis—and also showed the morbid curiosity of local inhabitants touring the field (figure 2.6).[68]

The most distinctive transformation in representation during the war occurred in the depiction of African Americans. Confronted by slaves'

flight to Union lines, their sheltering of Union soldiers who had escaped from southern prisons, and their self-possessed activities in the Union-controlled South Carolina Sea Islands, the illustrated press—in concert with the northern public generally—departed from its earlier anti-abolitionist stance to embrace emancipation. *Frank Leslie's,* along with its two competitors, supported the recruitment of black troops; and as they portrayed the troops' role in prosecuting the war, the familiar physiognomic codes of race evident in antebellum depictions of African Americans sometimes diminished. Engravings such as *Leslie's* "Assault of the Second Louisiana (Colored) Regiment on the Confederate Works at Port Hudson, May 27, 1863," based on a sketch by Frank H. Schell (figure 2.7), extolled the bravery of black troops as much as, a year later, its cuts depicting Confederate soldiers slaughtering captured black soldiers at Fort Pillow, Tennessee, testified to black soldiers' sacrifice for the Union cause.[69]

The overall change in the pictorial reporting of the Civil War was predicated at least in part on the artists' experiences in the field, where expectations and assumptions were progressively undermined by the reality of the war. But change cannot be located at only one source, and the alterations in representation also reflected interaction with the subjects of the imagery and the readers of the illustrated press, as well as competition between the papers themselves. As later chapters will discuss, the mediation of these forces of production and consumption, as they composed a social practice, would continue to affect the nature of news imagery in the years following the Civil War.

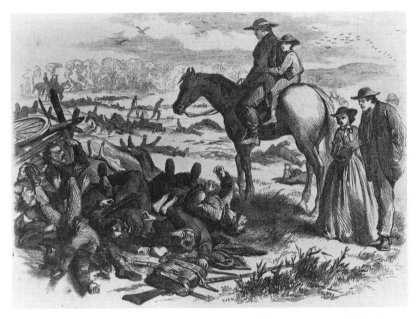

Figure 2.6 (above). "Maryland and Pennsylvania farmers visiting the battle-field of Antietam while the national troops were burying the dead and carrying off the wounded, Friday, Sept. 10." Wood engraving based on a sketch by Frank H. Schell, *Frank Leslie's Illustrated Newspaper,* October 18, 1862, 62. American Social History Project, New York.

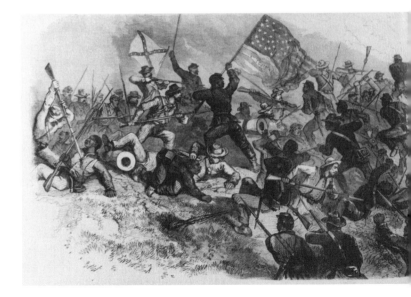

Figure 2.7 (below). "Assault of the Second Louisiana (Colored) Regiment on the Confederate Works at Port Hudson, May 27, 1863." Wood engraving based on a sketch by Frank H. Schell, *Frank Leslie's Illustrated Newspaper,* June 27, 1863, 216–17. American Social History Project, New York.

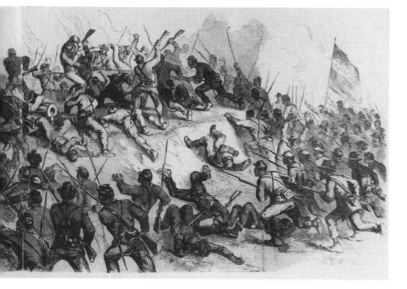

Constructing Representation, 1866–77

Discourse was deemed Man's noblest attribute,
And written words the glory of his hand;
Then followed Printing with enlarged command
For thought—dominion vast and absolute
For spreading truth, and making love expand.
Now prose and verse sunk into disrepute
Must lacquey a dumb Art that best can suit
The taste of this once-intellectual Land.
A backward movement surely have we here,
From manhood,—back to childhood; for the age—
Back towards caverned life's first rude career.
Avaunt this vile abuse of pictured page!
Must eyes be all in all, the tongue and ear
Nothing? Heaven keep us from a lower stage!

William Wordsworth

William Wordsworth's complaint on glimpsing a copy of the *Illustrated London News* around 1846 echoed resoundingly some thirty years later when the *Nation* editor E. L. Godkin composed his denunciation of the leveling threat of "chromo-civilization." Conservative criticism drew few distinctions among the forms of imagery produced by the nineteenth-century culture industry; its advertisements, fashion plates, art reproductions, story illustrations, portraits, stereographs, lithographs, and engravings constituted one big avalanche of lowered sensibilities and broadened tastes.[1]

But distinctions were important to Frank Leslie. As he and his editors constantly reiterated, *Frank Leslie's Illustrated Newspaper* was not just *any* illustrated periodical. In editorials and notices, *Leslie's* explained that its mission "to illustrate the passing events of the day, to reflect the spirit of the age" bore little resemblance to that of its American rivals, "the many merely *pictorial* papers."[2] *Frank Leslie's*, one 1872 notice asserted,

is, in fact, the only illustrated publication in this country which, strictly speaking, is entitled to the name of an illustrated NEWSpaper. It is the only one which, discarding reprints from foreign pictorials (except in the reduced form of the Spirit of the Foreign Illustrated Press), discarding illustrations of novels, discarding fancy pictures and copies of works of art, confines itself strictly to the duty expressed in its title—that of giving to the public original, accurate and faithful representations of the most prominent events of the day in every part of the globe. Its special character in this respect is so well known that, as soon as any important event occurs unexpectedly at any distant point, we are certain to receive at the earliest moment, from our correspondents, accurate sketches and reliable descriptions of it.[3]

Denouncing its rivals' dependence on engravings reproduced from British and Continental illustrated papers, *Leslie's* claimed to be "the sole purveyor of PICTORIAL NEWS in our country—the only journal doing a business and occupying a rank similar to that of the *Illustrated London News,* in England; the *Illustration* and *Monde Illustré,* in Paris; and the *Illustrirte Zeitung* in Leipsic [sic]."[4]

The pronunciamentos of P. T. Barnum's protégé should always be taken with a grain of salt: amid its art reproductions *Harper's Weekly* also found space to cover the news and, on occasion, *Leslie's* seemed to illustrate primarily regional businesses, summer spas, and short stories. Nevertheless, it is fair to say that over time, *Frank Leslie's* surpassed its weekly competitors in the number of original topical engravings published, the breadth of the subjects represented, and the energy that it exerted in beating its rivals to the first pictures of major events.

This is not to say that *Frank Leslie's Illustrated Newspaper* triumphed commercially over its pictorial peers. In 1865 its circulation decreased to 50,000. The decline was due in no small part to increases in the price of the magazine forced on *Leslie's* by wartime inflation and by taxes (on advertising revenue) that raised production and labor costs. Newsprint grew scarce, as its cost increased nearly 100 percent within a few months, and *Leslie's* came out at the losing end of a vicious price war conducted by the newspaper industry. In early December 1862 *Frank Leslie's* price rose one cent from the six cents to which it had fallen in its antebellum competition with *Harper's Weekly;* at the end of the month, *Leslie's* was selling at eight cents a copy. By 1863 *Harper's Weekly* had at last successfully undersold its rival, and *Frank Leslie's* now occupied a subordinate position.[5]

Frank Leslie's never again outstripped *Harper's Weekly* in circulation. And yet *Leslie's* had reached a plateau on which it could operate successfully. Although readership declined after the end of the Civil War, exhib-

iting a general revulsion from news, the postbellum period ensured that any complacency would be short-lived: the political and social turmoil surrounding Reconstruction, the aggressive expansion of capital and the social conflict it engendered, the Indian wars in the West, and the numerous industrial and natural disasters across the country all helped maintain an illustrated press that drew its lifeblood from crisis. *Harper's Weekly* would reach a circulation of 100,000 and more, but *Frank Leslie's* hovered profitably at 70,000, with sudden infusions of "sensation" prompting special editions that reached into the hundreds of thousands.[6]

As "A Journal of Civilization," the phrase emblazoned under its masthead, *Harper's Weekly*'s enduring supremacy derived only partly from its coverage of the news. Always addressing a more narrowly defined readership, it balanced news illustrations with "art" engravings (many from Europe) and other accoutrements of gentility. In the view of James C. Goldsmith, an editor of *Frank Leslie's* in the early 1870s, *Harper's Weekly*'s "pictures of sentiment, which *last* in the mind of the purchaser for years," were the key to its success. "*Leslie's,* on the other hand," Goldsmith argued in an 1875 interview, "runs all to 'events of the day,' something that happened recently. Leslie won't have romance, sentiment, illustration of human life in its many phases; he calls it 'allegory.'" Goldsmith cited circulation figures in George P. Rowell's *American Newspaper Directory* to "[prove] that the number of people who prefer 'allegory' is greater by two or three to one than the number of those who care only for transient and precarious news." To be sure, *Harper's Weekly* "should have more news illustrations. It could add thirty thousand to its circulation." But news, he concluded, did not guarantee reader loyalty: "Illustrated events make circulation; studies of character and life keep it."[7] This comment suggests that *Harper's Weekly*'s consistent success in the late nineteenth century was based on its adherence to literary and pictorial respectability and didacticism, its status as an illustrated "prescriptive" miscellany. *Leslie's,* pace Goldsmith, did not refrain from bowing to certain of the pieties, but its very topicality inevitably resulted in a fluctuating circulation, which also reflected the broader range of readers to whom *Leslie's* appealed. Circulation rarely sank below a base that, while less substantial than *Harper's Weekly*'s, never failed to turn a profit.

By the 1870s Frank Leslie's Publishing House, now at 537 Pearl Street, employed between three and four hundred people, including seventy engravers (figure 3.1).[8] Inaugurating a host of new publications, the firm never hesitated to swiftly drop or merge periodicals that proved fi-

nancially unprofitable. Out of this flood came fourteen magazines to address a cross section of the reading public. Twelve carried the name "Frank Leslie's" (the eponym awarded to survivors): in addition to its four prewar publications—the *Illustrated Newspaper, Illustrirte Zeitung* (1857–89), *Budget of Fun* (1859–96), and *Lady's Magazine* (1854–82, originally *Frank Leslie's Ladies Gazette of Fashion*)—Leslie's publishing house introduced two illustrated miscellanies aimed at the family market, *Frank Leslie's Ten Cent Monthly* (whose title soon changed to *Frank Leslie's Pleasant Hours,* 1863–96) and *Frank Leslie's Chimney Corner* (1865–84); the child-oriented *Frank Leslie's Boy's and Girl's Weekly* (1866–84) and *Frank Leslie's Boys of America* (1873–78); *Illustración Americana de Frank Leslie,* a Spanish edition of the *Illustrated Newspaper* aimed at Cuban and Central American readers (1866–70); the fashion-minded *Frank Leslie's Lady's Journal,* for part of its first year called *Once a Week* (1871–81); *Frank Leslie's Popular Monthly,* an inexpensive family miscellany (1876–1905, and continued from 1905 as the *American Magazine*); and *Frank Leslie's Sunday Magazine,* a family monthly containing material with a nondenominational Protestant slant (1877–89).[9]

Two additional publications, while successful, dabbled in humor or scandal too seamy to bear their publisher's name. *Jolly Joker* (1862–78) was a "men's" humor magazine containing jokes and cartoons deemed unsuitable for the *Budget of Fun* (itself popular among Northern troops during the Civil War). The sensational *The Days' Doings*—"Illustrating Current Events of Romance, Police Reports, Important Trials, and Sporting News"—brought Leslie perhaps more notoriety than even the enterprising publisher found useful. Beginning its existence as *The Last Sensation* in 1867 and renamed in 1868, *The Days' Doings* proclaimed on its masthead that James Watts and Company at 214 Centre Street was its proprietor, but any alert reader could note the frequent reprinting of engravings previously published in *Frank Leslie's Illustrated Newspaper,* the signatures of regular *Frank Leslie's* artists gracing many of its illustrations, and the ads for Leslie's publications dominating its back pages. Certainly Anthony Comstock was not deceived: in January 1873 he succeeded in getting Leslie indicted under the just-passed obscenity law. To the moral crusader's consternation, however, New York District Attorney Benjamin K. Phelps dropped the charges after Leslie promised to eliminate some of the weekly's more transgressive features. Nonetheless, *The Days' Doings,* renamed the *New York Illustrated Times* in 1876, continued to traffic in the scandalous and profane (albeit framed

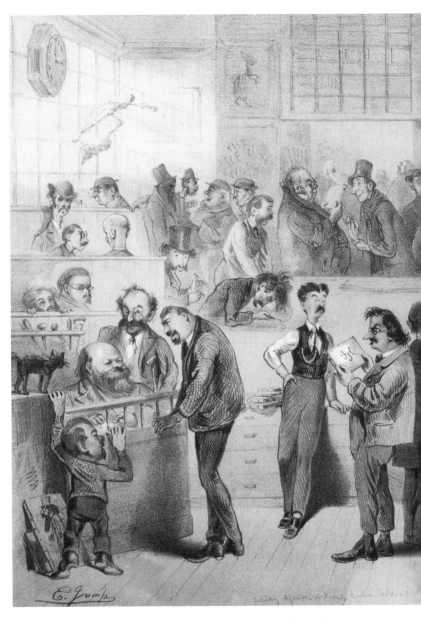

Figure 3.1. Edward Jump, "Saturday Afternoon at Frank Leslie's, 1868–69 (537 Pearl St N.Y. City)." Lithograph, 1868–69. Print Collection, Miriam and Ira D. Wallach Division of Art, Prints and Photographs, The New York Public Library, Astor, Lenox, and Tilden Foundations.

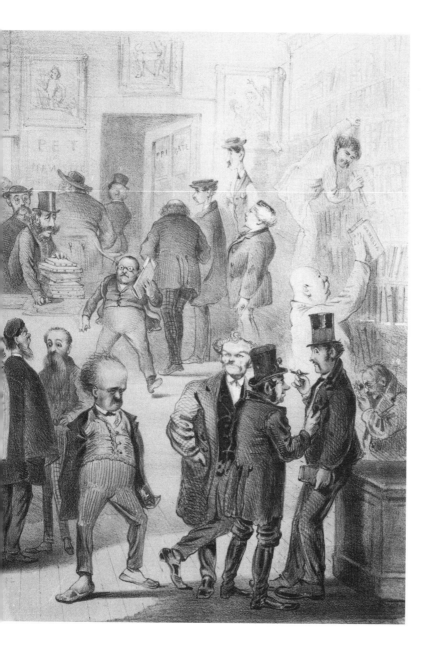

Reproduced in *Leslie's Weekly,* December 16, 1915, 661, the published version of this print included a new figure (the photographer James Wright) and a list of identifications that Frank Weitenkampf (1866–1962), the New York Public Library's first curator of prints (then called keeper of prints), determined to be inaccurate. Weitenkampf substituted his own handwritten key, placing it with the lithograph in the library's print collection:

1. Edward Jump, caricaturist, suicide
2. Frank (Harry) Leslie, Jr. died 1894
3. ———— Foreman of Press Room
4. ———— Asst. Advertising Agent
5. ———— Mr. Leslie's Private Secretary, died
6. Alfred Leslie
7. Charles Gaylor, author, died, playwright
8. Horace Baker, supt. of Engraving Dept
9. Dr. ———— author
10. ————
11. Newman, caricaturist, died
12. Dissosuray[?], Ins. Agent, died
13. Mr. Powell, Ed. of "Budget of Fun" died
14. ———— compositor [McCabe?]
15. Charles Dawson Shanley, author, died
16. Charles Rosenburg
17. "Ike" Reed, Ed. "Day's Doings"
18. Fiske, caricaturist
19. Dr. Brandis, Ed. German Ed'n "Illus News"
20. Photographer, outside work
21. Arthur Kittell, artist
22. "Joe" Becker
23. Malcolm Campbell, Mr.
24. Schimpf, artist
25. Joseph Beale
26. "Steve" Burlett, engraver
27. ———— Holcomb, Supt Art Dept
28. ("Jim") James H. [*sic*] Taylor, artist
29. ———— Hagar, sub editor
30. John Hyde, artist, died 1896
31. ———— Pillét, Editor [Joseph Keppler in *LW* caption]
32. Edward [*sic*] Forbes, artist died 1894
33. C. E. H. Bonwill
34. "Ben" Day
35. ———— Small, story writer
36. ———— White, Advertising Agent nickname "Foogle"
37. Frank Bellew, caricaturist [29 in *LW* version]
38. Albert Berghaus, artist
39. Mr. Wallin
40. ———— Miller, cashier
41. John Gilmary Shea, Literary Editor

by moralizing editorializations), its circulation hovering in the profitable range of 50,000.[10] The aggregate circulation of all of Leslie's weekly and monthly magazines, according to one contemporary source, averaged about a half a million copies weekly. In addition, Leslie's publishing house printed a wide range of popular books—adult and children's fiction, large-format picture books, Christmastime annuals and almanacs, and so on—much of their content consisting of material that first appeared in its periodicals.[11]

Frank Leslie's Publishing House was well-situated in the general publishing boom that followed the Civil War. No longer mere curiosities, images now took on a new stature that helped redefine the appearance and appeal of postwar periodicals. While literary monthlies such as the *Atlantic, Putnam's,* and the *Galaxy* continued to shun illustrations, new magazines appeared to demonstrate that the reading public, including its more genteel members, was as interested in viewing pictures as it was in reading text.[12] Beginning in 1869 a third New York illustrated weekly was introduced: *Appleton's Journal* resembled *Harper's Weekly* more than it did *Frank Leslie's,* printing pictorial views and genre scenes "suitable for framing."[13] *Scribner's Monthly* appeared in 1870 to compete directly with *Harper's Monthly.* Renamed *The Century Illustrated Monthly Magazine* in 1881, it would emerge as an innovator in applying photographic processes to wood engravings; it became a focal point for the "New School" of art engraving in the late 1870s and 1880s.[14] In 1871 the German immigrant Joseph Keppler helped found a new type of pictorial weekly consisting of satirical lithographs; in 1877, after starting a short-lived satirical magazine in St. Louis and then moving to New York to serve a brief stint on Leslie's art staff, Keppler began publishing *Puck* in English, adding richly detailed chromolithograph cartoons to the expanding field of pictorial political commentary.[15] A form of lithography also began to influence the pictorial representation of the news when, in 1873, the Canadian publishers William A. Leggo and Joseph Desbarets inaugurated the New York *Daily Graphic.* The first daily newspaper to consistently carry pictures—indeed, to *feature* pictures—the *Daily Graphic* experimented with a number of photolithographic processes to transfer artists' sketches directly to the lithographic stone. Four of its eight pages presented news images and cartoons; though they lacked the breadth of subject matter as well as the elaborateness and detail of wood engravings offered by the weekly pictorial press, they provided readers with immediate representations of news and opinion.[16] All these illustrated magazines were published in New York, contributing to the

city's postwar status as the nation's publishing center, far outdistancing Boston and Philadelphia.[17]

In the previous chapters we considered how *Leslie's* "beat" strategies for reporting and its production and marketing practices contributed to its commercial success. Turning away from the history of the publication itself, this and the following chapters explore the imagery of the illustrated press to evaluate how *Leslie's* "representations of the most prominent events of the day" operated in relationship to the social, political, and economic context of its time as well as to the lives and perceptions of its readers. We begin by looking at the visual strategies used by *Frank Leslie's* and the illustrated press in general to depict news in postbellum America, with particular emphasis on their portrayal of the tumultuous life of its cities. Adopting visual codes and narrative approaches derived from the antebellum era, the pictorial papers concocted an elaborate normative diagram for their readers that helped make sense of the changing society surrounding them. The practice of illustrated journalism embodied in their engravings served their audience up to a point, to the detriment of Americans located outside of the orbit of their circulation.

PROSCENIA ON THE PAGE

Accompanied by declarations of authenticity derived from the eye- or earwitness presence of the "Special Artist," supplemented by the work of an "ambulatory" photographic staff and by a vast photographic archive, *Frank Leslie's* illustrations regularly depicted events of the previous week. These wood engravings offered a representation of the news that differed markedly from that found in other popular visual media in the mid–nineteenth century. While photographs captured a moment (and usually a moment of stasis at that), wood engravings presented readers with pictorial narratives of events. Adopting many of the conventions of history painting—although often applied to "everyday life" themes more characteristic of genre painting—the images in the illustrated press were dramatic and detailed diagrams that invited thorough perusal.[18]

Viewing an engraving, readers registered a sequence constituting an event as well as that event's defining or decisive moment; framed within one image, time extended, and cause and effect became apparent. An 1871 engraving depicting the cataclysmic collision between a passenger express train and petroleum car near New Hamburg, New York, showed the instant of the impact (figure 3.2). But the chronology of the accident expanded within the one illustration: the locomotive and passenger cars,

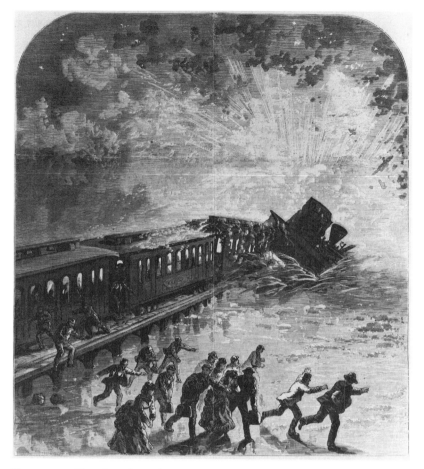

Figure 3.2. "Terrific railway disaster on the Hudson River road.—Collision of the Pacific express train with an oil train on the drawbridge over Wappinger Creek, near New Hamburg, N.Y., night of February 6th.—Moment of striking—The locomotive, with the baggage and express cars, forced from the bridge, deluged with petroleum, and fired." Wood engraving, *Frank Leslie's Illustrated Newspaper,* February 25, 1871, cover (389). American Social History Project, New York.

bathed in gasoline, catch on fire; the locomotive careens into Wappinger Creek; and, in the foreground, survivors escape from the explosion and flames. A chain of events also is evident in an 1866 cut of a disaster that occurred during President Andrew Johnson's visit to Johnstown, Pennsylvania (figure 3.3): citizens converge on the scene to greet the president; the bridge is crowded with gesticulating men, women, and children; and the bridge collapses, sending bodies tumbling down upon the railroad

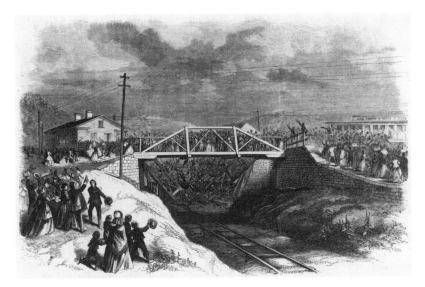

Figure 3.3. "Appalling calamity at Johnstown, Pa., on Friday, Sept. 14th, caused by the falling of a railroad bridge crowded with the citizens of the town, during the visit of President Johnson and suite—Four persons killed and over 350 wounded." Wood engraving based on a sketch by C. E. H. Bonwill, *Frank Leslie's Illustrated Newspaper*, October 6, 1866, 40. Prints and Photographs Division, Library of Congress.

tracks below. Depictions of accidents exemplified the sequential nature of wood engravings' representation, but even cuts showing less dramatic, more "ritualized" events such as political meetings and memorial gatherings carried a narrative; the latter also betrayed an implicit confusion in engravings' storytelling structure as, for example, the simultaneous ecstatic response of an audience and perorations of an orator seem to collide within their shared frame. The resulting awkwardness in such images, however, was a small price to pay for lending some dynamism to an otherwise mundane scene.[19] On occasion, *Leslie's* published news engravings based solely on photographs, usually duly noted in the captions; in contrast to the extended narrative of the standard news cuts, the engravings that faithfully reproduce photographs often appear detached and static, marking the importance of an event as opposed to delineating its meaning or atmosphere. "We do not depend upon the accidental transmission of photographs, with their corpse-like literalness," *Frank Leslie's* intoned in 1859, "but upon our own special artists."[20] Disingenuous as this remark was in the light of *Leslie's* use of photo-

graphs as source material, it nevertheless accurately described the differing representational effect of the two media.

The reader's participation was intrinsic to the operation of the representation. A complete narrative was not contained in any one image; its comprehension depended on a broader metanarrative possessed by *Frank Leslie's* readership that relied on print information supplied by the daily press. The weekly acknowledged this interaction: it described its service to readers as a supplement to the coverage of daily newspapers, "representing pictorially and vividly those things and events which the daily press at best can imperfectly describe."[21] The pictures added palpability to the news, displaying the context and content of events that would otherwise remain indistinct in the hazy realm of text. "It is a common mistake to overrate the power of language to describe," ran an 1873 editorial,

> and it arises from the profound impression that well-chosen words make upon the mind. Thus, even intelligent admirers of poetry would be likely to consider Byron's celebrated description of a storm among the Alps as "a perfect picture." But in reality it is not a picture at all, but simply produces a pictorial effect—two very different things. . . . A hundred artists, choosing it as a subject for illustration, will produce a hundred pictures each unlike the others, and they will all be different from the picture the poet had in mind when writing. Thus, it will be seen how inadequate words are to convey distinct ideas of things. . . . It is because words alone convey such vague impressions, that after an event has been fully published in the great daily papers, hundreds of thousands of people turn to our columns to see it faithfully depicted, and, until they do see, their imagination of its character must be inaccurate. Nothing can supply the want of exact illustration, and the enormous and rapidly increasing demand for illustrated papers is not merely because the people like to look at pleasing pictures, but because they depend upon the information which pictures furnish for a clear comprehension of the news of the day and world.[22]

If we set aside hyperbole and questions of authenticity for the moment, *Frank Leslie's* treatment of the textual passages that accompanied its engravings suggests the primacy of the pictures' representation. The images often were published with only brief descriptions applicable to the pictures (or with lengthy ancillary information, such as transcripts of speeches, testimony, etc.). Public figures assembled in an engraving went unnamed in the accompanying text in the expectation that readers would identify them from earlier appearances in *Leslie's* or from other pictorial sources. Similarly, readers could gain information, unremarked

on in the text, about aspects of an event as well as a qualitative sense of its context through the painfully detailed rendering of subjects and their dress, the decoration and layout of interiors, and the architecture and terrain of exteriors.[23] At times, as in an 1876 engraving showing the aftermath of a fire that devastated the Brooklyn Theatre, the picture's story extended far beyond the textual account (figure 3.4). While the description listed the personal property collected by authorities in an attempt to identify victims burned beyond recognition, the engraving portrayed an incident unreported in the text—a woman apparently recognizing the belongings of a relative.

To be sure, the descriptions were situated not only to convey some information, however limited, but to shape readers' attitudes toward the subject of the image as well. Despite *Leslie's* proclamations on the clarity of pictorial description, visual representations often required textual direction to convey meaning precisely or concisely. However, as we will see in this and later chapters, the text was hardly decisive in determining the meaning of images. Its interpretations sometimes aligned with, sometimes departed from, but always interacted with the ideological narratives that readers brought to the pictures; more important, the descriptions sometimes simplified the meanings contained in the images themselves.[24]

In their structure, conventions, and narrative, these wood engravings of news events were equivalent to performances. Framed as if on a proscenium, with the subjects and circumstances often layered much like actors against a resplendent stage setting, news images could be mistaken for the depictions of theater and opera productions that also appeared in *Frank Leslie's*.[25] The poses and gestures in the engravings conveyed emotions that readers readily recognized, having seen them performed on the popular stage (and in promotional theater lithographs and engravings dating back to the Jacksonian era). Indeed, the poses struck by figures in engravings could be equated with melodrama's convention of signaling (in Peter Brooks's phrase) the "resolution of meaning" of a scene or act in a tableau "where the characters' attitudes and gestures, compositionally arranged and frozen for a moment, give, like an illustrative painting, a visual summary of the emotional situation."[26] In short, readers of *Frank Leslie's* and the illustrated press in general were viewing weekly visual performances—evident constructions of an event whose claims to authenticity lay in the detail of circumstance, place, and dress presented while they also dramatically portrayed the line of a narrative. *Frank Leslie's* topical wood engravings conveyed to readers supplemen-

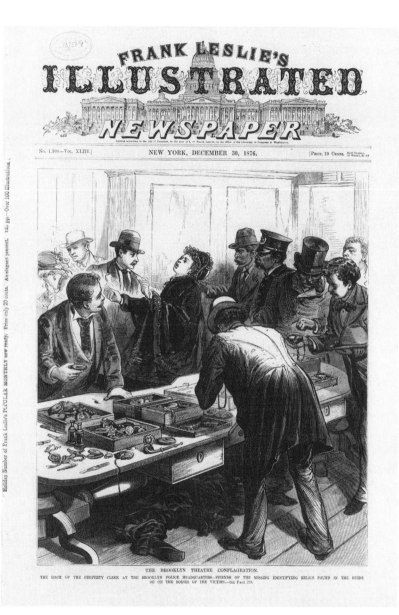

FRANK LESLIE'S
ILLUSTRATED
NEWSPAPER

No. 1,109—Vol. XLIII.] NEW YORK, DECEMBER 30, 1876. [Price, 10 Cents.

THE BROOKLYN THEATRE CONFLAGRATION.
THE ROOM OF THE PROPERTY CLERK AT THE BROOKLYN POLICE HEADQUARTERS—FRIENDS OF THE MISSING IDENTIFYING RELICS FOUND IN THE RUINS
OR ON THE BODIES OF THE VICTIMS.—See Page 279.

Figure 3.4. "The Brooklyn Theatre conflagration. The room of the property clerk at the Brooklyn Police headquarters—Friends of the missing identifying relics found in the ruins or on the bodies of the victims." Wood engraving, *Frank Leslie's Illustrated Newspaper*, December 30, 1876, cover (273). Prints and Photographs Division, Library of Congress.

tary, detailed information and a narrative diagram of an event, a combination of education and entertainment that characterized other successful commercial cultural forms.

ILLUSTRIOUS MASKS, TYPICAL FACES

In *Frank Leslie's* archive of places, events, and people, portraits were ubiquitous. Mathew Brady and his contemporaries may have captured the features of "illustrious Americans" on the photographic plate, but it was the illustrated press that made the faces of politicians and pundits, actors and artists, clergymen and charitable reformers, and diplomats and royalty familiar to the public. Nevertheless, the appearance of these engraved portraits was governed by conventions developed by commercial photography during the 1840s, when the likeness emerged as an effective tool in political campaigning. The daguerreotyped portrait, designed for exhibition and reproduction, configured a "public" face for politicians and statesmen; that face, in turn, engendered debate about the value of the likeness in revealing the subject's true identity (or "character," in contemporary parlance). Reception and production fed on one another: the public intensely scrutinized the faces of the famous, while commercial photographers endeavored to mold likenesses appropriate to the offices striven for or attained. Photographers codified conventions dating back to classical sculpture and neoclassical painting to construct formal public portraits worthy of viewers' emulation.[27]

The idealized face of the "emulatory" photographic portrait became the standard by which the notable were represented in the pages of *Frank Leslie's* and its competitors. Individual engraved portraits based on photographs supplied by studios graced every issue, a repetition of poses depicting solemn features and gazes averted in timeless reflection. Despite their transmogrification into a different medium, the engravings preserved the approved qualities of the emulatory photographs. Their presence in the pages of the illustrated press, *Frank Leslie's* repeatedly avowed, furthered moral and didactic goals. Thus, the portrait of Andrew Johnson that appeared on the cover of the May 19, 1866, issue

> is an accurate and spirited one, from an excellent photograph recently taken. The artist has succeeded admirably in catching the expression, and making the picture life-like and truthful, one that will bear study and scrutiny, and please more highly as it is more closely examined. These portraits of our prominent public men that we give from time to time, if retained, would form an admirable and valuable portfolio for preservation and reference.

In addition to marked intrinsic merit, they possess an importance from this fact, and, as their cost is insignificant, every family should possess a collection that, years hence, will be invaluable.[28]

While such portraits served the paper's didactic goals, their limitations grew apparent once the classical bust was left behind. Depictions of events involving notable figures remained in the vise of conventional photographic portraiture. The even, modulatory gaze of the posed shot tyrannized every cut, unchanging even in the most dramatic circumstances. A March 7, 1868, cover engraving illustrated Secretary of War Edwin M. Stanton barricaded in his office during the night of February 21 as he defied Andrew Johnson's dismissal order. "[A] grim sentinel guarding the treasures of official position, and ready to maintain possession against all comers," the accompanying description read, ". . . Mr. Stanton mounted guard in his sanctum and remained there, watchful and fearless, till the morning." But the Stanton rendered in the engraving hardly betrayed the emotions described in the text; the drama of the event seemed to be limited to a gust of smoke rising from a cheroot lodged in Stanton's mouth, the energy of his puffing unregistered in his placid features, which were lost in reflection.[29] When Charles Sumner lost the chair of the Senate Foreign Relations Committee on March 9, 1871, he was observed "pulling his hair over his forehead, then plunging both hands in his pockets, again giving his hair another pull, and anon throwing the lapels of his coat wide open[.]" However, the only evidence of Sumner's agitated state offered in the featured engraving (based on an eyewitness sketch by Henri H. Lovie) was the gingerly probing of his fingers at the tresses adorning his classical head (figure 3.5). Such engravings succeeded in supplying readers with the details of news events, delineating the assembled personages, the layout of rooms, and the composition of surrounding scenery. But the mission to preserve the official faces of notable Americans culminated in ideal heads planted onto ill-matched bodies, perpetuating (according to the *New York World* illustrator Valerian Gribayedoff) photography's creation of a new genus called "homo 'uprights'" (figure 3.6).[30]

Expressions appropriate to trying circumstances—unmasking and revealing the private, unholy countenances of the famous—were isolated on pages reserved for political caricatures and cartoons.[31] By the 1860s graphic satire had undergone a representational change: the baroque allegorical cartoons of Jacksonian lithography, featuring the stiffened countenances of the renowned and notorious (whether in antic or

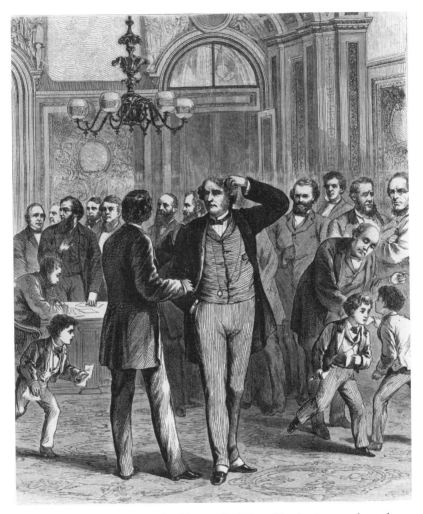

Figure 3.5. "Washington, D.C.—Removal of Hon. Charles Sumner from the chairmanship of the Committee on Foreign Relations—Scene in Reception Room, Capitol; Mr. Sumner receiving the sympathy of his colleagues." Wood engraving based on a sketch by Henri H. Lovie, *Frank Leslie's Illustrated Newspaper*, April 1, 1871, cover (33). American Social History Project, New York.

alarming situations), were replaced by engravings that focused on the exaggeration of famous faces caught performing theatrical-like roles. This turn to caricature, which first appeared in 1850s illustrated comic magazines like Thomas W. Strong's *Yankee Notions* (1852–75), was in no small part prompted by the very ubiquity of emulatory portraits, which afforded cartoonists sources for their untender ministrations (as

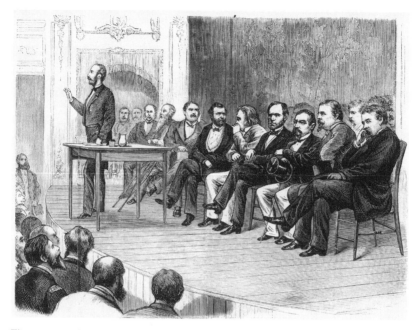

Figure 3.6. "Connecticut.—Reunion of the Army of the Potomac—General Devens delivering the oration, in Music Hall, at New Haven." Wood engraving based on a sketch by James E. Taylor, *Frank Leslie's Illustrated Newspaper*, May 31, 1873, cover (181). Prints and Photographs Division, Library of Congress.

well as supplying the necessary grounds of comparison, widely known and recognized, on which the power of their satire relied). At the same time, public interest in scrutinizing the meaning of likenesses motivated caricaturists to delve underneath the "official" masks of the famous to reveal their hidden traits. Both caricaturists' work and viewers' interpretation of their message were aided by a profusion of physiognomic and pathognomic studies that classified facial structure, expression, and pose as evidence of inner character and appropriate social role. The findings of these so-called sciences entered American popular consciousness through, among other vehicles, the exaggerated portrayals of antebellum comic and melodramatic theater.[32] The caricatured likeness, kept at a distance in the illustrated press from the reportorial emulatory portrait, presented famous people bearing "characteristic" expressions; caricature derived its power from subverting portrait conventions, undermining the formal representation of "illustrious Americans" as individuals above the societal fray. By rendering their faces and forms in

ways usually reserved for depictions of ordinary Americans, caricature brought the famous down to earth, situating them within an already constructed spectrum of recognizable social types.[33]

The discrete separation of the idealized and caricatured in the portrayals of notable figures did not apply to the greater balance of humanity portrayed in *Frank Leslie's Illustrated Newspaper*. When it came to the representation of events in the newly discovered terrain of the defeated South, the burgeoning settlements of the West, or the prosperous and poor neighborhoods of New York City, "anonymous" Americans took on explicit and exaggerated features, expressions, gestures, and poses. Distinguished by traits linked to specific regions of the nation (each in turn with its own variations and subgroups), the citizens differentiated into representational social types were instantly recognizable to readers. The device of typing dated back to the first years of the republic, but it had blossomed in the Jacksonian era's culture industry. The self-confident and calculating Yankee "Brother Jonathan" of New England, the independent and rapturously (or terrifyingly) irrepressible western frontiersman, the rude backwoods southern "cracker," and the pugnacious and preening urban plebeian "Mose" were among the most popular of the regional characters performed on the popular stage, described in popular literature, and illustrated in the crude woodcuts of comic almanacs and the "low" aesthetics of genre painting. All and none denoted the archetypal American, and each was equal in stature and derision with the other (except for African American and female types, who lacked the autonomy of the regional white male characters).[34]

The distinctive features, styles of dress, and poses of these social types signified predictable and predetermined characteristics that served as components for a normative description of American society. The practice of typing helped Americans master social and political difference in an increasingly heterogeneous, disorderly, and perplexing nineteenth-century reality marked by commercial competition between regions, emerging industrial conflict, and the chaotic expansion of the body politic. As a "structure of feeling" that prefigured class differentiations, typing articulated Americans' identities: a citizen either belonged to one type or stood in opposition to another. In what has become a familiar relationship between production and reception in the construction of commercial culture in the United States, the representations on the stage and page contributed to popular speech and dress as much as they were inspired by the appearances and behavior of audiences and readers.[35]

Relying on antebellum conventions and categories, the illustrated press added new subtypes in the years following the Civil War. To name only three: the old Kentuckian frontiersman found a plains counterpart in the cowboy; the miner (an amalgam of one old frontier type and several urban ethnic and plebeian types) arose to complicate the prototypical figure of the stalwart skilled craftsman; and a range of new African American characters emerged during and after the Civil War as alternatives to the childishness of the plantation slave and carefree lubricity of the northern free black.[36] As such old and new figures indicate, the pictorial press rejuvenated the practice of typing with its broader distribution, greater accessibility, and better reproduction techniques. In the antebellum period, types as visual images were subordinate to theatrical performance and literature, appearing mainly in crude woodcut illustrations of comic almanacs or in lithographs portraying actors as celebrated characters. The advent of the illustrated press in the 1850s prolonged the practice of social typing through the nineteenth century.[37]

Frank Leslie's and the pictorial press in general also extended the conventions instituted before the Civil War to depict social types. Types appeared in visual codes that, to those versed in the science of physiognomy, revealed their innate character and motive to a vast American public. Rooted (if more in assertion than in fact) in Aristotelian precepts of the ideal, physiognomy's long history had reached a milestone in the late eighteenth century with the publication of Johann Caspar Lavater's multivolume *Physiognomische Fragmente*. The Swiss theologian's work, translated into many languages, set forth precise rules for deducing essential moral and social qualities from facial structure and expression. Establishing the ideal in the classical Greek profile, in which the nose and forehead form a vertical line denoting intelligence and spirituality, Lavater's many diagrams delineated how deviations from classical balance and symmetry compared with traits found in animals to confirm characterological flaws, from idiocy to immorality.[38]

Lavater's physiognomic principles quickly found their critics—"What an immeasurable leap from the surface of the body to the interior of the soul!" scoffed the German physicist Georg Christoph Lichtenberg[39]— but their somatic clues to character gained general adherence throughout Europe and the United States. "Thus the habits of the soul become written on the countenance," wrote the prolific Samuel G. Goodrich in an 1844 instructional manual on children's manners, "what we call the expression of the face is only the story which the face tells about the feel-

ings of the heart. If the heart is habitually exercised by malice, then a malicious expression becomes habitually stamped upon the face. The expression of the countenance is a record which sets forth to the world the habitual feelings, the character of the heart."[40] Physiognomy and the related sciences of pathognomy (studying the meaning of anatomical proportion, pose, and expression) and phrenology (deciphering character by the shape of the skull) played a crucial role in redefining public and private behavior in the formation of a middle class. In short, these pseudo-sciences offered a way to comprehend and represent an increasingly complex and perplexing social reality.[41] More to the point, Lavater's diagrams served as models for artists, both in the studio and in the newspaper office, as they depicted the populace.[42] Rendering figures whose features and physiques were imbued with the rules of physiognomy, the illustrations in the pictorial press constructed an orderly, detectable, moral map for what seemed so hidden and chaotic in mid-nineteenth-century America. The pictorial representation of social types in *Frank Leslie's* suggests many of the conventions governing contemporary Parisian "social caricature";[43] but whereas French lithography relied on physiognomy and typing for satirical comment, these American pictures used the devices to report directly the conditions and events of the day.

FRANK LESLIE's NEW YORK: FAR FROM THE MADDING CROWD

The imperative for reading character and social role was particularly acute in the new, heterogeneous "world of strangers" of the mid-nineteenth-century American city. "[W]henever we walk through the denser part of town," Frederick Law Olmsted wrote in 1870, "to merely avoid collision with those we . . . pass upon the sidewalks, we have constantly to watch, to foresee, and to guard against their movements. . . . [We see] thousands of fellowmen, have met them face to face, have brushed against them, and yet have had no experience of anything in common with them."[44] The geographic growth and discomfiting mix of classes in cities like New York prompted the production of literary and visual categorizations that afforded an emerging, inchoate middle class with a means of identifying itself. City life might be composed of a series of shocks and collisions, but there were signs and procedures with which one might comprehend the physiognomics of the crowd while, at the same time, distinguishing oneself from that crowd. "Persons on the

street," warned one etiquette manual, "attract the attention of every passer-by by their dress, their conduct, and their manner of walking. Some critics say that character may be read by any of these as readily as by the features of the face. Nothing so quickly points out the low-bred as loudness of conduct or flashiness of dress on the street." [45] In private, looking over a pictorial newspaper, the respectable reader could let his or her eyes rove promiscuously over the urban scene. The threatening urban landscape could be read and, with this knowledge, safely traversed. The pictorial press played a crucial role in making the city seem decipherable, serving as the perfect complement to genteel rules of public behavior that required the controlled gaze of "civil inattention" in the street. [46]

Information guiding the citizen through the treacherous streets was readily available in the pictorial press, and it was New York City in particular, the home of *Frank Leslie's Illustrated Newspaper* and its competitors, that became the nation's paradigm for urban life. Society balls and political campaigns, building construction and conflagrations, theater openings and funerals, parks and processions—significant or not, events in New York predominated in *Frank Leslie's* coverage. The customs and manners of the city were portrayed through a range of social types (and their subcategories) stretching across the classes: Wall Street types tussled in the financial district; middle-class types thronged the ferries on weekend excursions; polite society types attended banquets and fancy balls; and a panoply of ethnic types engaged in their customary pastimes.

In their day-to-day lives real New Yorkers endured the promiscuous bustle of humanity, but on the pages of *Frank Leslie's* the spectacle of the mixed urban crowd faded from view. Like the expanding metropolis fragmented into enclaves defined by class and ethnicity, the panorama of the streets was viewed by the paper's readers in small bits. *Leslie's*, like the city guides of the period, mapped the city by gathering separate representations of distinct and contrasting social types, each populating its own characteristic haunts and environs. New York was perceptible only through its parts, a metropolis composed of several cities on a spectrum from sunshine to shadow: "the commercial metropolis," "the metropolis of vice," "the boarding house belt," and "the fashionable metropolis." [47]

A unified pictorial sense of the city existed but, like contemporary lithographic and photographic representations, it was largely confined to idealized aerial views, promotional pictures of new Grand Style build-

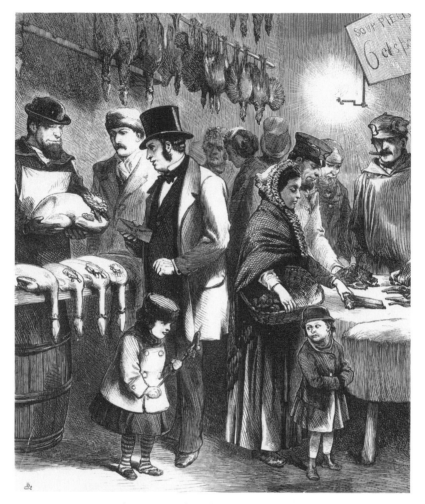

Figure 3.7. "New York City.—Rich and poor; or, the two Christmas dinners.
—A scene in Washington Market, sketched from real life." Wood engraving
based on a sketch by Fernando Miranda, *Frank Leslie's Illustrated Newspaper*,
January 4, 1873, cover (265). Prints and Photographs Division, Library of
Congress.

ings, laudatory cuts displaying urban improvements, or fantastic rendi-
tions of how the streets *should* look.[48] There were exceptions to the pic-
torial segmentation of the city, but such engravings portrayed the mixed
crowd to convey a sentimental or cautionary note. The contrast of wealth
and poverty in an 1873 engraving of a scene in the Washington Market
exemplified a predictable Christmas trope, although the poses of the

Figure 3.8. "An argument against whisky drinking": "In the prison pen—A Sunday morning scene at the police court"; "On the way to the island—Entering the 'Black Maria' prison-carriage, from the Tombs." Two engravings based on sketches by Joseph Becker, *Frank Leslie's Illustrated Newspaper,* March 14, 1874, 5. General Research Division, The New York Public Library, Astor, Lenox, and Tilden Foundations.

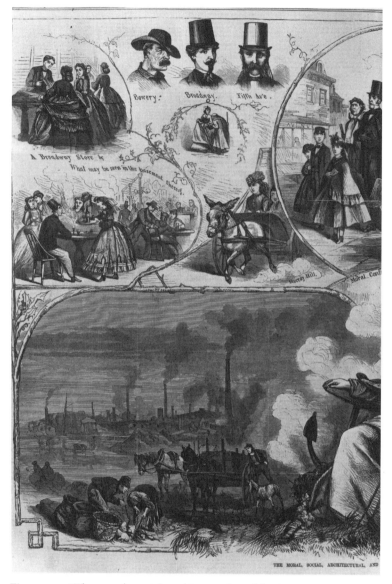

Figure 3.9. "The moral, social, architectural, and business contrasts of New York City." Wood engraving, *Frank Leslie's Illustrated Newspaper,* July 14, 1866, 264–65. American Social History Project, New York.

Bowery. Broadway. Fifth Av'e.

H. B. CLAFLIN

IMPORTED PICKLES

An Architectural Contrast.

Mackerelville.

Business Contrasts.

CONTRASTS OF NEW YORK CITY.—SEE PAGE 261.

subjects served to bifurcate the composition, effectively converting one picture into two (figure 3.7).[49] In other engravings, the mixing of social types appeared more dangerous. Although the description of the 1866 cut "Cattle driving in the streets" cited the abuse as "an example of what can be done to outrage a million of people living in a great city, by a few wealthy men engaged in the business of buying and selling cattle," the engraving conflated the frenzied activity of the roughly clad drovers with the menace of cattle careening toward unwary pedestrians.[50] The threat of chaos took a different form in engravings that delineated respectability succumbing to vice, as in the 1874 "An argument against whisky drinking," depicting the defilement of youthful virtue amid the hard cases accustomed to the Tombs (figure 3.8).[51] An exceptional scene like the 1869 cut of a mixed crowd that included "foreigners" applying for naturalization papers in the General Term Room of the superior court implied, through its mingling of different social characters (with an "illustrious face" peeking out from their midst), corrupt motivations and political manipulation.[52]

In the end, engravings that gestured toward inclusiveness preserved the exclusiveness of urban types. One of the most panoramic displays of contrasts, an 1866 double-page engraving called "The moral, social, architectural, and business contrasts of New York City," merely enunciated the segmentation (figure 3.9). The representation imposed order on the cacophony and chaos of urban existence described in the accompanying text:

> The quiet, orderly, virtuous citizen, while on his way to church with his family, will be almost deafened with the hoarse cries of newsboys, or shocked by the brutal cursings of the rabble, who defy law and outrage decency. The millionaire, whose costly mansion contains every luxury and convenience and comfort that money can command, may look from his lordly windows upon the rude hovel of the miserable squatter, who gladly calls some squalid shanty his home. The successful merchant, whose business is summed up by scores of millions, has an earnest competitor in the street vender of nuts, and candies, and toys.

Any doubts about using such a seemingly schematic image to report "reality" were allayed in the description: "[W]e present some of the contrasts that exist in our city, and make up its distinctive character. And these, so far from being exaggerations or caricatures, barely afford an idea of what would strike even the casual observer."[53]

THE POOR AND OTHER HAZARDS OF URBAN LIFE

Unlike the British illustrated press, which avoided the more unpleasant aspects of urban life, American pictorial papers offered a steady supply of pictures showing the dangerous city. While the genteel *Illustrated London News*, subscribing to Reynoldsian precepts of the ideal, simply erased the morbid aspects of city living (and *Punch* placed them within humorous frames that made their representation palatable), *Frank Leslie's Illustrated Newspaper* regularly depicted accidents, fires, hazards, crime, and—especially—poverty.[54] For example, the era's preoccupation with sanitary reform and the heavy sales that attended *Frank Leslie's* exposés of health scandals attested to the growing belief that hidden horrors could at any moment transcend the geographical boundaries of class to wreak havoc on the entire city. Readers needed to know the hazards lurking in the metropolis, and the value of the illustrated press lay in its ability to represent the threatening disorder of poverty, obviating the need to learn of danger through direct personal experience.[55]

From the late 1860s to the mid-1870s, readers of *Frank Leslie's* and its pictorial competitors were subjected to an archive of images that revealed the poverty underlying city life while also assuring its viewers that the problem was largely the result of individual moral failure. Invariably accompanied by descriptions of artist-reporters' journeys into darkness guided by jaded officers of the law, these engravings portrayed enduring social types, their faces and bodies diagrams of characterological failure, their lives passed in dark, crowded conditions that were the antithesis of the domestic ideal. The causes of their plight were readily apparent. Mrs. McMahan's wretched one-room "apartment" on Roosevelt Street, depicted in an 1867 cut, exhibited the destitution wrought by liquor; the sole male occupant was collapsed in an alcoholic stupor on the unswept floor (figure 3.10). While the averted face of the mother suckling her baby added a dollop of sentiment to the hovel's female occupants, the center of the composition was devoted to the slouching Mrs. McMahan. In her harsh, angular features, bereft of feminine virtues, the viewer ascertained the eventual fate of the younger women in the scene, its cause located in the liquor tankard weighing down Mrs. McMahan's right hand.[56]

Such views, *Leslie's* insisted, were not intended to titillate the viewer. Pictures of poverty and moral collapse were presented to prompt reform measures by giving "our readers, many of whom have but a vague notion of what a tenement-house is, some conception of its horrors." The text accompanying the engraving of Mrs. McMahan noted that Special

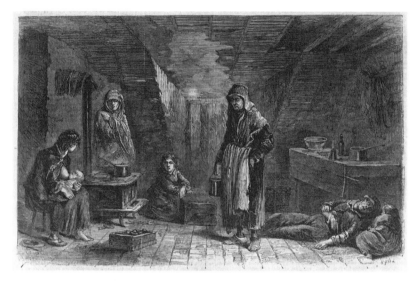

Figure 3.10. "The Mysteries and Miseries of New York City. Interior of Mrs. M'Mahan's apartment at No. 22 Roosevelt Street." Wood engraving based on a sketch by Albert Berghaus, *Frank Leslie's Illustrated Newspaper,* February 2, 1867, cover (307). American Social History Project, New York.

Artist Albert Berghaus had also drawn the mansion where the owner of the dilapidated Roosevelt Street tenement lived; since there was a possibility that the landlord was unaware of the condition of his property, that sketch had not been reproduced. Nevertheless, a clear threat underlay the comment.[57] Similarly, *Leslie's* occasionally felt constrained to note exceptions to its general rule of portraying poverty as degrading. The May 12, 1866, story "The Homes of the Poor" included one engraving—"The dead child—A scene in a tenement house in Mulberry Street, near Bleeker Street, New York"—that presented the predicament of the "worthy" poor. Picturing a destitute family coping with the death of an infant, the description concluded: "We must not judge people by their surroundings entirely; many tender hearts and gentle affections may be found in just such a room as this, and the blow that falls on such a family falls just as heavy as if it had descended in the splendid abode of wealth and taste."[58]

Still, the characterization of both scenes as "plague spots of New York" made clear the limited parameters of *Leslie's* notion of reform. Despite rare mentions of the misery of worthy individuals, overall degradation was assumed; there was little interest in alleviating the conditions of the more numerous unworthy poor, who demonstrated that

they belonged in that category both by their representation and by their attitude toward pictorial reportage. "It is one of the peculiarities . . . of the dwellers in such localities," *Leslie's* pronounced with characteristic self-dramatization, "that they object strenuously and sometimes forcibly to becoming objects of publicity; and no one who has never tried it can know the difficulty there is in gathering such information of the abuses in our midst as we show here, and have previously shown, and intend to show again. Without the aid of the police it would often be impossible to gather the information we need, and we must acknowledge the aid they have always afforded us[.]"[59] The focus of reform was actually directed toward the concerns of the audience of the illustrated press, with the goal of eradicating pestilence's threat to the "undeserving" reader (a menace all too apparent after the cholera epidemic of 1866).[60]

The pictorial papers unearthed the hidden horrors of poverty, but they also acknowledged its resolutely public manifestation in the city streets. Nowhere was this more apparent than in the city's immigrant working-class neighborhoods, epitomized by the infamous Five Points, heart of the "bloody ould" Sixth Ward. "At the Five Points," journalist Nathaniel Parker Willis had lamented in 1846, "nobody goes in doors except to eat and sleep. The streets swarm with men, women, and children. . . . They are all out in the sun, idling, jesting, quarreling, everything but weeping, or sighing, or complaining. . . . A viler place than Five Points by any light you could not find. Yet to a superficial eye, it is the merriest quarter of New York."[61]

The illustrated press ensured that the viewer's gaze would be more than glancing, but the vision presented by these publications varied little across the decades. Although the description that accompanied the 1873 "Among the poor.—A summer evening scene at the Five Points" was drenched in optimism, heralding missionary activities, the construction of new buildings, and the extension of Worth Street from Centre to Chatham as casting "daylight into the slums,"[62] the figures occupying the engraving reiterated types described and drawn ad infinitum, dating back to the decade before the Civil War (figure 3.11). The downcast gaze of a mother embracing her infant and the interchange between an ice-cream vendor and an urchin conveyed sentiment and the spirit of commerce respectively, but these positive elements were set beside a pile of rubble and the slumped figure of an unconscious man (most likely intoxicated but, in any case, inappropriate as he slumbered out in the open and during the day).[63]

But it was another man, unkempt, ill-proportioned, and staring defi-

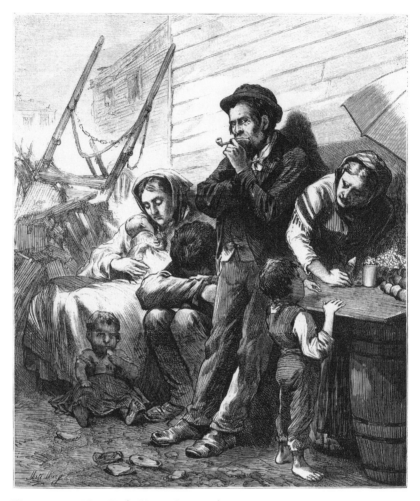

Figure 3.11. "New York City.—Among the poor—A summer evening scene
at the Five Points." Wood engraving based on a sketch by Matthew Somerville
Morgan, *Frank Leslie's Illustrated Newspaper,* August 16, 1873, cover (357).
Prints and Photographs Division, Library of Congress.

antly at the viewer, who held center stage in the tableau. He was the ar-
chetypal single-male Points tough—a gang member, saloon denizen, and
Tammany shoulder hitter. Insolently idle in the bustle of the day, he was
the epitome of the undeserving poor, of a predatory underworld that
mobilized energy only to wreak riot and mayhem. The textual descrip-
tion conferred a predictable career: "From Nowhere to a Gutter, from
Gutter to a Cell, from Cell to Court, and thence to the Tomb of the Liv-

ing or the Scaffold." [64] His features bore all these traits: his heavy brows, small nose, prominent cheekbones, broad upper lip, wide mouth, and jutting jaw defied the physiognomic ideal. The brutish face and posture, not to mention slovenly dress and clay pipe, were familiar to readers of *Frank Leslie's Illustrated Newspaper:* the subject was a variation on the simianized type of the low Irish immigrant that, ranging between care-free and vicious, had populated urban imagery since the 1840s famine migration. [65]

The Five Points figure in the 1873 engraving seems to bear many of the characteristics of the antebellum Bowery B'hoy; he is a version of Mose the Fire-Laddie, the archetypal single-male native-born mechanic of the rough republic of the streets. But this Irish immigrant "plug-ugly" assumed only the place and not the characteristics of the once-renowned youthful journeyman or apprentice. He no longer represented the urban working-class male; instead, he signified the impoverished and vicious "dangerous classes," a type that *Frank Leslie's* readers—including its working-class audience—viewed with suspicion and fear. The continuing representation of the Five Points tough made familiar in the antebellum era was significant in light of the disappearance, as native-born artisanry declined, of an urban working-class type in popular visual imagery. Mose had no postbellum counterpart: after the Civil War, the depiction of the urban working class was fractured, dispersed among a number of lower ethnic types that, like the Irish, had their origins in antebellum representation. The distinction was clear as early as 1857, when *Frank Leslie's* reported on the Dead Rabbit–Bowery Boy riot, a gang battle in the Five Points in response to the institution of a state-controlled metropolitan police force and a temperance law designed to undermine immigrant political power in New York City (figure 3.12). In the engravings portraying representative members of the rival gangs, the Irish Dead Rabbit resembled the 1873 Five Points tough; in contrast, the ostensibly native-born Bowery Boy gang member was a last vestige of the generic B'hoy, no longer with soap locks but familiarly dandified. [66]

"The gentleman with the clay pipe," the description accompanying the 1873 engraving concluded, "leaning in blissful repose against the unreliable fence, may be pondering on a short cut to an Aldermanic seat from the Bloody Sixth, or a place on the police force." [67] Urban politics had its images of ebullient crowds and enthusiastic processions, but more compelling were those that revealed a shadow world of deals and disorder. Although backroom maneuvers and smoke-filled rooms denoted the corruption of machine politics and "special interests," the

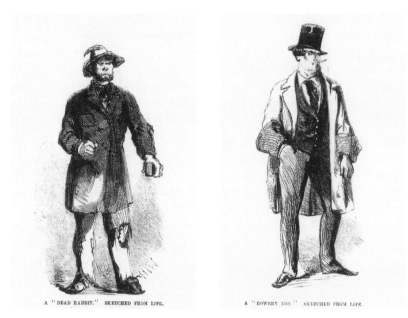

Figure 3.12. "A 'Dead Rabbit.'—Sketched from life." "A 'Bowery Boy.'—
Sketched from life." Wood engraving, *Frank Leslie's Illustrated Newspaper,*
July 18, 1857, 109. Prints and Photographs Division, Library of Congress.

clearest visual articulation of the canker in politics necessarily featured
the malevolent male tough.[68] "Some scenes and incidents, . . . which are
peculiar to our city elections, are best conveyed to the mind of the pub-
lic through the illustrated newspaper," ran the comment accompanying
Frank Leslie's 1871 engraving of an election-eve scene in the back room
of a Second Avenue liquor store, the local headquarters of a senatorial
candidate (figure 3.13). Aside from money changing hands, it was the
malevolent presence of the members of the Seventh District political
club—"a class of roughs, political guerrillas, who wage an individual
warfare for their own benefit, who must be paid, not for their support,
but to insure protection from their interference"—that marked the chaos
always threatening urban politics. Such pictures rarely carried a parti-
san political theme; in contrast to *Harper's Weekly, Frank Leslie's* down-
played pictorial coverage of the Tweed Ring.[69] The political tough could
as easily work for Republicans as for Democrats, as indicated in the 1872
"The Philadelphia election fraud," showing the freelance ministrations
of New York "repeaters" imported by the forces supporting the guber-

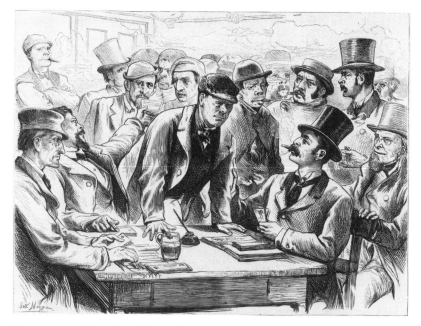

Figure 3.13. "New York City.—The night before election at a 'political headquarters' in the Bradley and O'Brien district—Distributing money to the workers." Wood engraving based on a sketch by Matthew Somerville Morgan, *Frank Leslie's Illustrated Newspaper,* November 25, 1871, cover (161). Prints and Photographs Division, Library of Congress.

natorial candidacy of Republican John F. Hartranft (figure 3.14). In this and other cuts, the figure of the political ruffian at times took on another aspect of the antebellum Mose, now appearing as a sporting type whose brutish features were highlighted by dandified dress.[70]

In the pages of *Frank Leslie's,* the predatory poor exhibited other forms of behavior disruptive of urban society. An 1866 engraving of a dogfight in Kit Burns's "Sportsmen's Hall" on Water Street presented "the intellectual faces of the spectators, showing what is the height in the moral scale necessary to enjoy dog-fights in their perfection" (see figure 2.3).[71] While the scene in the 1867 "Preparing for a quiet Sunday under the operation of the excise law" was less violent, its depiction of Fourth Ward denizens supplying themselves with whiskey on a Saturday night suggested the mayhem that would ensue on the temperance-enforced Sabbath (figure 3.15). "[T]his class of people," the description noted, endeavored to obtain liquor "even though some indispensable

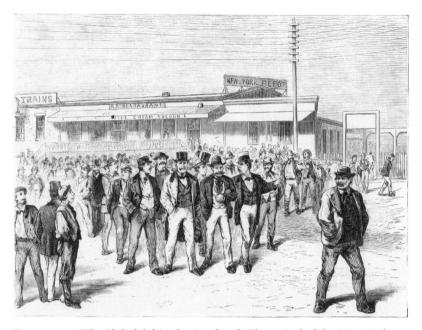

Figure 3.14. "The Philadelphia election fraud: The arrival of the New York re-peaters, engaged by the Hartranft party, at the railroad depot, West Philadel-phia." Wood engraving based on a sketch by Albert Berghaus, *Frank Leslie's Illustrated Newspaper,* October 26, 1872, cover (97). Prints and Photographs Division, Library of Congress.

tool or article of clothing goes to the pawnbroker's to obtain the need-ful cash." [72] Such engravings of violent and vice-ridden pastimes ex-plained to *Frank Leslie's* readers the "dangerous classes" (joined, in Sportsmen's Hall, by a few errant "swells"), conflating the condition of their lives with their degraded amusements. [73]

The inevitable results of vice were depicted in police court and prison scenes. And yet, depictions of the acts that led to prosecution in the Tombs police court or to conviction for inmates bound for Blackwell's Island received little attention in the pages of the illustrated press. [74] The threatened depredations of a criminal underworld nurtured in the slums rarely emerged in pictorial form to wreak havoc in the public thorough-fares used by respectable citizens. Engravings of such crimes were for the most part limited to the techniques of pickpockets on streetcars or bur-glars' methods of "cracking a crib" in the middle of the night. [75]

Perhaps most disconcerting to readers were those crimes not perpe-trated by the "legible" poor but carried out via deception and disguise.

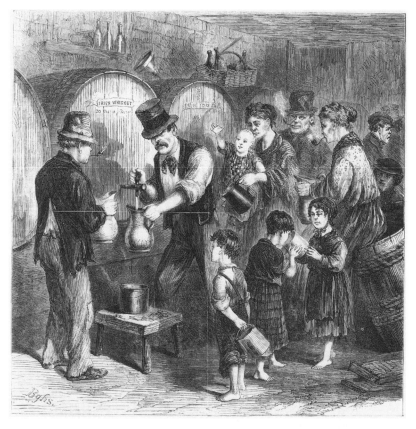

Figure 3.15. "Preparing for a quiet Sunday under the operation of the excise law." Wood engraving based on a sketch by Albert Berghaus, *Frank Leslie's Illustrated Newspaper,* November 30, 1867, cover (161). Prints and Photographs Division, Library of Congress.

These offenses were the work of criminal types who were able to elude detection, who could conceal their inner traits and true motives behind physiognomies that bespoke rectitude and trust. The 1873 engraving of a "high-toned" passenger in a railroad smoking car offering to play a sociable game of cards to pass the time presented but one example of the "social counterfeit" that, ranging from Broadway confidence men to Wall Street speculators, plagued Gilded Age society and commerce (figure 3.16). Such images required more than the usual cursory glance to evaluate character: in this case, the gentleman's "appearance of dazzling elegance" warned the reader that the subject was "possibly a little overdressed."[76]

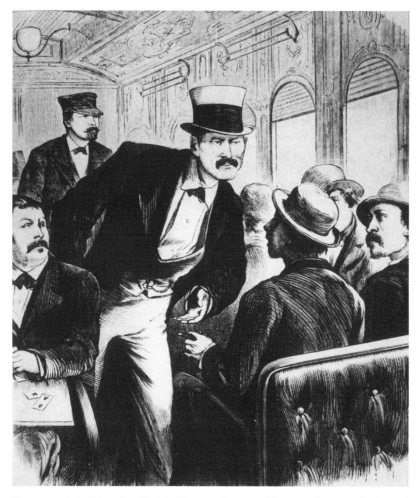

Figure 3.16. " 'Take a hand, sir?' The traveling gambler tempting the city-bound countryman to play a game of euchre—A scene in a smoking-car of an eastern railway." Wood engraving based on a sketch by Joseph Becker, *Frank Leslie's Illustrated Newspaper,* October 18, 1873, cover (85). American Social History Project, New York.

Although *Frank Leslie's* depicted a small range of crimes against person and property, engravings showing violent crimes against respectable persons—a common trope in present-day representations of urban crime—were virtually nonexistent. The murders (and their ensuing trials) that occasionally appeared focused instead on sensational crimes involving "uncharacteristic" perpetrators and victims. Murder in the Five Points was expected and did not require visualization. In contrast, the

1872 murder of Wall Street speculator James Fisk Jr. was the tragic result of the "insane pursuit of sudden wealth and unhealthy notoriety," a cautionary tale revealing the hazardous "spirit of the age."[77]

With Leslie's publication of *The Days' Doings* in 1868, *Frank Leslie's Illustrated Newspaper* ceased its regular depiction of violent crimes. Although pictures of the Fisk killing and other illustrations showing "scandalous" acts of violence still made an occasional appearance in the weekly's pages, subsequent visual reportage of murders for the most part veered away from the sort of re-creations featured in *The Days' Doings* and its inspiration, the *National Police Gazette*. Instead, *Leslie's* pictorial coverage of murder cases contained more temperate contextual information, such as the scene of the crime and portraits of the protagonists. While *The Days' Doings* and the *National Police Gazette* supplied a steady flow of murder to their readers, they tended to favor "crimes of passion," whose narratives combined titillation with cautionary morality, rather than the arbitrary anonymity of urban violence.

In short, *Frank Leslie's* engravings of poverty and its related disorders conveyed crucial information to readers, uncovering the dark side of urban life. But if the poor were to be a perpetual presence in the city, *Leslie's* would offer some relief and a rationale for its catalog of seemingly worsening conditions. The publication insisted that its display of "terrible pictures" was intended to incite ameliorative action and to press its readers to demand change. Within the limited definition of reform in Gilded Age America, *Leslie's* offset cuts of plague spots and social degradation with pictures depicting their removal. The 1866 engraving of the interior of the new city morgue on the East River carried a message about the fate of the city's wretched citizenry: the gruesome view possessed a measure of "sunshine," however, as its neat line of corpses and cleansing paraphernalia delineated and applauded policies that would prevent contagion.[78] Similarly, the weekly presented the activities of charitable institutions to prompt contributions by readers while also reassuring them that all was not mayhem in the slums. The suffering of the worthy poor was being alleviated, as demonstrated in an 1869 engraving showing a faultless mother and her well-kempt (if hungry) children waiting for Sunday breakfast in front of the new Howard Mission in the Five Points (figure 3.17). Nevertheless, the surrounding "elements of the grotesque," the dissolute males lurking about the mission's entrance, tempered any sentimental interpretation that good works could transform innate low traits.[79]

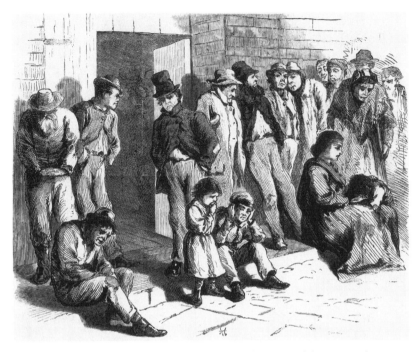

Figure 3.17. "Waiting for breakfast—Scene at the door of the Howard Mission, Five Points, New York." Wood engraving based on a sketch by Thomas Hogan (?), *Frank Leslie's Illustrated Newspaper,* March 6, 1869, 397. The Library Company of Philadelphia.

CHILDREN: HOPE AND DESPAIR IN THE STREETS

One specific source of hope stood out from the overall picture of physical and spiritual collapse. Abandoning the bulk of the "unregulated" adult poor as having irretrievably succumbed to vice, *Frank Leslie's* and the illustrated press in general cast a sympathetic eye on their progeny. A series of engravings in 1873 depicted the plight of "Italian street musicians," showing depraved "masters" beating indentured children for their failure to beg a requisite amount of money, and pictured urchins haunting the night streets because they feared such punishment (figure 3.18).[80] These engravings portrayed extreme behavior; but whether abused by masters or neglected by deficient parents, whether prematurely driven or released from the moral confines of the family to roam unsupervised in the streets, the children of the poor were largely depicted as the blameless victims of corrupted adults. They alone still suggested to readers that reform was possible.[81]

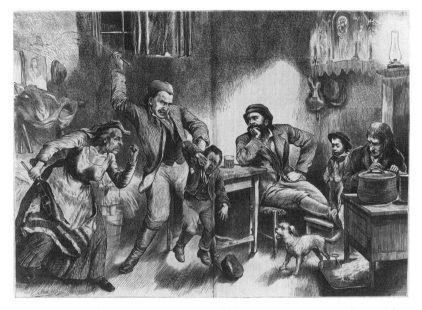

Figure 3.18. "Italian Street Musicians and Their Masters. New York City life.
—The brutal master punishing the little slave for not earning seventy-five cents
during the day with the violin." Wood engraving based on a sketch by Matthew
Somerville Morgan, *Frank Leslie's Illustrated Newspaper,* March 8, 1873,
416–17. American Social History Project, New York.

When pictured as victimized, children of the slums appeared in more
picturesque "character studies" of the streets that presented spirited and
well-scrubbed (if ragged) urchins. In these engravings newsboys found a
favored place, a juvenile urban type whose representation had barely
changed since first appearing in genre paintings and lithographs in the
1840s. An engraving like the 1869 "Courage and Despair," in which a
plucky, barefooted boy hawked newspapers during a nighttime blizzard
while another child crouched forlornly in the snow, played on the sen-
timentalism of bravery under duress, constructing a contrast that cele-
brated the newsboy's unvanquished spirit and reassured readers that
"intensity of character" could be located in the children of the slums.[82]

But there was a shadow side to the sentimentalized imagery of juve-
nile heroism. The spirit of commerce displayed by the newsboy, unme-
diated by supervision, could easily cross the boundaries of decorum and
legality. "All the neglect and bad education and evil example of a poor
class," warned Children's Aid Society founder Charles Loring Brace,
"tend to form others, who, as they mature, swell the ranks of ruffians
and criminals. So, at length, a great multitude of ignorant, untrained,

passionate, irreligious boys and young men are formed, who become the 'dangerous classes' of our city. They form the 'Nineteenth-Street Gangs,' the young burglars and murderers, the garroters and rioters, the thieves and flash-men, the 'repeaters' and ruffians, so well known to all who know this metropolis." [83] The threat embodied by the city's *"enfants perdus,* grown up to young manhood"* was a constant visual refrain in the pages of *Frank Leslie's Illustrated Newspaper.* The picturesque mischievousness of country boys represented in genre paintings took on a more malevolent aspect in engravings of urban children. In an 1867 cut, newsboys awaiting the evening edition of the *Daily News* resembled a fearsome menagerie more than exuberant youth awaiting their turn for the main chance. The entrepreneurial spirit appeared to go astray in another 1867 engraving that portrayed the methods used by "vagrant boys" to steal pet dogs to sell to the city pound.[84]

In short, these engravings demonstrated that the opportunity to save the children of the poor from the fate of their elders was fleeting. Exposed to the vice and degradation of the city streets, children all too quickly succumbed, lost forever to the ministrations of missionaries and reformers. The message conveyed in the 1868 "Graduate and student" was grimly explicit (figure 3.19): "The face of the detected criminal, who is being led to prison, reveals in his hardened features a career of lawlessness; the lineaments of the lad who, cigar in hand, stands mockingly at the threshold, as plainly show *his* early familiarity with vice. That boy is marked for a life of debauchery and villainy; and in the streets of the great city, in the slums that he frequents, in his home, if he have one, he has been educated to antagonism with society." [85]

If the children of the poor were to be saved, if readers were to be relieved of the fear of their inevitable decline, then early prevention was the answer. The engravings depicting juvenile poverty thus carried an ambivalent, cautionary message, their sentimentality placed within an ominous frame. In the end, only illustrations like the 1867 "Thanksgiving dinner to the poor children of the Five Points Mission," showing extremely young children harbored from the corrupt influences of their parents and neighborhoods, unequivocally offered solace to the readers of *Frank Leslie's.*[86]

* * *

The conventions and codes in *Frank Leslie's* pictorial coverage of New York indicated, to use Raymond Williams's phrase, an asymmetry in

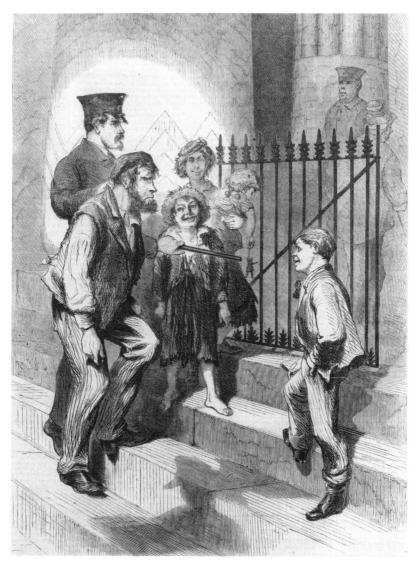

Figure 3.19. "Graduate and student—A scene on the steps of the 'Tombs' (city prison) New York City." Wood engraving, *Frank Leslie's Illustrated Newspaper*, November 14, 1868, cover (129). General Research Division, The New York Public Library, Astor, Lenox, and Tilden Foundations.

the relations between dominant and subordinate cultures in Gilded Age America.[87] At first glance, social typing and the construction of moralistic pictorial narratives in *Leslie's* appear to be the pictorial equivalent of other social and cultural practices that served to define the new urban middle class.[88] Pictorial publication was far too expensive for working-class institutions and periodicals; into the late 1880s, trade union and radical publications could at best afford to reproduce occasional cartoons.[89] No alternative visual news medium challenged the version of reality articulated in the commercial illustrated press. However, the nature of this asymmetry was more complicated than a split into high and low cultures would suggest. Many if not most of the representations of the city discussed in this chapter, particularly the construction of the degraded poor and dangerous classes, were widely accepted by the inchoate "producing classes," to whose broad definition so many working-class Americans laid claim in the Gilded Age.[90]

Harper's Weekly also revealed the degradations and dangers of urban America; along with the illustrated literary monthlies, it largely promulgated in their stead genteel pursuits and the high arts. In contrast, while *Frank Leslie's Illustrated Newspaper* may have excoriated degraded amusements, in embracing a broad if fluctuating middle readership it also included within its purview representations of entertainments and activities shunned by its competitors.[91] But, as we will see, for *Leslie's* the center could not hold. The pictorial vocabulary it used to describe the city was based on forms that had been created in the circumscribed antebellum visual culture, which had been directed to more exclusive audiences. After the Civil War the readership that sustained *Frank Leslie's* was increasingly defined by diversity, particularly in the face of the fluctuating fortunes and conflicting social relations of industrial capitalism. As an institution predicated on encompassing the differences embodied by its broad middle readership, *Leslie's* faced persistent volatility and perpetual conflicts. The paper's rigid pictorial conventions, especially its promulgation of recognizable and enduring social types, cracked under the weight of postbellum social and political change. As its illustration of gender and race reveals, the resulting representations were at times confusing—not so much breaking from antebellum conventions as applying variations on those old themes that undermined the previous certainty of the old pictorial order.

Balancing Act, 1866–77

The artist has completed his picture with the urchin who
stands grinning in his rags—a true type of the reckless child-
hood of a metropolitan gamin—and in the weary, sickly, but
vice tainted visage of the girl in the background, who, with
the neglected child on her arm, is gazing with stupid enjoy-
ment at the scene.

Frank Leslie's Illustrated Newspaper

Although the focal point of the November 1868 engraving "Graduate
and student" (see figure 3.19), set on the threshold of the city prison, was
its juxtaposition of a dangerous man and a dangerous man-to-be, an-
other disconcerting figure loomed in the background. Partly obscured in
shadow, "the weary, sickly, but vice tainted visage of the girl" presented
a travesty of maternalism.[1] The sole female figure in the scene, poised on
the steps of the Tombs, proposed the grim future of poor womanhood
in the New York streets. In light of *Leslie's* pictorial ordering of urban
poverty, yet one more depiction of youthful depravity was not likely to
surprise the weekly's readers. But while this characterization had the
strength of longevity, it was in constant danger of being severed from its
roots in the antebellum era as the social and political life of the country
shifted in the years following the Civil War. The grim certainty provided
by one image might, in fact, find its contradiction in another.

Rigid pictorial conventions offered readers an efficient and seemingly
consistent reference point—but only for as long as those devices could
reliably aid viewers in deciphering the meaning of events and circum-
stances. In the years following the Civil War, the alteration in women's

work and the emancipation of African Americans disrupted those devices: the longtime pictorial verities of gender and race that had been presented and preserved in antebellum imagery were set in flux by social and political change. These changes were erratic and, for freedpeople, all too short-lived, but out of the fissures they created in the nation's social relations and political discourse emerged images that were at times confusing and often unpredictable. From our early-twenty-first-century perspective, the scope of representational alternatives remained frustratingly small, but for postbellum readers many of these images conveyed the unsettling message that uncertainty had replaced the normative assurance provided by the old pictorial order.

WOMEN: HOPE, DESPAIR, AND CONFUSION IN THE STREETS

The November 1868 engraving's depiction of a girl positioned among rough boys fit into a broader moral narrative about women and the hazards of the sexual commerce of the streets. In the prescriptive literature and pictorial representations of the illustrated press, it was a short step from the unsupervised mingling of boys and girls in public to the wanton business of the concert saloons and commercial dance halls. In their physiognomies and dress, the prostitutes in an 1868 engraving of John Allen's infamous Water Street dance hall portrayed the full flowering of nascent vice (figure 4.1). Viewing the efforts of invading missionaries with undisguised hostility (in contrast to the toughs, who exhibit some interest in the sermon), their "faces are bloated, and whisky is the rouge with which they have reddened their complexions. . . . Dressed in tawdry finery, their clothes hanging round loose on their bodies, some of them dirty as filth and foulness and disease can make them . . ."[2]

Representations of "dangerous women"—whether dance hall "Delilahs" preying on addled males or domestic grotesques abusing children—demonstrated the most heinous effects of vice, carving its nefarious path across the women's very countenances (see figure 3.18).[3] In many cuts of urban poverty, however, the responsibility for female moral depravity could be placed on malicious male influence. The madonna figures shown crouching in hovels and on the street deviated from the prescriptions of bourgeois female domesticity; but the sentimental conventions of their depiction placed them in the role of victim, deprived of their rightful vocation by their husbands' abuse, abandonment, incapac-

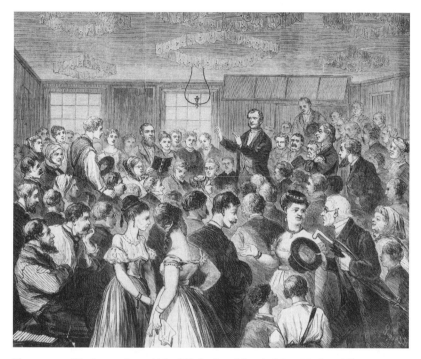

Figure 4.1. "Reformation of 'the Wickedest Man in New York'—The noon prayer meeting at John Allen's late dance house, Water Street, N.Y., Sept. 1st." Wood engraving based on a sketch by Albert Berghaus, *Frank Leslie's Illustrated Newspaper,* September 19, 1868, cover (1). General Research Division, The New York Public Library, Astor, Lenox, and Tilden Foundations.

ity, or death (see figures 3.10, 3.11, and 3.17).[4] The faces of these helpless women conveyed less the vicissitudes of vice than the drabness inevitable to their decline: swathed in rags and smeared with dirt, poor woman often seemed to be wilted versions of the physiognomic ideal. Thus, an engraving showing the "female lodging-room" of a Fourth Precinct station house—the first in a series published during March and April of 1872 promoting legislation to construct public rooming houses for the city's homeless—showed poor women bereft of all the material marks of domestic virtue, except for regular, if saddened, facial features.[5]

Rescued from their former commerce in the streets and dance halls, even prostitutes could lose the identifying marks of vice and take on the classical profile of proper womanhood (figure 4.2). Sheltered from corruption within the eastside House of the Good Shepherd, the reformed "fallen women" in an 1869 engraving were converted into "Magdalens"

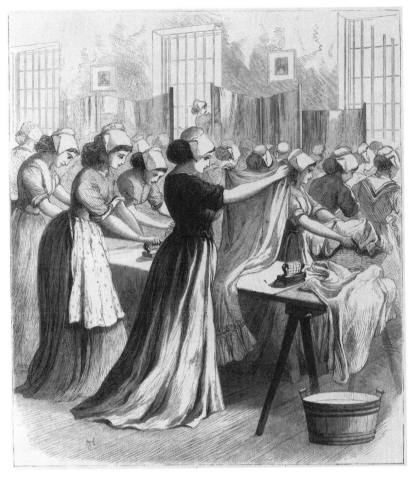

Figure 4.2. "The House of the Good Shepherd, an institution for the refor-
mation of fallen women, 89th and 90th Streets, East River, New York City—
The Magdalens at work in the laundry." Wood engraving based on a sketch
by Thomas Hogan (?), *Frank Leslie's Illustrated Newspaper,* August 21, 1869,
cover (353). Prints and Photographs Division, Library of Congress.

in both name and physiognomy. While their modest dress could not
compare with the ostentatious fashion displayed by the ladies pictured
in an 1873 engraving of Lord and Taylor's opening day (figure 4.3), little
distinguished the countenances of the converted working women and
of genteel feminine shoppers. Their complexions unblemished and pro-
files immaculately vertical, their eyes large and mouths diminutive, the
women's faces expressed the feminine ideal. Classical and anonymous,

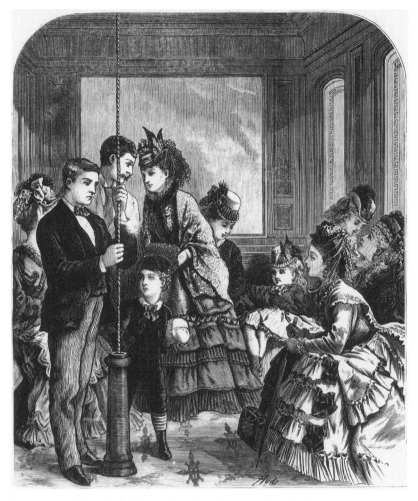

Figure 4.3. "New York City.— Opening day at Lord & Taylor's store, Broad-
way and Twentieth Street—Ladies ascending in the elevator." Wood engraving
based on a sketch by John N. Hyde, *Frank Leslie's Illustrated Newspaper,* Jan-
uary 11, 1873, 289. Prints and Photographs Division, Library of Congress.

their physiognomies were interchangeable, unmarked by expression or
experience.[6]

The relationship of setting to physiognomy was crucial. Subscribing
to a gendered vision that determined the proper location of women and
men as in the home and in public respectively, *Leslie's* idealized female
faces found their most perfect articulation in the rarefied atmosphere of
the respectable parlor. In its illustrations, a limited number of activities

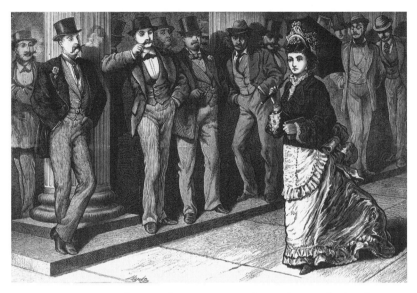

Figure 4.4. "Running the gauntlet.—A scene in front of a popular hotel in
New York City at five o'clock P.M." Wood engraving based on a sketch by
John N. Hyde, *Frank Leslie's Illustrated Newspaper,* May 16, 1874, 152.
American Social History Project, New York.

were available for women outside the home, where their repertoire of
behavior and expression was equally constrained. The engravings of the
Magdalens and Lord and Taylor's shoppers both placed their subjects in
such regulated scenes: one sheltered from commerce, the other in a shel-
tered public space for commerce. Other venues, however, were inde-
terminate and threatening. Whether on the Bowery, Broadway, or Wall
Street, one contemporary reported, "Beggars and millionaires, shoulder-
hitters and thinkers, burglars and scholars, fine women and fortune-
tellers, journalists and pawnbrokers, gamblers and mechanics, here, as
everywhere else, crowd and jostle each other, and all hold and fill their
places in some mysterious way." [7] To represent women's ventures into
this public turbulence, *Frank Leslie's* used a prescribed gendered cartog-
raphy of the city that labeled unescorted individual women, according
to their appearance, as either endangered or dangerous. Confronted by
a "gauntlet" of "fifteen or twenty well-dressed young men" outside a
hotel, the young woman in an 1874 engraving maintained the idealized
visage required by the precepts of feminine public invisibility (figure 4.4).
"With a slight palpitating tremor she advances," ran the description,
"and the profound silence is only broken by the tapping of her feet, un-

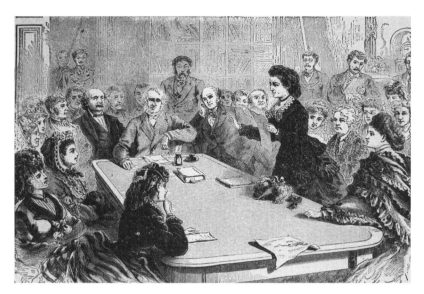

Figure 4.5. "Washington, D.C.—The Judiciary Committee of the House of Representatives receiving a deputation of female suffragists, January 11th—A lady delegate reading her argument in favor of woman's voting, on the basis of the Fourteenth and Fifteenth Constitutional Amendments." Wood engraving, *Frank Leslie's Illustrated Newspaper*, February 4, 1871, 349. American Social History Project, New York.

less one of the more experienced youths coughs or utters a low 'ahem!' Often her drooped eyes fall still lower, while a blush colors her cheeks. Sometimes she turns her head and covers her face with a vail. Like a Summer cloud she passes quickly. Then the young heroes congratulate themselves with significant remarks, and, after renewing their strength at a neighboring bar, they return and await the approach of another."[8]

One distinctive public realm defied the usual limits of female public activities. The spectacle of respectable women actively asserting the right to vote was greeted by *Leslie's* with a certain amount of editorial caution. The February 4, 1871, engraving showing a suffragist delegation addressing the House Judiciary Committee bestowed the kind of illustrious portraiture usually reserved for statesmen on the faces of Victoria Woodhull, Elizabeth Cady Stanton, and Susan B. Anthony (figure 4.5). But the smiles shown tracing the lips of the seated congressmen also subverted the overall solemnity presented by the women in the scene.[9] Notwithstanding occasional illustrations that (along with editorials) heralded women's achievements in new fields (emphasizing education), *Leslie's* interpreted women's intervention in politics as promoting, in the title

of a March 16, 1872, editorial, a "New Order of Amazons." Suffragist agitation represented yet another instance of freakish behavior lately exhibited by women, including the maraudings of female murderers, husband beaters, and the women Communards of Paris: "The crowing hen and the man-woman are equal anomalies, and equally disgusting. Within the sphere of her own peculiar duties let woman shine; but the revolver and the ballot-box let her leave to the coarser hands of the rougher part of the species, lest her greatest safeguard, her weakness, cease longer to assure her of love and protection." [10] Still, *Frank Leslie's* could not ignore the persistent public activism of reform-minded women, exemplified most spectacularly in the militant Ohio temperance campaigns of 1874. While the weekly endorsed such efforts—indeed, the campaign provoked illustrated reports on alcoholism in New York as well as a series of special supplements containing temperance cartoons—it could not refrain from portraying the activity of the female protagonists, however laudable, in a comical light: singing hymns and ardently praying before a dumbfounded crowd outside a Springfield saloon. [11]

Nevertheless, *Leslie's* overall construction of a public realm limited to endangered and dangerous females possessed its own hazards. Vast numbers of women used the New York streets every day who failed to comply with a rigid representational dichotomy. Women constituted one-third of the city's workforce by 1870; along with women working in the household, they were a consistent public presence, whether shopping for meals or going to and from work. At least until 1880 the gaze of *Frank Leslie's Illustrated Newspaper* was resolutely male, [12] but it occasionally contemplated the "respectable" working woman, attempting to locate her within prescribed codes of conduct and identifiable types (figure 4.6). Although the Catholic working-class women depicted in a Fourth Ward fish market lacked the requisite genteel grooming and dress—"bonnets and hats appear to be eschewed," remarked the description—the 1875 engraving clearly demonstrated that "beauty and grace are not altogether lacking among the humble people who frequent the market. Occasionally a bright-eyed damsel, like the girl with shawl-covered head shown in our artist's sketch, . . . and tidy, frugal housewives, can be found mingling with the crowd." A range of female types—varied in both face and dress—were shown interacting in the market, yet the most compelling portrayal of proper working-class womanhood remained separate from the promiscuous pack, her eyes averted and perfect features shielded as dictated by genteel rules of public conduct. [13]

The uncomfortable and indeterminate presence of young working-

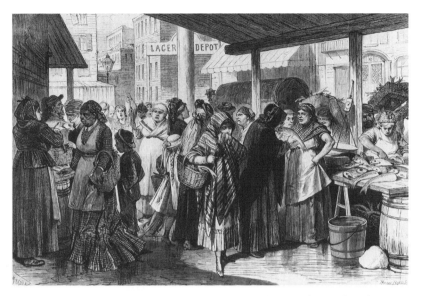

Figure 4.6. "New York City.—Friday morning in the Fourth Ward—The women's fish-market in Oak Street." Wood engraving based on a sketch by Fernando Miranda (Horace Baker, Sc.), *Frank Leslie's Illustrated Newspaper*, August 14, 1875, 396. General Research Division, The New York Public Library, Astor, Lenox, and Tilden Foundations.

class women in *Frank Leslie's* engravings marked a division between the antebellum and postbellum representation of working women. Like native-born male artisans, whose disappearance led to the fading of the Bowery B'hoy type (as discussed in the previous chapter), working-class women also possessed no singular social type to articulate their presence in post–Civil War New York. In place of the flamboyant and heterosocial Lize, Mose's female counterpart on the antebellum Bowery, working-class women were fractured into a range of ethnic and idealized types.[14] The 1874 engraving of "servant girls" placing advertisements for situations in the (very public) uptown offices of the New York *Herald* thus offered "all classes and all nationalities" to *Leslie's* readers (figure 4.7): "the refined lady in reduced circumstances who appeals for a position as governess; the widow who is striving to make a living by renting rooms, and hundreds of others who would be willing workers if they had the opportunity. But by far the largest number are the robust daughters of Europe, who have sought our shores to gain an honest livelihood. The rosy-cheeked German, the bright-eyed Irish girl, the French *bonne*, and the ebony daughters of Africa, go to make up the varied crowd."[15]

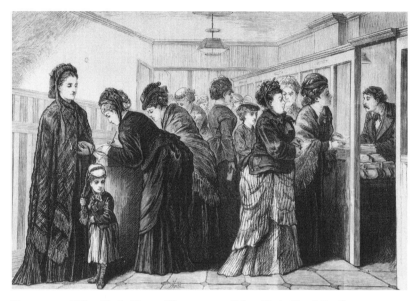

Figure 4.7. "New York City.—The uptown 'New York Herald' office.—
Servant-girls writing advertisements for situations." Wood engraving based
on a sketch by John N. Hyde, *Frank Leslie's Illustrated Newspaper*, Decem-
ber 19, 1874, 248. General Research Division, The New York Public Library,
Astor, Lenox, and Tilden Foundations.

The "varied crowd" also contained the "sewing-girls" who manufac-
tured garments on the fourth floor of A. T. Stewart's department store
in an 1875 engraving.[16] In effect, *Frank Leslie's* confused representation
of working women mirrored its broad middle readership, many of whom
clung to the precepts of gentility as they were sliding upon the icy terrain
of permanent wage work.

AFRICAN AMERICANS:
THE PREDICTABLE AND THE UNEXPECTED

In 1870 the Boston firm of Louis Prang and Company, one of the lead-
ing dealers of chromolithographs, published a portrait of the newly ad-
mitted senator from Mississippi. Prang felt that the portrait of Hiram R.
Revels, the first African American United States senator, would appeal
to the public's interest in the freedpeople "grown partly out of admira-
tion, partly out of curiosity." One prominent admirer of the chromo was
Frederick Douglass, to whom Prang sent a copy. "It strikes me as a faith-
ful representation of the man," Douglass wrote back to Prang in June

1870. "Whatever may be the prejudices of those who may look upon it, they will be compelled to admit that the Mississippi Senator is a man, and one who will easily pass for a man among men. We colored men so often see ourselves described and painted as monkeys, that we think it a great piece of good fortune to find an exception to this general rule." Perhaps, he continued, black Americans could now benefit from the virtues of pictorial representation enjoyed by white citizens: "Heretofore, colored Americans have thought little of adorning their parlors with pictures. They have had to do with the stern, and I may say, the ugly realities of life. Pictures come not with slavery and oppression and destitution, but with liberty, fair play, leisure, and refinement. These conditions are now possible to colored American citizens, and I think the walls of their houses will soon begin to bear evidences of their altered relations to the people about them." [17]

Although impressive in its color and clarity, the Prang portrait of Revels was hardly unique. During the era of Reconstruction the pictorial press reported on the radical experiment in racial equality by providing black and white Americans with new images of the freedpeople of the South. Before the Prang chromo was released, both *Harper's Weekly* and *Frank Leslie's* published portraits of Revels, as well as engravings depicting his admission to the Senate (figure 4.8).[18] These and other sympathetic pictures in the weekly illustrated press portraying freedpeople have generally been dismissed in the historiography of the black image.[19] According to the dominant view, the promise of a new African American imagery was betrayed: artists and illustrators seized on the reassuring stability of nostalgia, recapitulating and building on a limited range of sentimental and buffoonish black types derived from such figures of antebellum blackface minstrelsy as the "comic darkey" Jim Crow and the "darkey shyster" Zip Coon, as well as the caricatures of pompous and degraded free blacks found in antiabolitionist prints.[20] Faced with a popular postwar imagery that marginalized black life in a few debased and dehumanized figures, African Americans chose to use words instead of pictures to frame their self-image.[21]

A racist pictorial record inarguably held sway until the mid–twentieth century, and the cost of denying African Americans access to both informational and expressive visual media cannot be ignored. Yet in the decade following the Civil War, the representation of African Americans in the weekly illustrated press did not take the single-minded racist course suggested in most scholarship. Though *Frank Leslie's*, unlike *Harper's Weekly*, did not support the Republican Party, its racist illustrations

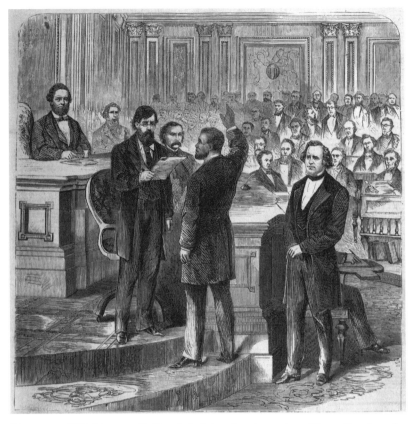

Figure 4.8. "Washington, D.C.—Administering the oath to Hiram Revels, colored senator from the state of Mississippi, in the Senate Chamber of the United States, on Friday, February 25, 1870." Wood engraving, *Frank Leslie's Illustrated Newspaper*, March 12, 1870, cover (425). American Social History Project, New York.

were tempered by its need to balance a varied readership. While we must sadly agree that Frederick Douglass's dream of a popular imagery portraying "altered relations" was for the most part betrayed during Reconstruction, we nonetheless find in the engravings in *Frank Leslie's* evidence that black Americans (and their white allies) could, in fact, locate "positive" images that they could hang on their walls.

* * *

In the aftermath of the war, the pictorial weeklies, along with many of the illustrated literary monthlies, sent artists and correspondents on tours of

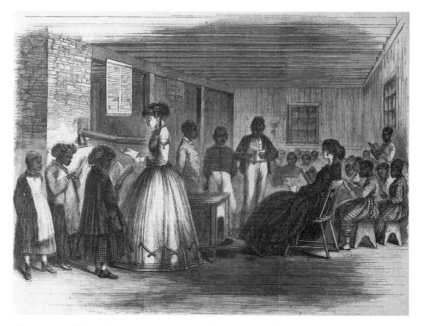

Figure 4.9. "The Misses Cooke's school-room, Freedmen's Bureau, Richmond, Va." Wood engraving based on a sketch by James E. Taylor, *Frank Leslie's Illustrated Newspaper*, November 17, 1866, 132. Prints and Photographs Division, Library of Congress.

the South to chart out what amounted to terra incognita for most northern readers. During 1866 and 1867, the former Civil War special artist James E. Taylor provided *Frank Leslie's* readers with a pictorial survey of the region's landscapes and settings.[22] Amid the engravings of urban markets, rural settlements, monument memorials, and burgeoning commerce, freedpeople appeared prominently.[23] But even though African Americans were ubiquitous figures in the representation of southern life, they were usually cloistered within all-too-familiar conventions. They were positioned as figures that characterized the southern landscape, and their activities tended toward the picturesque, their stance dependent. Thus, *Leslie's* engravings of the Freedmen's Bureau portrayed its services and derided the popular stereotype that the bureau catered to African Americans' indolence, yet the images placed freedpeople within a paternalistic frame. Taylor's November 1866 cut of a Richmond Freedmen's Bureau schoolroom set its crudely rendered black subjects in a traditional relationship to white benefactors (figure 4.9).[24] Circled about their white teachers, the black students were placed within a represen-

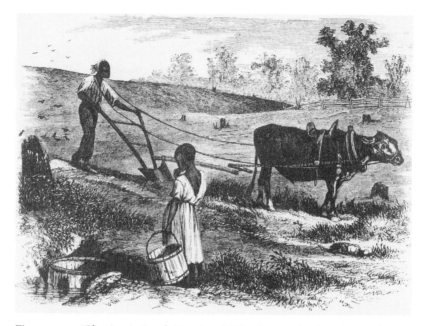

Figure 4.10. "Plowing in South Carolina." Wood engraving based on a sketch by James E. Taylor, *Frank Leslie's Illustrated Newspaper,* October 20, 1866, 76. American Social History Project, New York.

tation of productive activity but remained peripheral to its narrative.[25] The contrast between this engraving and a December 1866 *Harper's Weekly* illustration based on a sketch by Alfred Waud is striking: Waud's picture of black instructors and students in the Charleston "Zion" School for Colored Children, one of a series from his 1866 tour of the South, situated its African American subjects as active participants in their own emancipation.[26]

Taylor's tour engravings, however, conveyed more than the picturesque or dependent. His October 20, 1866, "Plowing in South Carolina" depicted a yeoman cultivating his homestead, presenting an African American as a quintessentially republican symbol of virtue, responsibility, and independence (figure 4.10). Conversely, some images that at first glance appeared to figure traditional codes of black servility actually warned of threats to freedpeople's liberty. A January 1867 engraving showing the auction of a freedman for his inability to pay the fine for an unspecified crime in Monticello, Florida, was a rare illustration (in *any* publication) of the enforcement of the infamous Black Codes (figure 4.11). The "leathern thong" binding the victim's wrists and the

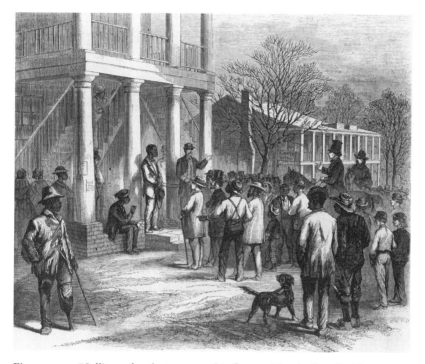

Figure 4.11. "Selling a freedman to pay his fine, at Monticello, Florida."
Wood engraving based on a sketch by James E. Taylor, *Frank Leslie's Illustrated Newspaper*, January 19, 1867, cover (273). American Social History
Project, New York.

ragged black figure on the left—his amputation signaling the savagery
of former servitude or his sacrifice as a Union soldier—lent a note of
alarm to an otherwise bizarrely placid scene.[27]

The portrayal of black political activity in engravings from 1866
through the early 1870s indicated evident tensions in *Leslie's* coverage
of southern Reconstruction that would be not so much resolved as re-
peated. The July 1869 engraving showing a Richmond scene during the
Virginia election at first comes across as an unusual depiction of politi-
cal organizing by African Americans (figure 4.12). The black speaker
addressing a "mass meeting" composed largely of black men clearly rep-
resented a new force in southern politics, as the consternation expressed
in the two white figures standing off to the right makes clear. Yet the en-
graving's distanced composition and the mixture of mayhem and indo-
lence in the crowd articulated less the virtues of republicanism than the
vices upheld in its name. A comparison with a similar cut in a July 1868

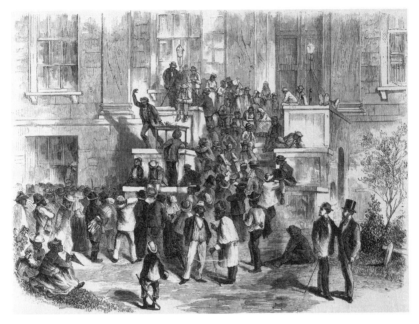

Figure 4.12. "The Virginia election—A scene in Richmond—Colored orator addressing a mass meeting." Wood engraving based on a sketch by William Ludwell Sheppard, *Frank Leslie's Illustrated Newspaper,* July 24, 1869, 296. Prints and Photographs Division, Library of Congress.

Harper's Weekly (figure 4.13) highlights the negative message of the *Leslie's* engraving. The *Harper's* illustration indisputably presented independent black political action, while the *Leslie's* picture stood as a curiosity of unsettled times.[28]

In light of *Frank Leslie's* antipathy toward the Republican Party, its picture of southern black politics as a travesty is hardly surprising. However, a double-page spread published in November 1867 composed of eight scenes based on Taylor's sketches undercuts any assumptions that the images must strictly adhere to editorial policy (figure 4.14). Among images of Reconstruction politics, "The operations of the registration laws and Negro suffrage in the South" uniquely conveyed information about the range of ways in which African Americans were exercising their rights as citizens. The cuts included views of an integrated grand jury, voter registration, white politicians courting black voters, animated political discussions, Election Day voting, and celebrations for victorious black candidates; in addition, two engravings conceptually bracketed the electoral activity by showing black laborers discharged by a

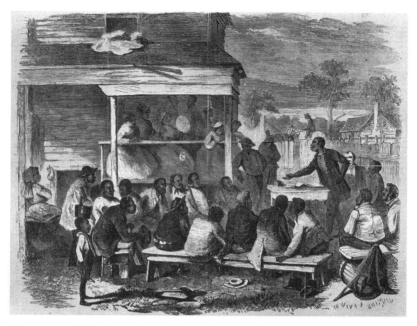

Figure 4.13. "Electioneering at the South." Wood engraving based on a sketch by William Ludwell Sheppard, *Harper's Weekly,* July 25, 1868, 468. American Social History Project, New York.

white employer for voting Republican and, conversely, a Freedmen's Bureau officer instructing a similar group about their rights. A clumsiness in rendering reduced some individual physiognomies to darkey types, but overall the exotic quality of the proceedings was balanced by an unusually broad presentation of variety and scope.

It is tempting to conjecture that this 1867 cut merely captured a moment in the heady years of Radical Reconstruction. After 1868 *Leslie's* "independent" political position increasingly conflated the corruption of the Grant administration with its maintenance, however half-hearted, of Reconstruction policies in the South, culminating in the publication's support of the Liberal Republicans in 1872. Yet while Matt Morgan's cover cartoons, countering Thomas Nast's work in *Harper's Weekly,* insisted that African Americans were rejecting Grant, *Leslie's* news engravings (such as a cut of an April 1872 "national convention of colored citizens" gathered at the Louisiana House of Representatives) showed orderly gatherings of southern black citizens condemning discriminatory policies and supporting the Republican Party.[29] Through the early 1870s the trajectory of *Frank Leslie's* anti-Republican editorial position

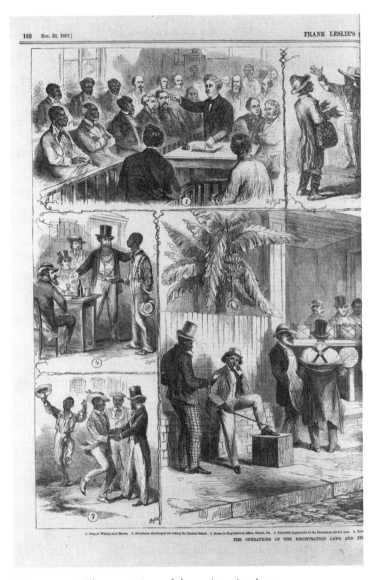

1. Jury of Whites and 6 Blacks. 2. Freedmen discharged for voting the Radical ticket. 3. Scene in Registration office, Macon, Ga. 4. Potential arguments to the Freedman for his vote. 5. Free

THE OPERATIONS OF THE REGISTRATION LAWS AND NE

Figure 4.14. "The operations of the registration laws and Negro suffrage in the South." Nine wood engravings based on sketches by James E. Taylor (Albert Berghaus, Del.), *Frank Leslie's Illustrated Newspaper*, November 30, 1867, 168–69. Prints and Photographs Division, Library of Congress.

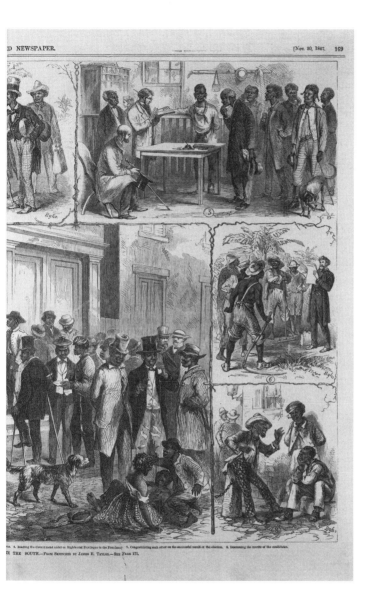

was easily discernible even as its representations of black politics remained unpredictable.[30]

By 1872, however, the representation of *everyday* southern black life was following a clearly racist pattern. Variations on the antebellum darkey buffoon figured prominently in engravings of life in the postbellum South, particularly in the frequent contributions of William Ludwell Sheppard (who also was responsible for the election scenes discussed above, figures 4.12 and 4.13). In anecdotal genre scenes, Sheppard, a transplanted Richmond native and veteran Confederate officer, harked back to the stage plantation's childishly contented, occasionally obstreperous, and always "picturesque" slave. Raggedly dressed or absurdly ostentatious, with broad expressions creasing their sagging, apish faces, southern blacks were freedpeople only by a trick of fate. As demonstrated by an 1872 Richmond street scene that depicted an organ-grinder's monkey harassing a black child to the delight of black onlookers and was titled "The Darwinian theory illustrated.—A case of natural selection," African Americans' natural inclination was toward the low comic, unwittingly at their own expense.[31] With such images appearing in *Leslie's* (as well as in *Harper's Weekly* and in the illustrated literary monthlies), the lament in one of its 1868 "Art Gossip" columns that "picturesque" subjects like the "genuine plantation 'niggers' of the South" had all but disappeared for American artists seemed, at the very least, premature.[32]

Nonetheless, *Leslie's* general depiction of African American life was disrupted by engravings that undercut a unilateral perspective. New types, often appearing in the same issue as buffoonish caricatures, emerged in engravings that presented African Americans in unprecedented social and political roles. As in the case of Senator Hiram Revels, illustrious black faces joined the archival portrait pantheon in scenes that showed African Americans accepting well-deserved positions in the governance of the nation.[33] From such Olympian heights, other engravings descended to the tumultuous streets to illustrate the participation of black citizens in ensuring that all Americans might exercise an unhampered and uncorrupted franchise (figure 4.15).[34] And when Spanish authorities finally released the crew of the *Virginius* in January 1874, black sailors found an honored place in the engraving that depicted the celebration marking their rescue from imprisonment in Cuba.[35]

Images of coercion and violence, however, marked the pictorial record of Reconstruction more indelibly. In the pages of *Frank Leslie's Illustrated Newspaper,* the nature of repressive force—its perpetrators, its victims, and its effects—changed over the course of a decade. An April

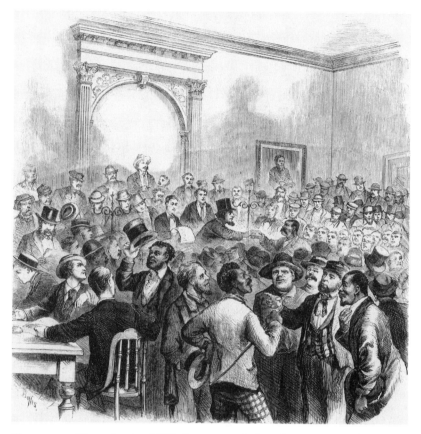

Figure 4.15. "Swearing in of U.S. deputy marshals and supervisors of registry and election, by Commissioner Davenport, in the U.S. Circuit Court, Chambers Street, Friday, October 28, 1870." Wood engraving based on a sketch by Albert Berghaus, *Frank Leslie's Illustrated Newspaper,* November 19, 1870, cover (145). Prints and Photographs Division, Library of Congress.

1868 cover engraving showed the assassination of a Columbus, Georgia, "scalawag" by the Ku Klux Klan, the stylized theatrical poses of the killers made menacing by their masked faces and formal dress (the latter implying the assassins' "respectable" standing in the community).[36] The October 1871 cut of an attempted execution by the Klan in Moore County, North Carolina, which was foiled by U.S. marshals, depicted the "Knights" in more cabalistic disguise (figure 4.16). These and other images in the late 1860s and early 1870s graphically presented the Klan's terrorism, albeit narrowing the pictorial range of victims to southern whites,[37] an approach differing markedly from that of the many en-

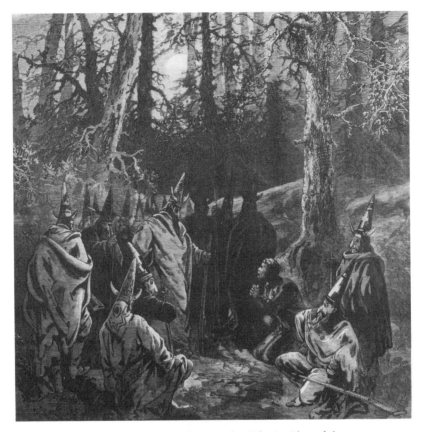

Figure 4.16. "North Carolina—'The Ku-Klux Klan'—Plan of the contem-
plated murder of John Campbell, on August 10th, 1871, in Moore County."
Wood engraving, *Frank Leslie's Illustrated Newspaper,* October 7, 1871, 60.
American Social History Project, New York.

gravings of violence against freedpeople published in *Harper's Weekly.*
Although *Leslie's* editorially denounced the "butchery" of the "rebel
rabble" (and blamed the collusion of Andrew Johnson) in the July 1866
New Orleans riot, unlike its weekly competitor it limited its vivid de-
scription and interpretation to its regimented columns of type.[38]

Characteristically, at times *Frank Leslie's* endeavored to "balance"
its depictions of white coercive force with images that installed Afri-
can Americans as violent subjects. Two weeks after the report of the
Columbus, Georgia, assassination, *Leslie's* cover featured an engraving
of toothy, knife-wielding black men dancing around a midnight bonfire
(figure 4.17). This May 9, 1868, picture claimed to show a ritual ("fre-

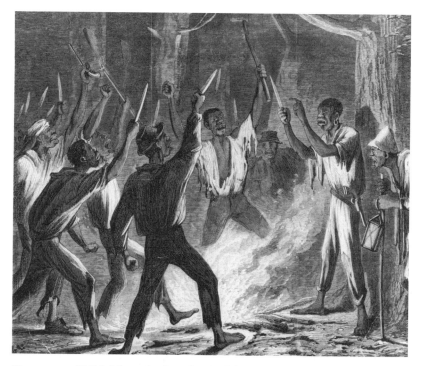

Figure 4.17. "Midnight gathering of a 'Red String League,' in the forests of North Carolina." Wood engraving, *Frank Leslie's Illustrated Newspaper,* May 9, 1868, cover (113). General Research Division, The New York Public Library, Astor, Lenox, and Tilden Foundations.

quent throughout the South") of the "Red String League," a secret order led by whites with "the entire negro population . . . avowed members." The League purportedly had been organized in 1867 in opposition to (and imitation of) the Klan "to strengthen and unite the negroes in their efforts to attain ascendancy." [39] A week later, the threat of black violence blossomed gruesomely with a full-page engraving of "A frightful scene near Omega Landing, Mississippi" (figure 4.18). But the scene did not depict violence against southern whites; the victims were two African Americans who, the text explained, had confessed to robbing and murdering a white woodcutter and his family. Nevertheless, the picture stood as a warning of "the danger of a relapse of the negro race in the South into barbarism [that] is too imminent to be disregarded. . . . Doubtless," the description concluded, "those fierce avengers were governed by their rude conception of retributive justice, but it will not do to permit those instincts to sway a race so numerous in the South, and so

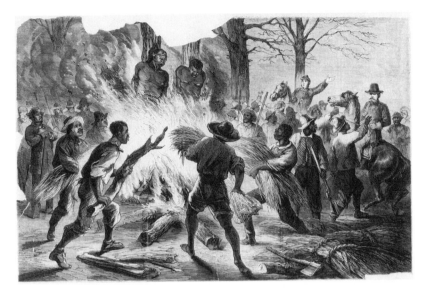

Figure 4.18. "A frightful scene near Omega Landing, Mississippi—Negro mur-
derers burned at the stake by a mob of their own race." Wood engraving, *Frank
Leslie's Illustrated Newspaper*, May 16, 1868, 136. General Research Divi-
sion, The New York Public Library, Astor, Lenox, and Tilden Foundations.

dangerous to the peace of communities, when under the influence of their
strong passions."[40]

In the background of the Omega Landing engraving, federal officers
were depicted fruitlessly attempting to stop the execution. A few years
later, the thrust of coercive force would be shown as emanating from rep-
resentatives of the federal government—or, more precisely, from a Re-
publican political machine—with African Americans the naive pawns
who were the aggressors against defenseless whites. The first images of
African Americans abusing white rights were connected with events in
the North. Having sided with the Liberal Republicans, *Leslie's* lavished
on its October 26, 1872, issue a number of engravings about the Penn-
sylvania gubernatorial election in Philadelphia, showing dissolute and
criminal African Americans under the tutelage of the Hartranft machine
voting "early and often," while imported New York "repeaters" intim-
idated white voters and city police barred whites from the polls.[41]

The trend after 1872 was to depict a deplorable southern "war of
races," instigated by the centralizing, "Caesarist" Grant administration,
though none of the images of blacks victimizing whites displayed the ex-
cessive violence threatened in earlier cuts. *Frank Leslie's* rarely showed

violence against African Americans, preferring to frame the escalation of Redemptionist attacks, riots, and coups in detached compositions that minimized bloodshed and obscured oppression. These engravings of the restriction of rights, like *Leslie's* editorials, focused on white subjugation under military rule in which blacks were implicated as the obedient servants of corrupt Republican carpetbaggers. In both images and words proffering a measure of remorse over the regrettable "necessity" of white force, *Leslie's* endorsed the Bourbon restoration while disavowing "irresponsible" charges of racist violence.[42]

Thus, eleven months after presenting an illustration of a schoolteacher testifying to a Senate committee about his torture by the Klan, ten months after printing an engraving of Grant as he signed the Ku Klux Klan Act into law and editorially endorsing the measure, and five months after displaying an engraving of the Klan assassination attempt in North Carolina (see figure 4.16 above), *Leslie's* published a March 1872 editorial that dismissed the organization as a threat. "We intend," the editorial—titled "The Ku Klux Klan Reports to Congress"—concluded, "to give the South the benefit of the doubt until the fact is proven against them (which it is not in either of these reports); and until then FRANK LESLIE'S ILLUSTRATED NEWSPAPER, neither by pen nor pencil, will add to the weight under which that stricken people are now suffering."[43] Subsequently, *Leslie's* did publish one particularly searing engraving of white terrorism against African Americans. But the September 19, 1874, front-page illustration showing Tennessee "regulators" killing three African American men denoted less black victimization than the sorry consequences of black insurgency: as the accompanying text asserted, the murdered men had led an "uprising."[44] Meanwhile, in stark contrast, *Harper's Weekly's* engravings vividly and unequivocally illustrated antiblack violence.[45]

By the end of 1876, after a year during which *Leslie's* boosted national unity in an avalanche of pictures about the Philadelphia Centennial Exposition and vociferously promoted the Democratic Party's "reconciliation" presidential ticket, its readers could hardly have been surprised to see engravings such as a December 16 view of the disputed South Carolina House of Representatives (figure 4.19). After all, two weeks before this depiction of black Republican members irresponsibly lounging and carousing in the legislative hall in Columbia, readers had been shown black officials in New Orleans, backed by federal troops, humiliating white citizens at the polls.[46] The corrupt black official had joined the now firmly resurrected image of the cheery plantation darkey as a stan-

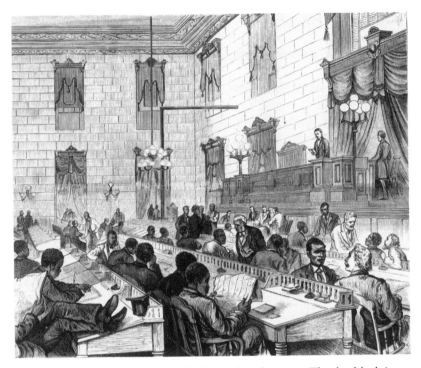

Figure 4.19. "South Carolina.—The November election—The dead-lock in the state legislature at Columbia.—Speaker MacKey swearing in the Republican members of the House, in Columbia, November 28th." Wood engraving based on a sketch by Harry Ogden, *Frank Leslie's Illustrated Newspaper,* December 16, 1876, cover (241). Prints and Photographs Division, Library of Congress.

dard African American type, although without the latter's telltale physiognomic codes.[47] One might thus expect that orderly and dignified representations of black politics would be limited to engravings showing African Americans joining the forces of "reconciliation" (as in a November 4, 1876, cut of black waiters employed at the Centennial Exposition's "Southern Restaurant" swearing allegiance to the Democratic Tilden ticket); but in the aftermath of the disputed presidential election, other cuts presented scenes of blacks organized in opposition to southern abuses of their electoral rights.[48]

In short, even as *Frank Leslie's Illustrated Newspaper* endorsed the collapse of Reconstruction, its image of the African American continued to be unpredictable and multifaceted.[49] To be sure, "picturesque" and nostalgic types that referred back to an illusory antebellum stability

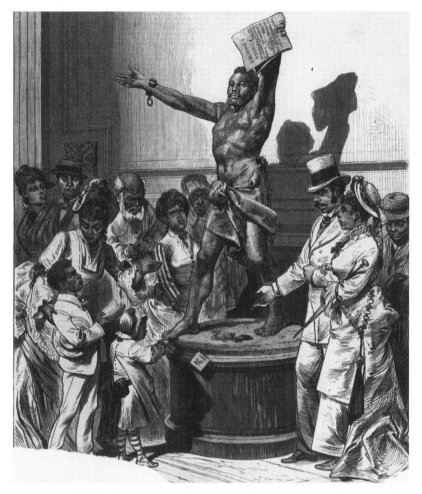

Figure 4.20. "Philadelphia, Pa.—The Centennial Exposition—The statue of 'The Freed Slave' in Memorial Hall." Wood engraving based on a sketch by Fernando Miranda, *Frank Leslie's Illustrated Newspaper,* August 5, 1876, cover (353). American Social History Project, New York.

took center stage on *Leslie's* engraved proscenium; but like troublesome reminders, there were other African American performers who denoted new roles, rendered in lines that abandoned the comfortable physiognomic codes of simplicity and obedience. It might be argued that the August 1876 scene of African Americans gathered around the "striking and impressive" statue *The Freed Slave* in the Philadelphia Centennial Exposition merely domesticated the black experience, safely relegating slav-

ery to a grim past and suggesting that freedom was unproblematically fulfilled (figure 4.20). However, if one takes into account the abuse that had been showered on the Austrian sculptor Francesco Pezzicar's Memorial Hall statue and the general exclusion of African Americans from the centennial's celebrations—as well as the dignified range of black types portrayed—the engraving stands as a powerful statement of dignity and equality.[50] In this and other engravings, African American equality maintained a palpable, if always embattled, presence in the pages of *Frank Leslie's Illustrated Newspaper.*[51]

<p style="text-align: center">* * *</p>

The subject matter of news illustration in the years following the Civil War proved to be an elusive target, too mobile and changeable for the pictorial press's rigid pictorial conventions. Mediated by a rapidly changing social context, *Leslie's* representations of the news shifted—often momentarily and haphazardly, sometimes contradictorily—in an effort to make representation fit new situations and to provide balance for readers whose expectations and experiences were changing.

The confusion demonstrated in *Leslie's* depiction of working-class women and African Americans would find its analog in other areas during the 1860s and 1870s. In the next chapter, we will see how the critical social issues of the Gilded Age, in particular the crises of depression and class conflict, along with increasing differention among readers, exerted pressure on the production of representation. At crucial moments the device of social typing destabilized and *Leslie's* pictorial narratives became ambiguous or contradictory. In unexpected places we find the creation of new types and the sundering of categories that should have been preserved if a middle-class ideal were holding sway.

Reconstructing Representation, 1866–77

I became manager of the art department of FRANK LESLIE'S in
1875. . . . Notwithstanding I was the chief of the department,
I often had to respond to "emergency calls" myself, and at
last it came to pass that when any important event requiring
illustration took place Becker had to go. I always in those
days kept a satchel, already packed, in the office, and was
prepared to leave at a moment's notice. Partly because I had
become the regular pictorial reporter, and partly because I
was born in and was familiar with the region, I went, in
1877, to northeastern Pennsylvania to depict scenes in the
sensational "Mollie Maguire" troubles.

Joseph Becker

In 1905, when Joseph Becker wrote a brief reminiscence of his forty-
one-year career with *Frank Leslie's Illustrated Newspaper,*[1] he severely
condensed his role in the pictorial coverage of life, labor, and especially
conflict in the anthracite coal region of eastern Pennsylvania.[2] In fact,
Becker was first dispatched to the area four years before he began super-
vising *Leslie's* art department. From March through May 1871 four en-
gravings attributed to him appeared in the weekly that depicted strikers
harassing and attacking "blackleg" replacements, along with three cuts
illustrating "mining operations."[3] After May 1871 Becker seems to have
moved on to other reportorial duties, leaving *Leslie's* depiction of disas-
ters in the Pittston mines later in the year to two other special artists.[4]

Leslie's interest in covering the miners' strike in spring 1871 may have
been prompted by contemporary events occurring across the Atlantic.

Earlier coverage of strikes had been limited to one episode in July 1867, with much greater emphasis given to mine disasters in 1869 and 1870.[5] Because *Leslie's* thrived on an atmosphere of crisis, its engravings of rioting strikers in 1871 appeared in unsettling if unremarked juxtaposition to scenes depicting the Paris Commune. Then, after its comparatively intensive pictorial consideration of coal miners' struggles, labor, and peril, *Leslie's* interest abruptly subsided; a three-year hiatus in coverage followed, broken only by one decidedly peaceful Fourth of July scene (not recorded by Becker) during the summer of 1873.[6]

The bitter "Long Strike" during the winter of 1874–75 brought Joseph Becker and *Frank Leslie's* back to eastern Pennsylvania. Franklin Gowen, president of the Reading Railroad, instigated the strike so that his company might gain total control of eastern Pennsylvania coal mining by destroying the miners' union, the Workingmen's Benevolent Association. For *Leslie's,* Becker's longtime familiarity with the area must have seemed particularly advantageous, as the region was steeped in suspicion, destitution, and violence engendered by Gowen's efforts.[7]

Becker's pictorial reportage of the strike began in December 1874 with a small engraving of miners' huts near Scranton. The secret society of the Molly Maguires was mentioned for the first time in the accompanying text, and both the description and the distant perspective of the cut offered an impartial view of the strikers.[8] A few months later, however, Becker's engravings and written reports (the additional textual information suggests that the special artist himself was their author) took a decidedly partisan turn toward Gowen's position. Depicting himself "among the 'Mollie Maguires'" of Pottsville, Becker constructed a portrait of "anarchy in the coal regions of Pennsylvania" promoted by the Irish miners' "criminal organization," and he blamed the destitution of mining families on a "spirit of lawlessness" produced by ignorance, alcoholism, and sloth.[9] "The last loaf," the engraving ("from real life") published in the March 13, 1875, issue, presented the "sad story of the suffering that frequently befalls the families of the mistaken workmen who follow the lead of the blatant demagogues—the orators who prate of the utility of strikes" (figure 5.1). In lines and words that recall representations of urban poverty, Becker depicted a familiar travesty of domesticity:

> The father of the family, a strong, athletic man whose labor could bring means to support his family in comfort, sits idly by his cabin-door carousing with his boon companions, while his hard-worked wife and almost starving children gather around the oven, as they place in it the last loaf, doubtful as

Figure 5.1. "Pennsylvania.—The last loaf—A scene in the coal region during the recent strike." Wood engraving based on a sketch by Joseph Becker, *Frank Leslie's Illustrated Newspaper*, March 13, 1875, 9. General Research Division, The New York Public Library, Astor, Lenox, and Tilden Foundations.

to where the next supply of food may come from. . . . In the distance are collieries lying idle for want of workmen such as he who thus allows his family to want. What a happy home this man might make for himself and family! A neat cot, with smiling wife and happy children to greet his return from an honest day's labor, might take the place of this dismal hovel and dejected family, would he but work contentedly for a fair remuneration.[10]

Becker's reminiscences thirty years later revealed that while his interpretation matched that of the Reading Railroad, his services extended far beyond reporting conditions of the Long Strike to *Leslie's* readers. Soon after arriving in Pennsylvania, he wrote in 1905, "I fell in with a detective, and together, unsuspected, but taking great risks, we traveled about, coming in contact with many 'Mollies,' and even getting on familiar terms with their leaders. In this way we acquired inside information which was of avail to the prosecuting officers."[11]

Becker's representations of self-inflicted degradation and his conflation of trade unionists with ringleaders of a secret criminal organization did not go uncontested. In April 1875, in a rare public acknowledgment

of reader response, *Frank Leslie's Illustrated Newspaper* addressed objections to its coverage of the Long Strike. In the wake of Becker's "pen and pencil pictures," *Frank Leslie's* received a flurry of "ill-spelled" and "violently abusive" letters from the mining districts; these, in the weekly's view, only confirmed the special artist's depictions. *Leslie's* felt obliged, however, to address the more measured protest of Hugh McGarvy, president of the State Council of the Workingmen's Benevolent Association. "[B]oth the illustration and the pen-picture of the Miners of Pennsylvania are unfair," McGarvy had complained; "the miners are not all drunkards." McGarvy went on to defend his members' morals and sobriety, stating that if they were given "fair remuneration" from their employers "there would be no trouble. They would willingly work, and make happy families and comfortable firesides." McGarvy concluded, "I was not surprised when first I saw such things in *Harper's Weekly*, but from FRANK LESLIE'S ILLUSTRATED NEWSPAPER better things were expected. We respectfully solicit at your hands simple truth and justice for the miners as a whole." [12]

In response to this criticism, *Leslie's* conceded that strikes "are sometimes the only, and in that case, the legitimate, resort of labor in a conflict with capital." But, the weekly added, "experience proves how ruinous strikes usually are to both, and particularly to the former." [13] Two more Becker contributions on the miners' strike appeared during 1875, one in the issue immediately following McGarvy's letter and the other in early September; neither relinquished much rhetorical ground. The accompanying descriptions forthrightly defended the engravings' accuracy and called on "all honest laborers to aid in discountenancing deeds that tend to degrade the dignity of labor[.]" [14]

The next time *Leslie's* illustrated labor conflict in the anthracite coal region was to cover the execution of the convicted Molly Maguire conspirators in June 1877. [15] Once again Joseph Becker journeyed to eastern Pennsylvania, although in this instance (perhaps as a cautionary measure) his sketchwork remained uncredited. As censorious as his Long Strike pictures had been, Becker's images of the Pottsville prison, the families and friends of the condemned men, the last rites, and the final march to the gallows were somber and respectful. [16] The solemn occasion, and no doubt *Leslie's* Catholic readers, prescribed this different approach. Becker's own attitude seems to have been fleetingly remorseful. "I could not bear to see these men swing," he later confessed, "and so I absented myself from their execution. Afterward I received from the ex-

ecutioner (the detective aforesaid) a two and a half inch section of each rope used in the hanging. I have these grim souvenirs still." [17]

In the short term this episode merely verifies the asymmetrical relationship between dominant and subordinate cultures in the reporting of news that characterized *Leslie's* depiction of the urban poor. But the significance of the Long Strike engravings lies less in Becker's collusion with the Pinkerton National Detective Agency than in the many letters *Leslie's* received denouncing his "pen and pencil pictures." Those letters indicate that in the decade following the Civil War, the weekly's readership extended even into isolated areas like the coalfields of Schuylkill County. Moreover, they showed specific readers firmly refusing to be reduced to a criminal, degraded social type in the pages of *Frank Leslie's.* To be sure, their protest had little immediate impact beyond tortured defenses of the engravings' depictions of violence and degradation. But Hugh McGarvy's closing remark—that "better things were expected" from *Frank Leslie's*—suggests something more. Although the paper was hardly the voice of beleaguered trade unionism, its reliance on a broad spectrum of readers compelled it to follow a treacherous course, attempting to bridge the increasing political, social, and cultural differences among its varied reading public. The exigencies of industrial capitalism and the resultant social conflict during the Gilded Age multiplied difference and threatened to fracture the broad readership on which the weekly relied.

Disorder presented both opportunity and hazard for *Frank Leslie's*—its potential bread and butter and also its representational problem. The paper's energetic promotion of the centennial celebration and the post–Civil War spirit of reconciliation, discussed in the previous chapter, were part of a larger effort to fend off a sense of pervasive disorder. Such tactics were understandable in a decade whose trajectory through financial conspiracy, political corruption, sexual scandal, economic collapse, and collective violence seemed to culminate in a disputed presidential election that momentarily threatened yet another sectional conflict. While *Leslie's* might portray Europeans tearing down monuments (the Paris Commune's destruction of the Vendôme column received particular attention), the publication endeavored in equal measure to depict Americans as preoccupied with putting them up.[18] But an outpouring of engravings showing Civil War monument dedications and unveilings of commemorative Central Park statuary was unpersuasive when juxtaposed, in *Leslie's* own pages, to images of domestic instability. Within months of the suppression of the Commune, troops were firing on Irish rioters in the

streets of New York; a few months later, Chicago went up in flames. Such images of turmoil and destruction at home, so uncomfortably reminiscent of Europe, were the very lifeblood of the weekly illustrated press. Born and legitimated in the national crisis of the 1850s and 1860s, *Frank Leslie's* and its competitors could be said to have thrived on the perpetuation of a sense of crisis in the 1870s: the worse the catastrophe, the higher the circulation.

Notwithstanding the weekly's need to pay bills and make a respectable profit, there were risks attendant to such unsettling representations. Over the course of the decade, *Frank Leslie's* found its pictorial vocabulary at times defective; based on social types that had been created in the circumscribed antebellum visual culture and directed to exclusive audiences, it often seemed anachronistic in the face of the fluctuating fortunes and conflicting social relations of Gilded Age America. The expansive postbellum "middle" readership that sustained *Frank Leslie's Illustrated Newspaper* was breaking down into increasingly diverse constituencies, and depictions of conflict and catastrophe increasingly focused on some of these readers. Confronted by pictures that, in their view, inadequately represented their appearances, conditions, and experiences, readers exerted pressure that required the publication to alter how it visually reported the news. The historical record affords us only brief glimpses of those reactions, such as the Schuylkill County miners expressed; but faced by different readers with differing views, *Leslie's* was unlikely to satisfy everyone. Something had to give, and we may divine some sense of the dynamic relationship between readers and the production of news images by tracing how the physical signs on which the illustrated press had relied in mapping American society were destabilized and unmoored. To be sure, enduring social types were maintained and replicated, but in unexpected places we find the creation of new types and the collapse of old categories. In particular, the physiognomic codes that previously demarcated types grew volatile and unpredictable; those alterations contradict a conventional wisdom that has insisted that the pages of the illustrated press harbored a middle-class ideal.

CRISIS AS A WAY OF LIFE

In chapter 3 we saw how *Frank Leslie's* representation of the poor— particularly of the idle, "unregulated" young men who attended low amusements and formed the street army of the political machine—conferred the simianized physiognomy of the dangerous classes on the shanty

Irish immigrant. Nevertheless, *Leslie's* also published notices from Irish organizations complimenting its coverage. The publication's editorials tended to support Irish nationalism and it took pains to illustrate, with respectful pomp, the ceremonies and ministrations of the Catholic Church and of related charities.[19] The observant viewer of *Leslie's* engravings can ascertain a representational strategy that seems to have satisfied *Leslie's* Irish American readers. Engravings that depicted Irish and Irish American events—the numerous cuts in 1866 showing the Fenian insurgency (and its repression) in Ireland, receptions and demonstrations supporting the movement in New York, and mobilization of the abortive Fenian invasion of Canada—presented, on the one hand, untyped "illustrious" portraits of nationalist leaders. They portrayed the Irish crowd, on the other hand, as composed of a range of types, including figures bearing shanty Irish physiognomies. In the pages of *Frank Leslie's Illustrated Newspaper,* the Irish American population was not limited to one ethnic type: it was divided by classes distinguished by appearance.[20] Conversely, when *Leslie's* depicted an Irish American event with an overabundance of brutish physiognomies, as in an April 1867 cover engraving of a St. Patrick's Day riot, the choice of physical types did not denote general revulsion felt toward one ethnic group (figure 5.2). This scene of marchers attacking police unquestionably resembled a cartoon of the riot published the same week in *Harper's Weekly* (figure 5.3). However, while Thomas Nast characteristically splashed his vitriol on all Irish Americans, the *Leslie's* cut, viewed in the context of its other more differentiated views, tied the "disgraceful riot" to one "dangerous" segment of immigrant Irish New Yorkers.[21] This application of typing dated back to *Leslie's* coverage of the 1863 draft riots where, unlike in *Harper's Weekly,* alternating cuts offered varied views of the rioters (figure 5.4).

But by the early 1870s, even this more "discriminating" use of physiognomic typing was problematic. The July 12, 1871, Orange Riot in New York City, which resulted in thirty-nine deaths, provided *Leslie's* with the opportunity to employ distinctive typing. In its editorial columns, *Frank Leslie's* joined other New York newspapers and periodicals in decrying the Irish Catholic threat to attack the Protestant march celebrating the Battle of the Boyne; after the riot, it was equally critical of Catholics' harassment and abuse of paraders, spectators, and troops, which precipitated the militia's deadly fusillade.[22] Its engravings, however, betrayed a much more ambivalent interpretation of the event. At a glance, the double-page engraving published in the July 29, 1871, issue, which depicted the Ninth, Eighty-fourth, and other regiments firing into

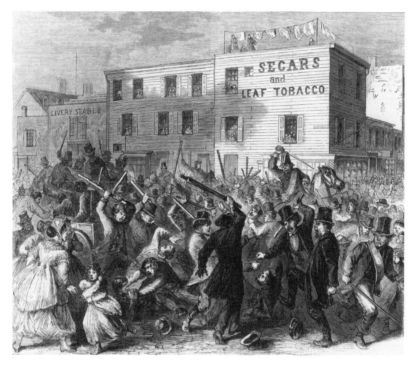

Figure 5.2. "The riot on St. Patrick's Day—The attack on the police at the corner of Grand and Pitt Streets, New York City." Wood engraving, *Frank Leslie's Illustrated Newspaper,* April 6, 1867, cover (33). Prints and Photographs Division, Library of Congress.

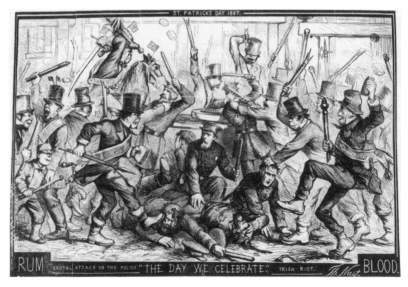

Figure 5.3. "St. Patrick's Day 1867—'The day we celebrate.'" Wood engraving based on a sketch by Thomas Nast, *Harper's Weekly,* April 6, 1867, 212. American Social History Project, New York.

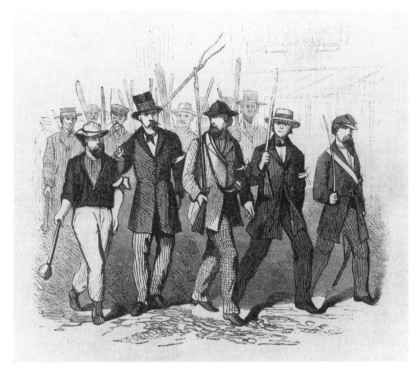

Figure 5.4. "Draft riots in New York—Exciting scenes during the reign of terror. Group of rioters marching down Avenue A." Wood engraving, *Frank Leslie's Illustrated Newspaper,* August 1, 1863, 300. American Social History Project, New York.

and driving back the "mob," appeared to favor the troops' use of deadly force (figure 5.5). Yet while the soldiers in this cut resembled the beleaguered but stalwart Versailliste troops in earlier pictures of the suppression of the Paris Commune, other aspects of the engraving indicated that the weekly's endorsement was less than full-throated. Justification for the troops' reaction was signaled by the depiction of soldiers in the left foreground: two soldiers were shown fallen to the ground and another clutched his head, wounded by the crowd's rocks, brickbats, and reported gunfire. On the extreme right, however, soldiers were shown withholding fire, one demonstratively clasping his brow in horror at the slaughter. Similarly, while *Leslie's* textual description could not refrain from a bout of self-adulation regarding its pictorial reportage (recalling its service under fire during the Civil War), a more generalized blame for the violence, consistent with the signs in the engraving, also came through:

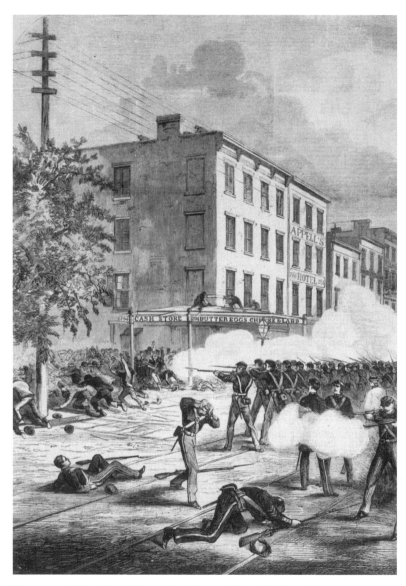

Figure 5.5. "New York City.—The Orange Riot of July 12th—
View on Eighth Avenue looking from Twenty-fifth Street toward the
Grand Opera House—Dispersal of the mob by the Ninth, Eighty-
fourth and other regiments." Wood engraving based on a sketch
by Albert Berghaus, *Frank Leslie's Illustrated Newspaper,* July 29,
1871, 328–29. American Social History Project, New York.

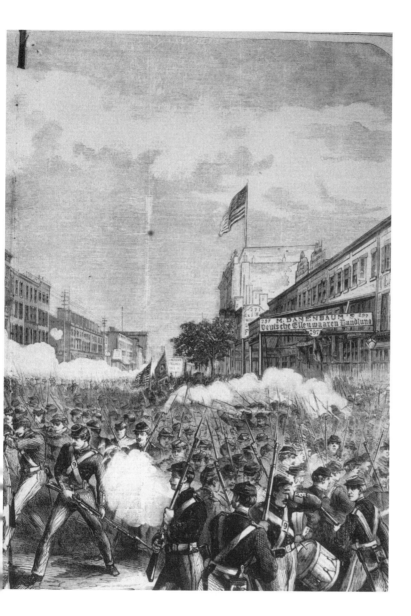

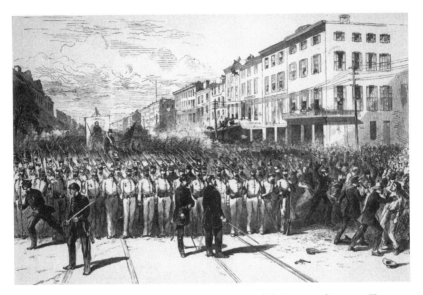

Figure 5.6. "The attack on the procession, on Eighth Avenue, between Twenty-fourth and Twenty-fifth Streets." Wood engraving, *Harper's Weekly,* July 29, 1871, 692. American Social History Project, New York.

"To the skillful pencils of these draughtsmen, exercised upon the spot with that facility of art-reporting only attained after immense practice, are due the life-like views we present of the hasty and unskillful fusillade on Eighth Avenue, the panic on the sidewalks, the ghastly accumulation of corpses, and minor incidents among the mob and spectators. These reliable tracings are Historic Art in her every-day robes." [23] In contrast, the depiction of the catastrophe in *Harper's Weekly* avoided any ambivalence by focusing on the initial attack on the procession (figure 5.6).

When *Frank Leslie's* turned to render the "civilian" victims of the violence—the "mob" that in the past so consistently served as a ground for facial typing—it did not follow its familiar practice. To be sure, engravings in the July 29 issue showed a range of Irish types, including simianized "Hibernian" women harassing orange-sashed ladies, as well as armed toughs waylaid by police along the procession route.[24] But these cuts depicted scenes before the troops opened fire. In the ensuing fusillade, the "respectable" and "degraded" elements composing the crowd could not be isolated: the soldiers' wild gunfire obliterated the distinction of spectator and rioter, and the physiognomic signs disappeared (figure 5.7). The dead, wounded, and fleeing lost the physical qualities

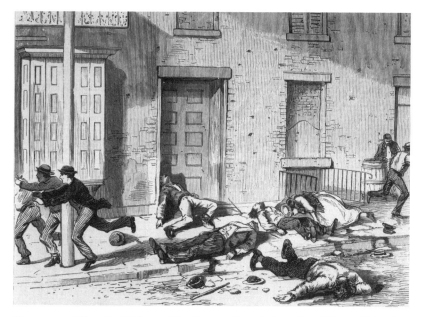

Figure 5.7. "New York City.—The Orange Riot, July 12th—Effects of the fusillade by the Eighty-fourth Regiment, on spectators and buildings.—Scene on Eighth Avenue, at the corner of Twenty-fourth Street." Wood engraving, *Frank Leslie's Illustrated Newspaper,* July 29, 1871, 333. American Social History Project, New York.

that designated social type, presaging the manner in which the blameless refugees of the Chicago Fire would shortly be portrayed in *Leslie's* pages. Confronted by a catastrophic event in which readers could, in effect, see themselves as victims—where readers viewing "Historic Art in her everyday robes" would feel a shock of recognition—*Leslie's* relinquished its usual practice: the dependable signs of character, role, and social placement could not work. As in the engravings of natural and industrial disasters, with their arbitrary and unpredictable effects, here the indiscriminate use of troops against citizens rendered the codes of typing dysfunctional.[25]

The following week, perhaps in response to complaints about its pictorial emphasis on the soldiers' victims, the paper conspicuously backpedaled to portray the solemn funeral rites for the two militia casualties. Nevertheless, even though its August 5 editorial called for a general ban on all popular processions (including those on July Fourth), *Leslie's* refrained from celebrating the violent repression.[26] In harsh contrast, the

cover of *Harper's Weekly* featured Thomas Nast's "Bravo! Bravo!" show-
ing a female Republic throttling a savage simian Irishman.[27] *Frank Les-
lie's Illustrated Newspaper* positioned itself firmly among the advocates
of the rule of law who wished to transform most public events in the late
nineteenth century from rituals of participation to spectacles of obser-
vance; but it had left a pictorial record of the Orange Riot that con-
veyed, in large part through its rejection of physiognomy, a decidedly
ambiguous interpretation.

* * *

Frank Leslie's images of disorder and destruction in the 1870s were not
limited to "ethnic" clashes. The Wall Street investors, stockbrokers, and
clerks shown clamoring at the doors of the sealed Stock Exchange or
struggling in front of failed banking houses in 1873 were, according to
engraving captions, in the throes of financial "panic." To *Leslie's* read-
ers glimpsing such scenes, "panic" indicated a specific type of rioting,
with different but equally ominous consequences.[28] Engravings showing
streets littered with wrecked fortunes were, however, less common than
cuts depicting devastating industrial and transportation disasters. Most
ubiquitous were illustrations of railroad accidents, their proscenia pre-
senting the cataclysmic moment, the carnage and flames, and the grue-
some aftermath (see figure 3.2 above). In their number and repetition
they may have seemed but a logical extension of the corruption and un-
accountability of the Crédit Mobiliers and the railroad wars.[29] Among
the pictured casualties and survivors, the physiognomic codes of char-
acter and place were erased as an overall message of official neglect and
blameless victimhood was conveyed.

The Panic of 1873 and the ensuing depression, the greatest crisis in-
dustrial capitalism had yet seen—lasting some five and a half years—
led to an unprecedented shift in the representation of the poor. Because
such a large proportion of the workforce relied on industrialized em-
ployment, this national disaster reconfigured the manner in which pov-
erty was rendered.[30]

At times, however, the changes were registered more in the degree of
misery depicted than in any redefinition of its typical characters. The
February 1875 engraving that showed a line of unemployed men wait-
ing for a meal outside of New York's Blackwell's Island almshouse was
perhaps the most searing portrait of hard times ever published in *Frank
Leslie's* pages (figure 5.8). On one level, the scene of destitution, with fig-

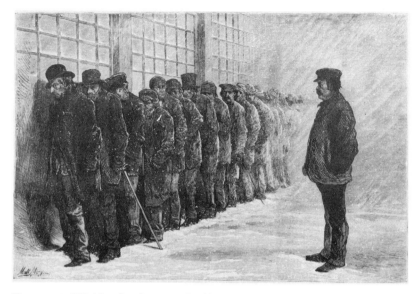

Figure 5.8. "Waiting for the second table.—Inmates of the poor-house on Randall's Island, East River, at New York City, forming in line for dinner." Wood engraving based on a sketch by Joseph Becker (Matthew Somerville Morgan, Del.), *Frank Leslie's Illustrated Newspaper,* February 13, 1875, 381. American Social History Project, New York.

ures huddled in the driving snow, offered readers a seemingly incontestable argument for charity. "Every grade of society, all shades of character, all phases of misfortune and failure, are represented," noted the accompanying text. "In each face is a history and a lesson. Let us study and profit by them, and let the philanthropist visit such scenes and he may find many cases where his helping hand may lift a fallen brother, make bright another's life, and reap for himself the reward that comes from good deeds done."[31]

The misery depicted in this engraving called for some form of humane rectification. Nevertheless, the scene—so reminiscent of earlier pictures of the degraded poor heading into or out of the Tombs (complete with a wary guard)—also carried an indictment of innate characterological flaws, a warning meant to quash any purely "humanitarian" response. Scanning the wretched figures and physiognomies, readers might identify some "deserving" victims; but they were more likely to discern identifiable types whose "histories" proffered "lessons" that sustained tried-and-true beliefs about moral failure. "Here are gathered the wrecks of ill-spent lives," *Leslie's* instructed,

the child of misfortune and too often the victim of knavery. Men who started life with bright prospects and high resolves; men who struggled valiantly in the battle of existence but met with disaster after disaster until hope and energy were crushed; men lacking the stamina of purpose, who drifted gradually down the stream until they stranded on the shores of Blackwell's Island; men, once the centre of a rollicking *coeterie,* who quaffed their wine and cracked their jokes heedless of the brink of destruction the bark of pleasure was carrying them to; men whose lives were blasted by the luring smiles of faithless women; men whose over-confidence in professed friends wrought their ruin; and men belonging to the ever-filled army of shiftless, purposeless, reckless and unfortunate human beings—all are to be found there.[32]

While *Leslie's* responded to the early years of the depression with stock figures of poverty, the persistence of economic catastrophe generated a new type of poor American for its representation. Born of the depression, the tramp presented a new brand of ambulatory corruption that threatened to become a permanent, aberrant "profession," as much deplored by the respectable mechanic as by the merchant. In many ways, the figure of the tramp was more an ominous variation on the theme of the undeserving poor than an object lesson in the exigencies of industrial capitalism. "The *genus* tramp," announced an 1876 *Frank Leslie's* editorial, "is a dangerous element in society, and ought to be dealt with accordingly."[33] As depicted in a July 1877 engraving, the transient poor exhibited an aggressive form of degradation, no longer content only to defile the streets and hovels of the lowly districts of the city and countryside (figure 5.9).

But in the face of continued depression, neither dependence on old adages about morality and fate nor reliance on new repressive recommendations seemed adequate. In a city like New York, where by the winter of 1873–74 some 100,000 people were unemployed, the reassuring predictability of "traditional" social types (or their slightly revised versions) could not be maintained. Images of the undeserving poor continued to appear in *Leslie's* pages, but they were now supplemented by engravings peopled with the "wrong" types. A November 1873 scene of a Mulberry Street dining hall run by the Protestant Episcopal Church Missionary Society met the conventional expectation of favoring voluntaristic charity over state intervention, but the "reception of respectable women for dinner" lacked the usual signs that conflated degradation with want. Similarly, a March 1874 engraving showing men, women, and children at the Delmonico-supervised "soup-house" on Centre Street failed to exhibit the mix of victimization and corruption that so often had characterized pictures of poor relief.[34]

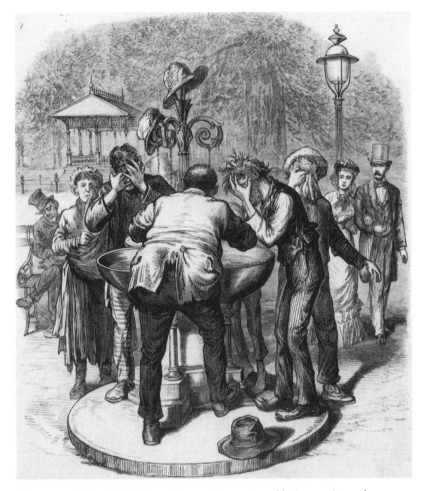

Figure 5.9. "New York City.—A tramp's morning ablutions—An early morning scene in Madison Square." Wood engraving, *Frank Leslie's Illustrated Newspaper,* July 21, 1877, cover (333). American Social History Project, New York.

The sundering of the signs of social typing was unmistakable in the February 1877 "Early morning at a police station—Turning out the vagrant night lodgers" (figure 5.10). Among the homeless poor pictured leaving the shelter of a New York City precinct house on a frigid February morning, readers uneasily noted faces and dress that did not belong in an engraving of "vagrants." "It has been noticed this Winter," *Frank Leslie's* warily commented, "that among the applicants for lodgings

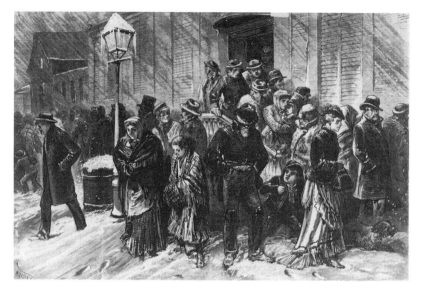

Figure 5.10. "New York City.—Early morning at a police station—Turning out the vagrant night lodgers." Wood engraving based on a sketch by Fernando Miranda, *Frank Leslie's Illustrated Newspaper,* February 10, 1877, 377. American Social History Project, New York.

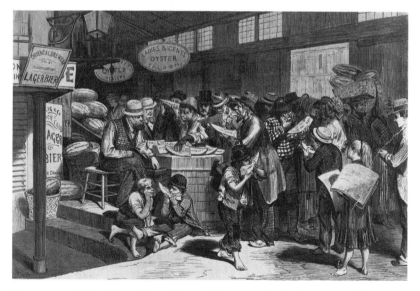

Figure 5.11. "New York City.—Fulton Market in the fruit season—'Here they are! Ripe watermelons—Fine Savannahs, fresh and sweet! Only five cents a slice!—Step right up, gentlemen!'" Wood engraving based on a sketch by Fernando Miranda, *Frank Leslie's Illustrated Newspaper,* September 4, 1875, 445. American Social History Project, New York.

at the stations an unusually large number represents a class of men and women unaccustomed to such dormitories." [35] Unlike the poor as familiarly depicted, the subjects of these and other engravings now potentially included some of *Frank Leslie's* readership. As the forces of industrial capitalism wantonly plucked victims from the population, the reliability of physiognomy to signify the "deserving" and "undeserving," the "respectable" and "degraded," faltered.

In the midst of persistent economic and social dislocation, engravings appeared that departed from the previous rejection of the mixed urban crowd. The 1875 "Fulton Market in the fruit season" depicted a range of social types amassed in one place, enthusiastically consuming watermelons on a sultry August afternoon (figure 5.11). The accompanying text clarified what the juxtaposition of the assembled figures meant: "The bootblack, the newsboy, the longshoreman, the rustic visitor, the merchant's clerk, and sometimes the merchant himself, gather around the *al-fresco* stand in a truly democratic manner to indulge in the juicy luxury." [36] More than representing a panorama of the streets, this cut strove to locate some unity, portraying a rare moment of equality (even across race) as the varied social statuses of its subjects were leveled in a symbolic feast.

In an atmosphere increasingly characterized by division, crisis, and instability, *Frank Leslie's* could no longer count on the shared perceptions of its reading public. Engravings of poverty and want grew more ambivalent or appeared in contradictory juxtapositions, their typed subjects gaining and losing coherence as use of the physiognomic enhancement of features came under attack. As with images of disasters, the engravings of destitution and want brought a shock of recognition to many readers: depression selected its victims with the arbitrariness of a railway accident or calamity of nature. *Leslie's* readers, no longer able to sequester everyday tragedy in the realm of private failure, found pictorial social typing unreliable and inauthentic. Requiring a broad and varied readership to sustain its expensive project, an audience now suffering different fates with different perceptions of causes and effects, *Leslie's* altered its methods of representing social types.

INTERLUDE: CRISIS ON PEARL STREET

By the late 1870s Frank Leslie seemed to embody the excesses and accidents, the fortunes and misfortunes, of his era. As if mirroring the structure of his publishing house and prized newsweekly, Frank Leslie as a

Gilded Age public figure teetered between the "respectable" and the "profane." His stature on Publishers' Row was marked by ubiquitous portraits and caricatures in periodicals featuring his graying, leonine head atop a now ballooning frame. In recognition of Leslie's place in publishing, he was appointed U.S. commissioner to the Paris Universal Exposition in 1867 to judge the fine arts exhibits (where he also received a gold medal from Napoleon III, an event covered with predictable ostentation in the pages of *Frank Leslie's*). Nine years later, he was selected as New York State commissioner to the Philadelphia Centennial Exposition and subsequently elected president by his fellow commissioners.[37]

But the 1867 trip to France also occasioned the first in a series of legal actions and business schemes that would construct Frank Leslie's public persona as more notorious. While he was abroad, Sarah Ann Welham Leslie filed a lawsuit against her estranged husband; meanwhile, his three sons, apparently disgruntled with their continued subordination in the publishing house, tried to establish a rival firm under the Leslie name. These legal and business contests, which extended to 1872, revealed more than discord within the family: Leslie's part in a ménage à trois became public. Ephraim G. Squier was a former archaeologist and diplomat who became editor of *Frank Leslie's Illustrated Newspaper* in 1861; his wife, Miriam Florence Follin Squier, became editor of *Frank Leslie's Lady's Magazine* and *Frank Leslie's Chimney Corner* in 1863 and 1865, respectively. The Squiers had shared their home with Leslie since the publisher's separation from his wife in 1861. By the time they headed to the Paris Exposition, the halcyon days of the threesome were long gone; Ephraim Squier had become inconvenient to the blossoming affair between Miriam Squier and Leslie. The couple's escapades in London— ostensibly awaiting the release of Ephraim Squier, who had been imprisoned for debt on his arrival in Liverpool by British authorities tipped off by Leslie—played a major role in winning Sarah Ann Leslie a large financial settlement when her divorce from her husband was finally decreed in 1872. Soon after, Miriam Squier wrested a divorce from her increasingly unstable and paranoid husband. The proceedings, which included threats by Leslie to expose Squier's own adultery in *The Days' Doings*, drove Squier into a catatonic depression that later required his commitment to a Long Island sanitarium. On July 13, 1874, Frank Leslie and Miriam Follin Squier were married.[38]

Leslie's second marriage took place in the midst of unprecedented national economic hardship, and by 1874 his own financial affairs were in a serious state of disrepair. His personal fortune was ravaged when spec-

ulative schemes collapsed in the Panic of 1873, and yet he continued to siphon income from his still profitable publishing house. Accustomed to living the life of a grand seigneur of Publishers' Row, and now married to a younger wife who was famous in her own right for ostentation (her diamonds and opals had drawn attention as far back as Lincoln's inaugural ball), Frank Leslie recklessly carved out an opulent oasis for his middle age. When the couple was not entertaining in the parlor of their 511 Fifth Avenue home (the former residence of William M. Tweed), they were greeting guests at "Interlaken," their estate overlooking Saratoga Lake. The Leslies were a mainstay of the Saratoga set, sponsoring racing yachts at the annual regattas and hosting what passed for the glitterati of the Gilded Age, from a lone William Vanderbilt to Emperor Dom Pedro of Brazil and his retinue.[39]

"Frank Leslie's," the publishing enterprise, seemed to require an equal amount of glamour. Leslie gilded his ceremonial role as a centennial commissioner at the Philadelphia Exposition site by spending lavishly. Leslie's pavilion, a resplendent way station where visitors to the fair could browse through stacks of the publishing house's periodicals, was matched by publication of *Frank Leslie's Illustrated Historical Register of the United States Centennial Exposition,* a bulky engraved souvenir available by subscription. But the *Historical Register* failed to find enough buyers (its engravings had, after all, appeared previously in *Frank Leslie's Illustrated Newspaper*), and a scheme to sell the book in conjunction with a lottery to unload other unsold centennial items led to further financial losses as well as a lawsuit and libel action. Nevertheless, the Leslies embarked on an even more flamboyant and expensive project in April 1877: accompanied by several friends, three artists, one photographer, an "official historian," a popular author of boys' books, and a (no doubt worried) business manager, the Leslies started on a transcontinental railroad excursion to California. Transported in sumptuous Palace cars, the entourage roamed the West, wringing publicity from every stop as they interviewed, photographed, and sketched a record of western life; the pictures and reports they sent off were reproduced, with due fanfare, in *Frank Leslie's Illustrated Newspaper* (and later that year in Miriam Leslie's *California: A Pleasure Trip from Gotham to the Golden Gate*).[40]

When the party returned to New York two months later there was little cause for celebration. Although Leslie's publishing house was still making a profit of between $60,000 and $100,000 a year, Leslie's financial liabilities had mushroomed to $335,555. His creditors could be put off no longer: in September, Leslie's property was assigned to Isaac W.

England, publisher of the *New York Sun*. Five of Leslie's creditors were appointed as trustees to oversee the business operation of his publishing house for three years. Under their supervision, Leslie would serve as a salaried general manager until his debts were paid, after which time control would be returned to him.[41]

For the next two years, while Leslie endeavored to reclaim control of his publishing house, his reputation, as usual, both flourished and faded. Completing arrangements begun before the court-ordered reassignment of his assets, in April 1878 he supervised the transfer of the publishing house to a new five-story building located on the northeast corner of Park and College Places.[42] Four months later, a new scandal broke when the *Territorial Enterprise* of Virginia City, Nevada, published an "extra" edition and twenty-four-page pamphlet detailing Miriam Leslie's "Life Drama of Crime and Licentiousness." Retaliating against Mrs. Leslie, whose *California* had contained uncomplimentary remarks about Virginia City's "God-forsaken" citizens and institutions, and with information supplied by Ephraim Squier, the pamphlet delineated the extremely wilted gentility of her New Orleans family, her illegitimate birth and first annulled marriage at age seventeen, her stage career as "Minnie Montez" (protégé of the notorious Lola Montez), her affair with former Tennessee congressman William M. Churchwell, and the sordid details of her liaison with Leslie.[43]

The uproar over the scandal was offset by Leslie's successful efforts to substantially decrease his indebtedness. By paring down unprofitable publications, spending more frugally, and renegotiating his debt agreement, Leslie had reduced his liabilities to $100,000 by the close of 1879.[44]

PICTURES OF LABOR

The precarious state of Leslie's reputation and fortune notwithstanding, for most of the 1870s his flagship newsweekly cast an unsympathetic eye on the desperate efforts of American workers to organize in the face of hard times. This had not always been the case. Since its first publication of a trade union image—a double-page engraving in 1860 depicting the workers' procession in Lynn, Massachusetts, during a shoemakers' strike (see figure 1.4)—*Frank Leslie's* had sporadically covered the labor movement. After the Civil War, the publication's generally dismissive and hostile stance toward the effort to win the eight-hour workday was expressed in numerous editorials but few engravings. Yet through the late 1860s, when *Leslie's* covered a strike or some organized union activity

(usually an event in New York), its portrayal was generally sympathetic.[45] The momentous year of 1871 brought Joseph Becker's pictures of eastern Pennsylvania mine violence, which seemed to augur a new era of class relations uncomfortably suggestive of the wholesale strife erupting in many European capitals. But *Leslie's* engravings of the New York labor movement remained calm and uncontentious. The cover cut of the September 13, 1871, "great eight-hour labor demonstration," with its decorous procession—marchers and spectators alike dressed in respectable finery—confirmed "an orderly and impressive occasion" attended by the city's "hardy sons of toil."[46]

Nine months later, the characteristically temperate tone of pictures and words disappeared. New York City's trade unions had escalated their eight-hour demand and launched a strike wave that, by June 1872, involved more than 100,000 workers, the largest combined labor action to hit an American city up to that time.[47] Thousands of "laboring men," *Leslie's* commented in its June 8 issue, "are battling for what they consider their rights—the eight-hour system, with full day's pay, and in some cases, increase of wages." Some trade unionists, however, were not "content to confine themselves to the 'passive policy' of not working in order to gain their ends, but . . . have resorted to force, in order to compel others, more patient or more satisfied with the existing order of things, to do the same."[48] *Leslie's* did not indulge in direct (or, as in the case of the *New York Times* and other anti-union papers, overheated) references to the Paris Commune; nor did it link "internecine" worker strife in New York to previously published scenes in Pennsylvania. Instead, the engraving that accompanied the passage quoted above encouraged readers to draw such connections (figure 5.12). Matt Morgan's picture showing a confrontation among quarrymen excavating new streets in upper Manhattan did not convey chaos, as Becker's Pennsylvania cuts had done; yet, though the engraving's violence was incipient, its likely source was plainly visible. His sleeves rolled and fists clenched, the thickset strike leader bore the physiognomy, albeit in a mild form, of the "lowly" Irish; in their appearance, stance, and dress, his equally aggressive companions—especially the suspiciously sashed figure on the extreme right—resurrected visions of the Communards. This engraving, the first to depict division among workers in New York City, proposed that the discord attending the eight-hour effort derived less from genuine domestic disputes than from imported conflicts (a point already made in *Leslie's* commentary on the 1871 Orange Riot).

Three weeks later, *Leslie's* extended its vision of "foreignness." The

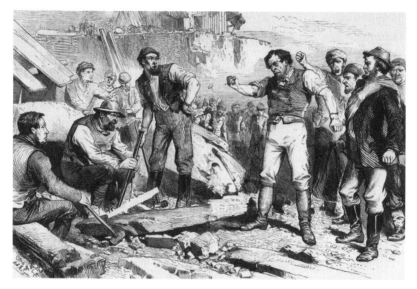

Figure 5.12. "New York City.—The Eight-hour Movement—A group of work-ingmen on a strike in one of the up-town wards." Wood engraving, based on a sketch by Matthew Somerville Morgan, *Frank Leslie's Illustrated Newspaper,* June 8, 1872, 197. American Social History Project, New York.

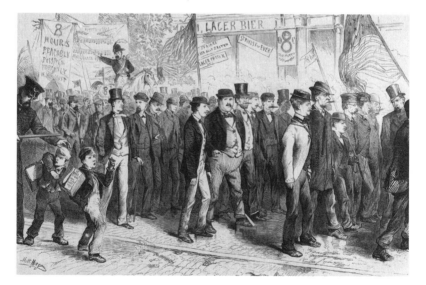

Figure 5.13. "New York City.—The Eight-hour Movement—Procession of workingmen on a 'strike,' in the Bowery, June 10th, 1872." Wood engraving based on a sketch by Matthew Somerville Morgan, *Frank Leslie's Illustrated Newspaper,* June 29, 1872, 253. American Social History Project, New York.

engraving of the June 10, 1872, parade, which capped the ultimately un-successful citywide trade union effort, worked up the Continental signs of the participants (figure 5.13). "[T]he promised procession of 40,000 dwindled down to 4,000 men," *Leslie's* observed in the accompanying text. "As a popular movement of the workingmen, the parade was a fail-ure. Very many, with commendable good sense, refused to take part in it, fearing that greater complications would thereby be engendered." While this perception, echoed in the *Times* and *Tribune,* was disputed in the pro-labor *Sun,* disagreement over the numbers involved was less important than the meaning of the scene, which downplayed the threat of violence in favor of buffoonery. Showing a grotesquely snarling figure on horseback in the background (reminiscent of the savage equestrian pictured in the 1867 St. Patrick's Day riot illustration, figure 5.2), the engraving nonetheless featured a collection of "foreign" physiognomies whose aggressiveness lay only in the absurd angle of their cigars. "It would be difficult," *Leslie's* concluded, "to convince ourselves that those who appeared were fair representatives of the workingmen of the city. They certainly did not exhibit the manly bone and sinew of the land." [49] Exhibiting a travesty of the American worker, *Leslie's* reduced the threat of disorder to the antics of two newsboys mimicking the marchers.

The trade unionists depicted in the June 1872 engraving may have failed to represent the "manly bone and sinew" of the genuine Ameri-can worker, but *Leslie's* could not easily oblige its readers with a picto-rial alternative. For the next five years, as the nation suffered through de-pression and saw its labor movement decimated through unemployment and repression, *Leslie's* only once attempted to present an emblematic American worker (figure 5.14). Pictured in the wake of the 1873 panic and solemnly posed in front of a closed iron mill, this postbellum indus-trial worker seemed lost among social types, borrowing most heavily the qualities traditionally exhibited by the perennial "noble yeoman." [50] The representational gap was consistent with the disappearance of a native-born artisan social type after the Civil War; a range of "ethnic" types served as imperfect surrogates, filling the place of the worker while be-ing rejected as "inauthentic" representations. For most of the 1870s, images of trade union organization and activity were limited to deluded or debased "Molly Maguire" Irish miners. [51] Their urban equivalents appeared on breadlines, or in police lodging houses, or as members of a troublesome minority merely posing as workers. The latter case was epitomized in the decidedly Continental countenances of the New York branch of the International Workingmen's Association (figure 5.15).

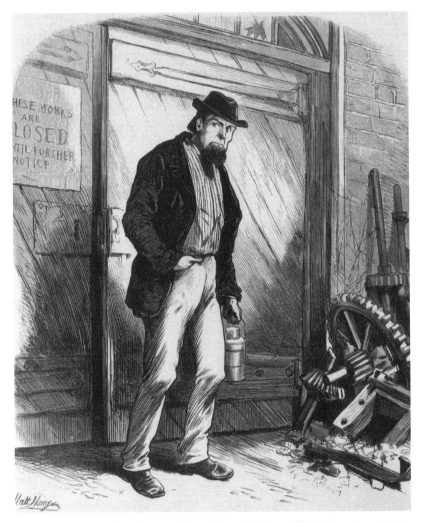

Figure 5.14. "Out of work. Saturday night at the iron mills during the crisis."
Wood engraving based on a sketch by Matthew Somerville Morgan, *Frank
Leslie's Illustrated Newspaper,* November 15, 1873, cover (157). American
Social History Project, New York.

While *Leslie's* consistently deplored the Internationalists' infusion of
foreign ideologies into the relationship of American labor and capital, its
coverage was surprisingly temperate, possibly in deference to the readers
of the paper's German edition: an engraving of a December 1871 memo-
rial procession for the Paris Commune showed a sober and unthreaten-
ing gathering (a view that, along with accompanying editorials and car-

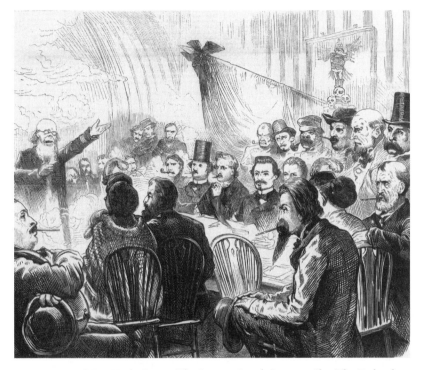

Figure 5.15. "New York City.—The Internationals in council—The Federal Committee of Workingmen assembled at their headquarters, No. 68 Grand Street, to receive the report of the delegation to Albany." Wood engraving, *Frank Leslie's Illustrated Newspaper,* December 30, 1871, cover (241). Prints and Photographs Division, Library of Congress.

toons, challenged police suppression of the demonstration), and *Leslie's* supplied detailed coverage of the visit to New York by the veteran Communard Henri de Rochefort in June 1874.[52]

Despite *Leslie's* generally moderate treatment of the Internationalists, the signs that marked its depictions as gatherings of aliens were easily transformed into more alarming scenes during the depression. The engraving that portrayed the January 13, 1874, Tompkins Square Riot relied on the representation of its participants to underscore that labor demonstration was illicit (figure 5.16). "Last week," the accompanying editorial titled "'Bread or Blood'" ran,

> several thousands of the lower grades of workingmen of New York City, most of them Germans, Frenchmen and Poles, finding themselves out of work, and hungry, with no prospects of immediate employment, determined to parade through the streets in huge demonstration of numbers,

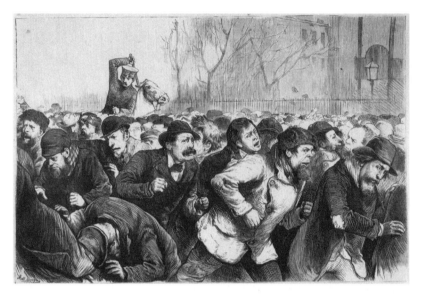

Figure 5.16. "The red flag in New York.—Riotous communist workingmen driven from Tompkins Square by the mounted police, Tuesday, January 13th." Wood engraving based on a sketch by Matthew Somerville Morgan, *Frank Leslie's Illustrated Newspaper,* January 31, 1874, 344. American Social History Project, New York.

> as a sign of their sadness and despair. They were incited to enthusiasm by leaders who think radically about the antagonism of labor to capital; and many of them knew no alternative to getting bread by the fairest means but that of obtaining it by force, even to the shedding of blood.[53]

Though it acknowledged the justice of the demand for relief, the engraving legitimated the suppression of the Tompkins Square demonstration. The "lower grades of workingmen" fleeing toward the viewer defined the violence as the sorry product of foreign agitation, infecting labor republicanism and the streets of the city with a divisive class-conscious ideology.[54]

While the depression and the depredations of the railroad and coal monopolies eventually prodded *Frank Leslie's* editorials to occasionally denounce capital as an agent of disorder and division, the representation of labor remained largely unchanged. With no visual social type for the urban or industrial worker, the preferred pictorial standard-bearer of American republican virtue became the midwestern farmer activist, the stalwart Granger. In a series of engravings published from September

1873 through February 1874, Grangers were shown at meetings and conventions that may have struck readers as oddly reminiscent of earlier cuts of labor meetings and strikes. The similarity was hardly accidental, as a February 1874 editorial titled "The Farmers' Union" suggested: "The intellectual and social purposes of their organization are far in advance of anything ever before undertaken in America on a large scale; and while they cling honestly together social anarchy and un-American uprisings are impossible." [55] The heritage of genuine "labor" as crusader against the abuses of capital and corruption of government was now bestowed on the figure of the native-born noble yeoman (and, in one case, woman), a development that the singular November 1873 engraving of the emblematic "Out of Work" ironworker only substantiated: he was an industrialized Yankee "Brother Jonathan," unemployed yet isolated from divisive, alien-inspired activism. [56]

Frank Leslie's Illustrated Newspaper would, over the course of the depression, acknowledge that strikes were sometimes an unavoidable (if probably ruinous) choice, and capital was sometimes provocative and unyielding. But these usually begrudging concessions (framed in laissez-faire reasoning) appeared solely in the publication's editorials. [57] In *Leslie's* engravings, militant workers and trade unionists continued to inhabit fairly rigid representational categories—usually exoticized, sometimes buffoonish, sometimes menacing.

* * *

The Great Uprising of July 1877 heralded the beginning of a new era of working-class protest and trade union organization. Emanating from isolated protests by railroad workers over arbitrary wage reductions, the strike quickly spread along the nation's tracks to halt commerce for two weeks during July 1877. Extending over fourteen states and paralyzing most of the country's industrial cities, the railroad strike took on the character of a revolt against persistent hard times and railroad corporation abuses. [58]

Frank Leslie's diligently covered the Great Uprising for three weeks (including a sixteen-page "Railroad Riot Extra" supplement edition), its engravings showing halted trains, massive demonstrations, mobilized troops, street battles, flaming buildings, and smoldering ruins. In the strike's aftermath, the publication's August 11, 1877, editorial assessed the impact of the unprecedented event. Looking abroad, *Les-*

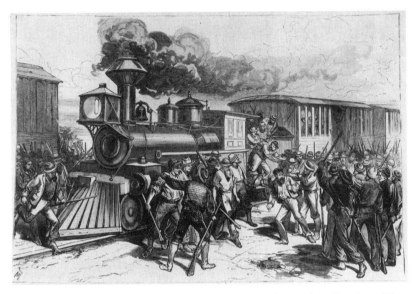

Figure 5.17. "West Virginia.—The Baltimore and Ohio Railroad strike—The disaffected workmen dragging firemen and engineers from a Baltimore freight train at Martinsburg, July 17th." Wood engraving based on a sketch by Fernando Miranda, *Frank Leslie's Illustrated Newspaper,* August 4, 1877, 373. American Social History Project, New York.

lie's bemoaned the damage to America's reputation, fearing the slowing of immigration and foreign investment as well as "the perpetuation of kingcraft" among European "advocates of monarchical impositions." Turning its attention toward home, *Leslie's* refrained from recommending draconian solutions, favoring "pluckier men in civil authority, and a militia so organized and drilled and trusted as to be effective in emergencies" over reliance on "a powerful standing army." Moreover, *Leslie's* proposed, "What is more wanted . . . [is] a kindlier treatment of employes by capitalists and corporations. It should need no political economist to demonstrate to corporations the necessity of fostering labor instead of grinding it into the dust." If there was "one good result" in the "gigantic demonstration" of the railroad strikers, it was "in showing the existence of an element whose rights must be respected in common with the rights of the millionaire." Recognizing the necessity to correct the imbalance in economic and social power, *Leslie's* warned that for the most part, "the element of disorganization and plunder, of incendiarism and murder, must not be confounded with the railroad strikers. This violent, revolutionary, and Communistic element is composed of the idle roughs

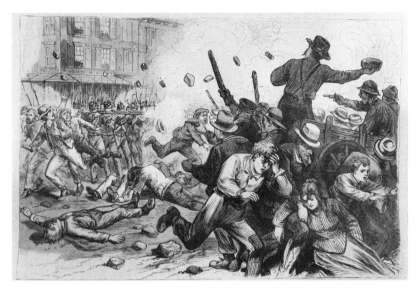

Figure 5.18. "Maryland.—The Baltimore and Ohio Railroad strike—The
Sixth Regiment, N.G.S.M., firing upon the mob, on the corner of Frederick
and Baltimore Streets, July 20th." Wood engraving, *Frank Leslie's Illustrated
Newspaper*, August 4, 1877, 372. American Social History Project, New York.

and the vagabond tramps who infest the country and hasten to the cen-
tres of trouble." [59]

The distinction appeared to be reinforced in *Leslie's* images of rail-
road strikers (figure 5.17). The engraving that depicted the July 17 inci-
dent at Martinsburg, West Virginia, that sparked the nationwide strike
showed heavily armed "disaffected workmen dragging firemen and en-
gineers" from a Baltimore and Ohio freight train; but the scene suggested
a disciplined military action rather than a disorderly mob. Based on *Les-
lie's* editorial differentiation of railroad strikers and "rioters," however,
one might assume that engravings of violence in the cities would resur-
rect the familiar physiognomic types of disorder and "foreign infusion."
The editorials and descriptions accompanying such cuts certainly pro-
posed that "we have among us an element as malicious, determined and
desperate as ever appeared in Paris under the Commune"; the partici-
pants were characterized as "malcontents, loafers, and disreputable per-
sons of both sexes." [60] Yet in such illustrations as the Sixth Regiment of
the Maryland National Guard "firing upon the mob" in the streets of
Baltimore, *Leslie's* pictures generally defied the expectations raised in its
text (figure 5.18).

Contradicting the visual typing suggested by its words, *Frank Leslie's* pictures reformulated the meaning of the Great Uprising. By their nature, the July events necessarily disrupted conventional categorizations. As the engravings showed, the strike placed unexpected types in the line of fire: in localities across the country, the broad "middle" came out to protest the abuses of the railroads. The illustration capping *Leslie's* "Railroad Riot Extra" supplement—a double-page panorama of the Philadelphia militia firing on the Pittsburgh crowd gathered near the Pennsylvania Railroad's Union Depot—was an extended visual performance demonstrating that potential readers had become "rioters" (figure 5.19).

To be sure, some engravings reverted to predictable social typing. Unlike in Pittsburgh, in Chicago the general strike split the city along class (and ethnic) lines, providing a ready frame within which the "traditional" agents of disorder could be persuasively rendered. *Leslie's* August 11 cover engraving, showing cavalry charging the rioters at the Halstead Street viaduct,[61] closely resembled in composition and characterization the rout of the disreputable in its earlier cut of the 1874 Tompkins Square Riot. But in most localities, the physiognomic signs denoting types no longer afforded readers an easy, useful guide to deciphering a news event. Just as physiognomy disappeared in depictions of the blameless victims of disasters—and the victims of the indiscriminate use of troops against citizens, first seen in the pictures of the 1871 Orange Riot—the signs of sedition and degradation formerly used to define the meaning of mayhem were now inoperable. The distancing function of social typing by facial appearance could not work in representing situations in which readers might, in effect, recognize themselves as participants and victims. Still framed in the conventions of history-painting narrative, the engravings of the strike depicted "anonymous Americans" without the predictable marks of moral character, social role, and motive.[62]

The Great Uprising thus marked a sea change in *Frank Leslie's* representation of American labor and set it apart from the rest of the illustrated press.[63] In contrast, *Harper's Weekly* engravings largely opted for distant, panoramic views of mass destruction and milling crowds; the three engravings that vividly depicted battles between strikers and militia or police—one in Baltimore, two in Chicago—presented a more limited cast of male rioters (figure 5.20).[64] The New York *Daily Graphic's* many illustrations of the strike are harder to decipher. Its pictures, rendered quickly, showed little detail; nonetheless, the *Daily Graphic's*

scenes of violence and looting (including a cover page containing picturesque and grotesque character studies of the Pittsburgh crowd's bacchanal after the destruction of the train yards) seemed little changed from previous representations of civil disorders. Certainly, as one editorial declared, the subjects of the strike coverage would never be confused with those who read the *Daily Graphic:* "It is hardly worth while for the press of the leading cities to be giving advice to the rioters on the railroads, or to be propounding lessons in good conduct which they will not heed. Those who are now in revolt against the constituted authorities in five States of the Union, are not as a class newspaper readers[.]" [65]

The shift in *Frank Leslie's* treatment of American labor was not lost on contemporary readers. In its August 18 issue, *Leslie's* reprinted an editorial that had appeared in the July 31 *Pittsburgh Leader* complimenting the former's engravings, based on sketches by the local artist John Donaghy, of the July 21 clash between the Philadelphia militia and striking Pittsburgh railroad workers and sympathizers (e.g., figure 5.19). The event culminated the following day in the burning of the Pennsylvania Railroad's train yards, the single most destructive incident in the nationwide strike. "The riots," the editorial began, "have given the illustrated newspapers an opportunity that they have availed themselves of to the fullest extent to curdle the blood of the law-abiding citizen with representations of the wild scenes of last week." It was evident, however, that "with the single exception of John Donaghy, of this city, special artist for FRANK LESLIE'S ILLUSTRATED NEWSPAPER," no artist was "near enough to 'the mob' they assume to depict to know what it really looks like. They represent it as a wild and heterogeneous collection of rough men and virago women, in every variety of costume, some with blouses, some in open shirts and bare arms, some with bandannas around their brows and all with coarse, brutish features, exhibiting every phase of ignorance and malignity." This was a *French* mob, derived from cuts by English artists in old studies about the French Revolution. "The American mob," the *Leader* editorial chided,

is a different sort of a body altogether. It has no varieties of costume except such as indicate the sex and social condition of the wearers. American workmen do not wear the Paris blouse at all, nor are they *sans-culottes.* Nor do they wear turbans or handkerchiefs around their heads. They dress in the ordinary male costume of coat, vest and pants, sometimes, however, going in their shirt-sleeves. They are generally very well-looking men. Railroad employes especially have the reputation of being quite fine-looking,

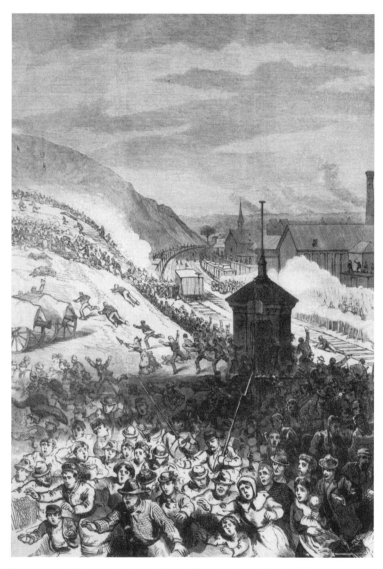

Figure 5.19. "Pennsylvania.—The railroad riot in Pittsburgh—
The Philadelphia militia firing on the mob, at the Twenty-eighth
Street crossing, near the Union Depot of the Pennsylvania Rail-

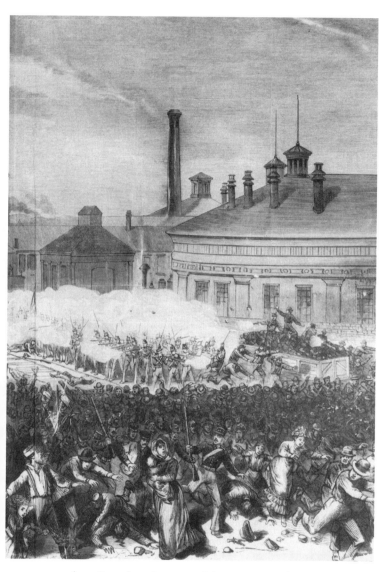

road, on Saturday afternoon, July 21st." Wood engraving based on a sketch by John Donaghy, *Frank Leslie's Illustrated Newspaper*, August 4, 1877, 8–9 (supplement). American Social History Project, New York.

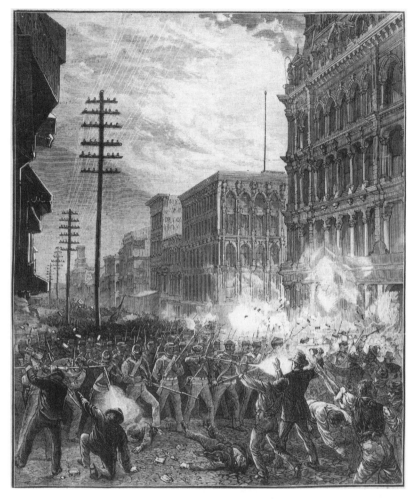

Figure 5.20. "The great strike—The Sixth Maryland Regiment fighting its way through Baltimore." Wood engraving based on a photograph by D. Bendann, *Harper's Weekly*, August 11, 1877, cover (617). American Social History Project, New York.

and playing havoc with the hearts of country girls. The South-side delegation, which marched up to the Round-House to help the strikers on that fatal Saturday evening, was led by a man in a good frock-coat, with a white neck-tie, and the men generally were well clad, and many of them had their boots blacked.

An "American mob," the *Leader* concluded, "especially when, as was the case at Twenty-eighth Street, there were mingled with the malcontents

large numbers of spectators and curiosity-seekers, is a pretty fair representation in appearance of the American people."[66]

* * *

What the *Leader* editorial observed—and what the unpredictability of depiction, unmooring of types, and lessening of physiognomy in the representation of African Americans, Irish Americans, the poor, and workers articulated—was a move toward realism. This call for the real may have had less to do with the much-vaunted hegemony of photographic practice than with the conflicting demands of a broad and increasingly diverse readership. The efficacy of physiognomic social typing relied on a widely shared cognitive map. As the Gilded Age progressed, a commonality of perceptions could not be assumed and, therefore, a reliance on pictorial social typing would undercut the very premise that made *Frank Leslie's Illustrated Newspaper* commercially viable.[67]

The general volatility of physiognomic types also affected, if less broadly, the previously sacrosanct bastion of "illustrious Americans." The conventions of portraiture used to represent notable figures underwent a transformation during the extended pictorial coverage of the Henry Ward Beecher–Theodore Tilton scandal. *Frank Leslie's* illustrations of Plymouth Church's investigation of the charges lodged against its minister in 1874 portrayed the protagonists with "traditional" portrait heads and narrative tableaux. By the time Beecher's trial for adultery began in January 1875, many of the engravings had departed from the safety of official portraiture, presenting instead "character sketches" that conveyed facial expression, gesture, and the idiosyncrasy of personalized poses appropriate to the high emotions of the event (figure 5.21).[68] In February 1877, official portraiture was again undermined: among the illustrations depicting the bipartisan Electoral Commission appointed to settle the disputed 1876 presidential election, readers were confronted by engravings that departed significantly from the expected history-painting tableau. In images "drawn with the freedom that distinguishes the pose of unconscious subjects," the commission's activities were fractured into vignettes, as the congressmen's expressions and exhausted and exasperated postures conveyed the urgency of the event.[69]

Official faces and stiff tableaux did not disappear from the pages of *Frank Leslie's*. The realist turn in official portraiture represented a departure rather than a trend; as reputations became mired in scandal, and the fate of the Union once again hung in the balance, the "hidden" faces

Figure 5.21. "The Tilton-Beecher trial.—Portraits and incidents." Wood engraving, *Frank Leslie's Illustrated Newspaper*, April 3, 1875, 56. American Social History Project, New York.

of the famous transcended the boundary of cartoons to invade news images.[70] As for "anonymous" Americans, by the 1870s the illustrated press found that its pictorial practice was inadequate. In a nation now seemingly locked in perpetual crisis, its middle readership had grown too broad and varied to accept representations rendered in exclusive codes derived from the antebellum period. Social typing would continue as a device for reading society and pictorially reporting the news; as we will see, in the 1880s physiognomic signs would locate new subjects in a new immigrant working class (as well as, persistently, in many images of African Americans). But while *Frank Leslie's* continued to frame its figures in the narrative and conventions of history painting, its need to address a range of readers opened the way for the newsweekly to experiment in capturing social reality without pictorial typing.

Balancing the Unbalanceable, 1878–89

For some time past . . . ultra-realisms have been apparent in works of fiction by even leading writers, and in devotion to naturalness artistic beauty has been lost and interest diminished. . . . [I]n the rage for analysis and scientific exposition, a philosophical generalization is lost. . . . Such attention to minute details becomes highly artificial, and, in a sense, untrue to nature, which appeals to the sympathies of the beholder rather by general characteristics than by heightening of any special feature. Those writers who have succeeded best in giving pleasing descriptions of scenery, have done so, not by displaying a minute faculty of observation, but rather by describing nature in its general aspects, as it strikes the observer. Even such a great writer as Dickens errs in this respect most glaringly, and offends good taste quite as much as he outrages art in the prominence given to mean details and trivial commonplaces.

Frank Leslie's Illustrated Newspaper

In a September 1883 editorial, *Frank Leslie's Illustrated Newspaper* defended romantic representation in fiction against the incursions of realism. Responding to comments by William Dean Howells that endorsed "naturalism, analysis and description," *Leslie's* upheld the virtues of genteel literature and went on to deplore "the same objectionable tendency" then exhibited in American painting: "The minute transcript of nature has been carried to the utmost verge of excess, and the sense of beauty and a dominating conception is sacrificed to a delicate perception of inconsequent features[.]" The truly great painter, the editorial concluded, "convey[s] much that the eye cannot see. . . . This genius accomplishes,

not by servile copying, but through an inspiration and a sympathy by which alone the artist can hope to rise equal to the majesty of nature."[1]

Concerned with what it perceived as an alarming development in literature and painting—the confusion between art and science that was subverting the former's idealist purposes—*Leslie's* 1883 editorial seems preoccupied by issues far removed from the weekly practice of pictorial journalism. But in its reiteration of art's function ("which appeals to the sympathies of the beholder . . . by general characteristics"), we catch a glimpse of a tension underlying the pictorial representation of the news during the 1880s. The images presented in *Frank Leslie's* pages were not Art in the sense espoused by contemporary literary publications such as *Harper's Monthly Magazine* and *Scribner's Monthly* (renamed *The Century* in 1881), with their engraved reproductions of drawings and paintings. *Leslie's* mission, from the start, departed from that of its genteel British progenitor: the weekly favored the pursuit of crisis over lofty academic instruction and uplifting imagery. Nevertheless, the codes and conventions of American illustrated journalism, whether in *Leslie's* or *Harper's Weekly,* were predicated on teaching greater "philosophical generalization," most particularly by conveying the true character of people and events through typification and physiognomy.

As we saw in the previous chapter, the exigencies of industrial capitalism during the 1870s undermined *Leslie's* approach to representation, as crises and conflicts differentially affected its broad middle audience. At pains to maintain a balance among readers whose interests and beliefs were increasingly at odds, *Leslie's* found its "traditional" reliance on physiognomic codes untenable. The protracted depression of the 1870s and the Great Uprising of 1877 prompted a move toward realism in depicting the urban poor and working class.

The realist turn, which undercut physiognomic codes, continued to operate within pictorial narratives during the 1880s. Typing persisted in these "performances," but the signs of role and character were coded more in dress, pose, and circumstance than in facial structure. This is not to say that news engravings no longer proffered interpretations of events. As before, *Leslie's* was not beyond catering to a number of perspectives, balancing representations from week to week and even within the same issue. Here realism could be helpful: individual pictures that might support multiple interpretations could satisfy varied constituencies. But the effort to achieve balance and multiple narratives proved unsustainable in a new decade marked by profound social conflict.

MRS. FRANK LESLIE'S ILLUSTRATED NEWSPAPER

By the close of 1879, Frank Leslie had lowered his debt to $100,000, but he never regained control of his publishing house. On January 10, 1880, he died, succumbing at fifty-nine to throat cancer that had been diagnosed only two months earlier.[2] Leslie's death did not spell the demise of his publishing house or, for that matter, his name. He bequeathed all his business and property to his second wife—including the sole right to the eponym "Frank Leslie," which he had succeeded in wresting from the claims of his eldest son only months before his death. Miriam Leslie spent a year battling family lawsuits and creditors' maneuvers that contested her control of the business. In May 1881, she paid off the last of her creditors; in the beginning of June, Frank Leslie's will was confirmed in court. Miriam Leslie, whose life was marked by repeated self-refashioning, marked her victory by inventing yet a new persona, legally assuming the title by which she thenceforth would be identified: "Mrs. Frank Leslie."[3]

Mrs. Frank Leslie constructed more than a persona during the next nine years. She became a prominent figure in the New York publishing world in her own right, personally managing the publishing house and supervising the editorial positions taken by each of her publications. She directed the redesign of *Frank Leslie's Illustrated Newspaper,* increasing its type size, decreasing the number of letterpress columns, and using higher quality newsprint to better display its engravings. She pared down the number of publications from six weeklies and six monthlies in 1880 to three weeklies and four monthlies by 1885 (by selling the provocative and profane *New York Illustrated Times,* formerly *The Days' Doings,* she divested her publishing house of one segment of readers); and she raised *Frank Leslie's* circulation, which had reached a low of 33,000 at her husband's death, to 50,000 by the mid-1880s.[4] Her handling of the coverage of James A. Garfield's assassination—including the risky decision, on learning of the president's death, to destroy the just-printed edition of *Leslie's* so that up-to-date pictures of the deathbed scene, autopsy, and funeral arrangements at Elberon, New Jersey, could appear on newsstands less than two days later—temporarily raised circulation to 200,000 and enabled her to fully pay off her debts.[5]

Her public reputation, like her late husband's, balanced images of profligate glamour and prodigious efficiency. Cultivating a position high atop New York society, Mrs. Leslie displayed her self-made wealth in regular Thursday evening salons for the glitterati and literati, interrupted

only by her regular summer tours of Europe. Exposés of her past continued to appear in the press, supplemented by new affairs with errant and youthful royalty (resulting in at least one duel between a favored Russian prince and a jilted French marquis). But her overarching role remained that of publisher: "When Mrs. Frank Leslie returned from her European trip the other day," the *Daily Graphic* reported in 1883, "instead of going home and there 'taking it easy' for a few days, she drove direct from the steamer to her office. On arriving there, with a vim and energy and a certain sort of heroism that few men would display, she took a seat at her desk and at once began to dispose of the business which awaited her decision. No wonder that she is making better papers and magazines and more money out of them even than did the founder of the great house she so admirably manages." [6]

Mrs. Leslie maintained *Frank Leslie's Illustrated Newspaper*'s traditionally independent editorial stance toward the political parties (though that professed position often nestled close to anti-Republican candidates and planks). Her outspoken advocacy of feminism, however, represented a new turn in the paper's history. From 1883 onward, *Frank Leslie's* editorials argued for women's suffrage and consistently hailed "advances" in American women's education and employment. Mrs. Leslie's feminism aligned comfortably with the hierarchical perspective of women's rights during the Gilded Age, which insisted that the "best" women should share in the fruits of a benevolent capitalism. Her stature in American publishing inspired many women in the printing trades: in 1888, for example, women compositors in Topeka, Kansas, formed a "Leslie Club" and featured her portrait in the first issue of their publication, *The Printer Girl*.[7]

* * *

The 1880s would be the final decade of *Frank Leslie's Illustrated Newspaper*, though the publication continued to exist for another thirty-three years after Miriam Leslie sold *Leslie's* to the Judge Publishing Company in 1889. But the close of the decade signaled more than the end of the Leslies' reign. During the 1890s the wood engravings used to illustrate *Frank Leslie's* progressively gave way to newer techniques of pictorial reproduction. During the course of the 1880s, daily newspapers began to publish news illustrations, supplanting the weekly news magazines' role, and the "half-tone" made its mark as a cheap and practical method for reproducing tonal pictures and photographs. As we will see, the trans-

formation was hardly cataclysmic, but the practice of producing news imagery that had defined an era was rapidly drawing to a close.

These technical and formal developments tend to dominate the historiography of the popular art and media of the period. The rise of a "New School" of wood engraving has received particular attention.[8] Once photography on wood (photoxylography) was perfected, original art could be transferred directly onto the woodblock; it was thus no longer necessary to redraw images on the block. Now confronted by photographed tones and brushwork on the woodblock surface, engravers experienced their own realist turn, and New School advocates endeavored to go beyond what wood engraving had accomplished with its linear codes of engraving by reproducing other media (dabbling in the type of attention to detail abhorred in the 1883 *Leslie's* editorial that introduced this chapter).

Frank Leslie's cuts reflected the change in technique during the 1880s as new pictorial codes and linework more effectively established atmosphere and mood. But while the New School inaugurated a "Golden Age" of magazine illustration, it had little impact on the representation of news. Formalist debates over the "art" of engraving, which briefly resuscitated the role of the engraver, largely ignored the "hackwork" of illustrating the news. In the following analysis of the trends of the 1880s, we will see that it was not so much a technical practice that determined the nature of representation as the continuing impact of a social practice.

LABOR: CONFLICT WITHOUT THE MARK OF DIFFERENCE

Under Mrs. Leslie's aegis, the publishing house remained a remarkably trouble-free workplace in the midst of the "Great Upheaval," the rise in labor activism during the 1880s. If contemporary commentaries are to be believed, labor conflict broke out only once, early in the decade, when engravers walked out in a dispute over an abusive foreman. Mrs. Leslie confronted the strikers with an argument that attempted to exploit her husband's craft origins even as it bristled with noblesse oblige: "I am ashamed of you to treat an engraver's widow in this way," she reportedly said. "You owe me some allegiance." Apparently, her employees thought otherwise; the strike lasted several days, after which the engravers returned to issue the next edition of *Frank Leslie's* on time.[9]

As for the world outside, in the aftermath of the Great Uprising of July 1877 *Frank Leslie's* largely refrained from covering the labor movement. With the exception of a brief consideration of the New York City

cigar makers' strike in the fall of 1877—two sober engravings depicting the manufacture of cigars in a factory and in a tenement apartment[10]— for the next few years the labor movement received virtually no visual treatment. Certainly, in the months following the nationwide strike no engravings were published by *Leslie's* that matched the images appearing in *Harper's Weekly. Leslie's* February 2, 1878, issue carried four pictures captioned "Episodes of tramp life on the Union and Central Pacific Railroads," which included one cut showing a vicious assault on a conductor. The accompanying text, however, was not particularly concerned about the issue of labor violence. As part of an extended series of essays and engravings titled "Across the Continent," chronicling the Leslies' extravagant railroad excursion during the spring and early summer of 1877, the illustrations were offered as examples of the sights a traveler might witness on a transcontinental trip.[11] In contrast, *Harper's Weekly* embellished its September 14, 1878, cover with an engraving of a single brutish male figure wielding a club. Rendered with great care so that his face was a veritable map of debauchery and menace, the worker gazed at the reader and demanded, in the dialect of melodrama, "Is sercierty to be reorganized? Is the workin'man to hev his rights? That's wot I wants to know." [12]

Though the labor movement received scant attention in *Frank Leslie's Illustrated Newspaper,* the worker as a distinctive social type was rejuvenated. As noted in chapter 3, after the Civil War the worker had disappeared as an identifiable visual type, replaced by a range of ethnic figures whose "foreign" countenances and dress bespoke inauthenticity. But in the year following the Great Uprising, *Leslie's* rediscovered the worker among the many sights offered readers in the publication's chronicle of the transcontinental excursion. During March 1878, the weekly carried a number of engravings illustrating a visit to silver mines located near Virginia City, Nevada. Deep below the earth's surface, the party came upon the idealized worker in the form of the western hardrock miner: he was pictured hacking at the rock face, and his classical proportions and finely rendered physique bore no signs of disparagement or defect, thereby ennobling (and also eroticizing) the meaning of labor (figure 6.1).[13] A variation on this theme could be found a year later in *Leslie's* coverage of life in the boomtown of Leadville, Colorado. Depicting rugged if not downright squalid surroundings, *Leslie's* spring 1879 engravings nonetheless celebrated the rambunctiousness of the town's silver miners; in this case, raucous and hirsute workers were ennobled by their incipient entrepreneurship. Meanwhile, one lone

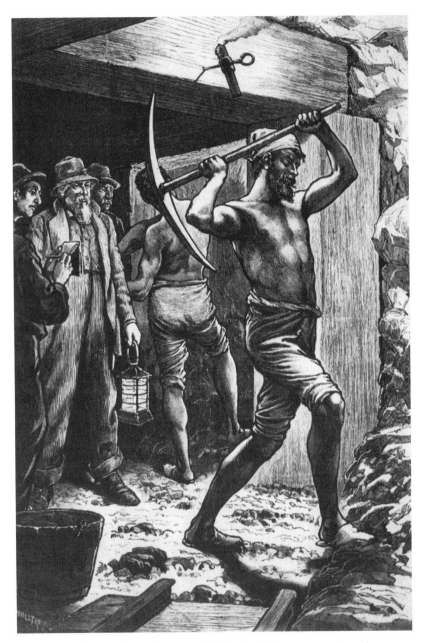

Figure 6.1. "Across the continent.—The Frank Leslie transcontinental excursion.—The party witnessing silver-miners 'picking' ore in the Consolidated Virginia silver mine, at Virginia City, Nevada." Wood engraving based on a sketch by Thur de Thulstrup, *Frank Leslie's Illustrated Newspaper*, March 9, 1878, 9. American Social History Project, New York.

April 1879 cut of a scene in Schuylkill County, Pennsylvania, significantly focused on the trade of an itinerant peddler instead of on labor in the mines.[14]

Perhaps the West was where the archetypal worker reigned, but it also appeared to be a locus for the kind of social and political ferment that *Leslie's* had earlier deplored in the East. In a March 1880 engraving, *Leslie's* depicted a Workingmen's Party of California nighttime rally in San Francisco, delineating in a threatening chiaroscuro composition labor militancy that merged political demands with agitation against Chinese immigrants.[15] Within a few months, portrayals of western "radicalism" would move from ominous rallies to deadly personal feuds (which involved San Francisco's Workingmen's Party mayor), culminating in a full-page engraving in November showing an anti-Chinese riot in Denver (figure 6.2).[16] Compared to these depictions of mayhem in the West, *Leslie's* coverage of the insurgent Greenback-Labor Party was decidedly anticlimactic. A solitary image of New York Internationalists published in August 1881, showing the socialists arguing over the recent shooting of President Garfield, seemed almost nostalgic.[17]

In 1882 another depression hit the American economy, setting off a new crisis.[18] As before, employers imposed drastic wage cuts on workers, which in turn provoked a militant labor response; supported by the new organizing base of the Knights of Labor, union membership and activism grew rapidly. The accompanying conflict prompted *Frank Leslie's* return to reporting on the labor movement. Over the next seven years, *Leslie's* covered the strikes, parades, conventions, and other activities of workers in engravings, editorials, and cartoons that far exceeded those of its competitors (as well as its own former level) in both number and scope. The labor reformer George McNeill titled his memorable 1887 survey of working-class organization *The Labor Movement: The Problem of To-day.*[19] The pages of *Frank Leslie's Illustrated Newspaper* during the mid-1880s would suggest to even the casual reader that McNeill was right to call labor conflict a defining feature of the era.

Once again, a conflict involving coal miners enables us to gauge *Leslie's* representations. The publication's editorial position on strikes did not stray much from the stance taken during the 1870s. When Knights of Labor unions in the bituminous coal-mining region of Cumberland, Maryland, struck in the spring of 1882, *Leslie's* recapitulated its position. "It is certainly to be hoped that the differences which have led to this formidable strike may be adjusted before the industries involved become disastrously deranged," began a June 10 editorial. "A strike never

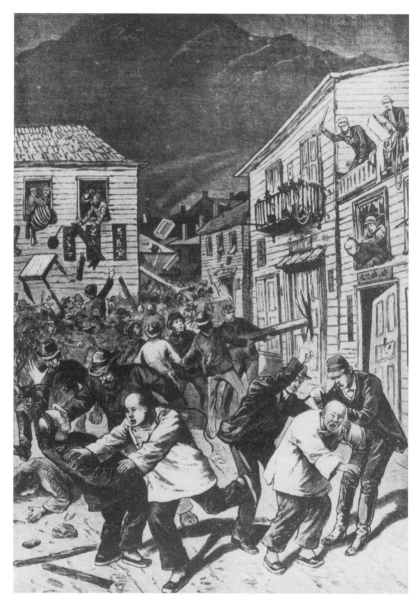

Figure 6.2. "Colorado.—The anti-Chinese riot in Denver, on October 31st." Wood engraving based on a sketch by N. B. Wilkins, *Frank Leslie's Illustrated Newspaper,* November 20, 1880, 189. American Social History Project, New York.

permanently remedies a wrong. It fosters and aggravates antagonisms between capital and labor, which ought never to exist, and as a rule puts the workingman at a disadvantage where, by a wise use of his opportunities, he might dominate the situation. Lock-outs should only be resorted to when every other means for the redress of actual grievances have altogether failed, and even then, so far as the public is concerned, they are likely to be rather detrimental than otherwise." [20] Situating itself as the public between labor and capital, *Leslie's* unequivocally abhorred strikes and placed the responsibility for disorder on the shoulders of the labor movement.

This editorial position notwithstanding, *Leslie's* coverage of the strike in the Cumberland region grew more complicated once readers moved from the textual to the pictorial realm. The June 10 issue included one image that seemed consistent with the accompanying editorial, showing Eckhart, Maryland, mining families berating the arriving immigrant strikebreakers, their wrath held in check by the coal and iron police.[21] The next issue featured a double-page engraving divided into three panels. The two lower panels presented two scenes in a Pittsburgh iron mill (another phase of the strike), contrasting an industrious and populated "Prosperity" to a shut-down and deserted "On Strike." The top panel (figure 6.3) offered readers a familiar mine strike narrative, reiterating a theme that dated back at least as far as *Leslie's* coverage of the 1874–75 "Long Strike" in eastern Pennsylvania. Titled "Strikers and those who suffer," this scene of the strike in Eckhart, Maryland, was not so much peaceful (a desirable condition) as idle. The striking men on the extreme left who carelessly lounged, bantered, and gambled were sharply juxtaposed to the two "dependents" with wary expressions on the right (as well as to the women anxiously clustered in the background). Nevertheless, this engraving was significantly more ambiguous than 1870s scenes of mining strikes and the degradation accompanying them: set in bucolic surroundings, the subjects were now respectably, almost formally, dressed, and their faces were devoid of any telltale physiognomic signs. The striking miners might be ill-advised in their actions, but this representation (no doubt influenced by the prosperous and settled nature of mining communities in western Maryland)[22] bore no larger lessons on the relationship between innate moral failure and misbehavior.

The cover engraving of the June 17 issue carried forward this ambiguous, "balanced" approach toward the strike (figure 6.4). The description accompanying the scene, "Merchants in the mining town of Frostburg closing their stores by order of the Knights of Labor," emphasized

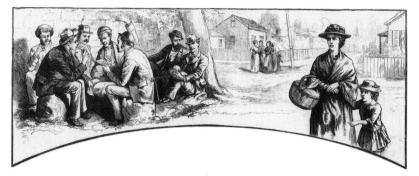

Figure 6.3. "The great labor strike in Maryland and Pennsylvania—Its incidents and results.—1. Strikers and those who suffer: A scene at Eckhart, Md." Detail of a wood engraving, *Frank Leslie's Illustrated Newspaper,* June 17, 1882, 264–65. Prints and Photographs Division, Library of Congress.

coercion: "The strikers hold full sway at Frostburg, Md. They readily displayed their power by requiring the shopkeepers to close their places of business at half-past seven o'clock each evening." Describing the "way in which this decree was given and obeyed," which involved a fourteen-year-old boy ringing a handbell, *Leslie's* correspondent (possibly Special Artist John N. Hyde) seemed bewildered by the response of the town's businessmen: "As the ragged, barefooted little emissary of the Knights passed down the street light after light disappeared, and in ten minutes there was not a store open in Frostburg with but two exceptions. Yet the storekeepers of this town as a class are well educated, courageous and good business men."[23] While the description emphasized reluctant obedience to coercion, the engraving suggested a decidedly more cooperative attitude. As indicated in the foremost history of the strike, the region remained generally peaceful during the work stoppage; more to the point, the unalarmed quality of the cut reflected the comfortable correspondence of the Knights' "decree" with an agreement worked out between local storekeepers and clerks regarding early closings, a new policy probably influenced by the labor group's general ethos.[24]

The role of the Noble and Holy Order of the Knights of Labor as the organizational base for what would emerge as the Great Upheaval of the 1880s may have contributed to *Leslie's* more nuanced, and at times outright contradictory, representation of labor conflict. The Knights' associational culture and critique of capitalism derived in no small part from an alternative vision of the republican heritage. As the first mass organization of the American working class, the Knights' legitimacy was lo-

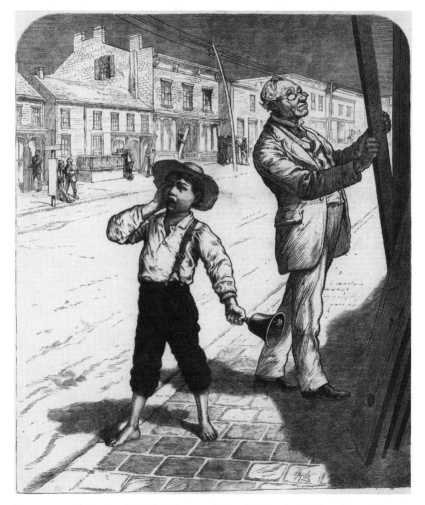

Figure 6.4. "Maryland.—The labor strike in the Cumberland region—Merchants in the mining town of Frostburg closing their stores by order of the Knights of Labor." Wood engraving based on a sketch by John N. Hyde, *Frank Leslie's Illustrated Newspaper,* June 17, 1882, cover (257). American Social History Project, New York.

cated in a mix of "emergent" and "residual" beliefs that defined its constituency as the "producing classes" of the nation. The Order's inclusive and broad appeal resonated with a sizable portion of *Frank Leslie's* own broad and varied readership. For example, *Leslie's* June 24 issue carried excerpts from a letter by a "workingman at Frostburg, Md." Correcting the paper's description of how the strike began (with a wage cut, not a

demand for higher wages), the unnamed correspondent went on to re-
monstrate against the employers' reliance on private police. Suggesting
to readers a different way to perceive engravings of the strike, he closed:
"The introduction of a police force is only a scheme of the companies to
poison the minds of the public against us."[25]

Frank Leslie's treatment of the 1882 Cumberland strike established a
pictorial approach to the labor movement that lasted into the late 1880s.
Its most respectful treatment focused on an annual event, the newly in-
stituted Labor Day parade. The September 13, 1884, engraving of the
workers' procession moving up Broadway was typical, graphically ac-
knowledging the significance of "the growing organization of labor" by
illustrating "a fine, orderly body of men."[26] While it is unsurprising that
such "orderly" and stately processions would receive *Leslie's* pictorial
and editorial endorsement, representations of the escalating labor strug-
gle also indicated that the publication was striving for balance in its illus-
trated coverage despite favoring capital in its editorials. In *Leslie's* text,
the rights of labor were sharply circumscribed; a September 13, 1884,
editorial accepted that workers could organize and stop work to garner
better pay, but beyond that the laws of trade were unalterable. "[T]he
workman's rights find a limit here," *Leslie's* pronounced: "He may not
set a guard around his late employer's premises and prevent him from
hiring anybody else. This is, more or less, a free country; and a work-
man has no more right to fix a price on other workmen's labor than a
farmer has a right to put a price upon another farmer's hay."[27]

This editorial, in effect, introduced *Leslie's* coverage of a six-month
mine strike in Hocking Valley, Ohio. Some of its engravings seemed
clearly to criticize the transgressions of labor, showing mining families
barely held at bay by company Pinkertons guarding imported "black-
legs," as well as depicting miners firing on strikebreakers.[28] Yet a No-
vember engraving extended more than the usual sympathy for the strait-
ened circumstances of striking mine families (figure 6.5). The destitute
Irish family huddled in one of the tents sheltering evicted strikers in Buch-
tel, Ohio, did not present a tableau of idleness and degradation such as
Leslie's readers had commonly viewed in the 1870s (see figure 5.1). The
1884 engraving departed entirely from the previous juxtaposition of ir-
responsible males and victimized women and children. Showing a for-
lorn miner gazing down at his sleeping children, the cut presented him
sharing in his family's misery and sacrificing his own small measure of
comfort on their behalf: "Not infrequently the miner removes his own
ragged coat to cover the couch of his little ones during the long night

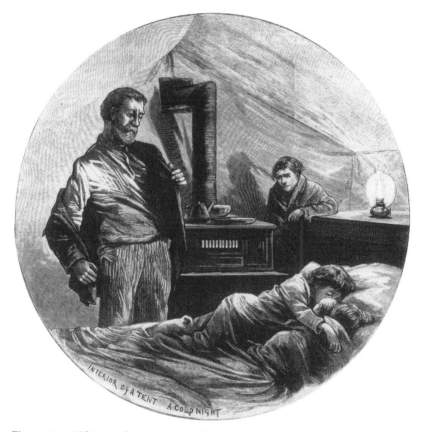

Figure 6.5. "Ohio.—The mining troubles in Hocking Valley.—Tent life of the striking miners. Interior of a tent—A cold night." Detail of a wood engraving based on a sketch by Joseph Becker, *Frank Leslie's Illustrated Newspaper,* November 15, 1884, 204. Prints and Photographs Division, Library of Congress.

hours."[29] It is no small testament to *Leslie's* balancing act to note that the artist credited with recording this and the other Hocking Valley pictures was that earlier reviler of the Irish miner, Joseph Becker.[30]

While unrelated to pictorial representation, perhaps the most compelling indication of *Leslie's* attempt to balance the diverse and potentially conflictual beliefs of its readers occurred during 1883. In its March 31 issue, *Leslie's* announced that a new weekly department, "Problems of To-day," would present writing by "some of the strongest thinkers and writers of the time" on such subjects as "the latest and more suggestive aspects of capital and labor; the free trade and protection questions; the people against monopoly; the rights and restrictions of corporate power;

the future of the merchant marine; the sphere and influence of the daily press, and other kindred topics of national interest and practical importance."[31] Beginning in the following issue, *Leslie's* handed the column to the popular labor reformer Henry George. In a thirteen-part series of articles called "Problems of the Time," George extended the arguments in his 1879 critique of private land ownership, *Progress and Poverty*, taking an antimonopoly position that advocated public ownership of corporations. The series continued into July, interrupted by occasional critical letters and their answers by George. Editorials and columns devoted to responding to issues raised in the series stretched into October. Although allowing George a platform was no doubt a savvy competitive move on *Leslie's* part, the amount of space given to him was extraordinary, especially in light of the objections the publication raised to his views in editorials during and after the series ("what all crime is in practice, Georgism is in theory").[32] "The Problems of the Time" appeared shortly after the serialization in *Harper's Weekly* of *What Social Classes Owe Each Other* by the Social Darwinist William Graham Sumner.[33]

Leslie's efforts at evenhanded treatment were assisted by new formalist techniques of engraving. The New School of wood engraving, with its codes that enhanced textures and mood, led to illustrations that suggested to readers multiple narratives of a given event, as some individual cuts became capable of conveying more than one perspective. With a picture's determinist signs delivered in details of dress and circumstance rather than in the physiognomic signs relied on in past engravings, varying readerships could now derive different meanings from the same image. Strike scenes, which during 1885 and the Great Upheaval of 1886 often included railroad and streetcar work stoppages, effectively conveyed multiple or indeterminate meanings. A March 1885 engraving of an incident during the Knights of Labor's strike against Jay Gould's Southwestern Railroad showed a freight train crew abandoning their locomotive at the behest of strikers; the glowing lamp and churning white mist against the hulking locomotive and silhouetted strikers created a dramatic composition—but one whose interpretation could vary with the orientation of the viewer.[34] An April 1886 engraving portrayed a more explicitly tense situation during the following year's strike against the Southwestern system (figure 6.6). Nevertheless, while the illustration of a confrontation between a member of the Citizens' Committee of Fort Worth, Texas, and a "turbulent" striker carefully delineated features and dress, it did not visually elaborate on the character of the protagonists. Engravings might dramatically show the destruction of railroad prop-

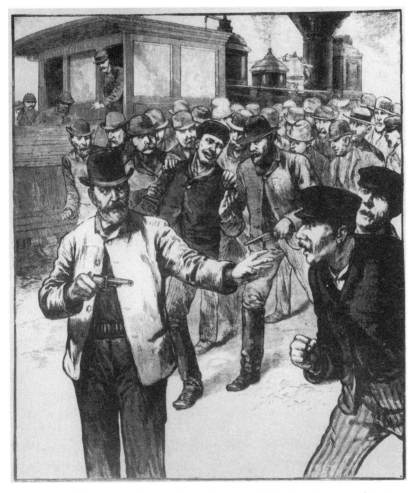

Figure 6.6. "The great railway strike in Texas and Illinois—Scenes and incidents.—1. The Citizens' Committee at Fort Worth, Texas, arresting a turbulent striker after the riot of April 3d." Wood engraving, *Frank Leslie's Illustrated Newspaper*, April 17, 1886, 141. American Social History Project, New York.

erty, tumultuous demonstrations, and violent clashes, but in many of these pictures the old signs demarcating the meaning of events were no longer apparent.[35] The realist turn that had dampened visual social typing, together with the effects of the New School of engraving, promoted "multi-accentuality" in the narratives of many cuts: diverse readers could engage in their own different interpretive "systems of viewing," no longer hampered by invidious physiognomic comparisons.[36]

But the social conflict of the 1880s introduced new subjects—or at least new variations on existing subjects—that eventually contributed to yet another alteration in the representation of the labor movement. With its coverage of the 1882 freighthandlers' strike on the New York and New Jersey waterfront, *Leslie's* introduced its readers to a new disruptive force in American society. In its August 5 issue, the weekly remarked on the railroad companies' success in recruiting strikebreakers. Many of the replacements were Italian, "and the enmity of the strikers and their sympathizers has been especially directed against them. . . . The strikers and their hoodlum followers have been quick to seize every opportunity to intimidate the Italians, and sometimes they have not stopped with attempts to frighten them." The cover engraving portrayed such a scene, "which has had many counterparts during the last few weeks" (figure 6.7). "One of the Italians," the description continued, "has become separated from his comrades, and a mob has set upon his heels. Unable to escape by flight, he has taken refuge in a corner, and drawing his knife, he bids defiance to his pursuers, who, much as they would like to harm him, shrink from coming within range of the ugly weapon wielded by a man whose determined air reminds one of a wild beast at bay."[37]

Titled "At bay," the engraving was imbued more with exoticism and its concomitant air of danger than with sympathy for the Italian immigrant's predicament. Previous pictures of the strike had taken a more jocular approach, showing Italian and Russian Jewish strikebreakers, fresh from Castle Garden, being ridiculed by strikers and emphasizing the immigrants' inability to perform simple manual tasks.[38] But whether dangerous exotics or incompetent oafs, the immigrant laborer was represented as a new source of domestic strife. Other cuts depicting Italians doing roadwork in upstate New York, or rushing through New York City streets from Castle Garden to the railroad depot, also emphasized their utter foreignness in appearance and behavior ("their make-up is strikingly brigandish").[39] The distinctive features of the Irish worker had been largely absorbed into the realist revision of the American worker, coinciding with the broad participation and leadership of Irish Americans in the labor movement. Signs of difference now settled on the new wave of immigrants from Italy and Eastern Europe. In physiognomy and costume, they conveyed instability: as "cheap foreign labor" their availability as strikebreakers reduced them, in *Leslie's* view, to a threat to the hoped-for orderly relations between labor and capital. Located outside of *Leslie's* range of constituencies, the new immigrants could be safely

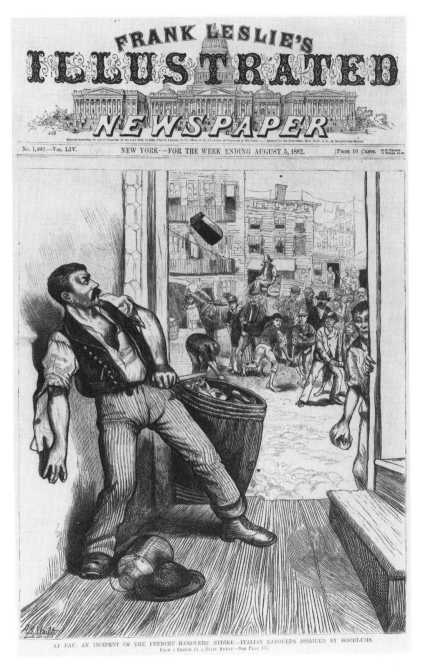

Figure 6.7. "At bay: An incident of the freight-handlers' strike—Italian laborers assailed by hoodlums." Wood engraving based on a sketch by A. B. Shults, *Frank Leslie's Illustrated Newspaper*, August 5, 1882, cover (369). American Social History Project, New York.

subjected to the kind of representation that the weekly had largely abandoned in its depictions of the "American" worker.[40]

The charge that immigrants exacerbated class conflict rested on more than their exploitation by capital as strikebreakers. In a series of three engravings in the February 6, 1886, issue of *Frank Leslie's,* their contribution to mayhem from the other side of the barricades was made readily apparent. The cuts showing Hungarian and Polish miners in Mt. Pleasant, Pennsylvania, attacking immigrant strikebreakers were framed in distant views, but they nonetheless indicated to readers the menace of a militant and unpredictable new force within the ranks of labor.[41] Whether strikers or strikebreakers, immigrants represented "Imported Trouble," as a February 13, 1886, editorial declared. Referring to the Mt. Pleasant conflict, *Leslie's* persisted in rejecting legal restrictions on the immigration of laborers as un-American, while contemplating the hazard of admitting a degraded population into the country. "The question suggested by the quarrel," *Leslie's* commented,

> is whether it is ordinarily profitable for American manufacturers to import laborers from Europe on the presumption that they are cheap? If they be ignorant and stolid, will they not be likely to become factors of disorder, violence, and crime, and swell the ranks of the reckless and vicious whenever fortune seems to set against them? Even for unskilled labor like coke-burning, which any man with hands can do, would it not be more profitable in the long run to employ men who feel some sense of their responsibility to society, and understand that the relations between employer and employed involve mutual obligations?[42]

THE CITY: "THE CHASM BETWEEN CLASS AND CLASS"

The new immigrants' degradation and instability were most compellingly shown in illustrations of 1880s city life. New York remained the prototypical metropolis for the weekly illustrated press; while other cities received occasional pictorial treatment (most often in the form of admiring surveys of their commercial and industrial expansion). New York, the home of the weekly pictorial press, stood as both positive and negative examplar of urban life. Its technological innovations, resplendent cultural events, and social reforms were consistently set against its structural decay, raucous popular amusements, and social turmoil.

Juxtaposition remained the operative method of representation: only rarely was the range—and, more pointedly, the mix—of classes and peoples depicted in one engraving. When such an urban crowd did occasionally appear, it seemed calculated to demonstrate atypical unity

or, most often, to underscore differences. A September 1878 engraving, "Ferry passengers depositing money in the yellow-fever box at Fulton Ferry," heralded a laudable moment of "intimacy" among types as they united in a benevolent response to distant calamity, "heeding the cry of distress from the fever-stricken South."[43] For the most part, the odd appearance of the urban crowd articulated contrasts: the November 1882 "Character sketches on the elevated railway" illustrated the uncomfortable indiscriminateness that characterized public transportation, with the various types seeming to studiously avoid contact on the crowded platform. The December 1885 "Holiday times in New York.—A character sketch on Fourteenth Street" provided a more traditional treatment of the crowd: the clutter of figures actually delineated two groups, as respectable women were forced to "run the gauntlet" of "the standing army of street-venders."[44]

Thus, in an approach to representation that remained remarkably consistent throughout the latter half of the nineteenth century, *Frank Leslie's* depiction of urban life offered readers a city fractured into various isolated enclaves. Some cuts were juxtaposed to provide a sense of the range of peoples, pursuits, and locations. While some of these juxtapositions proposed invidious comparisons, others seemed to celebrate difference and recognize the diverse mores of a varied readership.[45] "Two pictures! Two striking pictures!" *Leslie's* exulted in the description accompanying the April 1882 "Our metropolitan picture galleries"— two engravings labeled, respectively, "The closing hour in a gallery of the 'Upper Ten'" and "The people's gallery" (figure 6.8). "Art in the *salon*— Art in the street! Art on canvas—Art on brick walls!" The salon housed "the critics and the would-be critics, the cultured ones who rave and gush over half-tones, and aerial perspective and *chiaro-oscuro*," while outside were "gathered together the uncultured, the unaesthetic, who gaze in honest ecstasy at the illuminated playbills and vivid representations, done in every color in the rainbow. . . . Mark the faces in the *salon*," *Leslie's* continued,

> refined yet indolent, playing at earnestness; while in the street every eye is thirsty, and eager glances—from that of the baby held aloft by its father, to that of Mick Quinn, who emerges from his cellar—are riveted upon the flaming poster just being pasted by the energetic if not acrobatic bill-sticker. In the *salon* the cultured taste is appealed to by tender bits of landscape, luminous sea views, delicious *genre* scenes and life-like portraits. In the street the uncultured taste is appealed to by chromos and cunning devices in color-printing, with the similar result of pleasing and calling forth criticism.

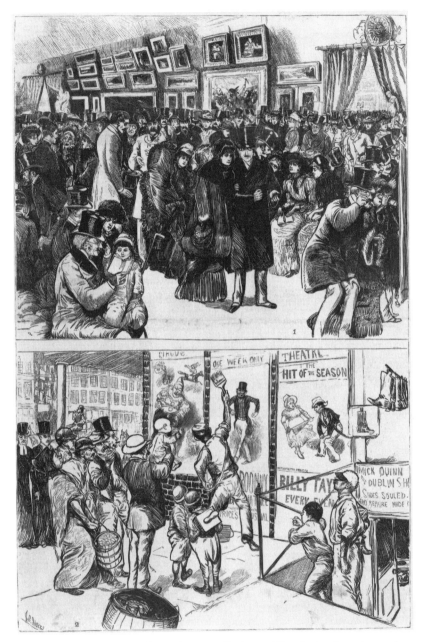

Figure 6.8. "Our metropolitan picture galleries. 1. The closing hour in a gallery of the 'Upper Ten.' 2. The people's gallery." Two wood engravings based on sketches by A. B. Shults, *Frank Leslie's Illustrated Newspaper*, April 22, 1882, 133. American Social History Project, New York.

Here we have the two art galleries, both with their admirers, both appealing to the artistic sense of their frequenters.[46]

Though *Leslie's* recognized popular pastimes and tweaked genteel pursuits, its perception of an ordered urban landscape was premised on maintaining the separation of classes. Its juxtapositions and compartmentalized representations might, taken together, address its broad, middle readership; but in the 1880s, this pictorial practice proposed that the differences—in the bifurcation of commercial and genteel culture as well as in the conflict between labor and capital—were permanent. Acknowledging the demands of many of its working-class readers, *Leslie's* supported the expansion of public education and campaigned for the abolition of Sabbatarian laws that prevented New Yorkers from attending museums and other refined cultural venues on Sundays. Nevertheless, separation was the only alternative, requiring (as proposed in a December 1883 editorial) that communal celebrations such as those held at Christmas be abandoned. "Increasing culture and refinement, even more than increasing wealth," *Leslie's* commented, "have widened the chasm between class and class, and it is now as impracticable as it would be undesirable to bridge the gulf by the common celebration of even one day in the year."[47]

Frank Leslie's admonitions against class mixing in the city implicitly justified its own existence: if relations between classes required careful mediation, what agent was more appropriate than the illustrated press? As the December 1885 "'Doing the slums'—A scene in the Five Points" illustrated, if readers wished to investigate the causes and nature of poverty, they need not pursue that knowledge through direct observation (figure 6.9). Such a "fashionable distraction" smacked of "slumming," which was a "pharisaical response to the 'bitter cry of the outcast poor.'" Adopted by many equally curious New Yorkers, the genteel pastime was, at worst, a tasteless exercise; at best, it was a useless gesture toward education. The tours usually comprised "very superficial inspection[s] of a few of the best known and most easily accessible quarters of the degraded and destitute." The dangers of walking through districts like the Five Points were "more imaginary than real," but the standard escort of a policeman tended to put the residents "in an attitude of defiance" that defeated "any real purpose on the part of the visitors to study beneath the surface."[48]

The best way to investigate urban poverty was through the medium of the illustrated press. *Leslie's* approach to depicting the 1880s poor

Figure 6.9. "New York City.—'Doing the slums'—A scene in the Five Points."
Wood engraving, *Frank Leslie's Illustrated Newspaper,* December 5, 1885,
245. American Social History Project, New York.

was essentially the same as its earlier practices. Pictures of the idealized
city, sparkling with improvements and technological wonders (exempli-
fied in the carefully charted construction and opening of the Brooklyn
Bridge) were set against cautionary cuts depicting want and degrada-
tion. Urban life was characterized by extremes existing in uncomfort-
able proximity to one another, the shadow world forever threatening to
obscure the sunlight. *Leslie's* gaze, in the 1880s, settled more often on the
health threat posed by poverty than on its criminal or political dimen-
sions. But the pictorial record maintained a sense of order with engrav-
ings that depicted measures taken by reformers and officials to combat
mayhem through "disinfecting" inspections and evictions, vaccination
campaigns, charitable good works, and plans for new housing.[49]

Through the 1870s, the pictorialization of the urban poor had shown
the "inflection" of Irish customs and, most tellingly, physiognomies. In
the 1880s, the Irish were succeeded as types, for the most part, by south-
ern Italians and eastern European Jews—a conglomerate of new immi-
grant poor carrying their own disquieting characterological, and thus

pictorial, traits. "Those who have seen the Italian peasants moving in gangs at early dawn towards the fields where they are at work," *Leslie's* commented in August 1885, "conducted by an overseer on horseback, can scarcely have avoided a mental comparison between them and the slave droves of ancient times." The erasure of the memory of more recent American scenes of enslavement notwithstanding, *Leslie's* vision of oppression was designed to elicit revulsion rather than sympathy: "Men and women bending to the ground, shivering in the chill mists of morning, toiling in mournful silence, they might be but a herd of human cattle, resembling their fellows, but belonging to a different and degraded race of captive helots." [50]

In comparison, eastern European Jews were greeted with a genteel anti-Semitism that strove to distinguish among the classes constituting the new immigrants. Commentary, cartoons, and cuts during 1881 and early 1882 portrayed newly arrived exiles from persecution in Germany as physiognomically distinctive (the males bearing identical emblematic noses) yet potentially assimilable. "With all their peculiarities," declared a January 1881 editorial, "their distinct if not lower civilization, their aggressiveness, their vulgarity, if one cares to call it so, there are among the Jews qualities the most valuable in citizenship. . . . It is always the poorer and least refined of any nation who emigrate to other lands, and hence American opinions of German Jews are formed upon the least favorable data." Even among this sorrier lot in America, *Leslie's* concluded, "the better qualities of the race may be discerned—the love of home and of family among the men, the superior intellectuality of the better class of women, the filial piety of the children which would surely tend to make them the best of citizens of any country which should be even in the least degree a *patrie*—a fatherland—to them." [51] The studied distinctions reflected the weekly newspaper's ecumenical coverage of religious observance in New York, which included respectful illustrations of the customs and charitable works of the city's prosperous German Jewish population; these dated back to "The Jewish Passover of 1858," an article by the *Tribune* reporter Mortimer Neal Thompson ("Doesticks") and illustrated by either the Jewish special artist Sol Eytinge Jr. or his adolescent associate, Thomas Nast. [52]

Leslie's tolerant attitude was based on the belief that the new wave of Jewish poor would rapidly move to the West. By 1882 it was clear that these expectations were unfounded, and within a few months the tone of the publication's commentary and engravings had changed. Negatives outweighed the earlier positives (backhanded as they had been), espe-

Figure 6.10. "New York City.—Russian Jews at Castle Garden—A scene in the early morning." Wood engraving based on a sketch by A. B. Shults (?), *Frank Leslie's Illustrated Newspaper,* August 5, 1882, 373. American Social History Project, New York.

cially regarding the influx of a new type of utterly "foreign" Jewish immigrant. "Many of the Russian Jews who have recently arrived at this port have been anything but desirable additions to our population," *Leslie's* observed in its description accompanying an engraving published in the August 5, 1882, issue (figure 6.10). The depiction of the "squalid, filthy and exclusive little community" gathered in temporary shelters in Castle Garden signaled the appearance of a new population

of degraded paupers: "The scenes in the inclosure of which the refugees had taken possession were often most offensive, men, women and children being huddled promiscuously together, many of them disgustingly filthy and none apparently having much regard for the restraints of morality." The engraving legitimated *Leslie's* urgent call, two weeks later, for the "Repatriation of the Russian Jews": "To say that a majority of Americans—native born or adopted, save only those of Hebrew birth—see nothing attractive in these outcasts from Russia, would . . . be a mild form of expression. . . . [I]t is an undoubted fact that when opportunities have been given them to earn an honest living by work, in a great many cases they have given it unmistakably to be understood that they prefer to be cared for and do nothing." [53]

The engraving of "Russian Jews in Castle Garden" appeared in the same issue of *Frank Leslie's* as "At bay," the cover cut showing an exotically clad, knife-wielding Italian strikebreaker (see figure 6.7). To readers, the two engravings' proximity would have seemed more than coincidental. Together, they conveyed a new, volatile element in the city's life, disrupting class relations, potentially spreading disease, and contributing to the persistence of immorality and idleness among the urban poor. These reprehensible traits of pauperism and brutality were made brazenly visible, as the subjects' innate characterological flaws were inscribed in utterly foreign, unassimilable physiognomies. The representation of the new immigrant poor marked the reemergence of pictorial social typing—but its return fit comfortably within the larger turn toward realism: the resurgent physiognomic codes were administered to subjects located outside of *Frank Leslie's* constituency of readers. As in the representation of the poor dominant until the 1870s depression, the new immigrant poor of the 1880s were portrayed as a band of outsiders with whom most readers could not identify or sympathize.[54]

Though physiognomic signs were abundant, *Frank Leslie's* did not rely on them solely to represent the immigrant poor. Indeed, many pictures of poverty or the pastimes of newcomers were devoid of didactic signs. Just as scenes of urban blight and infection were counterbalanced by engravings of resplendent social, cultural, and economic institutions and events, so the depiction of figures of a new "dangerous class" were counterposed to more attractive portrayals of picturesque rituals and pursuits. In addition, engravings of urban disasters, from collapsing tenements to the horribly ubiquitous slum fires, elicited images showing blameless victims divested of the facial signs of immorality.[55] Finally, while the children of the poor continued to appear as a pictorial subject

that denoted a future threat, their role as undeserving victims of adult depravity (especially when shown as saved by the intervention of reformers) offered readers a modicum of hope.[56] Nevertheless, the reemergence of physiognomic codes in depictions of the new immigrant served to frame the overall representation of the poor, stressing their most crucial aspects as consummate, irremediable outsiders.[57]

HAYMARKET AND ITS AFTERMATH

The reemergence of physiognomic codes may have been encouraged by Charles Guiteau's assassination of President James A. Garfield in 1881. For more than a year, *Leslie's* diligently covered Guiteau's crime, incarceration, sensational trial, and execution, during which time the assassin eagerly provided reporters and special artists with psychotic performances that practically cried out for the blunt tool of caricature and exaggeration. In the light of the traditional uses of physiognomic codes in depicting insanity, the representation of Guiteau may have served as a watershed and triggered a return to the device.[58]

Garfield's tortured road to death provided its own new somatic representations. As it had done in earlier engravings of behind-the-scenes maneuverings of the leaders of the body politic, *Leslie's* now revealed the (deteriorating) political body itself, despite efforts by the White House to curb such views. The cuts were extremely graphic in depicting Garfield's physical deterioration over the two months that followed his shooting, marking a decisive departure from official portraiture that presaged the invasion of privacy usually ascribed to the practice of photojournalism at the turn of the century. The degree of disclosure peaked when *Leslie's* published views of Garfield's embalming and autopsy (figure 6.11).[59]

But it was the bombing in Chicago's Haymarket Square on May 4, 1886, during a rally protesting police violence against anarchist-led strikers for an eight-hour day that legitimated and furthered the practice of pictorial social typing and, in the long run, reinvigorated former narrative conventions for depicting the poor, immigrants, and labor. In the immediate aftermath of the bloody incident (one policeman died in the blast and one demonstrator was killed in the ensuing police gunfire, which also wounded many more in the crowd, including officers) *Leslie's* portrayal of police raids and anarchist arrests highlighted hirsute, foreign physiognomies.[60] A May 22, 1886, engraving showing the capture of "leading anarchists at one of their dens" featured the "Bohemian vagabond" Dejnik, "who was dragged terror-stricken from his bed, to-

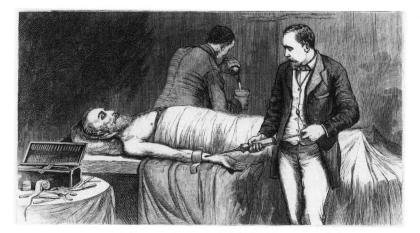

Figure 6.11. "The death of President Garfield.—Incidents at Elberon and on the route of the funeral train.—Embalming the body of the deceased, on the morning of September 20th." Wood engraving. *Frank Leslie's Illustrated Newspaper,* October 8, 1881, 85. Prints and Photographs Division, Library of Congress.

gether with two or three other shaggy conspirators." Dejnik's alien quality—his "shaggy" head, his face showing animal-like terror—was underscored by the "immoral" nature of his sleeping arrangements. Neither the picture nor its accompanying description noted that the location was in fact Dejnik's—actually Vaclav Djemek's—home, or mentioned the appearance of his reportedly frightened wife and children.[61] While *Leslie's* refrained from covering the trial of the accused Haymarket conspirators, it effectively imbued foreign physiognomies with criminal meanings in a July cover engraving (figure 6.12).[62] Titled "The anarchist trials at Chicago," the illustration of a criminal forced to pose for a rogues' gallery portrait maintained the negative view of anarchists that would have been belied by a rendering of the accused conspirators' dignified demeanor in the courtroom.[63]

 With such an archive depicting the depredations of foreign ideas and acts, *Leslie's* still sought some solace from among the ranks of the poor. "In the midst of labor agitation," began a July 1886 editorial titled "The Patience of the Poor,"

> though we are constantly reminded that Anarchists and Union men and Knights of Labor, and all the other noisy ones combined, do not number a tithe of the laboring population, we are still likely to overlook the fact that thousands of poor people are even now quietly standing in their lot, and enduring the limitations as well as the toils appointed them, with a pa-

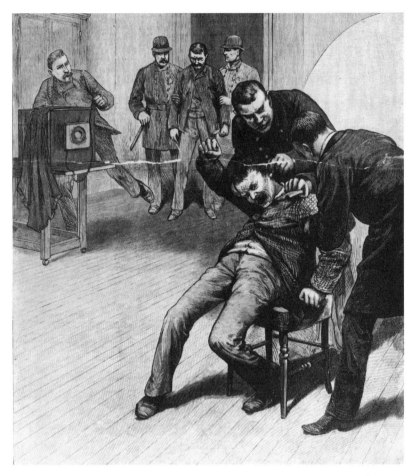

Figure 6.12. "Illinois.—The anarchist trials at Chicago—A scene at police headquarters—Photographing criminals." Wood engraving based on a sketch by Charles Upham, *Frank Leslie's Illustrated Newspaper*, July 31, 1886, cover (369). American Social History Project, New York.

tience that is little less than sublime. They have no philosophy to sustain them, little religion, no large views of the retributions that time brings round, and the ultimate triumph of right. They simply endure ill, as they have always endured it, "as a plain fact whose right or wrong they question not."

Significantly, *Leslie's* did not view acquiescence as legitimating the status quo. There was no status quo to maintain: "This is a time of overturning," the editorial concluded, "whether we will have it so or not,

and of a readjustment of the relations of class and class. A social change no less fundamental than that which did away with the feudal system is imminent." In *Leslie's* view, the "patience of the poor" was only temporary; "the rich should meet the problems of our time" before it was too late.[64]

In the wake of the Great Upheaval, the Haymarket bombing, and Henry George's surprisingly strong insurgent New York mayoral campaign, an ominous aura seemed to hover over *Leslie's* pictures and text. An 1886–87 series of illustrated articles, "Coast and Harbor Defense," emphasized "the defenselessness of our condition, and the provision which must be made to secure proper protection to New York and the Atlantic Coast."[65] But the most serious evidence of invasion *Leslie's* offered its readers was an 1888 series of engravings on "Italian immigration and its evils." Whereas the Germans and eastern Europeans pictured as making up the ranks of anarchists threatened to destabilize American society with their foreign beliefs,[66] other nationalities, particularly Italians, represented a larger infusion of wretchedly poor immigrants incapable of or resistant to assimilation. A July 1888 engraving showing a "summer-night scene in an alley of the Italian quarter, New York City" did not offer the previously commended trait of patience; instead, the scene of men, women, and children fitfully sleeping through the heat demonstrated "that the *padrone* system of traffic in wholesale Italian immigration has transferred to this city the horrors usually associated with the most squalid districts of swarming Naples."[67] The types swarming through "Mulberry Bend" were people who "have no desire to become citizens or to increase in knowledge and civilization. They seek only to gain a sufficiency to return." The personification (and progenitor) of such perversity in these scenes was the "tawny" padrone, "propped against lamp-posts, . . . keeping [an] eye upon the bands of newly arrived servitors"[68]—an Italian version of the political tough. Such engravings and commentary escalated over the course of 1888, in tandem with investigative hearings held by a congressional subcommittee. By the beginning of the new year *Leslie's* graphics and editorials had resolutely, if unspecifically, veered toward restricting immigration.[69] However, forever cognizant of its varied audience, the paper endeavored to balance its pictures of "immigration evil" with cuts of "worthy" immigrants, as if attempting to reassure some readers that *of course,* we were not talking about *you.*[70]

Among its ranks of worthy immigrants, *Leslie's* reserved a special place for the Chinese. Before the 1880s, the paper's most extensive con-

sideration of Chinese immigrants consisted of two series of engravings illustrating San Francisco's Chinatown. While Joseph Becker's spring and summer 1870 engravings titled "The Coming Man" were more crudely rendered than Harry Ogden and Walter Yeager's 1878–79 illustrations —the latter part of the weekly's coverage of the Leslies' 1877 transcontinental excursion—both series mixed representations of exotic pastimes and customs with an emphasis on the new immigrants' industriousness.[71] By the early 1880s, Leslie's portrayal of Chinese life and labor in the West was framed by narratives of exclusion and persecution. Although the weekly had noted that Chinese immigrants were being recruited as strikebreakers during the 1870s, it refrained from any illustrations of Chinese as a disruptive force in American class relations. Engravings of anti-Chinese agitation and violence invariably showed the immigrants as blameless victims of nativist thugs (see figure 6.2): "[W]hen an army of ruffianly hoodlums," Leslie's commented in May 1882, "undertake to drive out 75,000 peaceful people for no crime save that of working hard and saving money, a stern public sentiment ought to prevent it in the name of our national honor."[72]

Its sympathy toward the persecuted Chinese notwithstanding, Leslie's did publish images suggesting that, like Italians and eastern European Jews, the new Asian arrivals also bore dangerous baggage (figure 6.13). During the early 1880s, pictorial coverage swerved to Chinese settlement in New York City (in Leslie's view a result of their persecution in the West). More discomfiting proximity prompted more negative portrayals, featuring cluttered gambling rooms and murky opium dens (housing addicted white working women).[73] Although these cuts trafficked in the sort of sexual and criminal narratives favored by advocates of exclusion, the vast majority of Leslie's engravings celebrated the addition of new institutions and events to New York life (figure 6.14). Unlike its delineation of other new immigrants, here the weekly attempted to distinguish between the industrious majority of Chinese and an easily avoidable minority. "The Chinese maintain law and order among themselves with little or no outside interference," Leslie's commented in 1888, "and nothing is rarer than the sight of a Mongolian convict in jail or prison. . . . The really bad Chinese, who fight, levy blackmail, and lure white girls into 'opium joints,' mostly inhabit the neighborhood of Pell Street, between Mott Street and the Bowery. Whether or not they are as black as they are painted, they certainly contrive to practice their villainies without disturbing the public peace."[74]

The paper's pictorial representation of the Chinese tended toward

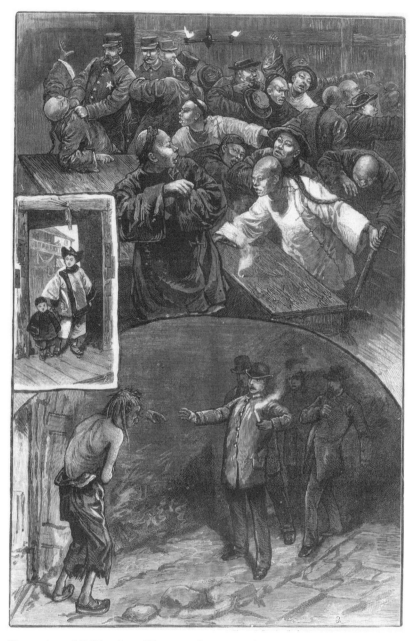

Figure 6.13. "California.—The crusade against the Chinese in San Francisco.
—1. A police raid on a gambling den. 2. Chinese lady and child. 3. An en-
counter with a leper." Wood engraving based on sketches by George F. Kelly,
Frank Leslie's Illustrated Newspaper, March 18, 1882, 53. American Social
History Project, New York.

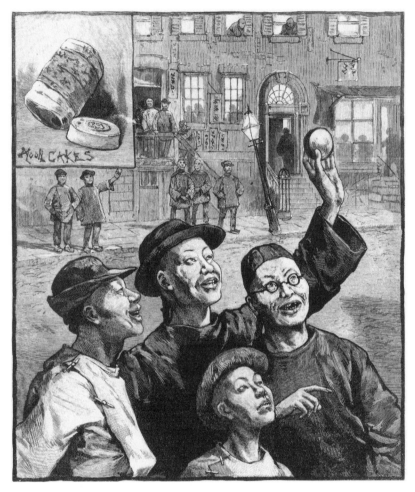

Figure 6.14. "New York City.—Celebrating the Chinese Moon Festival in Mott Street—Waiting for a glimpse of the moon." Wood engraving, *Frank Leslie's Illustrated Newspaper,* October 11, 1884, cover (113). Prints and Photographs Division, Library of Congress.

one, for the most part male, physiognomic type. Yet although, for all intents and purposes, the Chinese in engravings were interchangeable, *Leslie's* took the opportunity to publicize, on a number of occasions, one particular individual and newly founded institution. The February 17, 1883, issue reproduced a reduced-size facsimile of the front page of the premier edition of the *Chinese American,* "the first Chinese newspaper published in New York." "Such an enterprise," *Leslie's* noted, "will sur-

prise many people who have always been accustomed to regard the Chinese as illiterate barbarians, and it certainly shows a degree of advancement which is exceedingly creditable to them." In subsequent years, the *Chinese American*'s editor, Wong Ching Foo (Huang Qingfu), appeared in *Leslie's* pages, both as the subject of favorable commentary and as a contributing writer.[75]

* * *

Haymarket's impact on *Leslie's* representation of labor was more complicated, at times involving nuances that might have been discernible only to longtime readers. By 1888 the paper's editorial stance was unmistakable, and unprecedented, in its hostility to the labor movement. Engravings displayed the interconnection of foreignness, criminality, and the labor movement, and yet the illustrations' pictorial strategy tempered the messages conveyed in *Leslie's* text. While physiognomic codes returned, particularly in those images portraying violent events, many pictures retained their multi-accentuality; others turned to older prescriptive or proscriptive narratives, though now divested of the signs that had previously accompanied them.

During the latter half of 1886—in the midst of the Great Upheaval, roiling "red" hysteria engendered by Haymarket, and an insurgent New York mayoral campaign—*Leslie's* vituperation remained largely confined to its text.[76] An October 30 engraving of a Henry George rally was practically a study of multi-accentuality, highlighting the demonstration's energetic atmosphere by submerging its participants in an almost expressionistic swirl of torchlight.[77] Two weeks earlier, *Leslie's* respectfully documented the racially integrated proceedings of the Knights of Labor convention in Richmond, Virginia.[78]

But within one year, *Frank Leslie's* visual coverage of labor changed markedly. By the beginning of 1888, Haymarket and an employer counteroffensive had drained labor's organizational strength. In addition, the labor movement itself was split between the Knights of Labor's broad-based coalition of producers and the narrower craft orientation of beleaguered national unions of skilled workers (with *Leslie's* editorial sympathies drawn to the more conservative goals of the latter). As usual, engravings of conflict in the coalfields heralded the change in pictorial treatment. During the 1887 strike in the Lehigh region of Pennsylvania, *Leslie's* had presented its readers with a largely sympathetic depiction of the hardship experienced by miners, balancing the life and the labor of

Hungarian and Irish mining families with those of their Polish and Italian replacements.[79] By the time violence broke out between Polish and Hungarian strikers and strikebreakers during the Knights of Labor's 1888 strike against the Reading Railroad, engravings showed mob action that equated the immigrant worker with disorder. Responsibility now fell squarely on the shoulders of the striking anthracite miners. "As to this whole matter, one consideration rises above all others," *Leslie's* asserted in an editorial accompanying a February engraving showing a violent confrontation between striking Polish miners and the coal and iron police. "No man has any right to prevent another from working for any wages which he sees fit to accept. If the riotous Poles and Hungarians in the coal regions have not learned that this is a country of law and liberty, not of anarchy and Molly-Maguireism, they must be taught the lesson, if need be by bullets."[80]

We should not confuse the views of the publisher with his or her publication's pictorial expression, a more complex matter. But the turn in *Frank Leslie's* rhetoric, if not in its visual representation, appears to have mirrored its owner's turn of phrase. "Strikes must be suppressed by law," Miriam Leslie announced to Chicago reporters during a national lecture tour conducted shortly after she sold the publication in 1889. "Think of the discomforts endured by people of the better class who wished to travel during the New York Central strike!" Then, referring to the Haymarket conspirators, Mrs. Leslie commented, "Worthless discontented foreigners . . . sow the seeds of anarchy, and discontentment must be suppressed. Shoot them down like dogs."[81]

The charge laid down in *Frank Leslie's* editorials and Mrs. Frank Leslie's speeches failed to ignite in many of the paper's illustrations. Readers may have absorbed the message of the engravings of mining more from their "performance" than from the representation of those depicted. The engravings conveyed stories that dedicated readers could easily recall. Joseph Becker's September 1888 engraving, "A scene in the mining regions" (figure 6.15), showed "what is still too often to be seen on . . . pay-day in the Schuylkill region. The temptations of the saloon have proved too strong for the tired-out miner, and he has drunk himself stupid and sullen before consenting to go home. His poor wife, thankful that things are not even worse, trudges behind him uncomplainingly, bearing the entire burden of the marketing."[82]

Becker's illustration was rendered in the textures and techniques of the New School of wood engraving, but its narrative—one in which he had indulged during the 1870s—was familiar. Subtitled "Her lord

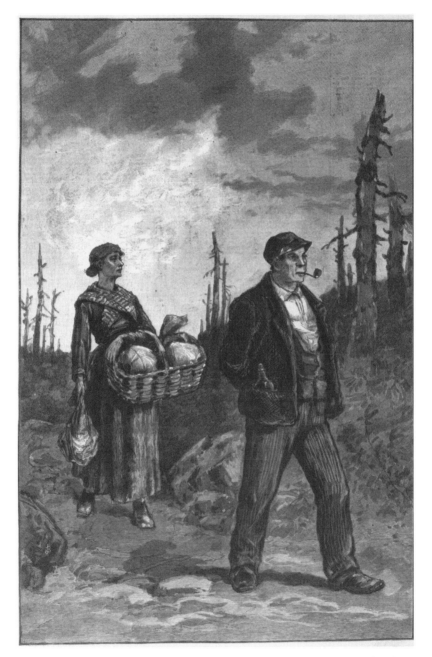

Figure 6.15. "Pennsylvania.—A scene in the mining regions—Her lord and master." Wood engraving based on a sketch by Joseph Becker, *Frank Leslie's Illustrated Newspaper*, September 22, 1888, 89. American Social History Project, New York.

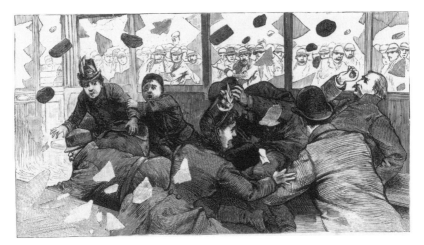

Figure 6.16. "Massachusetts.—Incidents of the street-car troubles in South
Boston and Cambridge.—1. Passengers escaping from a bombarded car."
Wood engraving, *Frank Leslie's Illustrated Newspaper,* March 5, 1887, 40.
Prints and Photographs Division, Library of Congress.

and master," the cut in part indicated the publication's turn to feminist
themes under Mrs. Leslie's aegis. Its depiction of the immigrant worker
also demonstrated a decisive return to the typing of the past. However,
in this and many other instances, physiognomy remained understated.
Indeed, such forbearance may have been a necessity, as the accompany-
ing text took great pains to suggest:

> The scene depicted in the drawing on page 89 is taken from life in the min-
> ing regions of Pennsylvania, though it might at a casual glance be thought
> to represent a study of peasant life in those parts of continental Europe
> where the women serve as beasts of burden. In common fairness, however,
> to the great intelligent, orderly and progressive class of Pennsylvania miners
> in general, it must be said that in this case the artist has chosen his charac-
> ters from amongst the newly settled foreign element which predominates
> in many of the mining districts.[83]

In this instance, at least, the use of pictorial social typing would have
confused *Leslie's* necessary distinction between subjects not included in
its audience and members of that audience, which contained a wide va-
riety of readers.

Streetcar strikes offered *Leslie's* one subject for which pictorial social
typing was less problematic. Unlike other conflicts between labor and
capital, the many streetcar strikes in New York and other major cities

convincingly involved "the public" as a third entity. The "public inter-est" was often rhetorically presented as the blameless victim of industrial disputes in *Leslie's* editorials during the 1880s. Militant streetcar strikes from 1886 onward provided scenes in which passengers could physi-cally embody what had been an abstract role (figure 6.16). In an engrav-ing of the 1887 Boston streetcar strike, the framing had changed: cow-ering under an onslaught of strikers' stones and bricks, the public was presented as the undeserving target of labor militants' violence.

In the new formulation, strikers necessarily took on the now demon-ized foreign physiognomies. An October 1888 cut about the Chicago transit strike neatly merged anarchism and labor in what may have seemed to older readers a reversion to the past (figure 6.17): in compo-sition and treatment, little differentiated this 1888 engraving from *Les-lie's* version of the Tompkins Square Riot fourteen years earlier (see fig-ure 5.16, above). While the use of pictorial social typing to illustrate a Chicago subject was not too surprising, given the city's infamous radi-cal labor politics, similar treatment was applied to the pictorial cover-age of other streetcar strikes.[84]

Even as illustrations of labor conflict registered a return to older pic-torial and narrative conventions, other engravings of strikes continued to support a range of interpretations. An April 1888 cut showing Chi-cago strikers and sympathizers attacking scab switchmen and brakemen during the Chicago, Burlington, and Quincy Railroad strike kept its por-trayal of violence ambiguous by carefully positioning the protagonists.[85] Even so, after Haymarket, as a weakened labor movement battled ag-gressive countermeasures and fractured internally into warring factions defined by skill, ethnicity, and race, images depicting more staid worker events such as processions veered away from multi-accentuality. The change was, at times, expressed in subtle perspectives and emphases: at face value, a June 1887 cover engraving showing a labor demonstration called in honor of the visiting *United Ireland* editor and Parnellite Wil-liam O'Brien respectfully recorded a massive and peaceful march (fig-ure 6.18). However, this engraving's perspective, from a sheltered bal-cony, rendered the marchers' banners and signs indecipherable; the distant participants were positioned away from the viewer, receding into the darkness.[86] While the engraving that recorded the annual La-bor Day parade later in 1887 was not quite as "detached"—the march-ers' placards were readable—the 1888 coverage of Labor Day situated the procession within a new frame. Divided into five panels, the illus-

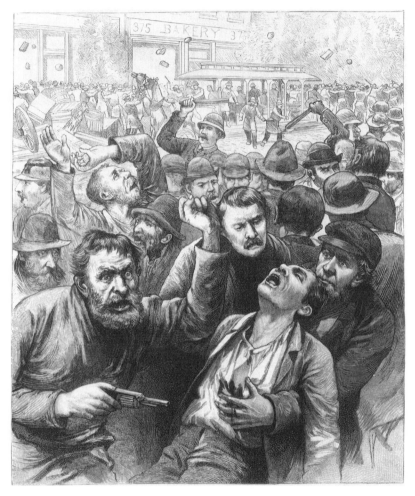

Figure 6.17. "Illinois.—The street-railway troubles in Chicago—The police
charging a mob of striker[s] and 'hoodlums' on Centre Street, North Side."
Wood engraving based on a sketch by Will E. Chapin, *Frank Leslie's Illus-
trated Newspaper,* October 20, 1888, 160. Prints and Photographs Division,
Library of Congress.

tration featured a portly "Brewer" wearing a floral bonnet, wrestling
firemen, a massive bread float carried by bakers, and a less festive pret-
zel vendor. *Leslie's* duly recognized Labor Day, now a legal New York
holiday, in its 1888 engraving while at the same time trivializing the
occasion.[87]

The next year, however, after its sale to the Republican-affiliated Judge
Publishing Company, *Frank Leslie's Illustrated Newspaper* refrained

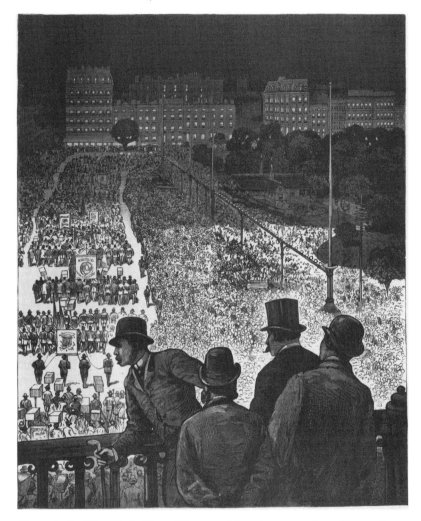

Figure 6.18. "New York City.—The great labor demonstration of June 4th—
The procession, headed by the Sixty-ninth Regiment, passing the reviewing
stand, Union Square plaza." Wood engraving, *Frank Leslie's Illustrated News-
paper,* June 11, 1887, cover (265). American Social History Project, New York.

from covering the Labor Day procession at all. Instead, it published an
editorial that questioned the "utility" of the holiday "from a practical
point of view." According to the weekly, the majority of New York work-
ers had not wanted Labor Day as a legal holiday. "Political influence
forces industrious workingmen to 'take a day' whether they care for it
or not. It does not permit them to make their own choice of holidays.

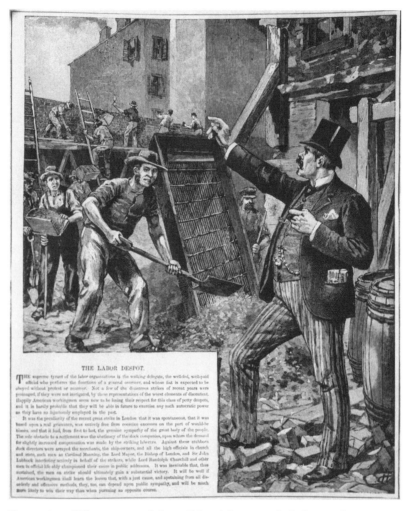

Figure 6.19. "The tyranny of the walking delegate.—Ordering workmen to 'go on strike.'" Wood engraving based on a sketch by J. Durkin, *Frank Leslie's Illustrated Newspaper*, September 21, 1889, cover (101). American Social History Project, New York.

We doubt if American workingmen like this sort of thing, or whether they will long submit to it."[88] As if to seal the argument, the cover of this September 21, 1889, issue of the "new" *Frank Leslie's* presented an engraving titled "The tyranny of the walking delegate" (figure 6.19). The cut showed a trade union official ordering construction workers to abandon a work site. In his carefully detailed appearance—his ornate

dress, dangling watch fob, smoldering cigar, broad girth, and heavy features—the trade unionist was, for all intents and purposes, a political boss. In the pictorial vocabulary adopted by the now Republican *Frank Leslie's,* organized labor had become nothing more than a working-class Tammany Hall.[89]

AFRICAN AMERICANS: STATUS QUO AND STRUGGLE

"It is well to look before leaping in the matter of celebrating historical events, and the Massachusetts Legislature, which was not well up in its history, has just received a lesson." This reproof, delivered in a June 1887 editorial comment, was triggered by an unremarkable incident: the vote by the Massachusetts legislature to erect a monument honoring Crispus Attucks and the other martyrs of the Boston Massacre. Constructing monuments was de rigueur in Gilded Age America, but in the wake of Haymarket some people and events were deemed undeserving of commemoration. "[T]hese men were rioters," *Leslie's* warned, "who got into a squabble with the soldiers, without any patriotic purpose, and their disorderly conduct has really no historical significance." Honoring an event of such dubious merit was "certain to destroy perspective, and make street brawlers and nobodies apparently as important figures as leaders of thought or action."[90] These vociferous editorial objections, however, proved to be momentary. Four months later, *Frank Leslie's* published an engraving showing the prospective monument to the "slaughtered patriots." "The much-needed and long-talked-of memorial of the Boston massacre of March 5th, 1770—the Crispus Attucks Monument, as it is generally called—is about to be put up in that city," ran the description. "The design is original and dramatic, embodying in a clear and striking manner, in inscription, statue and bass-relief [*sic*], the event, its place and date, the names of the victims, and above all, the idea for which they fell—America's call for liberty."[91]

Such blatant inconsistency regarding one monument could reflect mere editorial incompetence or sloppiness. But in light of *Leslie's* record, this example probably represents yet one more instance of the weekly's continual attempt to embody the diverse views of its range of readers. The publication's response to a historical event involving an African American also is instructive if we wish to evaluate its depictions of black citizens during the 1880s. With the collapse of Reconstruction, *Leslie's,* along with *Harper's Weekly* and the illustrated press in general, endeav-

ored to portray a "normalized" view of the "redeemed" South, in which African Americans were allotted their own unique place. For the most part, this representation ignored expanding social and political inequality to emphasize a nostalgic status quo, with African Americans assuming roles from a limited repertoire of familiar "darkey" types. In most cuts, African Americans appeared not as subjects but as identifying marks that defined a regional landscape.[92] Yet throughout the decade, *Leslie's* series of predictable, for the most part "amusing," performances was occasionally disrupted by news events that provoked figures into declaring a more self-conscious citizenship. While some of the engravings could be construed as proposing another aspect of the status quo—the achievement of an unfettered, unproblematic equality—others served as a reminder of the embattled state of African Americans during the 1880s.

Frank Leslie's testified to the "new South" in engravings that featured bustling entrepôt cities, languid rural settlements, expansive agricultural pursuits, and nascent but energetic industries. In such scenes, African Americans most often appeared as figures that characterized a particular locale. Mrs. Leslie's tour of the new South during spring 1883 produced cuts and commentaries that dwelled on the black contribution to the peculiar attractions of southern society. "The South, indeed, is full of revelations to the stranger tourist," ran one description accompanying a page of North Carolina, Florida, and Georgia views, including a picture showing black "light wood merchants" in a Savannah street. "The Ethiopian has a proneness for the picturesque, and the unstudied attitudes of the young merchants who peddle firewood through the streets of that populous city are sure to catch the eye of the visitor."[93]

While buffoonish "character studies" relied on harsh physiognomic codes, such darkey visual typification was applied more haphazardly in other cuts.[94] Whether rendered in overtly racist or more multi-accentual lines, African Americans were for the most part represented in *Frank Leslie's* by a limited range of types whose energy or indolence was founded on their putative innate, childlike qualities. Nowhere was this approach more evident than in the portrayal of black politics. While *Leslie's* editorials occasionally debated charges of racist intimidation and violence in southern campaigns, its illustrations emphasized African Americans' political participation as but one more feature in their panoply of colorful pastimes—nothing more than another opportunity to flaunt, flirt, and wear outlandish costumes.[95]

Despite *Leslie's* efforts to pictorially normalize southern race relations, actions taken by African Americans occasionally forced the weekly to

reorient the conventions and categories of representation.[96] In the beginning of April 1879, *Leslie's* took note of the ongoing migration of tens of thousands of blacks from the lower Mississippi Valley to Kansas. Editorials expressed surprise at the Exodusters' numbers and determination to leave, which in the paper's view contradicted the race's characteristic tie to the land. While deploring the effects of the migration on the southern economy, *Leslie's* felt obliged to acknowledge this "hegira" as evidence of the injustice and intimidation accompanying renewed Democratic control in the region. Although many of the Exodusters were said to be in desperate straits, when *Leslie's* published engravings in its April 19, 1879, issue showing the arrival of migrants in St. Louis, one panoramic cut depicted an orderly procession of homesteaders instead of the chaos of fleeing refugees (figure 6.20). Editorials may have registered skepticism about the practicality of the Exodusters' quest, given the limited opportunities then available in Kansas, but other illustrations portrayed refugees bathed in the solace and support provided by local black organizations in St. Louis.[97]

Three weeks later, *Leslie's* continued its coverage of the Exodusters in a full-page engraving, "A family of Negroes who do not favor the exodus" (figure 6.21): "Here we have a portion of a well-to-do colored family in Virginia," the weekly commented, "whose thrift, or 'good luck,' has enabled them to maintain themselves in comfort, and who, in consequence, find no occasion in their surroundings for joining in the general exodus." In contrast to the engravings of the flight to Kansas, this May 10 cut recorded one family returning home from "a shopping tour" in the town of New Market. "Contentment beams from the old folks, and positive happiness from the son and heir. Perhaps, too, there is a shade of a feeling of superiority to the average run of the Virginia negroes, such as might be justly borne by a landed proprietor of the interior, and something also of the assumptions of aristocracy. There can be no doubt," concluded the text, "but that they are far better off than those of their race now curled up for shelter beneath the platform of the railroad depot at Wyandotte."[98]

Rather than celebrating normalization and prosperity, however, the May 10 cut could be viewed as countering the previously published Exoduster illustrations. The contrast rises most starkly when the Virginia family and the group located at the head of the St. Louis procession are juxtaposed. The modest dress and calm demeanor of the latter only highlight the Virginians' travesty of gentility. In that respect, the Virginia family was reduced to the standard buffoonery of southern black types

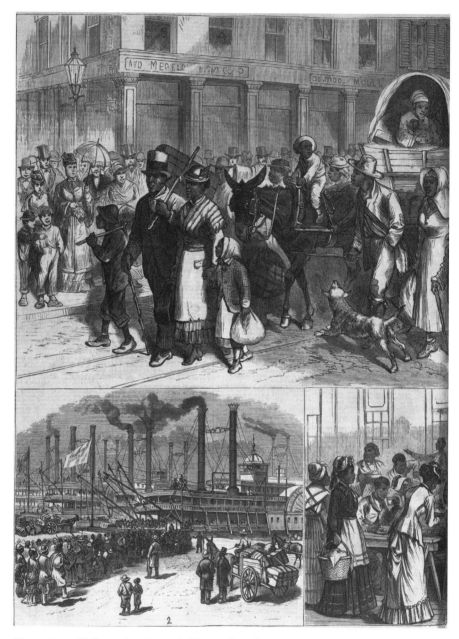

Figure 6.20. "Missouri.—Remarkable exodus of Ne-
groes from Louisiana and Mississippi—Incidents of the
arrival, support and departure of the refugees at St. Louis.
1. Procession of refugees from the steamboat landing
to the colored churches. 2. Embarkation for Kansas.

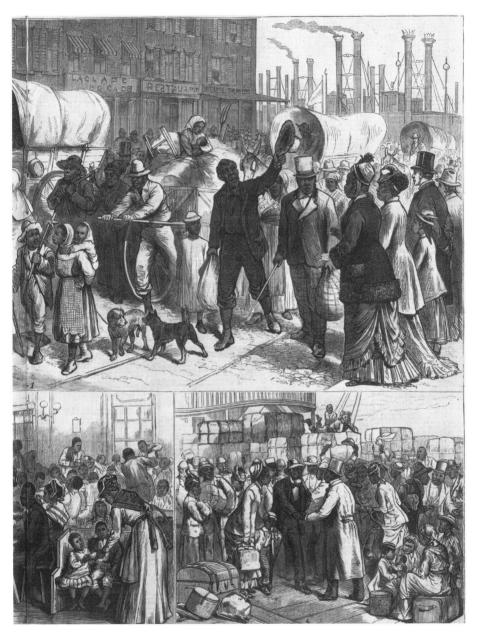

3. Feeding the refugees at one of the colored churches.
4. St. Louis colored citizens welcoming the emigrants
upon their arrival." Four wood engravings, *Frank Leslie's Illustrated Newspaper,* April 19, 1879, 104–5.
American Social History Project, New York.

Figure 6.21. "Virginia.—A family of Negroes who do not favor the exodus, returning from a purchasing trip to New Market." Wood engraving based on a sketch by Joseph Becker, *Frank Leslie's Illustrated Newspaper,* May 10, 1879, 153. Prints and Photographs Division, Library of Congress.

aspiring to rise above their appointed station. But in its comparison, *Leslie's* was also demarcating a new visual distinction between African Americans: in showing the desperation of the Exodusters, the cut of the migrants also emphasized the ambition and dignity of those who left, as opposed to the "characteristic" complacence of those who stayed.[99]

The Exodusters, in *Leslie's* pictorial typification, were exceptions to the southern African American rule. However, examples of leadership and achievement among black Americans continued to appear in the paper throughout the 1880s, proclaiming the orderly "progress" of the race as well as the tranquility of the region.[100] Included among such figures was at least one corresponding special artist. The May 26, 1883, issue presented a page composed of nine views of an archaeological survey of Indian mounds conducted in southeastern Arkansas by Edward Palmer of the Smithsonian Institution's Bureau of Ethnology. Featured among the mound cuts was one engraving depicting Palmer and a black man sorting through the relics. "The sketches which we present," noted *Leslie's,* "were made by the Professor's assistant, H. J. Lewis, a remarkably bright colored man, thirty years old, who was born a slave in Mississippi, and never had a day's schooling in his life, but has educated

himself, and without any instruction has developed very promising abil-ity as an artist."[101] Although he had not previously portrayed himself in a drawing, Henry Jackson Lewis had already contributed sketches to the illustrated weeklies from Pine Bluff, Arkansas, where he moved in 1872 to work as a laborer and artist. Aside from the May 26 page of engrav-ings, *Leslie's* published six other cuts based on Lewis's sketches during 1883, most depicting the effects of floods in the Lower Mississippi. Five years later, Lewis moved to Indianapolis, where he became staff artist and political cartoonist of *The Freeman* ("the *Harper's Weekly* of the Col-ored Race"). He died in Indianapolis in 1891.[102]

Many of *Leslie's* 1880s engravings presented African Americans as-suming equal status in the nation's society and politics without articulat-ing the significance of that change in the textual descriptions. Engravings of Republican Party conventions included black participants (along with the increasingly ubiquitous presence of women); black jurors and United States Marshals appeared in numerous cuts depicting the aftermath of Garfield's assassination.[103] Among such pictures, *Leslie's* occasionally published images—such as a May 1880 cut showing an investigation into a West Point hazing "outrage" against a black cadet—suggesting that the positions attained by African Americans had not been won with-out struggle.[104]

In contrast to the pictures of the previous decade, the most unusual indication of African Americans' "progress" during the 1880s appeared in the few engravings showing black participation in the labor movement. A February 1882 illustration presented a scene outside of the Midlothian coal mine in Chesterfield City, Virginia, shortly after an underground explosion (figure 6.22). The illustration was distinctive in its delinea-tion of shared catastrophe: black and white families intermingled in the crowd gathered at the mine entrance as an integrated rescue party, over-come by gas, was carried from the shaft cage.[105] Four years later, *Leslie's* covered the tenth annual meeting of the Knights of Labor in Richmond, Virginia, with a front-page picture showing Frank J. Ferrell, an African American delegate from New York City District Assembly 49, introduc-ing Grand Master Workman Terence Powderly to the General Assembly. In the wake of racial tensions provoked by the New York District As-sembly's insistence on equal access for its black delegate to services and institutions in segregated Richmond, *Frank Leslie's,* along with Pow-derly, took pains to assure agitated southern whites that the Order had "no purpose to interfere with or disrupt the social relations which may exist between the different races in the various parts of the country."

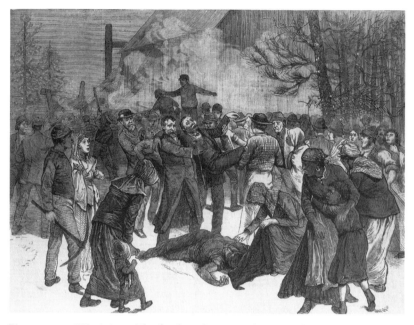

Figure 6.22. "Virginia.—The fatal explosion at the Midlothian coal mine, February 3d—Carrying from the shaft-cage a rescue party overcome by gas." Wood engraving based on a sketch by F. C. Burroughs, *Frank Leslie's Illustrated Newspaper,* February 18, 1882, 445. American Social History Project, New York.

Nevertheless, *Leslie's* October 16, 1886, cuts of the convention chose to mark the Knights' refusal to allow the imposition of the "color line" in its own proceedings and celebrated its commitment to the principle of "civil and political equality of all men" that "in the broad field of labor recognizes no distinction on account of color." [106] In both the Midlothian disaster and Richmond convention engravings, *Leslie's* offered its readers representations of equality that were framed in narratives that also testified to the costs attending black aspirations and the continuing obstacles to those goals.

Thus, *Leslie's* treatment of African Americans during the decade of the 1880s encompassed multiple viewpoints, albeit with a decided tilt toward racist typification in depicting southern scenes. In its own inimitable way, the weekly managed to entertain often wholly contradictory representations, sometimes literally next to one another. The five engravings based on sketches by Joseph Becker that composed "An artist's notes of a subtropical railway journey" of February 23, 1889, included

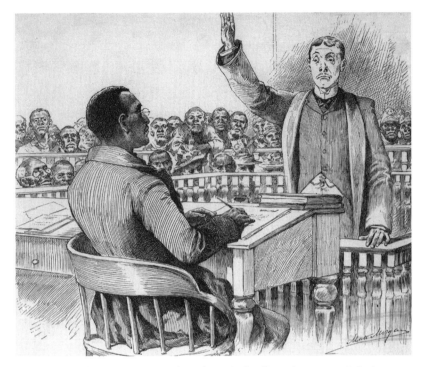

Figure 6.23. "An artist's notes of a subtropical railway journey.—A Jacksonville (Fla.) police court—The Negro justice reproves a disorderly white brother, and dismisses him with a fine." Detail of wood engraving based on a sketch by Joseph Becker (Matthew Somerville Morgan, Del.), *Frank Leslie's Illustrated Newspaper,* February 23, 1889, 28–29. American Social History Project, New York.

one picture showing white passengers perched on the "observation platform of a vestibule train" being entertained by a "bottle band" of black urchins, with a collection of darkey types ranged in the background.[107] Directly beneath this cut, another engraving presented a dignified "Negro justice" presiding over a "Jacksonville (Fla.) police court," passing sentence on "a disorderly white brother" (figure 6.23). And even amid the illustrations that sought to depict a southern landscape peopled by docile African American types, some images proposed more than one normalized interpretation. The text accompanying the December 1887 engraving titled "A day's work ended" waxed rhapsodic about the "picturesque" study of "Alabama negroes, with their shining ebon faces, broad smiles, and wooly heads" (figure 6.24). The scene, according to *Leslie's,* was reminiscent of "Jules Breton's or Millet's studies of toil,

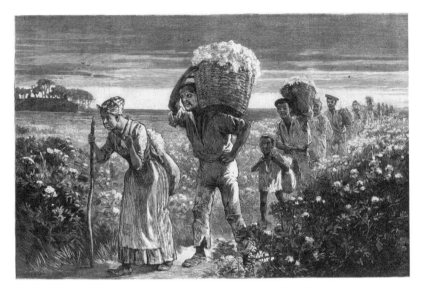

Figure 6.24. "A day's work ended." Wood engraving based on a sketch by
Matthew Somerville Morgan, *Frank Leslie's Illustrated Newspaper,* Decem-
ber 31, 1887, 333. Prints and Photographs Division, Library of Congress.

the 'homely joys and destiny obscure,' of the French peasants." Having
gathered "fleecy store of the luxuriant cotton-field all day beneath the
brilliant sun," the laborers now "wend their way cheerily homewards,
in single file, by the narrow, poppy-bordered path that winds to their
clustered cabins." But to many readers (including, one assumes, those
with a less nostalgic interpretation of Millet's work), the engraving's
narrative did not so much celebrate the homely joys of rural southern
black laborers as delineate the exhaustion of field work performed un-
der the brilliant sun.[108]

"WOMAN'S EXPANDING SPHERE"

The engravings showing the proceedings of the October 1886 Knights
of Labor General Assembly were particularly vivid depictions of an in-
terracial labor organization established on the principle of equality. It is
therefore striking that although the description remarked on "the good
number of women" who attended the convention as delegates, the pic-
tures themselves conveyed an overwhelmingly male presence.[109] It is dif-
ficult to account for the absence of women here, for, in fact, *Leslie's* cov-
erage of the "woman's sphere" (as it was so often termed in captions and

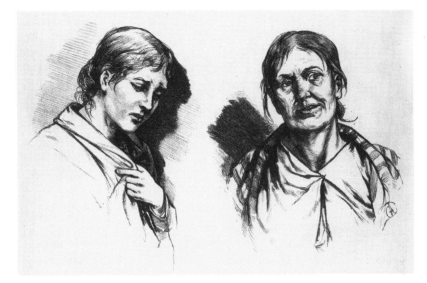

Figure 6.25. "Sketches of life and character in a New York police-court. Her first Offense. An old Offender." Wood engraving based on a sketch by Georgina A. Davis, *Frank Leslie's Illustrated Newspaper*, August 2, 1884, 373. American Social History Project, New York.

editorials) perceptibly expanded during the 1880s to include previously unacknowledged activities and organizations. While one should always hesitate to dub any era "transitional," *Leslie's* 1880s engravings both continued existing conventions and narratives about women's appropriate role in American society and profoundly altered and enlarged the repertoire of women's represented behavior and expression.

To be sure, *Leslie's* categorization of women continued to foster invidious comparisons between idealized and degraded types.[110] The distinction was most forcefully posed in illustrations of poverty that articulated an argument about its sinister moral impact on women by juxtaposing physiognomic "character sketches" (figure 6.25). "Our illustration depicting two types of character in a city police-court tells its own story," began the description that accompanied two August 1884 portraits labeled respectively "Her first Offense" and "An old Offender."

> The contrast could scarcely be sharper than that between the poor unfortunate arraigned for her first offense and the old and hardened offender for whom vice has charms which virtue never offered. In the one case, shame, perplexity and remorse; in the other, callous indifference and contemptuous defiance of all wholesome restraints. For the one, there is still hope and the possibility of reclamation; life still has paths of bloom and beauty which the

wayward feet may find and follow; for the other, corrupted to the core, life is in perpetual eclipse and hope has gone for ever.

In closing, *Leslie's* commented that the "scene is one which may well excite the pity of all beholders," but then added grimly, "it has become so common that even this sentiment is sometimes swallowed up in intense disgust." Portraying the vulnerability of poor young women, this engraving and others like it were less successful (not to mention interested) in stimulating sympathy toward their subjects than in tolling once again the oft-sounded alarm about the making of "dangerous classes."[111]

While less sympathetic toward "old offenders," some illustrations showed how the fall into immorality could be reversed, provided it was interrupted early enough. Pictures that showed the transformation of "vicious girls" within the confines of institutions offered the readers hope of reform.[112] Along with other cuts depicting poverty, these engravings also located the source of female vice, placing their "fallen" women in melodrama-derived narratives of victimization at the hands of predatory men.[113] The city remained in such pictures a dangerous terrain for young women: images of female corpses pulled from the river conveyed familiar stories of seduction, abandonment, and suicide, while new hazards were revealed in engravings that depicted murky female figures in the gloom of downtown opium dens. In such pictures *Leslie's* demonstrated its ability to exploit sensation while addressing a middle readership; its representations of female victimization referred to well-known narratives of urban vice, avoiding the cruder titillations of male-oriented pictorial publications like the *National Police Gazette*.[114]

Yet even though *Leslie's* could sometimes mitigate the "unseemly" through implication and moral atmospherics, certain subjects remained beyond the ken of its audience. For example, coverage of the 1878 arrest of Ann Trow Lohman, better known as the notorious abortionist Madame Restell, was diverted to the pages of the publishing house's "barbershop" *New York Illustrated Times* (formerly *The Days' Doings*). Somewhat chastened after its brush with an obscenity indictment in 1873, the paper rendered the event in a benign tableau that relied on its framing story to provide the requisite mix of morality and luridness (figure 6.26). Nonetheless, no matter how unremarkable the representation, no matter how thoroughly mediated by moral proscriptions and cautionary accounts, Madame Restell's story was off limits for *Frank Leslie's* readers, indicating the bounds of sensation for a middle audience.[115]

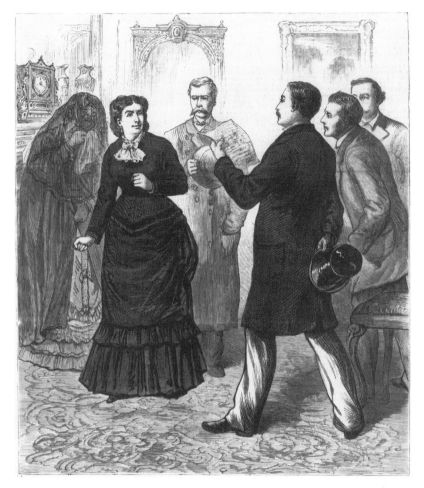

Figure 6.26. "Madame Restell arrested on charges of malpractice." Wood en-
graving, *New York Illustrated Times,* February 23, 1878, cover (305). Prints
and Photographs Division, Library of Congress.

In many of these illustrations of female vice, the victims were denoted
as "working girls," displaying wilting physiognomies that still preserved
the classical features of femininity. Among the haunts of urban victim-
ization illustrated during the 1880s, *Leslie's* presented a new vicious lo-
cation: the workshop. While most images of industrial work tended to
herald technological processes and commercial advances, the November
1888 engraving titled "The female slaves of New York" depicted a dark,
claustrophobic garment "sweatshop." Oppressive working conditions,
bullying supervision, and the concomitant story of exhaustion followed

by insanity or death added a new dimension to the older theme of the lonely seamstress confined to a garret. But the portrayal of working women's victimization was here preoccupied less with recognizing the nature of "sweated" female labor than with providing one more example in *Leslie's* escalating pictorial campaign against "pauper" immigration. The cowering women and her brutish "sweater" employer represented "a condition resulting from over-immigration and over-crowding in the slums of great cities," rather than one of the abuses common in industrial capitalism.[116]

Leslie's attention to victimization prompted other cuts showing efforts to ameliorate the plight of working women. Engravings chronicling the activities of female benevolent associations endorsed the efforts of their upper- and middle-class founders, but they also strove to demonstrate distinctions among working-class women to indicate that not all poor women need take a path toward degradation. "Nursery establishment by Grace (P.E.) Church, for the care of children of workingwomen during business hours," a September 1878 engraving, highlighted a group of rambunctious toddlers in the foreground while their mothers hovered in the background: the women's uniformly robust appearance and neat dress testified that they were "not generally of the pauper class, but poor respectable working-women who, without the help of this nursery, would have to *pay* for having the child looked after at home, or else lose their daily employment."[117] A February 1881 cut of women applying for assistance in the waiting room of the Working Woman's Protective Union, an association established by wealthy women after the draft riots that was intended to help single working-class women find employment and mediate wage disputes, showed a range of unmarried working women whose features and dress, despite their vulnerable positions in the city, no longer projected moral or ethnic traits (figure 6.27).[118] As in other pictures of reform institutions, the women's appearance indicated their deliverance through elite regulation and supervision; at the same time, the delineation of a range of types satisfied those female readers whose own experience fit that of neither paupers nor idle ladies.

Leslie's representation of working-class women was not limited to cautionary scenes of victimization or to reassuring pictures of elite-sponsored reform. In utter contrast to earlier practice, a handful of images depicted working women as active agents in their own deliverance. A February 1885 engraving presented Philadelphia carpet weavers outside a closed factory during a strike. A group of dignified and fashionably dressed strikers patrolled the sidewalk in the foreground, while their

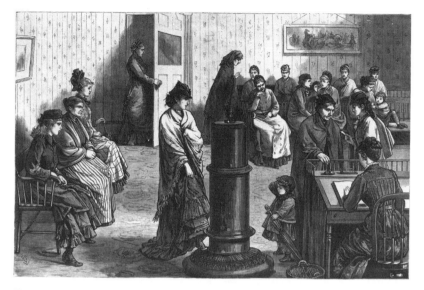

Figure 6.27. "New York City.—The waiting-room in the building of the Workingwoman's Protective Union." Wood engraving based on a sketch by Georgina A. Davis, *Frank Leslie's Illustrated Newspaper,* February 5, 1881, 380. American Social History Project, New York.

"sisters" calmly remonstrated with unidentified women (possibly potential strikebreakers) in the background. This engraving of orderly female activism still relied on a gendered hierarchy of roles, however: while the carpet weavers marched in the streets, an inset revealed a male "committee of arbitration" negotiating with the employer.[119]

Frank Leslie's Illustrated Newspaper offered its readers only a small number of illustrations showing working-class women as active agents. But in the decade during which control switched from Frank Leslie to the feminist Mrs. Frank Leslie, the weekly magazine published many engravings, as well as columns of prose, that trumpeted "Woman's Enlarging Sphere." Reflecting the Gilded Age feminist movement, *Leslie's* celebrated the achievements of women in higher education and the professions with pictures showing the activities of women's colleges and portraits of individuals who had broken into male bastions of power.[120] Protesting discriminatory treatment of women who strove for independence and self-improvement (and offering recommendations for the reform of the laws governing marriage and divorce—an area in which Mrs. Leslie possessed extensive personal knowledge),[121] the weekly also publicized in text and pictures the work of feminist organizations and

reform associations dominated by women activists.[122] It could be argued that *Leslie's* feminist message was more strongly expressed in print than in images; the vast majority of engravings still idealized domestic gentility and cultural pursuits that displayed women's moral and aesthetic superiority. Nonetheless, women's expansion into the "public" sphere was articulated in the many pictures by Special Artist Georgina A. Davis (see figures 6.25 and 6.27, above). Davis was first noted as a participant in the Leslies' 1877 transcontinental excursion; her images covering a wide range of topics, duly credited and signed in her stylized initials, appeared regularly throughout the 1880s.[123]

A decisive change in *Leslie's* coverage of women's activities was the illustration of public participation in the political process. Voting rights were still limited to specific, localized plebiscites and some territorial elections, but *Leslie's* used those occasions as opportunities to mark women's legitimated political activity. Despite the small turnout of women voters during Boston's schoolboard elections (due, in part, to the imposition of a poll tax), the December 20, 1879, issue featured two pages of engravings showing the "enfranchised ones and their doings on this eventful day" (figure 6.28).[124] The respectable female types depicted included characterizations that bowed to reigning conceptions of "political" women, bespectacled and bowler-hatted; but other cuts suggested that women's electoral participation helped uplift the cruder aspects of what had been a male-only process. Taken as a whole, the overall stateliness of the female figures amid the male tumult and the broad display of their participation celebrated women's entrance, however limited, into the franchise. Later, an 1888 engraving showing women at the polls in Cheyenne, Wyoming, proudly recorded equal participation in the territory's electoral process.[125]

More provocative than women's exercise of the ballot was their active intervention in the rough-and-tumble of political campaigning. "Why not?" *Leslie's* responded when the Washington, D.C., attorney Belva A. Lockwood was announced as the Woman's National Equal Rights Party candidate for president in 1884. "We are accustomed to seeing her on the stage, in literature and journalism, in music and art, and even, of late, in the pulpit and at the Bar. She is known to be persevering and strong in faith. What reason have we for believing that she will pause in her triumphant course while the world of politics still awaits her conquest?"[126] Lockwood's candidacy provided the occasion for *Frank Leslie's* to acknowledge the growing range of women's political activity (figure 6.29). Yet *Leslie's* relied on female types that evoked equal measures

of celebration and derision. Extremes were set against one another: classically featured young women aided "infirm voters" in one cut, while in another "electioneering" Maine harridans "waylaid unprotected male voters, and in many cases intimidated them into voting their ticket on the Prohibition amendment." The engraving showing an African American "Chloe" putting "the finishing touches" on her husband's costume in preparation for a torchlight parade severely bracketed black women's political participation; the cut's rendition of spousal support also may have been positioned as a corrective to the inverted domestic relations displayed in the adjacent picture titled "Voting by proxy." [127]

The typing of women engaged in politics betrayed an ambivalence toward women's public activities, possibly in recognition of the differing views of the publication's readers. *Leslie's* engravings enthusiastically endorsed woman's suffrage, but other pictures and editorials wavered over aspects of women's intervention into American politics that seemed more transgressive. An April 1887 cut, "Fashionable ladies of Leavenworth soliciting votes at the polls," lent a note of farce to politically active women, applying and subtracting heft to their frames—perhaps in an effort to lessen the alarm of more conservative readers.[128] Although *Leslie's* recognized the influence of the "professional female lobbyist," its illustrations invested Washington scenes with a condescending humor that suggested the impropriety of the tenacious "sirens of the lobby" (figure 6.30):

> She is not to be denied. She lies in ambush. She pounces upon him when he least expects her. She buttonholes him. She separates him from his friends. She is not limp, but she clings. She will take no denial. "No" is a word that she fails to comprehend. She uses adjectives, some of them strong. She gushes, if needs be, and is ready on occasion to weep. If she is goodlooking, she works the battery of her charms with a skill that defies description. She knows the haunts of the luckless Representative, and does not hesitate to disturb him at his meal, even at the post-prandial cocktail. Her beseechments are pathetic or menacing. She is a nuisance, and she knows it. It is a sight for the gods to behold a Representative in the hands of these singularly uninteresting persons. They surround him. They attack him *en masse*. They bar his passage and all talk at once. In vain he endeavors to get away, to free himself, pleading important business. What more important business than theirs? None. In his despair he is impolite. That doesn't matter. They have their prey in their hands and will never let go their hold.[129]

However, *Frank Leslie's,* like feminist politicians, occasionally espoused tactics that successfully lessened the threat of transgressive behavior without diminishing its overall impact. "It is the custom in every

THE SOLITARY WOMAN VOTER OF WARD SEVEN, BOSTON.

WOMEN DEPOSITING THEIR BALLOT

RETURNING FROM THE FIRST EXERCISE OF THE ELECTIVE FRANCHISE, CAMBRIDGE.

ARISTOCRATIC VOTERS AT THE MOUNT VERNON STREET POLLS, BOSTON.

MASSACHUSETTS.—WOMAN SUFFRAGE IN THE BAY STATE—SCENES AT THE POLLS IN CAMBRIDGE, DECEMBER 2D, AND BO

Figure 6.28. "Massachusetts.—Woman suffrage in the Bay
State—Scenes at the polls in Cambridge, December 2d,
and Boston, December 9th, during the municipal elec-
tions, when women were permitted to vote for the school

A FAIR VOTER BESIEGED BY WARD CANVASSERS IN BOSTON.

AT THE POLICE COURT POLLS, CAMBRIDGE.

NO SMOKING

AN INNOVATION AT THE POLLS—"NO SMOKING ALLOWED."

WOMEN CANVASSERS BESIEGING BEACON HILL VOTERS, BOSTON.

BOSTON, DECEMBER 9TH, DURING THE MUNICIPAL ELECTIONS, WHEN WOMEN WERE PERMITTED TO VOTE FOR THE SCHOOL BOARDS.

BY H. A. OGDEN.—SEE PAGE 279.

boards." Seven wood engravings based on sketches by Harry A. Ogden, *Frank Leslie's Illustrated Newspaper*, December 20, 1879, 276–77. American Social History Project, New York.

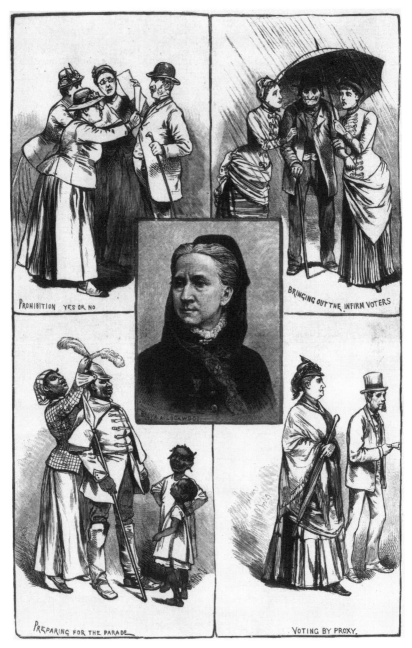

Figure 6.29. "The American woman in politics." Five wood engravings, *Frank Leslie's Illustrated Newspaper*, September 20, 1884, 72. American Social History Project, New York.

Figure 6.30. "An artist's rambles in Washington.—No. 3: The Senate lobby and the floor of the House. Female lobbyists in the Marble Room of the Senate." Wood engraving based on a sketch by John N. Hyde, *Frank Leslie's Illustrated Newspaper*, January 5, 1884, 309. Prints and Photographs Division, Library of Congress.

city and town of the United States, as election day approaches," began the description accompanying a November 1, 1884, engraving, "to organize torchlight parades for the purpose of impressing upon an admiring world the resources of campaign clubs and the glory of the respective candidates." *Leslie's* then observed that the "streets for the past month have been alive with Blaine processions, Cleveland processions, and even Butler processions; but it seems to us that the women's candidate, Mrs. Belva Lockwood, has been unaccountably neglected." Tantalizingly, the paper momentarily considered "the picturesque possibilities of a female torchlight procession," but then cautiously added that "the fair sex do not like to set the example of staying out late o' nights." [130] In tribute to both the expanding sphere of women's politics and the continuing proscriptions of women's public performance, the Rahway, New Jersey, supporters of Belva Lockwood's candidacy devised the perfect middle

Figure 6.31. "New Jersey.—The humors of the political campaign—Parade of the Belva Lockwood Club of the city of Rahway." Wood engraving based on a sketch by John N. Hyde, *Frank Leslie's Illustrated Newspaper*, November 1, 1884, 169. American Social History Project, New York.

subject for a *Leslie's* representation (figure 6.31). Inverting "proper" public roles, the engraving titled "Parade of the Belva Lockwood Club of the city of Rahway" endorsed the Woman's National Equal Rights Party presidential candidate while also aligning itself with dominant attitudes toward women's appropriate political behavior. By placing feminism within a humorous frame, in this one image *Frank Leslie's Illustrated Newspaper* successfully wended its way through the thicket of its diverse reading public.

Epilogue

By 1889 Mrs. Frank Leslie had grown weary of the constant striving and precarious fortunes of weekly illustrated journalism. In February she sold *Frank Leslie's Illustrated Newspaper,* along with its German edition, to the Judge Publishing Company for between $300,000 and $400,000.[1] Soon after, she discontinued all her publications except *Frank Leslie's Popular Monthly.* Now in her early fifties and extremely wealthy, she preferred the more demure atmosphere and slower pace of a monthly magazine. But the narrowing of her publishing responsibilities did not diminish Mrs. Leslie's public activity or her predilection for controversy. She became an active member of the Woman's Press Club of New York City soon after its founding in 1889 and remained a prominent proponent of women's rights; her lecture tours, syndicated articles, and books melded feminism with a boundless elitism preoccupied with the customs and manners of European royalty and with increasing cantankerousness about the unwieldiness of American class relations. In 1891 she married William ("Willie") Charles Kingsbury Wills Wilde, seventeen years her junior and known as much for his alcoholism as for his being Oscar Wilde's older brother: the marriage lasted less than two years. In 1895 Mrs. Leslie leased out the *Popular Monthly,* but she resumed her role as publisher three years later, revamping the magazine's format and returning its declining circulation to a healthy 200,000. However, she would finally lose control of her last publication in 1905 (a year later, purchased by McClure's, the *Popular Monthly* became the *American Magazine*).

Retired from publishing, Mrs. Leslie spent her last years in the Chelsea Hotel when not traveling in Europe; on one trip she finally achieved her lifelong ambition to secure her family's claim to nobility and returned bearing the title Baroness de Bazus. Mrs. Leslie died on September 18, 1914, at the age of seventy-eight, leaving half of her estate of $1,800,000 to Carrie Chapman Catt for "the furtherance of the cause of Women's Suffrage." [2]

Frank Leslie's Illustrated Newspaper continued under the ownership of the Judge Publishing Company for nine years. The firm, owned by W. J. Arkell and Russell B. Harrison (son of the twenty-third U.S. president), was best known for its illustrated satirical weekly *Judge,* started in 1881 by a group of artists who seceded from *Puck*. Arkell and Harrison moved the operations of *Leslie's Weekly* (the streamlined title was adopted in 1894) to their offices at 110 Fifth Avenue, shifted its editorial stance to support of the Republican Party, and changed its format to conform with the larger type and display graphics that characterized the mass-market magazines of the 1890s. Four pages were added in 1890 to the weekly's original sixteen; in keeping with the commercial impetus of the new magazines, the additional space was devoted to advertising. In 1898 *Leslie's Weekly* was bought by one of its editors, John A. Schleicher. Under his supervision, its circulation grew substantially, aided by coverage of the imperialist wars of the late nineteenth and early twentieth century (during the Spanish-American War, *Leslie's Weekly*'s circulation rose to 75,000). Although its readership during World War I reached an unprecedented 400,000, the fortunes of the paper flagged precipitously in the war's aftermath. On June 24, 1922, the last periodical to still carry the name "Leslie" ceased publication,[3] having outlasted its longtime weekly competitor by seven years. *Harper's Weekly* began to lose circulation during the presidential campaign of 1884, as its opposition to James G. Blaine's candidacy alienated its previously dedicated Republican following. The weekly never regained circulation; and after the House of Harper failed in 1899, *Harper's Weekly* was sold several times. In 1915 it was merged with a religious weekly, the *Independent*.[4]

By the time *Leslie's Weekly* folded, the heyday of the illustrated weeklies was long gone. Neil Harris's influential 1979 essay, "Iconography and Intellectual History: The Half-Tone Effect," proposed that the technological innovations permitting the reproduction of photography on the printed page in the late nineteenth century inaugurated an iconographic revolution in popular perceptions and tastes. In its vanguard was a new form of pictorial journalism, based on the compelling author-

ity and rapid dissemination of the half-tone photograph. This new me-
dium, Harris argued, reoriented the public's relationship to issues of so-
cial reform, personal privacy, and political authority: "[I]n a period of
ten or fifteen years the whole system of packaging visual information
was transformed, made more appealing and persuadable, and assumed
a form and adopted conventions that have persisted right through the
present. . . . The single generation of Americans living between 1885
and 1910 went through an experience of visual reorientation that had
few earlier precedents[.]"[5] When we consider the "half-tone effect,"
Mrs. Frank Leslie's decision to sell her weekly illustrated newspaper in
1889 hardly seems capricious. The decade had witnessed innovations in
print technology that displaced wood engraving as the preeminent me-
dium for cheap pictorial reproduction and would soon contribute to the
decline of the illustrated weeklies and to a general realignment of the
American periodical market.

By the mid-1880s, daily newspapers began to publish news illustra-
tions as a regular feature. The circulation increase spurred by the ap-
pearance of Valerian Gribayedoff's illustrations in the New York World
overcame Joseph Pulitzer's skepticism about hiring the first full-time
staff artist on a newspaper and quickly bred imitators among the city's
other major papers. While the role of daily newspaper artists differed
little from that of the special artists of the weekly illustrated press, the
time lag between sketch and public consumption was sharply curtailed:
unlike the weekly pictorial papers, newspapers published their illustra-
tions the day after the event. The speed of publication was greatly en-
hanced with the adoption of zincography, a photomechanical process by
which a drawing was transferred onto a treated zinc plate that was then
bathed in acid, leaving the artist's lines in high relief. This form of "pro-
cess line engraving" was accomplished in a matter of hours, though
until the late 1890s the plates' vulnerability to ink clots limited the pic-
torial technique to crude contour line drawings. Nevertheless, the im-
mediacy of such news pictures—aided by the use of ready-made "stock
cuts" and, beginning in 1885, the national syndication of pictures by the
American Press Association—helped newspapers eclipse the weekly il-
lustrated press, which had previously monopolized that reportorial role.[6]

At the same time that daily newspaper illustration was beginning to
challenge the pictorial weeklies' claims to timely coverage, the rise of a
new type of illustrated monthly magazine undermined their broader rep-
resentational role. Gaining prominence in the 1890s, these lavishly il-
lustrated, topical, and inexpensive periodicals offered a sharp contrast

to the exclusivity and cost of the established literary monthlies, and low price was no small part of their success during the long 1890s depression. Subsidized not by subscribers but by advertisers, *Munsey's, McClure's, Cosmopolitan,* and the other new ten-cent, general interest magazines presented a broad national readership with many more pages (including many more pages of advertisements) that featured a vast range of imagery and topics. Recent studies of the turn-of-the-century mass-market magazines differ over the nature of their circulation (hampered by the same sort of limited evidence that has plagued studies of the weekly illustrated press), but they all recognize how the magazines' form and content addressed the hopes and desires of their readers by mimicking the plentitude and variety of that other emporium of the era, the department store. Constructing their readers as consumers, the new magazines conflated the dissemination of information with advertising promotion, reaching hundreds of thousands of readers each month as they pioneered a national mass culture.[7]

A major reason for the 1890s mass-market magazines' success was the previous decade's invention of photomechanical pictorial processes that enabled an increase in the number, range, and quality of illustrations while simultaneously decreasing their costs. The most important innovation was the half-tone process that transferred photographs and other tonal illustrations to the printed page. Building on experiments of the 1860s and 1870s that proved too volatile and incompatible with letterpress, during the 1880s Frederick Eugene Ives perfected a method that essentially rephotographed the original image through a cross-lined screen that converted the varied tones into tiny dots.[8] The half-tone became a ubiquitous feature in magazine illustration almost immediately. "Automatic" engraving not only successfully reproduced a wide range of imagery, it achieved its effect much more quickly than "hand" engraving, and much more cheaply. "Now," the British journalist Clement Shorter commented in 1899, "instead of the twenty-four men taking twelve hours apiece, the whole block is forthcoming by mechanical process in eight hours or so, and at one-sixth of the cost of engraving."[9]

The institution of the half-tone process marked the end of the hegemony of wood engraving and the decline of the engraving trade. Engravings would continue to be used into the twentieth century—especially as illustrations in the literary monthlies, which deployed the painterly techniques of the New School of art engraving as a high art rampart against the onslaught of commercial illustration in the new magazines.[10]

Although *The Century*'s dedication to the hand-engraved line would eventually succumb to *Munsey's* photo-engraved dot, the transition was protracted. The half-tone effect, particularly the photograph's dominance in print, was not as immediate or all-pervasive as might have been expected. Despite key inventions—smaller cameras with faster shutters, more light-sensitive plates and roll film, and new forms of artificial illumination—photography's greater flexibility and expressiveness were barely evident in illustrated magazines (and nonexistent in newspapers until 1897). Publishers opted for the greater aesthetic attraction of tonal art forms, and artists found their work to be in even greater demand, as observers heralded a "golden age" of American magazine illustration. "Roughly estimated," the *World*'s Gribayedoff wrote in 1891, "I should say that there are 5000 illustrated periodicals in this country. . . . The artists at work in this field certainly exceed 1000 in number, and supply on an average 10,000 drawings a week." [11] Amid the half-tones of wash drawings and process line engravings of pen and ink sketches, wood engravings would still find a prominent place in magazine illustration into the 1890s. Though some artists, long frustrated by the engraver's mediation, favored the half-tone's faithfulness to their original efforts, other artists decried the effect of such reproductions. The *Harper's Weekly* artist William Rogers reflected that "while the half-tone plate is a thing of mechanical beauty in itself, it inevitably flattens values. Over a drawing of extreme delicacy or of elusive quality it runs with the crushing effect of a steam roller. A rough, crude original fares better; its hard edges are softened. But a wood engraving at its best follows the mood and the method of the artist. The sensitive art of the engraver joins hands with the art of the draftsman." Faced with these new and old media, the illustrated magazine became a hybrid of pictorial techniques. [12]

Under its new management, *Frank Leslie's* continued to produce wood-engraved imagery into the final decade of the nineteenth century. But its sale to the Judge Publishing Company triggered an immediate, if uneven, expansion of pictorial reproduction techniques. [13] In the first two years of the "new" *Leslie's*, wood engravings were accompanied by what were clearly process line engravings, as well as by occasional half-tone reproductions of wash drawings. [14] Perhaps the best expression of the mix of media occurred in *Leslie's* coverage of the 1890 Sioux "uprising," which alternated photographs, line drawings (wood and zinc engravings), and half-tone wash drawings—sometimes on the same page (figure 7.1). [15] The half-tone may have made it possible for advertisers to

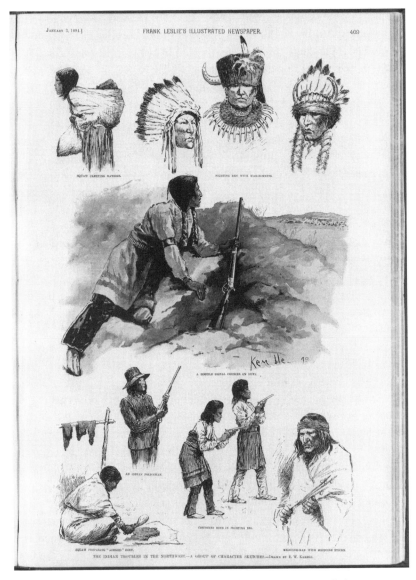

Figure 7.1. "The Indian troubles in the Northwest.—A group of character sketches." Zinc engravings (?) and wash drawing by E. W. Kemble, *Frank Leslie's Illustrated Newspaper,* January 3, 1891, 409. Prints and Photographs Division, Library of Congress.

combine different types of media into one compelling composition, but the initial half-tone effect on news images seemed a hodgepodge of static and narrative imagery.[16]

After a half-tone photograph was published in the September 28, 1889, issue as part of *Leslie's* coverage of the Paris Exposition, photographs became a regular part of the weekly's pictorial format, although generally a decidedly murky and indistinct feature.[17] Nevertheless, the photograph made distinct headway in the paper during 1890 with the announcement of an "Amateur Photographic Contest." More significant than the $100 first prize was *Leslie's* proposal to publish the entries: beginning in March, for five months each issue carried either full-page or double-page displays of half-tone photographs from across the country.[18] Aided by the invention of the Kodak camera and roll film, abetted by the half-tone process, *Leslie's* seemed to establish a new relationship with its readership.[19] However, the arrangement also could be interpreted as the logical extension of Frank Leslie's call in 1855 for contributions by corresponding artists and photographers. The departure may have been located more in quantity than in quality: with each issue extending well beyond the initial sixteen-page format (an increase prompted by the cheaper pictorial processes, the inclusion of more advertisements, and the competition posed by the new mass-market magazines), the contestants provided needed pictures—if less news coverage. By 1899 the photographs overwhelmed other illustrations in the weekly. Clement Shorter reported that out of forty-seven pictures in one March 1899 issue of *Leslie's Weekly,* forty-four were half-tone photographs. Reflecting the new division of pictorial labor established during the last decade of the nineteenth century, *Leslie's* photographs now illustrated topical and news items, while drawings were left to garnish fiction.[20]

* * *

Further research will be required before we can adequately assess the impact of the half-tone revolution on the production and reception of news imagery. Nonetheless, an impressionistic consideration of pictorial reporting during the generation following the triumph of the news photograph suggests the persistence of many of the visual techniques and narrative conventions of the wood-engraving era. Through the turn of the century, even as the photographic half-tone was victorious in the aggregate, news illustration continued to serve as the medium for conveying action. Strikes and riots, for example, were covered in photographs

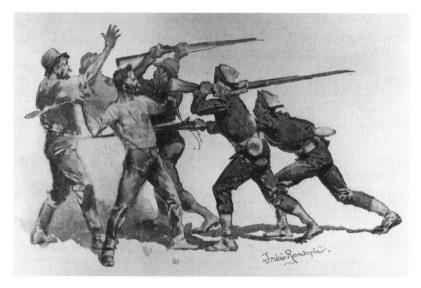

Figure 7.2. "'Giving the butt'—The way the 'regular' infantry tackles a mob."
Pen and ink drawing by Frederic Remington, *Harper's Weekly*, July 21, 1894,
680. American Social History Project, New York.

that recorded people, places, and conditions; but it was in accompany-
ing wash drawings that pivotal events and dramatic clashes were repre-
sented, with continued reliance on the familiar conventions of extended
narrative (figure 7.2). The Spanish-American War may have been the
first major war covered primarily by photographers rather than drafts-
men, but the depictions of battles still emanated from the pencils, pens,
and brushes (and, at times, imaginations) of artists.[21]

Rather than the media being viewed as alternatives, the difference be-
tween illustration and photography—between "imitation" and "authen-
ticity," in Miles Orvell's phrase—remained blurred in the retouched
photographs and other hybrid pictorial forms featured in turn-of-the-
century newspapers and magazines, and favored in display advertis-
ing.[22] Advertisers in particular were not loath to retouch half-tone plates
of photographic images to "enhance" their "realistic" impact, but this
practical approach was also shared by newspaper professionals; one
New York Times art director as late as 1929 recommended the erasure
of "superfluous matter" in news pictures to make them "more pleasing
to the eye."[23] The latter approach, despite the disapproval of contem-
porary journalists, found its logical extension in the sensational tabloids
of the 1920s, notably Bernarr Macfadden's New York *Evening Graphic*

(1924–32) with its staged and retouched "composographs" depicting ostensible news events (which also continued the "re-created" performances of the nineteenth-century pictorial press).[24]

News and documentary photography, now reproduced in purportedly unmediated half-tones, also articulated the socially constructed pictorial conventions and narrative strategies of wood engravings. Recent studies of early social documentary photographers such as Jacob Riis have examined how the photographer's choice of pose and framing reiterated the narrative and rhetorical strategies familiar to longtime readers of the pictorial press. The seemingly new realist turn to photographic representation in depicting the poor kept the moral subtexts and social typing of earlier illustration, a metonymic representational strategy also characteristic of nineteenth-century photography "whereby the pictured subject, with all its concrete particularity, *stands for* a more general class of like subjects."[25]

The physiognomic codes used in social typing did not disappear at the turn of the century. While greater realism also characterized the representation of African Americans and the ethnic working class in news illustration, pictorial stereotypes continued to appear in magazine and newspaper cartoons. Indeed, if anything, the realm of crude physiognomic typing expanded with the emergence of the daily newspaper comic strip and spectacular Sunday color supplements (not to mention the introduction of the animated cartoon around 1910).[26] But the contrast between the grotesque or buffoonish attributes of the comic characters housed in the humor pages of popular publications and the "photographic" characters in news illustrations may have obscured a more subtle, if pervasive, use of typing. Whereas the November 1898 cover of *Collier's Weekly,* "A scene in the race disturbance at Wilmington, N.C." (figure 7.3), portrayed African Americans without relying on somatic signs of racist caricature, the drawing clearly placed gun-toting black terrorists at the heart of what was, in fact, a brutal white riot.[27] In such illustrations of domestic racial and class confrontation, now increasingly accompanied by pictures of American imperial adventures abroad (and their manifestations at home, exemplified in a series of world's fairs), the photo-realist conventions of news illustration helped reify the "objectivity" of typing—an objectivity that was, in turn, legitimated by new scientific theories about racial and class hierarchies.[28] In this light, the ostensible gulf between the wood-engraved news imagery of *Frank Leslie's Illustrated Newspaper* and the photographic and tonal illustrations instantiating the half-tone effect marked less an epistemological or

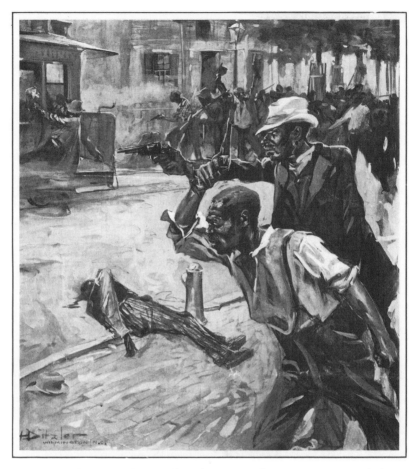

Figure 7.3. "A scene in the race disturbance at Wilmington, N.C." Wash draw-
ing by H. Ditzler, *Collier's Weekly,* November 26, 1898, cover. American So-
cial History Project, New York.

representational break from earlier practices than the application of new
"realist" methods to very old purposes.[29]

While the half-tone era perpetuated many of the representational
codes and narrative conventions of nineteenth-century wood-engraved
pictorial journalism, a significant gap had formed in the relationship
between readers and the publications they purchased. As late-twentieth-
century scholars have argued, in both mass-market magazines and mass-
circulation newspapers the increased number and heightened credibility
of images—aided by new design strategies and new vernacular writing
styles—helped engender greater passivity on the part of readers, shap-

ing them into a mass of consumers even as these innovations addressed their individual needs and desires. Photojournalism, for example, offered an illusory sense of participation via a plethora of pictorial news that was often expressly staged for the camera.[30]

I am not making a brief for some golden age of pictorial journalism—some commercial idyll (if you'll pardon the oxymoron) wherein authenticity of expression and inclusiveness of subject matter once dwelled. But if there is a crucial distinction between the wood-engraving and half-tone eras, it lies in a social equation that eroded in the twentieth century as commercial pictorial news was influenced by advertising rather than by subscribers or purchasers. Technology, particularly the innovation of the half-tone, altered the production side of that equation. The characteristic operation of *Frank Leslie's Illustrated Newspaper* (including the haphazard journey of artist's sketch to engraver's block and the different ways in which the paper's audience perceived the results) was riddled with fissures that allowed it to be influenced, however reluctantly, by both the producers of pictorial news and its readers (who were often its subjects as well). It was a process particularly sensitive to the exigencies of the Gilded Age. Its ensuing "simplification" at the turn of the century, in both production and consumption, diminished the interventions that often made illustrated journalism into a pictorial balancing act. *Leslie's* may have differed from many of its contemporary publications in its sometimes tortured efforts to appease a divided readership, but the weekly demonstrated that the nineteenth-century pictorial press was not monolithic in either its practice or its appeal. The new century's news representations would be less responsive to the differing systems of viewing that publications like *Leslie's* had imperfectly addressed over the course of thirty-four years.

Notes

INTRODUCTION

1. See John Berger, Sven Blomberg, Chris Fox, Michael Dibb, and Richard Hollis, *Ways of Seeing* (New York: Viking, 1973). My visualization confessions are recorded in Joshua Brown, "Visualizing the Nineteenth Century: Notes on Making a Social History Documentary Film," *Radical History Review,* no. 38 (April 1987): 114–25.

2. See Neil Harris, "Iconography and Intellectual History: The Half-Tone Effect," in *New Directions in American Intellectual History,* ed. John Higham and Paul K. Conkin (Baltimore: Johns Hopkins University Press, 1979), 196–211; Estelle Jussim, *Visual Communication and the Graphic Arts: Photographic Technologies in the Nineteenth Century,* new ed. (New York: R. R. Bowker, 1983); Peter Bacon Hales, *Silver Cities: The Photography of American Urbanization, 1839–1915* (Philadelphia: Temple University Press, 1984); Michael L. Carlebach, *The Origins of Photojournalism in America* (Washington, D.C.: Smithsonian Institution Press, 1992).

3. For examples of recent art exhibitions that view engraved news imagery as hackwork, see Sarah Burns's comments in "Modernizing Winslow Homer," *American Quarterly* 49.3 (September 1997): 627–28, as well as Trevor Fairbrother's review of *American Impressionism and Realism: The Painting of Modern Life, 1885–1915* [Metropolitan Museum of Art exhibition and catalog], *Archives of American Art Journal* 33.4 (1993): 21 n. 6.

4. Michael Schudson, *Discovering the News: A Social History of American Newspapers* (New York: Basic Books, 1978).

5. See Lawrence W. Levine, *Highbrow/Lowbrow: The Emergence of Cultural Hierarchy in America* (Cambridge, Mass.: Harvard University Press, 1988); Robert J. Scholnick, "*Scribner's Monthly* and the 'Pictorial Representation of Life and Truth' in Post–Civil War America," *American Periodicals* 1.1 (fall 1991),

46–69; Kathleen Diffley, "Home on the Range: Turner, Slavery, and the Landscape Illustrations in *Harper's New Monthly Magazine, 1861–1876*," *Prospects* 14 (1989): 175–202. On the *National Police Gazette,* see Dan Schiller, *Objectivity and the News: The Public and the Rise of Commercial Journalism* (Philadelphia: University of Pennsylvania Press, 1981), and Elliott J. Gorn, "The Wicked World: The *National Police Gazette* and Gilded-Age America," *Media Studies Journal* 6.1 (winter 1992): 1–15.

6. Budd Leslie Gambee Jr., "Frank Leslie and His Illustrated Newspaper, 1855–1860: Artistic and Technical Operations of a Pioneer Pictorial News Weekly in America" (Ph.D. diss., University of Michigan, 1963); Madeleine Bettina Stern, *Purple Passage: The Life of Mrs. Frank Leslie* (Norman: University of Oklahoma Press, 1953); Robert Taft, *Artists and Illustrators of the Old West, 1850–1900* (New York: Charles Scribner's Sons, 1953); Frank Luther Mott, *A History of American Magazines, 1850–1865* (Cambridge, Mass.: Harvard University Press, 1938); idem, *A History of American Magazines, 1865–1885* (Cambridge, Mass.: Harvard University Press, 1938); idem, *A History of American Magazines, 1885–1905* (Cambridge, Mass.: Harvard University Press, 1957). Among the many studies of the illustrated press during the Civil War, see in particular W. Fletcher Thompson Jr., *The Image of War: The Pictorial Reporting of the American Civil War* (New York: Thomas Yoseloff, 1959), and William P. Campbell, *The Civil War: A Centennial Exhibition of Eyewitness Drawings* (Washington, D.C.: National Gallery of Art, 1961). There are also myriad picture books that contain sketches of artist-reporters and wood engravings published in the illustrated press (along with the photographic record of the war): Philip Van Doren Stern, *They Were There: The Civil War in Action as Seen by Its Combat Artists* (New York: Crown, 1959), and *Leslie's Illustrated Civil War* (Jackson: University Press of Mississippi, 1992)—a facsimile edition of *The Soldier in Our Civil War* (New York: Stanley-Bradley Publishing Company, 1894), a compendium of *Frank Leslie's* war engravings—are but two titles representative of a substantial body of work.

7. Such availability cannot be taken for granted; as Nicholson Baker has recently warned, archives are "de-accessioning" their paper copies of newspapers and periodicals in favor of microfilm, often poorly shot, at an alarming rate. See *Double Fold: Libraries and the Assault on Paper* (New York: Random House, 2001).

8. For admonitions against a scholarly "iconoclasm" that would ignore these images, see Roy Porter, "Seeing the Past," *Past and Present,* no. 118 (February 1988): 186–205; idem, "Prinney, Boney, Boot," *London Review of Books,* March 20, 1986, 19–20; B. E. Maidment, *Reading Popular Prints, 1790–1870* (Manchester: Manchester University Press, 1996), 1–26.

There are, of course, huge numbers of books that lavish attention on nineteenth-century wood engravings depicting political events, social relations, cultural pursuits, and economic conflict. The pictures in Lally Weymouth, *America in 1876: The Way We Were* (New York: Vintage, 1976), and John Grafton, *New York in the Nineteenth Century* (New York: Dover, 1977)—to name but two in shelf after shelf of pictorial histories—derive from the pages of the illustrated press, but the emphasis of such works is often nostalgic and antiquarian.

9. See Michele H. Bogart, *Artists, Advertising, and the Borders of Art* (Chicago: University of Chicago Press, 1995); Rebecca Zurier, Robert W. Snyder, and Virginia M. Mecklenburg, *Metropolitan Lives: The Ashcan Artists and Their New York* (New York: W. W. Norton, 1995); Rebecca Zurier, "Picturing the City: New York in the Press and the Art of the Ashcan School, 1890–1917" (Ph.D. diss., Yale University, 1988). The boundary-breaking trend has been nurtured by the still-amorphous field of "visual culture" studies: see Nicholas Mirzoeff, *An Introduction to Visual Culture* (New York: Routledge, 1999), esp. 1–33; Emily Fourmy Cutrer, "Visualizing Nineteenth-Century American Culture," *American Quarterly* 51.4 (December 1999): 895–909.

10. See Sally Stein, "Making Connections with the Camera: Photography and Social Mobility in the Career of Jacob Riis," *Afterimage,* May 1983, 9–16; Maren Stange, *Symbols of Ideal Life: Social Documentary Photography in America, 1890–1950* (New York: Cambridge University Press, 1989); Sarah Burns, *Pastoral Inventions: Rural Life in Nineteenth-Century American Art and Culture* (Philadelphia: Temple University Press, 1989).

11. See Celina Fox, *Graphic Journalism in England during the 1830s and 1840s* (New York: Garland, 1988); eadem, "The Development of Social Reportage in English Periodical Illustration during the 1840s and Early 1850s," *Past and Present,* no. 74 (February 1977): 90–111; Michael Wolff and Celina Fox, "Pictures from the Magazines," in *The Victorian City: Images and Reality,* ed. H. J. Dyos and Michael Wolff (London: Routledge and Kegan Paul, 1973), 559–82; Maidment, *Reading Popular Prints.*

12. See Michele H. Bogart, *Public Sculpture and the Civic Ideal in New York City, 1890–1930* (Chicago: University of Chicago Press, 1989); Kirk Savage, *Standing Soldiers, Kneeling Slaves: Race, War, and Monument in Nineteenth-Century America* (Princeton: Princeton University Press, 1997).

13. See Matthew Schneirov, *The Dream of a New Social Order: Popular Magazines in America, 1893–1914* (New York: Columbia University Press, 1994); Helen Damon-Moore, *Magazines for the Millions: Gender and Commerce in the "Ladies' Home Journal" and the "Saturday Evening Post": 1880–1910* (Albany: State University of New York Press, 1994); Jennifer Scanlon, *Inarticulate Longings: The "Ladies' Home Journal," Gender, and the Promises of Consumer Culture* (New York: Routledge, 1995); Ellen Garvey, *The Adman and the Parlor: Magazines and the Gendering of Consumer Culture, 1880s to 1910s* (New York: Oxford University Press, 1996); Richard Ohmann, *Selling Culture: Magazines, Markets, and Class at the Turn of the Century* (London: Verso, 1996). See also Michael Denning, *Mechanic Accents: Dime Novels and Working-Class Culture in America* (London: Verso, 1987); Kenneth M. Price and Susan Belasco Smith, eds., *Periodical Literature in Nineteenth-Century America* (Charlottesville: University Press of Virginia, 1995). For a useful survey of the field, see Wayne A. Wiegand, "Introduction: Theoretical Foundations for Analyzing Print Culture as Agency and Practice in a Diverse Modern America," in *Print Culture in a Diverse America,* ed. James P. Danky and Wayne A. Wiegand (Urbana: University of Illinois Press, 1998), 1–13.

14. Stern, *Purple Passage;* Gambee, "Frank Leslie and His Illustrated Newspaper." See also William E. Huntzicker, "Frank Leslie (Henry Carter)," in *Amer-*

ican Magazine Journalists, 1850–1900, ed. Sam G. Riley, vol. 79 of *Dictionary of Literary Biography* (Detroit: Gale Research, 1989), 216–19.

15. Porter, "Seeing the Past," 188–89; Maidment, *Reading Popular Prints,* 9–10, 14–16.

16. Walter Benjamin, "The Work of Art in the Age of Mechanical Reproduction," in *Illuminations,* ed. Hannah Arendt, trans. Harry Zohn (New York: Schocken Books, 1969), 217–51; see also Maidment, *Reading Popular Prints,* 3–5.

17. For useful comments on "essentialist" illusion, see Zurier, Snyder, and Mecklenburg, *Metropolitan Lives,* 25–27.

18. T. J. Clark, "Preliminaries to a Possible Treatment of 'Olympia' in 1865," *Screen* 21.1 (spring 1980): 40.

CHAPTER 1. PICTORIAL JOURNALISM IN ANTEBELLUM AMERICA

1. Frederic Hudson, *Journalism in the United States, from 1690 to 1872* (New York: Harper and Brothers, 1873), 705.

2. Ibid., 705–9; on Hudson, see Joseph P. McKerns, ed., *Biographical Dictionary of American Journalism* (Westport, Conn.: Greenwood Press, 1989), 359–61.

3. *Cosmopolitan Art Journal* 1 (January 1857): 3, quoted in Frank Luther Mott, *A History of American Magazines, 1850–1865* (Cambridge, Mass.: Harvard University Press, 1938), 192.

4. Jean-Louis Comolli, "Machines of the Visible," in *The Cinematic Apparatus,* ed. Teresa de Lauretis and Stephen Heath (New York: St. Martin's Press, 1980), 122–23.

5. E. L. Godkin, "Chromo-Civilization," *Nation,* September 24, 1874, quoted in Peter C. Marzio, *The Democratic Art: Pictures for a Nineteenth-Century America* (London: Scolar Press, 1980), 1–2; Lawrence W. Levine, *Highbrow/Lowbrow: The Emergence of Cultural Hierarchy in America* (Cambridge, Mass.: Harvard University Press, 1988), 160.

6. Clarence S. Brigham, *Paul Revere's Engravings,* rev. ed. (New York: Atheneum, 1969); Donald Cresswell, comp., *The American Revolution in Drawings and Prints: A Checklist of 1765–1790 Graphics in the Library of Congress* (Washington, D.C.: Library of Congress, 1975); Museum of Graphic Art, *American Printmaking: The First 150 Years* (Washington, D.C.: Smithsonian Institution Press, 1969); Thomas C. Leonard, *The Power of the Press: The Birth of American Political Reporting* (New York: Oxford University Press, 1986), 44–45, 98. Revere's print was itself plagiarized from the work of a fellow Boston engraver.

7. See David P. Jaffee, "An Artisan-Entrepreneur's Portrait of the Industrializing North, 1790–1860," in *Essays from the Lowell Conference on Industrial History, 1982 and 1983,* ed. Robert Weible (North Andover, Mass.: Museum of American Textile History, 1985), 165–84; idem, "Peddlers of Progress and the Transformation of the Rural North, 1760–1860," *Journal of American History* 78.2 (September 1991): 511–35; Alan Trachtenberg, *Reading American Photographs: Images as History: Mathew Brady to Walker Evans* (New York: Hill and

Wang, 1989), 21–70. Robert Taft, in *Photography and the American Scene: A Social History, 1839–1889* ([New York: Macmillan, 1938], 81), estimates that over three million daguerreotypes were taken annually in the United States between 1849 and 1853; by 1850, there were ninety-three daguerrean studios along Broadway alone.

8. Georgia Brady Bumgardner, "George and William Endicott: Commercial Lithography in New York, 1831–51," in *Prints and Printmakers of New York State, 1825–1940*, ed. David Tatham (Syracuse, N.Y.: Syracuse University Press, 1986), 43–65; Jo Ann Early Levin, "The Golden Age of Illustration: Popular Art in American Magazines, 1850–1925" (Ph.D. diss., University of Pennsylvania, 1980), 4–5; Marzio, *Democratic Art,* 117–26. For an insightful reading of the rules of domestic imagery, see Lori E. Rotskoff, "Decorating the Dining-Room: Still-Life Chromolithographs and Domestic Ideology in Nineteenth-Century America," *Journal of American Studies* 31.1 (April 1997): 19–42.

9. Catharine Esther Beecher and Harriet Beecher Stowe, *The American Woman's Home* (New York: J. B. Ford, 1869); quoted in Marzio, *Democratic Art,* 117, 123, 125. *The American Woman's Home* was an expansion of Beecher's *Treatise on Domestic Economy,* which was repeatedly reprinted after its first publication in 1841.

10. Wendy Wick Reaves, "Portraits in Every Parlor," in *American Portrait Prints: Proceedings of the Tenth Annual Print Conference* (Charlottesville: University Press of Virginia, 1984), 83–134.

11. Robert W. Johannsen, *To the Halls of Montezuma: The Mexican War in the American Imagination* (New York: Oxford University Press, 1985), 222–30; Martha A. Sandweiss, Rick Stewart, and Ben W. Huseman, *Eyewitness to War: Prints and Daguerreotypes of the Mexican War, 1846–48* (Washington, D.C.: Smithsonian Institution Press, 1989).

12. See Malcolm Johnson, *David Claypool Johnston: American Graphic Humorist, 1798–1865,* exhib. cat., American Antiquarian Society et al. (Lunenberg, Vt.: Stinehour Press, 1970); David Tatham, "David Claypoole Johnston's Theatrical Portraits," in *American Portrait Prints,* 162–93; Peter C. Welsh, "Henry R. Robinson: Printmaker to the Whig Party," *New York History* 53.1 (January 1972): 25–53; Nancy R. Davison, "E. W. Clay and the American Political Caricature Business," in Tatham, *Prints and Printmakers of New York State,* 91–110; Bernard Reilly Jr., "Comic Drawing in New York in the 1850s," in ibid., 147–62; Stephen Hess and Milton Kaplan, *The Ungentlemanly Art: A History of American Political Cartoons,* rev. ed. (New York: Macmillan, 1975), 65–79; Marzio, *Democratic Art,* 43–44. While Marzio largely ignores the "rough" lithography trade, Harold Holzer, Gabor S. Boritt, and Mark E. Neely, in *The Lincoln Image: Abraham Lincoln and the Popular Print* ([New York: Charles Scribner's Sons, 1984], 3–4), assert that political prints were placed in the home; see also Robert Philippe, *Political Graphics: Art as Weapon* (New York: Abbeville Press, 1980), 7, 172.

13. Michael Schudson, *Discovering the News: A Social History of American Newspapers* (New York: Basic Books, 1978), 14–31; Dan Schiller, *Objectivity and the News: The Public and the Rise of Commercial Journalism* (Philadelphia: University of Pennsylvania Press, 1981), 12–75; Rebecca Zurier, "Picturing the

City: New York in the Press and the Art of the Ashcan School, 1890–1917"
(Ph.D. diss., Yale University, 1988), 72–81; Andie Tucher, *Froth and Scum:
Beauty, Goodness, and the Ax Murder in America's First Mass Medium* (Chapel
Hill: University of North Carolina Press, 1994), 7–20. The *Sun* editorial of No-
vember 9, 1833, is quoted in Frank M. O'Brien, *The Story of "The Sun"* (New
York: D. Appleton, 1928), 25.

14. Roger Butterfield, "Pictures in the Papers," *American Heritage,* June
1962, 96–97; Zurier, "Picturing the City," 83–84. On the *Herald's* pictorial
coverage of the Mexican War, see Johannsen, *To the Halls of Montezuma,* 225;
Sandweiss, Stewart, and Huseman, *Eyewitness to War,* 18, 19, 114, 139. These
newspaper pictures were an improvement over the crude woodcuts and engrav-
ings that decorated chapbooks, almanacs, and cheap street literature; produced
as "stock cuts," such pictures appeared repeatedly in different publications (Su-
san G. Davis, " 'All-me-knack'; or, a Working Paper on Popular Culture" [type-
script, University of Pennsylvania, 1980]; Susan G. Davis and Dan Schiller,
"Street Literature and the Delineation of Deviance in the United States, 1830–
1860" [typescript, University of Pennsylvania, n.d.]).

15. Butterfield, "Pictures in the Papers," 96–97; Zurier, "Picturing the
City," 81–84; Neil Harris, *Humbug: The Art of P. T. Barnum* (Boston: Little,
Brown, 1973), 68–70; Tucher, *Froth and Scum,* 46–61. Inspired by the *Sun's*
hoax, Poe manufactured a seventy-five-hour transatlantic balloon voyage for an
1844 article. The 1848 admirer of the *Herald* is quoted in Schiller, *Objectivity
and the News,* 88. On the influence of "photographic realism" on reporting, see
Schiller, *Objectivity and the News,* 88–95; idem, "Realism, Photography, and
Journalistic Objectivity in Nineteenth Century America," *Studies in the Anthro-
pology of Visual Communication* 4.2 (winter 1977): 86–98.

16. Levin, "The Golden Age of Illustration," 20; Butterfield, "Pictures in the
Papers," 97. The exceptional case of the New York *Daily Graphic* (1873–89)
will be discussed later in this book.

17. "Preface," *Illustrated London News* (hereafter *ILN*) 1 (1842); quoted in
Celina Fox, "The Development of Social Reportage in English Periodical Illus-
tration during the 1840s and Early 1850s," *Past and Present,* no. 74 (February
1977): 92.

18. Fox, "The Development of Social Reportage," 90–91; on Bewick, see
William M. Ivins Jr., *Prints and Visual Communication* (1953; reprint, Cam-
bridge, Mass.: MIT Press, 1969), 86–87; Levin, "The Golden Age of Illustra-
tion," 20–23; John Brewer, *The Pleasures of the Imagination: English Culture
in the Eighteenth Century* (New York: Farrar, Straus, and Giroux, 1997), 499–
530. According to *Illustrated London News* co-founder Henry Vizetelly, In-
gram's original intent had been a far cry from what eventually emerged. Having
established himself, in partnership with his brother-in-law, as a Nottingham
printer, bookseller, and newsagent, Ingram had noticed that his customers
seemed particularly interested in cheap London weekly papers such as the *Ob-
server* and *Weekly Chronicle* that, adorned with small woodcuts, proffered sto-
ries about murders and sports. Ingram enthusiastically joined in, publishing an
illustrated broadside about the current notorious Greenacre murder case. After
another venture, a life-lengthening placebo called Parr's Pills, proved financially

successful, Ingram and his brother-in-law moved to London, intent on publishing a crime periodical. If Vizetelly's version is true (and, in the light of his alienation from Ingram only a year after the founding of the *Illustrated London News,* some skepticism is in order), sometime before the inauguration of the newsweekly he became enamored of loftier—and, as we will see, more remunerative—goals. See Mason Jackson, *The Pictorial Press: Its Origins and Progress* (London: Hurst and Blackett, 1885), 306–11; Clement Shorter, "Illustrated Journalism: Its Past and Its Future," *Contemporary Review* 75 (April 1899): 485–86.

19. Jackson, *The Pictorial Press,* 284–304; Christopher Hibbert, *"The Illustrated London News": Social History of Victorian Britain* (London: Angus and Robertson, 1975), 11–13; Michael Wolff and Celina Fox, "Pictures from the Magazines," in *The Victorian City: Images and Reality,* ed. H. J. Dyos and Michael Wolff (London: Routledge and Kegan Paul, 1973), 561.

20. Fox, "The Development of Social Reportage," 92–93; Wolff and Fox, "Pictures from the Magazines," 561–65; Alex Potts, "Picturing the Modern Metropolis: Images of London in the Nineteenth Century," *History Workshop,* no. 26 (autumn 1988): 28–56; Caroline Arslott, Griselda Pollock, and Janet Wolff, "The Partial View: The Visual Representation of the Early Nineteenth-Century City," in *The Culture of Capital: Art, Power, and the Nineteenth-Century Middle Class,* ed. Janet Wolff and John Seed (Manchester: University of Manchester Press, 1988), 191–233.

21. Charles Knight, *Passages of a Working Life During Half a Century,* vol. 3 (London, 1864–65); quoted in Fox, "The Development of Social Reportage," 93. On Knight and the *Penny Magazine,* see Celina Fox, *Graphic Journalism in England during the 1830s and 1840s* (New York: Garland, 1988), 138–57; Patricia Anderson, *The Printed Image and the Transformation of Popular Culture, 1790–1860* (Oxford: Clarendon Press, 1991), 50–83.

22. "Preface," *ILN,* July 8, 1843; quoted in Fox, "The Development of Social Reportage," 92–93.

23. Jackson, *The Pictorial Press,* 300–304; Hibbert, *The Illustrated London News,* 14.

24. See Richard D. Altick, *"Punch": The Lively Youth of a British Institution, 1841–51* (Columbus: Ohio State University Press, 1997). In "Pictures from the Magazines" (565–67), Wolff and Fox note that in contrast to the *Illustrated London News*'s blinkered vision of urban society, humor magazines like *Punch* depicted poverty; but they argue that humor made sordid conditions and appearances palatable, demonstrated the innate unworthiness of the poor through their representation, and defused any sensational impact by placing the images in a humorous (and, in the case of George Cruikshank's "Progress" tales, didactic) frame. Peter G. Buckley, in "Comic and Social Types: From Egan to Mayhew" (paper presented at the American Historical Association Annual Meeting, New York, December 1990), suggests a different relationship, seeing the comic as a structure of feeling out of which social reportage and critique emerged.

25. Fox, "The Development of Social Reportage," 100–111; Jackson, *The Pictorial Press,* 311–12. *Pictorial Times,* February 7, 1846, is quoted in Fox, "The Development of Social Reportage," 101. For the broader field of British

pictorial publishing in the first half of the nineteenth century, see Anderson, *The Printed Image and the Transformation of Popular Culture.*

26. "Frank Leslie," *Frank Leslie's Illustrated Newspaper* (hereafter *FLIN*), January 24, 1880, 382; Richard B. Kimball, "Frank Leslie," *Frank Leslie's Popular Monthly* 9.3 (March 1880): 258; Budd Leslie Gambee Jr., *Frank Leslie and His Illustrated Newspaper, 1855–1860,* University of Michigan Department of Library Science Studies 8 (Ann Arbor: University of Michigan, 1964), 4–6.

27. "Frank Leslie," *FLIN*, 382; Kimball, "Frank Leslie," 258; Gambee, *Frank Leslie,* 6–8. On engravers' status, see F. B. Smith, *Radical Artisan: William James Linton, 1812–97* (Manchester: Manchester University Press, 1973), 4; Fox, *Graphic Journalism in England,* 26–72.

28. "Frank Leslie," *FLIN*, 382; Gambee, *Frank Leslie,* 8; Mott, *American Magazines, 1850–1865,* 452–53. Leslie quickly gained fame as a wood engraver in his new home; he was awarded a medal for excellence in wood engraving at the American Institute's 1848 exhibit, an achievement that very likely recommended him to Barnum. On the Jenny Lind tour, see Harris, *Humbug,* 111–41; Peter George Buckley, "To the Opera House: Culture and Society in New York City, 1820–1860" (Ph.D. diss., State University of New York at Stony Brook, 1984), 498–540.

29. *Gleason's Pictorial Drawing-Room Companion* (hereafter *GP*), January 17, 1852, 45. See Mott, *American Magazines, 1850–1865,* 2, 43, 409–12; Butterfield, "Pictures in the Papers," 97–98. The eight pages of engravings were printed on one side of the uncut folio paper. Mott (*American Magazines, 1850–1865,* 44 n. 70) notes that it was Leslie who cited Chevalier Wikoff's *Picture Gallery,* an eight-page supplement to his *Republic* newspaper during its short 1843 life, as the first actual attempt to establish a weekly American pictorial journal; see also F. J. Splitstone, "Our Sixtieth Birthday," *Leslie's Weekly,* December 16, 1915, 661.

30. *GP*, December 11, 1852, 381.

31. *GP*, August 16, 1851, 253; January 3, 1852, 13. For a description of the process and costs, see *GP*, January 17, 1852, 45.

32. *GP*, December 11, 1852, 381; "Frank Leslie," *FLIN*, 382; Kimball, "Frank Leslie," 258–59; Gambee, *Frank Leslie,* 9. On "sc" see A. Hyatt Mayor, "Terms and Abbreviations Found on Prints," in *Prints and People: A Social History of Printed Pictures* (New York: Metropolitan Museum of Art, 1971), n.p.; *Oxford English Dictionary,* 2nd ed., s.v. "sculptor."

33. Mott, *American Magazines, 1850–1865,* 43–44.

34. P. T. Barnum, *Struggles and Triumphs; or, Forty Years' Recollections* (1871; reprint, Harmondsworth: Penguin, 1981), 234–35; "Frank Leslie," *FLIN*, 382; Kimball, "Frank Leslie," 259; Gambee, *Frank Leslie,* 10; Harris, *Humbug,* 319; A. H. Saxon, *P. T. Barnum: The Legend and the Man* (New York: Columbia University Press, 1989), 188–89.

35. "Frank Leslie," *FLIN*, 382; Kimball, "Frank Leslie," 259; Gambee, *Frank Leslie,* 10–11; Mott, *American Magazines, 1850–1865,* 437–38, 453; William E. Huntzicker, "Frank Leslie (Henry Carter)," in *American Magazine Journalists, 1850–1900,* ed. Sam G. Riley, vol. 79 of *Dictionary of Literary Biography* (Detroit: Gale Research, 1989), 211–12. Stephens's decision to move

to Leslie's magazine was probably in part provoked by her frustration with her status at *Peterson's:* although she was listed as the monthly's editor, its publisher, Charles J. Peterson, was interested only in securing a woman's name on the masthead to help attract female readers and actually edited the magazine himself (John Tebbel and Mary Ellen Zuckerman, *The Magazine in America, 1740–1990* [New York: Oxford University Press, 1991], 37). On Stephens, see Madeleine B. Stern, *We the Women: Career Firsts in Nineteenth-Century America* (New York: Schulte, 1963), 29–54.

36. David D. Hall, "Introduction: The Uses of Literacy in New England, 1600–1850," in *Printing and Society in Early America,* ed. William L. Joyce et al. (Worcester, Mass.: American Antiquarian Society, 1983), 1–47; Mary Kelley, *Private Woman, Public Stage: Literary Domesticity in Nineteenth-Century America* (New York: Oxford University Press, 1984), 7–12. On the impact of a new commercial literary market on the practice of several American authors, see R. Jackson Wilson, *Figures of Speech: American Writers and the Literary Marketplace, from Benjamin Franklin to Emily Dickinson* (New York: Alfred A. Knopf, 1989). The creation of the reading public has been equated by some historians with the defining of shared values in the formation of a new middle class, a perspective that overlooks how such values changed meaning as they crossed class boundaries. See John F. Kasson, *Rudeness and Civility: Manners in Nineteenth-Century Urban America* (New York: Hill and Wang, 1990), 37–43; in contrast, see studies of the restructuring of labor and working-class formation in antebellum America: e.g., Alan Dawley, *Class and Community: The Industrial Revolution in Lynn* (Cambridge, Mass.: Harvard University Press, 1976); Bruce G. Laurie, *Working People of Philadelphia, 1800–1850* (Philadelphia: Temple University Press, 1980); Paul G. Faler, *Mechanics and Manufacturers in the Early Industrial Revolution: Lynn, Massachusetts, 1780–1860* (Albany: State University of New York Press, 1981).

37. Ronald J. Zboray, "Antebellum Reading and the Ironies of Technological Innovation," *American Quarterly* 40.1 (March 1988): 65–82; Hall, "The Uses of Literacy in New England"; Kelley, *Private Woman, Public Stage,* 7–12; Mott, *American Magazines, 1850–1865,* 3; Peter C. Marzio, *The Men and Machines of American Journalism* (Washington, D.C.: National Museum of History and Technology, Smithsonian Institution, 1973), 47, 55–59; Levin, "The Golden Age of Illustration," 27–28.

38. Zboray, "Antebellum Reading and the Ironies of Technological Innovation," 68–72. Zboray also delineates the destructive impact of the Harpers' innovations on the printing trade.

39. *Putnam's Monthly* 9 (March 1857); quoted in Mott, *American Magazines, 1850–1865,* 391. The figures are given in Levin, "The Golden Age of Illustration," 32–37. See also Eugene Exman, *The House of Harper: One Hundred and Fifty Years of Publishing* (New York: Harper and Row, 1967), 69–79; Mott, *American Magazines, 1850–1865,* 383–91; Tebbel and Zuckerman, *The Magazine in America,* 20–22.

40. Kathleen Diffley, "Home on the Range: Turner, Slavery, and the Landscape Illustrations in *Harper's New Monthly Magazine, 1861–1876," Prospects* 14 (1989): 175–202.

41. Gambee, *Frank Leslie*, 60–63; idem, "Frank Leslie and His Illustrated Newspaper, 1855–1860: Artistic and Technical Operations of a Pioneer Pictorial News Weekly in America" (Ph.D. diss., University of Michigan, 1963), 381–420.

42. The friend is quoted in Kimball, "Frank Leslie," 259. See also Gambee, *Frank Leslie*, 63–64; Mott, *American Magazines, 1850–1865*, 454–55.

43. Albert Bigelow Paine, *Th. Nast: His Period and His Pictures* (New York: Macmillan, 1904), 23–24; "The late Thomas Powell, author and journalist," *FLIN*, January 22, 1887, 392; John Parker Davis, letters written to Albert Bigelow Paine, in *Life in Letters: American Autograph Journal* 4.2 (May 1940): 290.

44. Leslie, quoted in Kimball, "Frank Leslie," 259.

45. Gambee, *Frank Leslie*, 65–66; Edward Hatton, "Domestic Assassins: Gender, Murder, and the Middle Class in Antebellum America" (Ph.D. diss., Temple University, 1997), 320–71.

46. Gambee, *Frank Leslie*, 67–68 (comment about *Harper's Weekly* from *FLIN*, December 5, 1857, quoted on 68); Mott, *American Magazines, 1850–1865*, 469–74; Huntzicker, "Frank Leslie (Henry Carter)," 211, 214–15; Exman, *The House of Harper*, 80. For the *Illustrirte Zeitung*, see the issue of October 3, 1874, which is the only copy of the paper in the New York Public Library's Steiger Collection of German American Newspapers: with the exception of a cover and back-page engraving, the German-language edition includes all the news illustrations in the October 3, 1874, issue of *Frank Leslie's* (though in a different order).

47. Mott, *American Magazines, 1850–1865*, 4–5: excluding newspapers, approximately 685 periodicals existed in 1850; ten years later the number was reduced to 575. Between 1850 and 1865, about 2,500 magazines were published, on average lasting about four years before folding. The illustrated weeklies killed off the single-sheet lithographic trade in New York: individual publication of caricatures and cartoons could not compete with the new periodicals that included comic illustration along with news images. See Davison, "E. W. Clay and the American Political Caricature Business."

48. Kimball, "Frank Leslie," 259; Gambee, *Frank Leslie*, 69–72, 128–34, 295–98; Mott, *American Magazines, 1850–1865*, 456–58; Andrea G. Pearson, "*Frank Leslie's Illustrated Newspaper* and *Harper's Weekly:* Innovation and Imitation in Nineteenth-Century American Pictorial Reporting," *Journal of Popular Culture* 23.4 (spring 1990): 82–86. The artists responsible for sketching the swill milk scenes—chief artist Albert Berghaus and staff artists Thomas Nast and Sol Eytinge Jr.—were not credited in captions, to thwart possible libel actions from political supporters of the dairy owners that might stop the campaign (Gambee, *Frank Leslie*, 133).

49. *FLIN*, March 17, 1860, 242, 251 (illustrations of the strike appeared as well in the April 7 issue); Gambee, *Frank Leslie*, 76, 80. Moreover, Leslie featured the strike in the May 1860 cover cartoon of his new humor magazine, *Frank Leslie's Budget of Fun;* see Gary L. Bunker, "Antebellum Caricature and Woman's Sphere," *Journal of Women's History* 3.3 (winter 1992): 37. Illustrations of the Pemberton disaster also appeared in the January 21, 1860, issue of the New York *Illustrated News*, a new *Leslie's* competitor.

The engraving of the Lynn strikers' procession may have been the first image

of a strike to appear in the American press. In contrast, the visual realm of industrialization was dominated by monumental imagery of invention and technological development, exemplified in the illustrations published in *Scientific American*. See James P. Shenton, ed., *Free Enterprise Forever! "Scientific American" in the Nineteenth Century* (New York: Images Graphiques, 1977); Marianne Doezema, "The Clean Machine: Technology in American Magazine Illustration," *Journal of American Culture* 11.4 (winter 1988): 73–92.

50. Elliott J. Gorn, *The Manly Art: Bare-Knuckle Prize Fighting in America* (Ithaca, N.Y.: Cornell University Press, 1986), 148–57; Gambee, *Frank Leslie,* 80; idem, "Frank Leslie," 147–64, 304–5; Mott, *American Magazines, 1850–1865,* 458–59; Davis, letters, 292–94. For Nast's coverage of the fight, see Paine, *Th. Nast,* 37–44. *Harper's Weekly* denounced the celebration of blood sports, but ended up printing a full-page cut of the match.

51. Letter quoted in Splitstone, "Our Sixtieth Birthday," 661.

52. Gambee, *Frank Leslie,* 77–80, 81, 86; idem, "Frank Leslie," 141–47. On the illustrated press's efforts not to lose readers, including its publication of innocuous southern views that for the most part downplayed such ubiquitous and distressing sights as slave auctions, see W. Fletcher Thompson, *The Image of War: The Pictorial Reporting of the American Civil War* (New York: Thomas Yoseloff, 1959), 87. The *Frank Leslie's* artist William S. L. Jewett was forced to flee Virginia in November after it was learned that he had sold a John Brown drawing to the *New York Tribune. Leslie's* chose to report the incident in a three-panel cartoon, perhaps in an attempt to defuse the rancor surrounding the event. See "The Retreat of our Artist from Charlestown, Virginia," *FLIN,* November 26, 1858, reprinted in Gambee, *Frank Leslie,* 79. For *Harper's Weekly's* curtailed coverage, see Boyd B. Stutler, "An Eyewitness Describes the Hanging of John Brown," *American Heritage,* February 1955, 4–9; Cecil D. Eby Jr., *"Porte Crayon": The Life of David Hunter Strother* (Chapel Hill: University of North Carolina Press, 1960), 103–9.

53. Gambee, *Frank Leslie,* 86; "The Home of Illustrated Literature," *Frank Leslie's Popular Monthly* 16.2 (August 1883): 129. Aside from his *Illustrated Newspaper,* Leslie's 1860 publications aimed at more narrow readerships included *Frank Leslie's New Family Magazine, Frank Leslie's Illustrirte Zeitung, Frank Leslie's Budget of Fun,* and *Stars and Stripes* (Madeleine Bettina Stern, *Purple Passage: The Life of Mrs. Frank Leslie* [Norman: University of Oklahoma Press, 1953], 197).

54. Mott, *American Magazines, 1850–1865,* 10–11, notes that *Frank Leslie's Illustrated Newspaper* and *Harper's Weekly* were among only thirteen magazines in the United States during this period whose circulation surpassed 100,000. Moreover, all American pictorial news now came from three papers located in one American city.

CHAPTER 2. ILLUSTRATING THE NEWS

1. Charles Dickens, *Bleak House* (1853; reprint, Harmondsworth: Penguin, 1971), 523–24.

2. By 1858, with its purchase of a new high-speed press, *Frank Leslie's* lead

time was often reduced to one week. This achievement has been obscured by historians' reliance on the date appearing on *Leslie's* masthead, which seems to suggest a two-week gap between an event and *Leslie's* newsstand appearance; in fact, *Leslie's* was advance-dated one week and the printed date marked the end of that issue's week, not its beginning. Therefore, as Budd Gambee has pointed out, an issue dated December 22 actually appeared on newsstands on December 15 (Budd Leslie Gambee Jr., *Frank Leslie and His Illustrated Newspaper, 1855–1860,* University of Michigan Department of Library Science Studies 8 [Ann Arbor: University of Michigan, 1964], 56); see also Roger Butterfield, "Pictures in the Papers," *American Heritage,* June 1962, 98.

3. Budd Leslie Gambee Jr., "Frank Leslie and His Illustrated Newspaper, 1855–1860: Artistic and Technical Operations of a Pioneer Pictorial News Weekly in America" (Ph.D. diss., University of Michigan, 1963), provides the most valuable account of the early work of *Frank Leslie's* artists, particularly chief artist Albert Berghaus (who worked for the weekly from its inception into the 1880s), Jacob A. Dallas, Charles Parsons (an established lithographer who, in 1863, became the longtime supervisor of the Harper Brothers' art department), Sol Eytinge Jr., Henry Louis Stephens, Granville Perkins, and Thomas Nast. The experience of Nast, who began his employment with *Leslie's* at the age of fifteen, also has been chronicled in Albert Bigelow Paine, *Th. Nast: His Period and His Pictures* (New York: Macmillan, 1904); see also the less laudatory account in "Nast's Early Endeavor," *New York Sun,* June 24, 1877 (interview with Frank Leslie); John Parker Davis, letters written to Albert Bigelow Paine, *Life in Letters: American Autograph Journal* 4.2 (May 1940): 289–90.

Leslie's also imported talent from abroad: its most notable acquisition was the British cartoonist Matthew Somerville Morgan, hired to compete with *Harper's Weekly's* Thomas Nast during the 1872 presidential campaign (Paine, *Th. Nast,* 246–61). On the limitations of American artists' figurative proficiency, cited as one reason for *Leslie's* hiring of European artists, see the letter by the British art editor Henry Blackburn to the Louisville *Courier-Journal,* reprinted in "Editorial Topics," *Frank Leslie's Illustrated Newspaper* (hereafter *FLIN*), November 14, 1874, 147; see also Frank Leslie's derogatory remarks about American artists, made in a quasi-official capacity, in his "Report on the Fine Arts," in *Reports of the United States Commissioners to the Paris Universal Exposition, 1867,* ed. William P. Blake (Washington, D.C.: Government Printing Office, 1870), quoted in Mark Thistlewaite, "The Most Important Themes: History Painting and Its Place in American Art," in *Grand Illusions: History Painting in America,* ed. William H. Gerdts and Mark Thistlewaite (Fort Worth: Amon Carter Museum, 1988), 51.

4. See, for example, the request to "committees of fairs, exhibitions, dedications, and everything of a similar nature" to notify *Leslie's* beforehand to make arrangements for illustration; *FLIN,* December 4, 1869, 186.

5. See, for example, the notice to artists and professional and amateur photographers to send their addresses to *Frank Leslie's* offices; *FLIN,* May 26, 1877, 198.

6. *FLIN,* April 26, 1873, 102. Gambee (*Frank Leslie,* 40–42) compares the secondhand procedures of print journalism to artist-reporters' work. Like print

reporters, artist-reporters did more than report the news: their personae became part of its chronicling. As the coverage of the "swill milk" scandal and John Brown's trial and execution demonstrated, the artist often appeared as a character in news engravings, delineating his role both as recorder and as surrogate for the reader: see Andrea G. Pearson, "*Frank Leslie's Illustrated Newspaper* and *Harper's Weekly:* Innovation and Imitation in Nineteenth-Century American Pictorial Reporting," *Journal of Popular Culture* 23.4 (spring 1990): 81–111.

7. Reinhart, quoted in William Allen Rogers, *A World Worth While: A Record of "Auld Acquaintance"* (New York: Harper and Brothers, 1922), 236.

8. See *FLIN,* April 16, 1870, 75, and February 11, 1871, 363, on the publication's traveling photography van and its "system of ambulant photographers" respectively.

9. Frederic Ray, *Alfred R. Waud: Civil War Artist* (New York: Viking, 1974); Jo Ann Early Levin, "The Golden Age of Illustration: Popular Art in American Magazines, 1850–1925" (Ph.D. diss., University of Pennsylvania, 1980); Rebecca Zurier, "Picturing the City: New York in the Press and the Art of the Ashcan School, 1890–1917" (Ph.D. diss., Yale University, 1988); Peter Bacon Hales, *Silver Cities: The Photography of American Urbanization, 1839–1915* (Philadelphia: Temple University Press, 1984).

10. My description of the process is based on the following sources: "How Illustrated Newspapers Are Made," *FLIN,* August 2, 1856, 125–26; "How an Illustrated Paper Is Made," *FLIN,* July 7, 1866, 251 (a reprint of an article originally published in the *New York Evening Post*); "The Home of Illustrated Literature," *Frank Leslie's Popular Monthly* 16.2 (August 1883): 129–31; Rogers, *A World Worth While,* 12–15; Mason Jackson, *The Pictorial Press: Its Origins and Progress* (London: Hurst and Blackett, 1885), 315–26; William M. Ivins Jr., *Prints and Visual Communication* (1953; reprint, Cambridge, Mass.: Massachusetts Institute of Technology Press, 1969), 97–99, 99–108; Levin, "The Golden Age of Illustration," 22–23, 26–27, 28–31, 43–44, 49; Gambee, *Frank Leslie,* 46–55; Peter C. Marzio, *The Men and Machines of American Journalism* (Washington, D.C.: National Museum of History and Technology, Smithsonian Institution, 1973), 64–69.

11. Ivins, *Prints and Visual Communication,* 86–87; Levin, "The Golden Age of Illustration," 20–23; John Brewer, *The Pleasures of the Imagination: English Culture in the Eighteenth Century* (New York: Farrar, Straus, and Giroux, 1997), 499–530.

12. A full-page engraving in *Frank Leslie's* measured 9 by 14 inches; a double-page cut measured 14 by 20 inches, and could be divided into as many as thirty-six sections. Harriet Quimby, in "How Frank Leslie Started the First Illustrated Weekly" (*Leslie's Weekly,* December 14, 1905, 568), credits Leslie for inventing the jointed block; Celina Fox, in *Graphic Journalism in England during the 1830s and 1840s* ([New York: Garland, 1988], 62 n. 2), argues that Charles Wells, a British cabinetmaker and boxwood importer, devised the innovation around 1860. As Gambee suggests, "it might be safer to say that he [Leslie] was the first to make extensive and successful use of the device" (*Frank Leslie,* 47).

13. For artists' specializations in *Frank Leslie's* first year, see Gambee, "Frank Leslie," 118–19: Albert Berghaus did architectural and mechanical drawings;

Jacob Dallas, human figures; Charles Parsons, sea- and landscapes; and Samuel Waller, portraits, while Frank Bellew and John McLenan were responsible for cartoons.

14. Timothy Cole, *Considerations on Engraving* (New York: W. E. Rudge, 1921); cited in James Watrous, *American Printmaking: A Century of American Printmaking, 1880–1980* (Madison: University of Wisconsin Press, 1984), 20. For a vivid, illustrated discussion of engraving, see William M. Ivins Jr., *How Prints Look*, rev. ed. (Boston: Beacon Press, 1987), 28–43.

15. William J. Linton, "Art in Engraving on Wood," *Atlantic Monthly* 43 (June 1879); quoted in Levin, "The Golden Age of Illustration," 43–44. On Linton at *Frank Leslie's*, see *FLIN*, February 2, 1867, cover (369); William James Linton, *Memories* (London: Lawrence and Bullon, 1895), 207 (published in the United States as *Threescore and Ten Years, 1820 to 1890*); F. B. Smith, *Radical Artisan: William James Linton, 1812–97* (Manchester: Manchester University Press, 1973), 160, 178.

16. Ivins, *Print and Visual Communication*, 98–99.

17. John P. Davis in "A Symposium of Wood-Engravers," *Harper's New Monthly Magazine* 60 (February 1880); quoted in Levin, "The Golden Age of Illustration," 49. See also Ann Prentice Wagner, "The Graver, the Brush, and the Ruling Machine: The Training of Late-Nineteenth-Century Wood Engravers," *Proceedings of the American Antiquarian Society* 105, pt. 1 (1995): 167–91.

18. Wagner, "The Graver, the Brush, and the Ruling Machine," 182–85; Helena E. Wright, *With Pen and Graver: Women Graphic Artists before 1900* (Washington, D.C.: National Museum of American History, Smithsonian Institution, 1995), 7–8. On women in the British trade, see Fox, *Graphic Journalism in England*, 66–70. See also *FLIN*, April 14, 1883, 125, 126; and see the *Magazine of Art* 40 (October 1947): 243, for a photograph of the engraving class (with Peter Cooper and, possibly, William Linton observing).

19. By 1866, *Leslie's* was employing photoxylography to transfer some images directly onto the wood surface, circumventing the earlier stages of artists' work on the block ("How an Illustrated Paper Is Made," 251). At the time, this process was apparently reserved for transferring photographs, since the 1866 *Frank Leslie's* article describing the process also listed twelve artists assigned to sketch pictures onto the block. Photoxylography would be perfected in the 1870s. See Levin, "The Golden Age of Illustration," 49–55; Watrous, *American Printmaking*, 20–26.

20. Hiram Campbell Merrill, *Wood Engraving and Wood Engravers* (Boston: Society of Printers, 1937), 5–6; quoted in Wagner, "The Graver, the Brush, and the Ruling Machine," 181–82.

21. Leslie estimated that each engraving cost approximately $30 to draw and cut; double-page engravings, involving as many as thirty-six pieces, ran up to $130. In 1866, when Leslie employed twelve in-house artists and more than forty engravers, the weekly bill for engraving alone came to more than $2,000 (Gambee, *Frank Leslie*, 67–68; "How an Illustrated Paper Is Made," 251). Similar costs were accrued for engravings in *Harper's Monthly*, which we can assume reflects *Harper's Weekly*'s expenses: see "Making the Magazine," *Harper's New Monthly Magazine* 32 (December 1865): 1–31; Frank Luther Mott, *A His-*

tory of American Magazines, 1850–1865 (Cambridge, Mass.: Harvard University Press, 1938), 193. It is instructive to compare the above description of the subdivided process to that of the process it replaced, published in *Gleason's Pictorial Drawing-Room Companion,* January 17, 1852, 45.

22. "The Home of Illustrated Literature," 130; Levin, "The Golden Age of Illustration," 28–31; Ronald J. Zboray, "Antebellum Reading and the Ironies of Technological Innovation," *American Quarterly* 40.1 (March 1988): 72–73. *Harper's Monthly* was the first illustrated publication to substitute electrotyping for stereotyping.

23. "How Illustrated Newspapers Are Made," 251.

24. "The Taylor Perfecting Press," *FLIN,* March 20, 1858, 125–26; Gambee, *Frank Leslie,* 49–53. Leslie's use of new printing technology stands in contrast to the House of Harper, which continued to use an outmoded Adams press to print pictures into the late 1870s (Levin, "The Golden Age of Illustration," 28–29). According to "How an Illustrated Paper Is Made," after failing to locate either domestic or imported inks of "the right quality," Leslie began manufacturing his own formula. Gambee (*Frank Leslie,* 86) reports that in 1860 Leslie was expending between $6,000 and $7,000 annually for ink, an insignificant figure compared to the $160,000 allotted for paper.

25. On less genteel amusements, see *FLIN,* August 8, 1868, 329. See also "The 'Tribune's' Doubts," *FLIN,* August 22, 1868, 354, which quotes the *New York Tribune*'s criticism of *Leslie's* sensational engravings: "proofs of our civic degradation being multiplied and scattered all over the country, debauch the imaginations of our rural population." On the *National Police Gazette,* see Dan Schiller, *Objectivity and the News: The Public and the Rise of Commercial Journalism* (Philadelphia: University of Pennsylvania Press, 1981); Elliott J. Gorn, "The Wicked World: The *National Police Gazette* and Gilded Age America," *Media Studies Journal* 6.1 (winter 1992): 1–15; Edward Van Every, *Sins of New York, as "Exposed" by the "National Police Gazette"* (New York: Frederick A. Stokes, 1930); Gene Smith and Jane Barry Smith, eds., *The Police Gazette* (New York: Simon and Schuster, 1972); Mott, *American Magazines, 1850–1865,* 325–37.

26. On boxing, see *FLIN,* January 25, 1868, cover (289), versus June 13, 1868, 205. On Kit Burns, see *FLIN,* December 8, 1866, 181 (seven cuts), and December 22, 1866, 217.

27. "Look on This Picture and on That," *FLIN,* December 29, 1866, 226. For other declarations in *FLIN* that sensational pictures had reformist goals, see "Horrible Pictures. The Duties of the Illustrated Press," February 15, 1868, 338; "The 'Tribune' not 'Orthodox,'" February 8, 1873, 346–47. On Burns, see Daniel Czitrom, "Wickedest Ward in New York," *Seaport* 20.3 (winter 1986–87): 20–26.

28. *New York Express,* quoted in *FLIN,* March 21, 1868, 3. The portrayal of pointless evangelical intervention was published as two engravings in *FLIN,* October 10, 1868, 56. See also, as both an alternative to the earlier cut of John Allen's establishment and a tweak to reform efforts, "Reformation of 'the Wickedest Man in New York'—The noon prayer meeting at John Allen's late Dance

House, Water Street, N.Y., Sept. 1st," *FLIN*, September 19, 1868, cover (1). In contrast, see *Harper's Weekly*'s reverent "Prayer-meeting in the 'Wickedest Man's' dance-house," September 19, 1868, cover (593).

29. On theater's increasing bifurcation, see Lawrence W. Levine, *Highbrow/Lowbrow: The Emergence of Cultural Hierarchy in America* (Cambridge, Mass.: Harvard University Press, 1988); Peter George Buckley, "To the Opera House: Culture and Society in New York City, 1820–1860" (Ph.D. diss., State University of New York at Stony Brook, 1984).

30. *New York Catholic Total Abstinence Union*, quoted in *FLIN*, October 2, 1875, 51.

31. J. C. Derby, *Fifty Years among Authors, Books, and Publishers* (New York: G. W. Carleton, 1884), 692–93.

32. On Leslie's book publishing, ranging from expensive compendia of previously published illustrations to "Frank Leslie's Home Library of Standard Works by the Most Celebrated Authors" (the thirty-five titles of which, despite its title, were almost exclusively available on or in the proximity of trains), see Madeleine B. Stern, *Imprints on History: Book Publishers and American Frontiers* (Bloomington: Indiana University Press, 1956), 226–29; eadem, ed., *Publishers for Mass Entertainment in Nineteenth Century America* (Boston: G. K. Hall, 1980), 183–86.

33. Succeeding the short-lived *Last Sensation, The Days' Doings* began publication in June 1868, purportedly under the auspices of James Watts and Company. However, Leslie's ownership was apparent from the start, evidenced in the reprinting of illustrations published in *Frank Leslie's Illustrated Newspaper* (see, e.g., coverage of Kit Burns's dogfights in the issues of September 26, 1868, and October 3, 1868, using material published in *Frank Leslie's* in 1866), the featuring of engravings signed by familiar Leslie artists (notably chief artist Albert Berghaus), and the substantial listings of other Leslie publications among its back advertisements. On *The Days' Doings*, see Madeleine Bettina Stern, *Purple Passage: The Life of Mrs. Frank Leslie* (Norman: University of Oklahoma Press, 1953), 52, 191, 223; Fulton Oursler, "Frank Leslie," *American Mercury*, May 1930, 98–99; and Frank Luther Mott, *A History of American Magazines, 1865–1885* (Cambridge, Mass.: Harvard University Press, 1938), 44 (differing somewhat from Stern's account). By the time he began publishing *The Days' Doings*, Leslie himself had become a figure of notoriety based on his heedlessly flamboyant style of living—almost a caricature of the Gilded Age—and the scandal-ridden circumstances surrounding his divorce from his first wife and his second marriage.

34. My thanks to Peter Buckley and Dan Schiller for discussions and correspondence that contributed to some of the ideas in this paragraph. My consideration of a middle reading public departs from recent historiography of popular culture in the nineteenth century (exemplified by Levine, *Highbrow/Lowbrow*) that proposes a rapid and decisive split into "high" and "low" constituencies.

35. *FLIN*, January 23, 1869, 290; November 20, 1869, 154.

36. David Paul Nord, "Working-Class Readers: Family, Community, and Reading in Late Nineteenth-Century America," *Communication Research* 13.2

(April 1986): 156–81. Regarding working-class readers of *Frank Leslie's,* see letters printed in *FLIN,* April 3, 1875, 51; June 24, 1882, 275.

37. James Parton, "Pittsburg," *Atlantic Monthly* 21 (January 1868): 34–35; quoted in Francis G. Couvares, *The Remaking of Pittsburgh: Class and Culture in an Industrializing City, 1877–1919* (Albany: State University of New York Press, 1984), 37. On the range of public reading experiences offered by the city, see David Henkin, *City Reading: Written Words and Public Spaces in Antebellum New York* (New York: Columbia University Press, 1999). Nicholas Salvatore's research on Amos Webber, an African American wire mill worker living in Worcester, Massachusetts, during the 1880s, has revealed Webber's extensive reliance on materials available in the Worcester Free Library and local YMCA reading room, including reference to *Frank Leslie's;* see Amos Webber, Temperature Book and Diary, vol. 122, July 23, 1885, 103 (American Steel and Wire Collection, Baker Library, Harvard Graduate School of Business Administration, Boston [reference provided by Nicholas Salvatore]), and Nick Salvatore, *We All Got History: The Memory Books of Amos Webber* (New York: New York Times/Random House, 1996), 237–38.

38. Buckley, "To the Opera House," 486–95, 540; Neil Harris, *Humbug: The Art of P. T. Barnum* (Boston: Little, Brown, 1973), 54–57, 107–8, 165–72, 179–81; Bluford Adams, *E Pluribus Barnum: The Great Showman and the Making of U.S. Popular Culture* (Minneapolis: University of Minnesota Press, 1997), 75–163, esp. 87–89. Leslie engraved *Barnum's American Museum Illustrated* (New York: William Van Norden and Frank Leslie, 1850).

39. *Savannah News,* January 10, 1861; quoted in Mott, *American Magazines, 1850–1865,* 108. See also W. Fletcher Thompson, *The Image of War: The Pictorial Reporting of the American Civil War* (New York: Thomas Yoseloff, 1959), 87; Mott, *American Magazines, 1850–1865,* 7.

40. On the role of the press in propelling the Civil War, see Thomas C. Leonard, *The Power of the Press: The Birth of American Political Reporting* (New York: Oxford University Press, 1986), 90–96. A copious pictorial battle between abolitionist and proslavery forces, largely carried out in individually published prints and broadsides, antedated the illustrated press. For surveys of the decades-long representational struggle, which heightened southern sensitivity to pictorial coverage, see Bernard F. Reilly Jr., "The Art of the Antislavery Movement," in *Courage and Conscience: Black and White Abolitionists in Boston,* ed. Donald M. Jacobs (Bloomington: Indiana University Press, 1993), 47–73; Phillip Lapansky, "Graphic Discord: Abolitionist and Antiabolitionist Images," in *The Abolitionist Sisterhood: Women's Political Culture in Antebellum America,* ed. Jean Fagan Yellin and John C. Van Horne (Ithaca, N.Y.: Cornell University Press, 1994), 201–30.

41. *FLIN,* February 2, 1861; quoted in Stuart William Becker, "*Frank Leslie's Illustrated Newspaper* from 1860 to the Battle of Gettysburg" (M.A. thesis, University of Missouri, Columbia, 1960), 55; see also 52–57.

42. Notice in *FLIN,* April 27, 1861; quoted in Jan Zita Grover, "The First Living-Room War: The Civil War in the Illustrated Press," *Afterimage,* February 1984, 9, 11. On *Harper's Weekly* during the secession crisis, see Mott, *American Magazines, 1850–1865,* 472–74. *Leslie's* position is given in *FLIN,* No-

vember 24, 1860; quoted in Becker, "*Frank Leslie's* from 1860 to the Battle of Gettysburg," 52.

43. Becker, "*Frank Leslie's* from 1860 to the Battle of Gettysburg," 19; Mott, *American Magazines, 1850–1865,* 7; Marzio, *The Men and Machines of American Journalism,* 61, 64–67; Zurier, "Picturing the City," 85. See also Francis H. Schell, "Recollections of a Leslie's Special Artist in the Civil War: No. 1 Baltimore in 1861; Generals Butler and Banks and the Baffled Insurrectionists," *Imprint: Journal of the American Historical Print Collectors Society* 23.1 (spring 1998): 18–26, for early *Leslie's* coverage of the war.

44. While Grover ("The First Living-Room War") exemplifies the view that Civil War photographs conveyed the "authenticity" of warfare, Alan Trachtenberg, in *Reading American Photographs: Images as History: Mathew Brady to Walker Evans* ([New York: Hill and Wang, 1982], 71–118), suggests that these images may have not so much led to sobering reflections on the part of viewers as legitimated already-held beliefs. Authenticity is, of course, a thorny subject in the interpretive history of Civil War photography; as recent scholarship has noted, photographs were often staged with the subjects posed to connote informality, and photographers may have gone so far as to shift the position of corpses to gain a more theatrical effect (William Frassanito, *Gettysburg: A Journey in Time* [New York: Charles Scribner's Sons, 1975], 186–92).

45. *Times* (London), quoted in Trachtenberg, *Reading American Photographs,* 73. On the photography of the Civil War, see Trachtenberg, *Reading American Photographs,* 71–118; Grover, "The First Living-Room War"; Michael L. Carlebach, *The Origins of Photojournalism in America* (Washington, D.C.: Smithsonian Institution Press, 1992), 62–101; Robert Taft, *Photography and the American Scene: A Social History, 1839–1889* (New York: Macmillan, 1938), 223–47.

46. On the number of engravings, see Roger Butterfield, "Pictures in the Papers," *American Heritage,* June 1962, 99. William P. Campbell, in *The Civil War: A Centennial Exhibition of Eyewitness Drawings* ([Washington, D.C.: National Gallery of Art, 1961], 107), lists 2,625 engravings based on artists' sketches (1,322 for *Frank Leslie's,* 759 for *Harper's Weekly,* and 411 for the New York *Illustrated News*), suggesting that if Butterfield's total is anywhere near correct, the difference reflects engravings not based on the work of or ascribed to a particular special artist.

47. *Harper's Weekly,* June 3, 1865; quoted in Harold Holzer, Gabor S. Boritt, and Mark E. Neely, *The Lincoln Image: Abraham Lincoln and the Popular Print* (New York: Charles Scribner's Sons, 1984), 84.

48. Robert Ferguson, *America during and after the War* (London: Longmans, Green, Reader, and Dyer, 1866); quoted in Thompson, *The Image of War,* 137. On soldiers and the illustrated press, see David Kaser, *Books and Libraries in Camp and Battle: The Civil War Experience* (Westport, Conn.: Greenwood Press, 1984), 33–34, 56–57; Thompson, *The Image of War,* 136–37.

49. Thomas Wentworth Higginson, *Army Life in a Black Regiment* (1870; reprint, East Lansing: Michigan State University Press, 1961), 16; report by J. W. Alvord, inspector of schools and finances, to the commissioners of the Freedmen's Bureau, January 1, 1866, appended to his testimony to the Joint Committee on

Reconstruction on February 3, 1866, in House, *Report of the Joint Committee on Reconstruction,* 39th Cong., 1st sess., 1866, H. Doc. 30, part 2, 256–57.

50. Eliza Francis Andrews, *The War-Time Journal of a Georgia Girl, 1864–1865* (New York: D. Appleton, 1908); quoted in William Fletcher Thompson Jr., "Illustrating the Civil War," *Wisconsin Magazine of History* 45.1 (autumn 1961): 20.

51. *Southern Illustrated News,* July 1863; quoted in Thompson, *The Image of War,* 23.

52. Campbell, *The Civil War,* 11; Mott, *American Magazines, 1850–1865,* 8–9, 112–13. For examples of the *Southern Illustrated News*'s engravings, see Lamont Buchanan, *A Pictorial History of the Confederacy* (New York: Crown, 1951).

53. W. Stanley Hoole, *Vizetelly Covers the Confederacy* (Tuscaloosa, Ala.: Confederate Publishing, 1957); Thompson, *The Image of War,* 189 n. 20; Campbell, *The Civil War,* 11–13, 134–35, and passim. Vizetelly, who received the appointment of "honorary captain" after serving as a messenger for General Longstreet during the Battle of Chickamauga, returned to England after the Civil War. He disappeared in Egypt in 1883 while covering the Sudanese War for the London *Graphic* (*FLIN,* November 29, 1884, 227; February 7, 1885, 403).

54. Lovie in *FLIN,* December 7, 1861; quoted in Campbell, *The Civil War,* 27. See Louis M. Starr, *Bohemian Brigade: Civil War Newsmen in Action* (1954; reprint, Madison: University of Wisconsin Press, 1987), 252–55.

55. *FLIN,* December 10, 1864; quoted in Mott, *American Magazines, 1850–1865,* 460.

56. Campbell (*The Civil War,* 107) counts ten artists for *Harper's Weekly* and four for the New York *Illustrated News. Frank Leslie's* artists, according to Campbell, included Arthur Lumley, William T. Crane, Frank H. Schell, Edwin Forbes, Henri Lovie, William Waud. Joseph Becker, C. E. H. Bonwill, Joseph (*sic,* for James) E. Taylor, Fred. B. Schell, J. F. E. Hillen, Bradley S. Osbon (one published picture), William R. McComas, Edward S. Hall, Andrew McCallum, E. F. Mullen, and James W. McLaughlin. Two decades after the Civil War, Leslie's Publishing House still persisted in claiming that it had employed eighty artists during the war, listing by name twenty-seven artists, misspelling a number of those names, leaving out its then art department supervisor Joseph Becker, substituting *Harper's Weekly*'s Alfred R. Waud for his brother William, and including at least one artist, Thomas Nast, who had ceased working for *Leslie's* by the time the war began ("The Home of Illustrated Literature," 134). More generally, see Thompson, *The Image of War,* 30–31; Campbell, *The Civil War,* 101–2 n. 9.

57. According to Lovie, Sherman declared, "You fellows make the best spies that can be bought. Jeff Davis owes more to you newspapermen than to his army" (*FLIN,* December 7, 1861; quoted in Becker, "*Frank Leslie's* from 1860 to the Battle of Gettysburg," 40); see also Campbell, *The Civil War,* 59. On the other hand, many officers, cognizant that pictorial publicity might further their careers, gladly accepted the company of artists—at least one to his own detriment: a Captain De Golyer was fatally wounded at Vicksburg while admiring a

Harper's Weekly engraving of his battery (Theodore R. Davis, "How a Battle Is Sketched," *St. Nicholas* 16 [July 1889]: 664; idem, "Grant under Fire," *Cosmopolitan* 14 [January 1893]: 337). On John Hillen, see Thompson, *The Image of War*, 84; Campbell, *The Civil War*, 39.

58. *FLIN*, May 17, 1862; quoted in Ray, *Alfred R. Waud*, 29.

59. Edwin Forbes, *Thirty Years After: An Artist's Story of the Great War Told and Illustrated with Nearly 300 Relief-etchings after Sketches in the Field and 20 Half-tone Equestrian Portraits from Original Oil Paintings*, vol. 1 (New York: Fords, Howard, and Hulbert, 1890); quoted in Thompson, *The Image of War*, 121.

60. On Forbes, see Thompson, *The Image of War*; Campbell, *The Civil War*, 42, 45–46, 49–50, 52, 54. See Davis, "How a Battle Is Sketched," 661–68; Frank H. Schell, "Sketching under Fire at Antietam," *McClure's Magazine* 22 (February 1904): 418–29.

61. Lovie, *FLIN*, May 17, 1862; quoted in Campbell, *The Civil War*, 86–88. The most detailed retrospective account of the wartime life and work of the special artist appears to be "With Sheridan up the Shenandoah Valley in 1864: Leaves from a Special Artist's Sketch Book and Diary," by the *Leslie's* artist James E. Taylor; these illustrated memoirs, completed in 1898, were never published, but excerpts in *American Heritage* make it clear that they are a valuable source; see Oliver Jensen, "War Correspondent: 1864: The Sketchbooks of James E. Taylor," *American Heritage*, August–September 1980, 48–64.

62. At the end of the war, *Frank Leslie's* stated that "many of the pictures and nearly all the portraits, which our readers admire weekly, are photographed directly on the wood. . . . [C]omparatively little work or skill is then requisite to fit it for the hand of the engraver" (*FLIN*, December 16, 1865; quoted in Campbell, *The Civil War*, 103 n. 42). The process of photoxylography seems to have been instituted at the weekly during the war. Although it clearly facilitated the transfer of images, since many of the special artists' sketches were rough or not proportioned to the woodblock, the process may have been used mainly to transfer photographs (see n. 19 above). Photoxylography was not perfected until the late 1870s, suggesting that *Leslie's* announcement was aimed more at fending off charges of fabrication than at reflecting usual practice.

63. Campbell, *The Civil War*, 72, 74–75; cf. Thompson, *The Image of War*, 83–84. The most notorious change involved Alfred Waud's sketch showing a surgical procedure on the Antietam battlefield, where artists at *Harper's Weekly* office reversed the position of the body of a wounded soldier on an operating table to hide the stump of his amputated leg. The engraving, "Carrying off the Wounded after the Battle," was published in the October 11, 1862, edition; see Ray, *Alfred R. Waud*, 112–13, for a comparison of the sketch and cut.

64. Waud, quoted in Campbell, *The Civil War*, 65.

65. William J. Hoppin, *United States Army and Navy Journal* 1 (1863–64); quoted in Grover, "The First Living-Room War," 9. For *Leslie's* editorial positions critical of the Lincoln administration and military officers while displaying goodwill toward soldiers (reflecting in part the weekly's perception of a broad northern readership), see Becker, "*Frank Leslie's* from 1860 to the Battle of Get-

tysburg," 61–68. *Leslie's* supported Lincoln's decision to institute conscription, although it proposed substantially higher pay scales than those codified in the law. On soldiers' critiques of engravings, see Thompson, *The Image of War,* 137–39; Kaser, *Books and Libraries in Camp and Battle,* 33–34.

Soldiers' enthusiastic yet skeptical attitude toward the pictorial press persisted long after the war, as shown on the occasion in 1880 when the *Leslie's* artist Georgina A. Davis visited the Washington, D.C., Soldiers' Home established for Civil War veterans (*FLIN,* July 24, 1880, 351): "As the artist rapidly sketched [the institution's dining hall], our guide betrayed a nervous anxiety lest any detail should be disrespectfully slurred over. 'Be sure there's seven chairs to each table,' he repeated, feelingly. 'Every man here'll see the picture, and count 'em up to see if they're all right. You can't make any mistake but what they'll hit on it.'" Later, in the institution's hospital ward, the guide elaborates:

> "No, the men don't mind you," he adds, in reply to a question; "it's something for them to look at and talk about after you're gone; and they'll see the pictures when they come out, and if there's a pencil-stroke out of the way in the leg of a table, they'll know it," he warns the artist, cheerfully.
>
> So we depart, conscious of a body of stern censors who are ready to pounce on our notes and sketches as soon as they see the light in the columns of FRANK LESLIE'S ILLUSTRATED NEWSPAPER.

66. On soldiers' testimonials, see Thompson, *The Image of War,* 138–39; Campbell, *The Civil War,* 63–65. On papers' accusations of competitors' fabrication, see Becker, "*Frank Leslie's* from 1860 to the Battle of Gettysburg," 27; Zurier, "Picturing the City," 89. For satiric commentary on fabrications, see "Our own artist sketching 'A view of Gen. Banks' army on the spot, from a drawing by our artist,'" *Vanity Fair,* September 14, 1861, 130; "Explosion of the 'Merrimac,' or any other ship," *Vanity Fair,* May 31, 1862, 262.

67. The advent of bylines was provoked by a War Department edict designed to make censorship easier: see Michael Schudson, *Discovering the News: A Social History of American Newspapers* (New York: Basic Books, 1978), 68; Marzio, *Men and Machines of American Journalism,* 62; Zurier, "Picturing the City," 90–91. On *Frank Leslie's* drawing pads, see Campbell, *The Civil War,* 112.

68. The August 1861 engraving left Lyon atop his horse and heroically urging on his troops; Lovie's original sketch caught him toppling off his horse. See the comparison of the sketch and cut in Campbell, *The Civil War,* 88–89; see also Thompson, *The Image of War,* 60–61. On the Antietam engravings, see ibid., 57–58.

69. The Fort Pillow engravings appeared in *FLIN,* May 7, 1864, 97, and July 16, 1864, 259. See Sidney Kaplan, "The Black Soldier of the Civil War in Literature and Art," in *The Chancellor's Lecture Series, 1979–1980* (Amherst: University of Massachusetts, 1981), 1–39 (Kaplan mistakenly credits several *Leslie's* cuts to *Harper's Weekly*); Thompson, *The Image of War,* 172–74; Becker, "*Frank Leslie's* from 1860 to the Battle of Gettysburg," 68–70. *Leslie's* supported black troops because they offered a practical contribution to the Union war effort; *Harper's Weekly,* in contrast, saw their inclusion in the military as a right.

CHAPTER 3. CONSTRUCTING REPRESENTATION, 1866–77

1. William Wordsworth, "Illustrated Books and Newspapers," in *The Poetical Works of William Wordsworth*, ed. William Knight, vol. 8 (Edinburgh: William Paterson, 1886), 172; see Lawrence W. Levine, *Highbrow/Lowbrow: The Emergence of Cultural Hierarchy in America* (Cambridge, Mass.: Harvard University Press, 1988), 160–66.

2. "Our New Volume," *Frank Leslie's Illustrated Newspaper* (hereafter *FLIN*), March 16, 1872, 2.

3. "A New Volume," *FLIN*, September 14, 1872, 2.

4. "Notice," *FLIN*, September 2, 1871, 414. In its early years, *Leslie's* did not hesitate to "borrow" images of European events from the foreign press, especially from the publisher's former employer. However, after it instituted "The Pictorial Spirit of the Illustrated Foreign Press" in December 1866, *Leslie's* regularly devoted its fourth page to anywhere from four to ten reduced engravings derived from its French, German, and British counterparts. The department ended in May 1889 after *Leslie's* was sold to the Judge Publishing Company. On early piracy, see Budd Leslie Gambee Jr., "Frank Leslie and His Illustrated Newspaper, 1855–1860: Artistic and Technical Operations of a Pioneer Pictorial News Weekly in America" (Ph.D. diss., University of Michigan, 1963), 381–420. For denunciations of competitors' use of foreign sources in *FLIN*, see "The Handsomest Illustrated Newspaper," January 8, 1870, 274; "What Is an 'American Illustrated Newspaper'?" January 29, 1870, 330; "Illustrated Newspapers, Again," April 9, 1870, 50; "Notice," September 2, 1871, 414.

5. Stuart William Becker, "*Frank Leslie's Illustrated Newspaper* from 1860 to the Battle of Gettysburg" (M.A. thesis, University of Missouri, Columbia, 1960), 20–21; W. Fletcher Thompson, *The Image of War: The Pictorial Reporting of the American Civil War* (New York: Thomas Yoseloff, 1959), 125–26. While the Civil War created difficulties for *Frank Leslie's,* it devastated the New York *Illustrated News,* whose war coverage was never comparable to either of its rivals. In January 1864 the journal was sold and began a new, if brief, life as *Demorest's New York Illustrated News.* The paper included less and less news until, in August, it was merged with Demorest's *Mirror of Fashion* (Frank Luther Mott, *A History of American Magazines, 1850–1865* [Cambridge, Mass.: Harvard University Press, 1938], 45).

6. For circulation figures, see George P. Rowell, ed., *Geo. P. Rowell and Co.'s American Newspaper Directory* (New York: G. P. Rowell, 1869), 72, 73; Budd Leslie Gambee Jr., *Frank Leslie and His Illustrated Newspaper, 1855–1860,* University of Michigan Department of Library Science Studies 8 (Ann Arbor: University of Michigan, 1964), 14; Mott, *American Magazines, 1850–1865,* 460, 476. For example, according to *Leslie's,* pictorial coverage of the 1871 Chicago Fire sent circulation up to 470,000 (*FLIN,* November 11, 1871, 131).

7. Goldsmith, in Charles F. Wingate, ed., *Views and Interviews on Journalism* (New York: F. B. Patterson, 1875), 104–5. Goldsmith apparently lasted only two years as editor of *Frank Leslie's.* As his career with *Leslie's* indicates, throughout its history the paper (or its proprietor) ran through a stream of editors who, for the most part, have remained anonymous. With the exception of

Ephraim Squier (discussed in chapter 5), evidence about other editors is afforded
by chance references such as *Leslie's* obituary of its first editor, Thomas Powell
(*FLIN*, January 22, 1887, 391), or comments in Joseph Henry Harper's mem-
oir, *The House of Harper: A Century of Publishing in Franklin Square* ([New
York: Harper and Brothers, 1912], 224), about John Y. Foster, a young journal-
ist from the Newark *Daily Advertiser* who briefly took over *Harper's Weekly's*
editorship around 1863 and subsequently assumed the role at *Frank Leslie's* at
an undisclosed date. As for Goldsmith, Madeleine Bettina Stern (*Purple Passage:
The Life of Mrs. Frank Leslie* [Norman: University of Oklahoma Press, 1956],
95) notes that Frank Leslie later suspected him of contributing to a widely cir-
culated 1878 pamphlet detailing Mrs. Leslie's checkered past; Goldsmith later
authored *Himself Again; a Novel* (New York: Funk and Wagnalls, 1884).

 8. Frank Leslie's Publishing House moved to Pearl Street in 1864, leaving
72 Duane Street (where it had briefly settled in 1863, after leaving 19 Chatham
Street). Leslie's also established branch offices around the country where dupli-
cate plates were sent to facilitate distribution in the West. See the reference to a
Chicago office in "How an Illustrated Paper Is Made," *FLIN*, July 7, 1866, 251
(reprint of article originally published in the *New York Evening Post*).

 9. Gambee, *Frank Leslie*, 12–20. This list omits periodicals that lasted less
than four years; for a year-by-year breakdown of all Leslie's publications from
1854 to 1905, see Stern, *Purple Passage*, 189–98; see also William E. Huntzicker,
"Frank Leslie (Henry Carter)," in *American Magazine Journalists, 1850–1900*,
ed. Sam G. Riley, vol. 79 of *Dictionary of Literary Biography* (Detroit: Gale Re-
search, 1989), 209–22. Kirsten Silva Gruesz, in "Brave *Mundo Nuevo*: Spheres
of Influence in Martí's New York" (paper delivered at the American Literature
Association conference, Baltimore, May 23, 1997), discusses *El Mundo Nuevo*
(1871–74), a Spanish-language miscellany published under Leslie's auspices
that previous histories of the firm have overlooked. Edited by the Cuban emi-
gré Enrique Piñeyro, the twice-monthly magazine was directed to Cubans
and other Spanish-speaking readers in the United States as well as to Cubans
and Latin Americans abroad, apparently succeeding *Illustracíon Americana de
Frank Leslie*.

 10. Gambee, *Frank Leslie*, 14–15; Heywood Broun and Margaret Leech,
Anthony Comstock: Roundsman of the Lord (New York: Albert and Charles
Boni, 1927), 128–29; Anna Louise Bates, *Weeder in the Garden of the Lord:
Anthony Comstock's Life and Career* (New York: University Press of America,
1995), 78–79; Janet Farrell Brodie, *Contraception and Abortion in Nineteenth-
Century America* (Ithaca, N.Y.: Cornell University Press, 1994), 227; George P.
Rowell, ed., *Geo. P. Rowell and Co.'s American Newspaper Directory* (New
York: G. P. Rowell, 1874), 135. James Watts disappeared from *The Days' Do-
ings's* masthead around 1870, with a new address at 535 Pearl Street, conve-
niently next door to Leslie's publishing house; the fiction was finally eliminated
after the house moved to Park Place in 1878. For an indication of the readership
for *The Days' Doings*, see the cartoon "Fond of pictures—Too fond nearly by
half," *The Days' Doings*, June 5, 1869, 16, showing a customer (and danger-
ously diverted barber) reading the paper in the male preserve of a barbershop.
While objecting to *The Days' Doings's* illustrations, Comstock was especially

incensed by the advertisements that appeared in the back of the paper for abortifacients and notices for "homosexual" illustrated books sold by W. Jones in Greenpoint, Brooklyn, three of which (*The Secrets of Affection, The Spice of Life,* and *Scenes among the Nuns*) he purchased as grounds for his complaint to the district attorney. On these advertisements and the nature of the male "libertine" press, see Helen Lefkowitz Horowitz, "Victoria Woodhull, Anthony Comstock, and Conflict over Sex in the United States in the 1870s," *Journal of American History* 87.2 (September 2000): 423–26.

11. Frederic Hudson, *Journalism in the United States, from 1690 to 1872* (New York: Harper and Brothers, 1873), 706; Madeleine B. Stern, *Imprints on History: Book Publishers and American Frontiers* (Bloomington: Indiana University Press, 1956), 221–32.

12. Frank Luther Mott, *A History of American Magazines, 1865–1885* (Cambridge, Mass.: Harvard University Press, 1938), 5. Mott estimates that 700 magazines (excluding newspapers) were published across the country in 1865; five years later, there were more than 1,200; by 1880 the number of magazines doubled, and in 1885 it reached 3,300.

13. Ibid., 41, 187, 417–21; Sue Rainey, *Creating "Picturesque America": Monument to the Natural and Cultural Landscape* (Nashville: Vanderbilt University Press, 1994), 3–18 and passim. *Appleton's Journal,* which failed to outsell either of its weekly competitors, went monthly in 1876, and finally ceased publication in 1881.

14. Mott, *American Magazines, 1865–1885,* 34, 457–80; Arthur John, *The Best Years of the "Century": Richard Watson Gilder, "Scribner's Monthly," and the "Century Magazine," 1870–1909* (Urbana: University of Illinois Press, 1981); Robert J. Scholnick, "*Scribner's Monthly* and the 'Pictorial Representation of Life and Truth' in Post–Civil War America," *American Periodicals* 1.1 (fall 1991): 46–69.

15. Mott, *American Magazines, 1865–1885,* 520–32; Richard Samuel West, *Satire on Stone: The Political Cartoons of Joseph Keppler* (Urbana: University of Illinois Press, 1988); see also William Allen Rogers, *A World Worth While: A Record of "Auld Acquaintance"* (New York: Harper and Brothers, 1922), 217–18, on Keppler and the German conventions of representation that inform *Puck*'s imagery.

16. The New York *Daily Graphic* was the first periodical to experiment with a crude form of half-tone screen in reproducing photography when it published a photograph of a New York shantytown in its March 4, 1880, edition. The daily paper ceased publication in 1889, unable to compete with the *New York World* and *Sun,* which by that time were publishing pictures regularly. See Rebecca Zurier, "Picturing the City: New York in the Press and the Art of the Ashcan School, 1890–1917" (Ph.D. diss., Yale University, 1988), 91–100; Stephen Henry Horgan, "The World's First Illustrated Newspaper," *Penrose Annual* 35 (1933): 23–24; Frank Luther Mott, *American Journalism: A History of Newspapers in the United States through 250 Years, 1690–1940* (New York: Macmillan, 1941), 502; Rogers, *A World Worth While,* 6–10, for character portraits of the *Daily Graphic*'s artists and their unofficial headquarters at Mouquin's Restaurant on Ann Street; see also Wingate, *Views and Interviews on Journalism,*

317–58, for interviews with the *Daily Graphic* editor David Croly that include comments that echo Goldsmith's about respectable publications' rejection of news imagery in favor of "higher and better" pictures (324), as well as disparaging remarks regarding the "animal nature" of the "workingman" and its implications for "his" inclusion as a member of the reading public (349–52).

17. Mott, *American Magazines, 1865–1885*, 25–26. Of the periodicals with circulations of 100,000, two-thirds were published in New York.

18. Estelle Jussim, "The Eternal Moment: Photography and Time," in *The Eternal Moment: Essays on the Photographic Image* (New York: Aperture, 1989), 49–60; B. E. Maidment, *Reading Popular Prints, 1790–1870* (Manchester: Manchester University Press, 1996), 145–47; on wood engraving's narrative, in contrast to lithography's at-a-glance message, see Beatrice Farwell, *The Cult of Images (Le Culte des Images): Baudelaire and the Nineteenth-Century Media Explosion* (Santa Barbara: University of California, Santa Barbara Art Museum, 1977), 9–10. See also William H. Gerdts and Mark Thistlethwaite, *Grand Illusions: History Painting in America* (Fort Worth: Amon Carter Museum, 1988); Elizabeth Johns, *American Genre Painting: The Politics of Everyday Life* (New Haven: Yale University Press, 1991).

19. For a similar confusion in the depiction of a disaster, see an 1874 engraving of a fire in a Fall River granite mill; trapped workers were forced to leap from the factory's windows, but in the engraving's temporal confusion the victims' fatal plunges appear as an avalanche of bodies (*FLIN*, October 3, 1874, cover [49]).

20. *FLIN*, April 2, 1859 (referring to pictorial coverage of the Sickles murder case); quoted in Gambee, *Frank Leslie*, 41. For one example of a static, distanced photo-based engraving, see *FLIN*, November 28, 1974, 188.

21. "Our Twenty-Eighth Volume," *FLIN*, March 13, 1869, 401.

22. "Illustrated Journalism," *FLIN*, August 23, 1873, 374; see also Maidment, *Reading Popular Prints*, 9, 15.

23. On readers' ability to glean information from engravings on several levels, see Zurier, "Picturing the City," 89–90. Maidment's distinction between the expository and narrative attributes of engravings is particularly useful (*Reading Popular Prints*, 145–47).

24. On textual descriptions and how they determine images' meaning in the illustrated press, see Dan Schiller, "Realism, Photography and Journalistic Objectivity in Nineteenth Century America," *Studies in the Anthropology of Visual Communication* 4.2 (winter 1977): 92; Roger B. Stein, "Picture and Text: The Literary World of Winslow Homer," in *Winslow Homer: A Symposium,* ed. Nicolai Cikovsky Jr., Studies in the History of Art 26 (Washington, D.C.: National Gallery of Art, 1990), 33–59. On ideology as narrative, see Fredric Jameson, *The Political Unconscious: Narrative as a Socially Symbolic Act* (Ithaca, N.Y.: Cornell University Press, 1981).

25. See, for example, *FLIN*, March 27, 1875, 44.

26. Peter Brooks, *The Melodramatic Imagination: Balzac, Henry James, Melodrama, and the Mode of Excess* (New Haven: Yale University Press, 1976), 56–65; quotation, 48. However, engravings' gestures and poses often displayed a constricted repertoire, no doubt the result of the limits of the artist's imagina-

tion. See, for example, *FLIN*, November 24, 1874, 173. For insight on the artist's reliance on a limited repertoire of types and gestures, see E. H. Gombrich, *Art and Illusion: A Study of the Psychology of Pictorial Representation* (1960; reprint, Princeton: Princeton University Press, 1969), 86–87.

27. Alan Trachtenberg, *Reading American Photographs: Images as History: Mathew Brady to Walker Evans* (New York: Hill and Wang, 1989), 21–52. On photographic portraits and their role in the construction of a political career, see Harold Holzer, Gabor S. Boritt, and Mark E. Neely Jr., *The Lincoln Image: Abraham Lincoln and the Popular Print* (New York: Charles Scribner's Sons, 1984); on the daguerreotype portrait and the construction of celebrity, see Peter Buckley, "To the Opera House: Culture and Society in New York City, 1820–1860" (Ph.D. diss., State University of New York at Stony Brook, 1984), 502–10, 540. On continuities in the construction of likenesses in art and photography, see Richard Brilliant, *Portraiture* (Cambridge, Mass.: Harvard University Press, 1991). Richard Avedon's comments on portraiture as performance are instructive in their suggestion of the perpetuation of earlier precepts: Avedon, "Borrowed Dogs," *Grand Street* 7.1 (autumn 1987): 52–64.

28. *FLIN*, May 19, 1866, 131. *Frank Leslie's* often published series of "theme" portraits in succeeding issues, as well as occasional supplementary "premiums": for an example of the former, see the series of portraits of members of the New York State judiciary, beginning with November 28, 1868; for the latter case, see the "National Portrait Gallery" series of "full-length portraits of leading public men of the country, engraved the full size of a page of FRANK LESLIE'S ILLUSTRATED NEWSPAPER, on an extra leaf, and given away with each number," beginning with the April 6, 1867, edition (notice in March 16, 1867, 402). See also "Photographic Portraits," *Harper's Weekly* (hereafter *HW*), April 24, 1858, 258, heralding Brady's portraits while also contending that yearly subscribers obtain "fifty-two portraits of eminent men . . . for one-half the cost of one of Brady's photographs."

29. *FLIN*, March 7, 1868, cover (385).

30. Valerian Gribayedoff, "Pictorial Journalism," *Cosmopolitan* 11.4 (August 1891): 479; see also Thomas C. Leonard, *The Power of the Press: The Birth of American Political Reporting* (New York: Oxford University Press, 1986), 103–5.

31. The political caricatures in *Frank Leslie's* never achieved the impact of Thomas Nast's work in *Harper's Weekly*. Leslie imported the British cartoonist Matthew Somerville Morgan in 1870 to compete with Nast's acerbic and highly popular pro-Republican cartoons. Coming in a distant second in the publications' cartoon rivalry during the 1872 presidential campaign and the subsequent off-year election, Morgan had moved on by 1876. His replacement, Joseph Keppler, would himself soon leave *Leslie's* to start the satirical weekly *Puck;* Keppler was succeeded by James Albert Wales (later a prominent contributor to *Puck* and *Judge*). On Nast, see Albert Bigelow Paine, *Th. Nast: His Period and His Pictures* (New York: Macmillan, 1904); Morton Keller, *The Art and Politics of Thomas Nast* (New York: Oxford University Press, 1968); and the growing archive of materials collected in the annual *Journal of the Thomas Nast Society*. For the most illuminating recent considerations of Nast's impact, see Leonard,

The Power of the Press, 97–131; Roger A. Fischer, *Them Damned Pictures: Explorations in American Political Cartoon Art* (North Haven, Conn.: Archon Books, 1996), 1–23. On Morgan, see Thomas Milton Kemnitz, "The Cartoon as a Historical Source," *Journal of Interdisciplinary History* 4.1 (summer 1973): 81–93; idem, "Matt Morgan of 'Tomahawk' and English Cartooning, 1867–1870," *Victorian Studies* 19.1 (September 1975): 5–34; L. Perry Curtis Jr., *Apes and Angels: The Irishman in Victorian Caricature* (Washington, D.C.: Smithsonian Institution Press, 1971), 48; Rogers, *A World Worth While,* 284. On Keppler, see West, *Satire on Stone.* On Wales's career, see Curtis, *Apes and Angels,* 62; Rogers, *A World Worth While,* 57–58; West, *Satire on Stone,* 131–32, 192–94, 199, 241–42, 321–22, 433–34.

32. Bernard Reilly, "Comic Drawing in New York in the 1850s," in *Prints and Printmakers of New York State, 1825–1940,* ed. David Tatham (Syracuse, N.Y.: Syracuse University Press), 147–62. Discussing *Yankee Notions,* Reilly identifies New York's Chatham Square as the locus for the production of caricature—both in comic periodicals and in the illustrated weeklies devoted to the news—and notes it also was the heart of the city's popular theater scene.

33. The scholarship of caricature is vast, but E. H. Gombrich and Ernst Kris, *Caricature* (Harmondsworth: Penguin, 1940) is noteworthy as a pioneering work; for a sense of the scope of more recent scholarship, particularly on the conditions of the production and reception of nineteenth-century British and French caricature, see the articles in Judith Wechsler, ed., *The Issue of Caricature,* a special issue of *Art Journal* (43.4 [winter 1983]).

34. Johns, *American Genre Painting,* 1–23; Joshua C. Taylor, *America as Art* (Washington, D.C.: Smithsonian Institution Press, 1976), 37–94; Constance Rourke, *American Humor: A Study of the National Character* (New York: Harcourt, Brace, 1931). For studies of specific types and regions, see particularly William R. Taylor, *Cavalier and Yankee: The Old South and American National Character* (New York: George Braziller, 1961); Sarah Burns, *Pastoral Inventions: Rural Life in Nineteenth-Century American Art and Culture* (Philadelphia: Temple University Press, 1989).

35. Johns, *American Genre Painting,* 1–23; Taylor, *America as Art,* 37–94. Ludmilla Jordanova's book review essay, "Reading Faces in the Nineteenth Century" (*Art History* 13.4 [December 1990]: 570–75), cites the rise of universal manhood suffrage as a factor in similar typing in popular and more rarefied imagery in nineteenth-century England and Europe. On "structures of feeling," see Raymond Williams, *Marxism and Literature* (New York: Oxford University Press, 1977), 128–35. On the intersection of genre and audience, from characterizations on stage to characterizations in the street, see Peter G. Buckley, "The Case against Ned Buntline: The 'Words, Signs, and Gestures' of Popular Authorship," *Prospects* 13 (1988): 249–72.

36. For a self-conscious instance of typification, see "Citizens of the United States, according to popular impressions," *HW,* January 12, 1867, 29 (eight cuts). See chapters 4, 5, and 6 of this book for representations of African Americans and labor. While some types were generated by new figures in the social formation, typification sometimes kicked in as real-life analogs were in fact dis-

appearing. The legendary Mississippi keel boatman Mike Fink was most celebrated just as the steamboat made him redundant after 1815; the Bowery B'hoy Mose gained his greatest stage acclaim as the nativist butcher–fire laddie was receding from New York's working-class milieu. See Taylor, *America as Art,* 84–85; Peter G. Buckley, "Mose Revisited: The Audience and Local Drama in New York, 1840–1860" (paper presented at American Studies Biennial Conference, Philadelphia, November 1983).

37. Johns (*American Genre Painting,* 197–203) proposes that social typing declined with the Civil War. While polite preference for the aesthetic over local and mundane subjects may have characterized the turn in the art market, a consideration of postbellum popular print culture points to the opposite conclusion.

38. On Lavater, his *Physiognomische Fragmente,* and physiognomy's history, see Graeme Tytler, *Physiognomy in the European Novel: Faces and Fortunes* (Princeton: Princeton University Press, 1982), 3–81; Mary Cowling, *The Artist as Anthropologist: The Representation of Type and Character in Victorian Art* (New York: Cambridge University Press, 1989), 7–86; Curtis, *Apes and Angels,* 1–15; Aaron Sheon, "Caricature and the Physiognomy of the Insane," *Gazette des Beaux-Arts,* 6th ser., 88, no. 1293 (October 1976): 145–50.

39. Lichtenberg (who nonetheless accepted characterological evidence in pathognomy), quoted in Rudolf Arnheim, "The Rationale of Deformation," *Art Journal* 43.4 (winter 1983): 32.

40. Samuel G. Goodrich [Peter Parley, pseud.], *What to Do, and How to Do It; or, Morals and Manners Taught by Examples* (New York, 1844), 28; quoted in Karen Halttunen, *Confidence Men and Painted Women: A Study of Middle-Class Culture in America, 1830–1870* (New Haven: Yale University Press, 1982), 41–42.

41. On phrenology, a veritable craze in mid-nineteenth-century Europe and America, see Ronald G. Walters, *American Reformers, 1815–1860* (New York: Hill and Wang, 1978), 156–63. See Allan Sekula, "The Body and the Archive," *October,* no. 39 (winter 1986): 3–64, on how the intersection of physiognomic codes with the practice of photography contributed to the construction of a vast normative "archive" of criminal types.

42. Cowling, *The Artist as Anthropologist,* 87–120; see also Charles Colbert, *A Measure of Perfection: Phrenology and the Fine Arts in America* (Chapel Hill: University of North Carolina Press, 1997). For Lavater "the art of painting" was 'mother and daughter' of physiognomy"; see George L. Mosse, *Toward the Final Solution: A History of European Racism* (1978; reprint, Madison: University of Wisconsin Press, 1985), 25.

43. See Judith Wechsler, *A Human Comedy: Physiognomy and Caricature in Nineteenth Century Paris* (Chicago: University of Chicago Press, 1982).

44. Frederick Law Olmsted, *Public Parks and the Enlargement of Towns* (Cambridge, Mass., 1870); quoted in David Scobey, "Anatomy of the Promenade: The Politics of Bourgeois Sociability in Nineteenth-Century New York," *Social History* 17.2 (May 1992): 212.

45. *Our Manners at Home and Abroad: A Complete Manual on the Manners, Customs, and Social Forms of the Best American Society . . .* (Harrisburg:

Pennsylvania Publishing Company, 1883); quoted in John F. Kasson, *Rudeness and Civility: Manners in Nineteenth-Century Urban America* (New York: Hill and Wang, 1990), 98.

46. On new notions and codes of decorum and behavior, see Halttunen, *Confidence Men and Painted Women;* Kasson, *Rudeness and Civility;* Guy Szuberla, "Ladies, Gentlemen, Flirts, Mashers, Snoozers, and the Breaking of Etiquette's Code," *Prospects* 15 (1990): 169–96; Scobey, "Anatomy of the Promenade," 203–27. My interpretation of the role of the pictorial press departs from these scholars' emphasis on a new bourgeoisie's anxiety over the unreliability of appearances; they view the city as ultimately remaining unreadable for the uneasy middle class. On the trope of the strolling urban *flâneur,* defined by the act of looking and evaluating the crowd, see Walter Benjamin, "Paris, Capital of the Nineteenth Century," in *Reflections: Essays, Aphorisms, Autobiographical Writings,* ed. Peter Demetz, trans. Edmund Jephcott (1978; reprint, Schocken Books, 1986), 146–62. On "civil inattention," see Erving Goffman, *Behavior in Public Places* (New York: Free Press, 1963); cited in Kasson, *Rudeness and Civility,* 126.

47. These labels are used in "The Cities of New York," *FLIN,* October 24, 1874, 98. On the spatial relations of New York's neighborhoods, see Edward K. Spann, *The New Metropolis: New York City, 1840–1857* (New York: Columbia University Press, 1981), 94–116; Elizabeth Blackmar, *Manhattan for Rent, 1785–1850* (Ithaca, N.Y.: Cornell University Press, 1989). On the segmented, polarized city as displayed in city guides in the period, see Stuart M. Blumin, "Explaining the New Metropolis: Perception, Depiction, and Analysis in Mid-Nineteenth-Century New York City," *Journal of Urban History* 11.1 (November 1984): 9–38; idem, "Introduction: George G. Foster and the Emerging Metropolis," in *New York by Gas-Light and Other Urban Sketches,* by George G. Foster (Berkeley: University of California Press, 1990), 1–61.

48. As random examples of cuts showing urban improvements and idealization in *FLIN,* see "The bridge about to be erected at the corners of Broadway and Fulton Street, New York City, by Ritch & Griffiths, architects," February 16, 1867, cover (337) (which is set in contrast to the earlier "The city barricades—Scene on Broadway, between Fulton and Ann Streets, during the first week of the Dry Dock Railroad imbroglio," November 17, 1866, cover [129]); see also May 9, 1868, 120; February 19, 1870, 381; February 15, 1873, 369. On urban boosterism and images of the ideal city, see David M. Scobey, "Empire City: Politics, Culture, and Urbanism in Gilded-Age New York" (Ph.D. diss., Yale University, 1989); John W. Reps, *Views and Viewmakers of Urban America: Lithographs of Towns and Cities in the United States and Canada, Notes on the Artists and Publishers, and a Union Catalog of Their Work, 1825–1925* (Columbia: University of Missouri Press, 1984); Peter Bacon Hales, *Silver Cities: The Photography of American Urbanization, 1839–1915* (Philadelphia: Temple University Press, 1984), 67–130.

49. See also "Christmas contrasts," *FLIN,* January 2, 1869, 248; "Character sketches in the metropolis—Lights and shades of holiday week," January 1, 1876, 272. See also "Rich and poor," *HW,* January 11, 1873, 33. Hales (*Silver Cities,* 192) discusses the imposition of sentimental models on the "deserving" poor.

50. *FLIN*, April 28, 1866, cover (81); see also June 2, 1866, cover (161). For a *Harper's Weekly* approach to the unpleasantness of social intermingling, see "Tompkins Square, New York—Out for a breath of fresh air," *HW*, September 13, 1873, 800.

51. See also *FLIN*, June 8, 1867, 189; "The adventures of a missing man; or, twenty-four hours in the metropolis," *HW*, January 26, 1867, 56–57. The fatal effects of social mixing also characterized illustrations in Leslie's more lurid publications: see, for example, "The Fate of a Missing Man," *The Days' Doings*, November 21, 1868, 393. These cautionary cuts depicting virtue's decline into vice seemingly were inspired by British cartoonist George Cruikshank's popular eight-plate temperance sequence *The Bottle* (1847). See David Kunzle, *The History of the Comic Strip: The Nineteenth Century* (Berkeley: University of California Press, 1990), 23–25.

52. *FLIN*, November 13, 1869, 141; see also "Securing certificates of naturalization in the clerk's office, City Hall," *HW*, October 10, 1868, 649, and "Examining and swearing naturalized citizens," ibid. Other exceptions proving the rule of segmentation include scenes displaying picturesque street-types, conventional urban character studies whose origin dated back to Nicolino Calyo's 1840s watercolors and lithographs of street hawkers and peddlers. See, for example, *FLIN*, February 20, 1869, cover (353); "Character sketches in the metropolis—The street-milliner—Trying on a hat," *FLIN*, November 6, 1875, 133.

53. *FLIN*, July 14, 1866, 261. Sections of the cut were reprinted in Junius Henri Browne, *The Great Metropolis; A Mirror of New York* (Hartford, Conn.: American Publishing Company, 1868), 23.

54. In contrast, the illustrated literary monthlies eschewed unpleasant urban themes, favoring the ideal and the picturesque: see Scholnick, "*Scribner's Monthly* and the 'Pictorial Representation of Life and Truth,'" 59.

55. The twofold utility of the illustrated press to shield and educate was espoused by the directors of the Association for the Improvement of the Condition of the Poor when they hired an artist to illustrate the organization's 1884 *Annual Report*, with the intent of showing contributors how and where the poor lived without requiring them to suffer the hardship of personal exploration (Robert H. Bremner, *From the Depths: The Discovery of Poverty in the United States* [New York: New York University Press, 1956], 116). This function suggests a revision of Benjamin's peripatetic urban observer of the crowd (see n. 46 above): the *flâneur*, as Franco Moretti has proposed, actually situates his perusal of the laissez-faire city *not* in the streets (where, aside from the constraints of etiquette, there is simply no time to observe), but in the home—not in public space but in private life. See Moretti, "Homo Palpitans: Balzac's Novels and Urban Personality," in his *Signs Taken for Wonders: Essays in the Sociology of Literary Forms*, trans. Susan Fischer, David Forgacs, and David Miller, rev. ed. (London: Verso, 1988), 124–29.

56. For the conventions of domesticity, and their antitheses, in nineteenth-century imagery of the family, see Lee M. Edwards, *Domestic Bliss: Family Life in American Painting, 1840–1910* (Yonkers, N.Y.: Hudson River Museum, 1986).

57. *FLIN*, February 2, 1867, 309.

58. "The Homes of the Poor," *FLIN*, May 12, 1866, 124.

59. Ibid.

60. For other reports on the potential health danger of the tenements, see *FLIN*, September 15, 1866, 405. On the cholera epidemic, see Charles E. Rosenberg, *The Cholera Years: The United States in 1832, 1849, and 1866* (Chicago: University of Chicago Press, 1962). On the limitations of social reform in the mid–nineteenth century, see Paul Boyer, *Urban Masses and Moral Order in America: 1820–1920* (Cambridge, Mass.: Harvard University Press, 1978).

61. Nathaniel Parker Willis, quoted in typescript in the I. N. Phelps Stokes Collection on New York slums, p. 673; cited in Christine Stansell, *City of Women: Sex and Class in New York, 1789–1860* (1986; reprint, Urbana: University of Illinois Press, 1987), 74. Similar observations run through the reform and travel literature of the period: see Ladies of the Mission, *The Old Brewery, and the New Mission House at the Five Points* (New York: Stringer and Townsend, 1854), 31–43; "A Sabbath with the Children at the Five Points House of Industry," *Five Points Monthly Record*, May 1857, 19–20; Charles Dickens, *American Notes* (1842; reprint, Oxford: Oxford University Press, 1966), 88–92. On antebellum descriptions of the Five Points, with an evaluation of their distortions, see Carol Groneman Pernicone, "The 'Bloody Ould Sixth:' A Social Analysis of a New York City Working-Class Community in the Mid-Nineteenth Century" (Ph.D. diss., University of Rochester, 1973).

62. *FLIN*, August 16, 1873, 363.

63. See also *FLIN*, May 8, 1869, 129, a more panoramic perspective of the Five Points that nonetheless delineates degradation in its composition. For a similar *Harper's Weekly* treatment, see *HW*, August 8, 1868, 504.

64. *FLIN*, August 16, 1873, 363.

65. See Curtis, *Apes and Angels*, 58–67; James H. Dormon, "Ethnic Stereotyping in American Popular Culture: The Depiction of American Ethnics in the Cartoon Periodicals of the Gilded Age," *Amerikastudien* 30.4 (1985): 489–507; John J. Appel, "From Shanties to Lace Curtains: The Irish Image in *Puck*, 1876–1910," *Comparative Studies in Society and History* 13.4 (October 1971): 365–75. See also Matthew Frye Jacobson, *Whiteness of a Different Color: European Immigrants and the Alchemy of Race* (Cambridge, Mass.: Harvard University Press, 1998), 43–56; and on the literary physiognomy of the Irish, see Dale T. Knobel, *Paddy and the Republic: Ethnicity and Nationality in Antebellum America* (Middletown, Conn.: Wesleyan University Press, 1986), 122–28. The Irish American type found its origins in the British pictorial press—where this engraving's artist, Matt Morgan, had gained fame as a cartoonist in his short-lived satirical weekly *Tomahawk*, in which Irish physiognomies were ubiquitous. However, as Curtis demonstrates (*Apes and Angels*, 48–51), Irish American physiognomics presented a less simianized appearance than their British counterparts, favoring prognathous faces that nonetheless displayed more obtuse facial angles. A comparison of Morgan's *Tomahawk* cartoons with this image indicates a transatlantic change (possibly influenced by the Irish faces of his rival Thomas Nast). But Kemnitz argues ("Matt Morgan of 'Tomahawk,'" 15–10, 29–30) that Morgan's grotesque Irish caricatures were rare and may have been a response to Fenian violence.

66. On the social roots of Mose and the Bowery B'hoys and their role in the culture of the Bowery, see Buckley, "Mose Revisited" and "To the Opera House," 294–409; Sean Wilentz, *Chants Democratic: New York City and the Rise of the American Working Class, 1788–1850* (New York: Oxford University Press, 1984), 300–301; Stansell, *City of Women*, 89–101; Elliott J. Gorn, "'Good-Bye Boys, I Die a True American': Homicide, Nativism, and Working-Class Culture in Antebellum New York City," *Journal of American History* 74.2 (September 1987): 388–410; David S. Reynolds, *Beneath the American Renaissance: The Subversive Imagination in the Age of Emerson and Melville* (Cambridge, Mass.: Harvard University Press, 1989), 463–66, 508–16; Taylor, *America as Art*, 55–67; Johns, *American Genre Painting*, 20, 178. Alexander Saxton, in *The Rise and Fall of the White Republic: Class Politics and Mass Culture in Nineteenth-Century America* ([London: Verso, 1990], 169–70); David R. Roediger, in *The Wages of Whiteness: Race and the Making of the American Working Class* ([London: Verso, 1991], 99–100); and Eric Lott, in *Love and Theft: Blackface Minstrelsy and the American Working Class* ([New York: Oxford University Press, 1993], 80–88), chart the trajectory of Mose on the New York stage and the transformation of the preening Bowery hero into blackface; by the early 1850s Mose had become a dandified free urban African American, taking on the marginality of his white mechanic predecessor. On the 1857 riot, see Joshua Brown, "The 'Dead Rabbit'–Bowery Boy Riot: An Analysis of the Antebellum New York Gang" (M.A. thesis, Columbia University, 1976); Paul O. Weinbaum, "Temperance, Politics, and the New York City Riots of 1857," *New-York Historical Society Quarterly* 59 (July 1975): 246–70; and Tyler Anbinder, *Five Points: The 19th-Century New York City Neighborhood That Invented Tap Dance, Stole Elections, and Became the World's Most Notorious Slum* (New York: Free Press, 2001), 280–92.

67. *FLIN*, August 16, 1873, 363.

68. See, for example, "New Jersey.—Lobbyists in a committee-room of the legislature, at Trenton, on March 10th, marshaling their forces for next day's vote on the General Railroad Bill," *FLIN*, March 29, 1873, cover (37).

69. *FLIN*, November 25, 1871, 165. *Leslie's* stance toward the Ring scandal characteristically teetered until the finality of Tweed's downfall was indisputable: for complimentary cuts of Tweed, see April 18, 1868, 76; January 21, 1871, 313. Coverage of Tweed's downfall includes September 23, 1871, 21; October 7, 1871, 57; November 11, 1871, cover (129). Although *Leslie's* covered his subsequent trial (e.g., February 15, 1873, cover [361]), it seemed to lavish the most attention on Tweed once he became a fugitive.

70. See also *FLIN*, October 4, 1873, 53. For the sporting-type political tough in *FLIN*, see Matt Morgan's emblematic "Ruffianism Triumphant. Design for a statue to be erected in New York, commemorating the year 1872," January 4, 1873, 273, and November 16, 1872, 156; as well as cartoons such as October 10, 1868, 64, and October 26, 1872, 112. "The election 'striker'" on the cover of the October 23, 1874, New York *Daily Graphic* (hereafter *DG*) is a particularly forceful contrast of physiognomy and dress.

71. *FLIN*, December 8, 1866, 181. The 1866 cut was reprinted in *The Day's Doings*, September 26, 1868, 261, and in James D. McCabe Jr., *Lights and*

Shadows of New York Life; or, the Sights and Sensations of the Great City (Philadelphia: National Publishing Company, 1872), 543, as "The Rough's Paradise." Among the cuts illustrating "Kit Burns' Dog-Paradise in Water Street," the portrait of the establishment's proprietor epitomized the crude, prognathous, yet dandified appearance of the sportsman-ruffian type.

72. *FLIN*, November 30, 1867, 163. See also *HW*, February 16, 1867, cover. Coverage of degraded amusements also extended to types who capitalized on vice, such as the "popular pawnbroker's shop" depicted in *FLIN*, December 28, 1872, 261. In contrast, see "The Holly Tree Inn, on Cambridge Street, Boston—A cheap temperance restaurant for the working classes," *FLIN*, September 7, 1872.

73. As noted in chapter 2, *Leslie's* for a time waffled in its representation of boxing, exploiting curiosity and interest in the subterranean sport while bristling with moral indignation in its editorials. Nevertheless, boxing would disappear from *Frank Leslie's* pages by the early 1870s (taking up residence in *The Days' Doings*), replaced by races, regattas, and baseball (see the series of portraits published in 1866, and the declaration in the edition of August 11, 1866, in response to letters, that the paper represented only sports figures of good character). On boxing and sports coverage in the early years, see Elliott J. Gorn, *The Manly Art: Bare-Knuckle Prize Fighting in America* (Ithaca, N.Y.: Cornell University Press, 1986), 150–51.

74. See "The Black Maria—Prisoners leaving the van at the foot of Twenty-sixth Street, New York City, to embark for Blackwell's Island," *FLIN*, September 5, 1868, cover (385); "Life sketches in the metropolis.—A Sunday morning scene at the Tombs police court," *FLIN*, February 3, 1872, 329; "A prison van at the Tombs," *HW*, November 4, 1871, 1044 (supplement). Compare these cuts with "Saturday in a Bleecker Street savings-bank," *FLIN*, February 11, 1871, 369: although the latter depicts frugality among the poor, the overall confusion portrayed in the engraving could be seen as attending more profligate activities.

75. See *FLIN*, September 21, 1867, cover (1); March 21, 1874, 21; April 25, 1874, 109; see as well "Beauties of streetcar travel in New York," *HW*, May 20, 1871.

76. *FLIN*, October 18, 1873, cover (85). See also "A lesson for the uninitiated—Three-card monte players on Coney Island beach," *FLIN*, August 31, 1867, cover (369). For a *Harper's Weekly* version of the latter, see *HW*, September 8, 1866, 572. On the figure of the confidence man and social and economic deception in the construction of genteel rules of conduct, see Halttunen, *Confidence Men and Painted Women*, 1–55; Kasson, *Rudeness and Civility*, 92–111. On professional gamblers and the meaning of gambling and anti-gambling reform, see Ann Fabian, *Card Sharps, Dream Books, and Bucket Shops: Gambling in Nineteenth-Century America* (Ithaca, N.Y.: Cornell University Press, 1990).

77. *FLIN*, January 20, 1872, cover (289); "The Recent Tragedy," January 27, 1872, 306 (editorial). See also December 12, 1868, 201.

78. "The morgue—Room in which the bodies are placed for recognition," *FLIN*, July 7, 1866, cover (241); see also September 14, 1867, 408; August 12, 1871, 369; July 5, 1873, 272; August 16, 1873, 369. For similar cuts in *Harper's Weekly*, see *HW*, July 7, 1866, 429; October 6, 1866, 629; July 12, 1873, 604.

On the illustrated press's agitation for health reform, see Bert Hansen, "The Image and Advocacy of Public Health in American Caricature and Cartoons from 1860 to 1900," *American Journal of Public Health* 87.11 (November 1997): 1798–807. Engravings showing effective law enforcement were equally reassuring in delineating the maintenance of order against threatening chaos: see the cuts cited in nn. 74 and 75 above.

79. *FLIN*, March 6, 1869, 397. See also *FLIN*, December 14, 1867, 201.

80. See also "New York City.—Italian street musicians, afraid to go home without the requisite pennies, sleeping under a cart," *FLIN*, March 22, 1873, 28. This series of engravings (also appearing in March 29, 1873, 44) was part of a broader press campaign, spearheaded by the *New York Times,* that contributed to the passage of federal and New York state legislation in 1874 and culminated in actions by the Italian government to curb the traffic in child musicians. *Leslie's* celebrated the Italian news in its April 17, 1875, issue with excessive self-congratulation on its own role in the reform effort (87). *Harper's Weekly* also devoted space to the exploitation of Italian child musicians: see "Italian minstrel boys and their masters," *HW,* March 8, 1873, 188; "The Italian boys in New York—Torturers of the training-room," September 13, 1873, 801. On the conditions and campaign in New York, see John E. Zucchi, *The Little Slaves of the Harp: Italian Child Musicians in Nineteenth-Century Paris, London, and New York* (Montreal: McGill-Queen's University Press, 1992), 111–43.

81. See also *FLIN*, April 25, 1868, 88; July 13, 1872, 277; August 29, 1874, 397. On reformers' indictment of parental neglect, which fell most heavily on the shoulders of poor women, and policies to retrieve children from their vicious influence, see Stansell, *City of Women,* 193–216; Carroll Smith-Rosenberg, *Religion and the Rise of the American City: The New York City Mission Movement, 1812–1870* (Ithaca, N.Y.: Cornell University Press, 1971), 216–17, 221–22, 235–37.

82. *FLIN*, January 9, 1869, cover (257), quotation, 259; see also January 6, 1872, cover (257). On the image of the newsboy, see Vincent DiGirolamo, "The Negro Newsboy: Black Child in a White Myth," *Columbia Journal of American Studies* 4.1 (2000): 57–80. On genre painting's portrayal of street children, see Johns, *American Genre Painting,* 184–96; Edwards, *Domestic Bliss,* 26; Lisa N. Peters, "Images of the Homeless in American Art, 1860–1910," in *On Being Homeless: Historical Perspectives,* ed. Rick Beard (New York: Museum of the City of New York, 1987), 44–53.

83. Charles Loring Brace, *The Dangerous Classes of New York and Twenty Years' among Them,* 3d ed. (New York: Wynkoop and Hallenbeck, 1880), 30.

84. The reference to "*enfants perdus*" is from ibid. For the newsboys, see *FLIN*, December 28, 1867, 233; for the "vagrant boys," see *FLIN*, August 24, 1867, cover (353). *Harper's Weekly* also featured newsboys in its pictures of poor children: for a sentimentalized view, see HW, May 18, 1867, 312–13; more hardened physiognomies are visible in August 12, 1871, 740. A New York *Daily Graphic* rendition focused on self-promotion: "The newsboy's rush at the office of 'The Daily Graphic' on the day of Foster's execution," *DG,* March 24, 1873. On imagery of nineteenth-century childhood, see Jadviga M. Da Costa Nunes, "The Naughty Child in Nineteenth-Century American Art," *Journal of*

American Studies 21.2 (1987): 225–47; on contrasts of country and city youth, see Burns, *Pastoral Inventions,* 308–13.

85. *FLIN,* November 14, 1868, 131. For a similar portrayal of inevitable vice, see "Story of a Waif," *HW,* March 23, 1872, 233.

86. *FLIN,* December 14, 1867, 200. See also Stansell, *City of Women,* 203–16; Smith-Rosenberg, *Religion and the Rise of the American City,* 235–37; Boyer, *Urban Masses and Moral Order in America,* 97–102. This ambivalence would continue in later representations of juvenile poverty, including Jacob Riis's (and his colleagues') documentary photography. See Maren Stange, *Symbols of Ideal Life: Social Documentary Photography in America, 1890–1950* (New York: Cambridge University Press, 1989), 1–26; Sally Stein, "Making Connections with the Camera: Photography and Social Mobility in the Career of Jacob Riis," *Afterimage,* May 1983, 9–16.

87. Raymond Williams, *Culture* (Glasgow: Fontana, 1981), 99.

88. On the formation of the middle class during the nineteenth century, see, along with Halttunen (*Confidence Men and Painted Women*) and Kasson (*Rudeness and Civility*), Stuart M. Blumin, "The Hypothesis of Middle-Class Formation in Nineteenth-Century America: A Critique and Some Proposals," *American Historical Review* 90.2 (April 1985): 299–338; Altina L. Waller, *Reverend Beecher and Mrs. Tilton: Sex and Class in Victorian America* (Amherst: University of Massachusetts Press, 1982).

89. Robert E. Weir, *Beyond Labor's Veil: The Culture of the Knights of Labor* (University Park: Pennsylvania State University Press, 1996), 235, 260–61, 267–74.

90. For recent considerations of the "new" labor history's approach to class-consciousness and the concept of the producing classes in the Gilded Age, see Leon Fink, *Workingmen's Democracy: The Knights of Labor and American Politics* (Urbana: University of Illinois Press, 1983), 3–17; idem, "The New Labor History and the Powers of Historical Pessimism: Consensus, Hegemony, and the Case of the Knights of Labor," *Journal of American History* 75.1 (June 1988): 115–36; Bruce Laurie, *Artisans into Workers: Labor in Nineteenth-Century America* (New York: Hill and Wang, 1989), 3–14. A compelling visualization of the "producing class" perspective of poverty and vice can be seen in a two-panel cartoon published in the Boston *Labor Leader* of October 6, 1894, comparing the homes of a "union workman" and "scab workman" (reprinted in American Social History Project, *Who Built America? Working People and the Nation's Economy, Politics, Culture, and Society,* vol. 2 [New York: Pantheon, 1992], 81). That class cultures in the nineteenth century were bifurcated is forcibly argued in Levine, *Highbrow/Lowbrow.*

91. See the discussion of *Leslie's* coverage in chapter 2 above. On the literary monthlies' visualization of a middle-class ideal, see Scholnick, "*Scribner's Monthly* and the 'Pictorial Representation of Life and Truth.'"

CHAPTER 4. BALANCING ACT, 1866–77

1. *Frank Leslie's Illustrated Newspaper* (hereafter *FLIN*), November 14, 1868, cover (129), 131 (description).

2. *FLIN*, September 19, 1868, 3. See also January 25, 1868, 296; August 8, 1868, 329. See also *Harper's Weekly* (hereafter *HW*), August 8, 1868, 505. On Allen and his professed conversion to a new path, see Junius Henri Browne, *The Great Metropolis; A Mirror of New York* (Hartford, Conn.: American Publishing Company, 1868), 659–62; Sarah Burns, *Pastoral Inventions: Rural Life in Nineteenth-Century American Art and Culture* (Philadelphia: Temple University Press, 1989), 239–40; Daniel Czitrom, "Wickedest Ward in New York," *Seaport* 20.3 (winter 1986–87): 20–26. On the social and cultural construction of prostitution in New York, see Timothy Gilfoyle, *City of Eros: New York City, Prostitution, and the Commercialization of Sex, 1790–1920* (New York: W. W. Norton, 1992); Marilynn Wood Hill, *Their Sisters' Keepers: Prostitution in New York City, 1830–1870* (Berkeley: University of California Press, 1993); Christine Stansell, *City of Women: Sex and Class in New York, 1789–1860* (1986; reprint, Urbana: University of Illinois Press, 1987), 171–92; Mary P. Ryan, *Women in Public: Between Banners and Ballots, 1825–1880* (Baltimore: Johns Hopkins University Press, 1990), 71–73, 88–90, 95–129.

3. See also "New York City.—The Italian crone preparing the evening meal," *FLIN*, March 22, 1873, 28.

4. Even the hardened features of lost women such as John Allen's prostitutes and the wretched Mrs. McMahan bore stories of male seduction and abandonment. Images portraying poor women in the pictorial press inverted the domestic tranquility displayed in conventional American genre painting: see Elizabeth Johns, *American Genre Painting: The Politics of Everyday Life* (New Haven: Yale University Press, 1991), 157; on women in genre art, 19–20, 137–75, 201–2.

5. *FLIN*, March 2, 1872, 392. A letter by Ann S. Stephens (a former editor of *Frank Leslie's Gazette of Fashion*, later *Frank Leslie's Lady's Magazine*) published in *FLIN*, March 2, 1872, 390 (and corresponding editorial, 386), under the title "Our Homeless Poor; or, 'How the Other Half of the World Lives,'" prompted the series of engravings. See also in this series March 9, 1872, 408–9 (though here, in the promiscuous mix of men and women in the choked garret of a "cheap lodging-house," idealized female physiognomies were erased); March 23, 1872, 29.

6. It is worth noting that the House of the Good Shepherd was a Catholic institution, indicating *Leslie's* stance—much more ecumenical than that of *Harper's Weekly*—toward coverage of the city's religious activities. For genteel women see, among many other cuts, *FLIN*, March 26, 1870, 24; August 3, 1872, 332. Although it focuses on the visualization of idealized female types at the turn of the century, Martha Banta's *Imaging American Women: Idea and Ideals in Cultural History* (New York: Columbia University Press, 1987) is valuable in delineating their physiognomic codes; see esp. 92–139.

7. Browne, *The Great Metropolis*, 28–29.

8. *FLIN*, May 16, 1874, 156–57. On the gendered boundaries of the streets and the etiquette of female public performance, see Ryan, *Women in Public*, 58–94, esp. 69–71; John F. Kasson, *Rudeness and Civility: Manners in Nineteenth-Century Urban America* (New York: Hill and Wang, 1990), 112–46; Guy Szuberla, "Ladies, Gentlemen, Flirts, Mashers, Snoozers, and the Breaking of Etiquette's Code," *Prospects* 15 (1990): 169–96. For another type of cut depicting

the public threat to endangered women, see "'Found drowned.'—Scene at a coroner's inquest . . . on the Hudson River, New York City," *FLIN*, July 18, 1874, 296–97, and B. E. Maidment, "Did She Jump or Was She Pushed? Narratives of Social Responsibility and Suicide in Mid-Victorian London," in his *Reading Popular Prints, 1790–1870* (Manchester: Manchester University Press, 1996), 138–73.

9. See also *FLIN*, February 15, 1873, 365 (an illustration of a New York City woman's rights meeting). *Harper's Weekly* favored the more obstreperous Woodhull: "Mrs. Woodhull asserting her right to vote," *HW*, November 25, 1871, 1109. Woodhull's notoriety earned her greater coverage in Leslie's scandal-adoring *The Days' Doings*. However, after Leslie bargained his way out of an indictment under the "Comstock Law" of 1873 barring obscene matter from the mail, Woodhull was among the sensational subjects that disappeared from the pages of the weekly. See Amanda Frisken, "Tabloid Representations of Victoria Woodhull: *The Days' Doings, 1870–72*" (paper presented at the Bowery Seminar, Cooper Union, New York, March 1997). For an interesting consideration of physiognomy and female intelligence, see "Pen Portraits of Some Noted Women," *FLIN*, September 2, 1876, 430.

10. "The New Order of Amazons," *FLIN*, March 16, 1872, cover (1). See also "Women's Notions of Women's Rights," March 6, 1869, 306; "Lo, the Poor Woman!" January 22, 1870, 314; editorial comment, February 25, 1871, 391. In contrast, see "Fighting Women," June 7, 1873, 198, espousing "the development of the fighting quality in women" and woman suffrage. For cuts and editorials endorsing progress in women's education and work, see "New York City.—Medical College for Women, East Twelfth Street and Second Avenue—Student dissecting a leg," April 16, 1870, cover (65; one of four cuts); A. K. Gardner, M.D., "Woman Doctors," ibid.; "Matters and Things," July 18, 1868, 274; "Equal Pay for Equal Service, Irrespective of Sex," March 11, 1871, 422–23.

11. "Women's whisky war in Ohio.—Open-air prayer-meeting in front of Dotze's Saloon, Springfield, Ohio," *FLIN*, February 28, 1874, 413. See also February 21, 1874, 392. For more restrained depictions, see February 28, 1874, cover (401), 408, 412. The ensuing coverage espousing temperance included March 14, 1874, cover (1), 5, 12; April 11, 1874, 69; and a series of special supplement cartoons by Matt Morgan, "The Modern Dance of Death; A Sermon in Six Cartoons," beginning April 18, 1874. For other farcical images of women's public intervention, see March 6, 1869, 393; June 20, 1874, cover (225). For an extensive survey of the antecedents of this imagery, see Gary L. Bunker, "Antebellum Caricature and Woman's Sphere," *Journal of Women's History* 3.3 (winter 1992): 6–43.

12. Until 1880, when Georgina A. Davis was first listed as a member of *Leslie's* art staff, the paper's corps of sketch artists appears to have been composed only of men. See chapter 6 for changes in the representation of women after the paper passed under Mrs. Frank Leslie's aegis.

13. *FLIN*, August 14, 1875, 399. This engraving (along with the 1874 "Running the gauntlet") is reminiscent of Joseph Becker's 1869 depiction of a respectable white woman passing through a "gauntlet" of black marketwomen:

see "The market at Charleston, South Carolina—The season of early vegetables," *FLIN,* June 19, 1869, cover (209).

14. On the "Bowery Gal," see Stansell, *City of Women,* 89–100.

15. *FLIN,* December 19, 1874, 247. March 5, 1870, 416, also offers a range of "servant-girl" types while delineating the institution of a service to ensure that unreliable or criminal women not be employed (i.e., in the mix of faces, appearances may be deceptive). See Elizabeth L. O'Leary, *At Beck and Call: The Representation of Domestic Servants in Nineteenth-Century American Painting* (Washington, D.C.: Smithsonian Institution Press, 1996), esp. 126–28, which offers a distinctly somber contrast in an antebellum depiction of a similar scene, William Henry Burr's 1849 *The Intelligence Office* (which seems to have been the inspiration for "The labor exchange at Castle Garden—Choosing a girl," *HW,* January 25, 1873, cover [73]). On the transformation of the personnel and meaning of service work, see Faye E. Dudden, *Serving Women: Household Service in Nineteenth-Century America* (Middletown, Conn.: Wesleyan University Press, 1983); David M. Katzman, *Seven Days a Week: Women and Domestic Service in Industrializing America* (Urbana: University of Illinois Press, 1978).

16. *FLIN,* April 24, 1875, 109 (see also the cut of the store's lunchroom, 105).

17. Douglass is quoted in *Prang's Chromo,* September 1870; quoted in Katharine Morrison McClinton, *The Chromolithographs of Louis Prang* (New York: Clarkson N. Potter, 1973), 37, and in Peter C. Marzio, *The Democratic Art: Pictures for a Nineteenth Century America* (London: Scolar Press, 1980), 104. See also Frederick Douglass, "Pictures and Progress," in *The Frederick Douglass Papers,* series 1, *Speeches, Debates, and Interviews,* ed. John W. Blassingame, vol. 3 (New Haven: Yale University Press, 1985), 452–73, 619–20. The Prang lithograph was based on an oil painting by Theodore Kaufmann.

18. Aside from the March 12 engraving, *Leslie's* published a portrait of Revels in the February 26, 1870, issue (401); *Harper's Weekly's* Revels portrait appeared February 19, 1870, 116 (see also Thomas Nast's cartoon, "Time works wonders," *HW,* April 29, 1870, 232).

19. As Guy C. McElroy has written in *Facing History: The Black Image in American Art, 1710–1940* ([Washington, D.C.: Corcoran Gallery of Art, 1990], xviii), "Cartoonists and print artists supplied caustic images that openly embraced racist sentiment or encouraged a view of black citizens as separate and different from their white counterparts. . . . [P]rint artists . . . returned with obvious gusto to pre–Civil War ideas of black people as extremely compliant, servile, or painfully antic characters." See also Albert Boime, *The Art of Exclusion: Representing Blacks in the Nineteenth Century* (Washington, D.C.: Smithsonian Institution Press, 1990); Francis J. Martin Jr., "The Image of Black People in American Illustration from 1825 to 1925" (Ph.D. diss., University of California, Los Angeles, 1986); Peter H. Wood and Karen C. C. Dalton, *Winslow Homer's Images of Blacks: The Civil War and Reconstruction Years* (Austin: University of Texas Press, 1988). Articles on images in the illustrated literary monthlies that stress exclusion and racism include Kathleen Diffley, "Home on the Range: Turner, Slavery, and the Landscape Illustrations in *Harper's New Monthly Magazine, 1861–1876,*" *Prospects* 14 (1989): 175–202; Robert J. Scholnick, "*Scribner's Monthly* and the 'Pictorial Representation of

Life and Truth' in Post–Civil War America," *American Periodicals* 1.1 (fall 1991): 61–62.

20. On the functions of blackface minstrelsy for white audiences, and the black types that emerged from its performances, see, among many works, Robert C. Toll, *Blacking Up: The Minstrel Show in Nineteenth-Century America* (New York: Oxford University Press, 1974); Alexander Saxton, *The Rise and Fall of the White Republic: Class Politics and Mass Culture in Nineteenth-Century America* (London: Verso, 1990), 165–82; David R. Roediger, *The Wages of Whiteness: Race and the Making of the American Working Class* (London: Verso, 1991), 97–98, 105, 115–31; Eric Lott, *Love and Theft: Blackface Minstrelsy and the American Working Class* (New York: Oxford University Press, 1993). The enduring black stereotypes of antiabolitionist pictorial propaganda are discussed in Phillip Lapansky, "Graphic Discord: Abolitionist and Antiabolitionist Images," in *The Abolitionist Sisterhood: Women's Political Culture in Antebellum America,* ed. Jean Fagan Yellin and John C. Van Horne (Ithaca, N.Y.: Cornell University Press, 1994), 201–30; Bernard F. Reilly Jr., "The Art of the Antislavery Movement," in *Courage and Conscience: Black and White Abolitionists in Boston,* ed. Donald M. Jacobs (Bloomington: Indiana University Press, 1993), 47–73. See also, for representative black figures in antebellum imagery, Johns, *American Genre Painting,* 100–136.

21. Henry Louis Gates Jr., "The Face and Voice of Blackness," in McElroy, *Facing History,* xxix–xliv. Similarly, see Toni Morrison, *Beloved* (New York: Alfred A. Knopf, 1987), 155–56.

22. On Taylor, see Oliver Jensen, "War Correspondent: 1864," *American Heritage,* August–September 1980, 48–64; Robert Taft, *Artists and Illustrators of the Old West, 1850–1900* (New York: Charles Scribner's Sons, 1953), 297. Theodore R. Davis and Alfred R. Waud covered the South for *Harper's Weekly* during 1866. For Waud's trip, see Frederic E. Ray, *Alfred R. Waud, Civil War Artist* (New York: Viking, 1974), 53–57; Taft, *Artists and Illustrators of the Old West,* 59–61. For Davis's trip, see ibid., 65. The most celebrated illustrated postwar tour was *Scribner's Monthly*'s series of 1873 to 1874, "The Great South," written by Edward King and illustrated by J. Wells Champney (later published as *The Great South: A Record of Journeys . . .* [Hartford, Conn.: American Publishing Company, 1875]): see Arthur John, *The Best Years of "The Century": Richard Watson Gilder, "Scribner's Monthly," and "The Century Magazine," 1870–1909* (Urbana: University of Illinois Press, 1981), 39–41; Scholnick, "*Scribner's Monthly* and the 'Pictorial Representation of Life and Truth,'" 61–62; Frank Luther Mott, *A History of American Magazines, 1865–1885* (Cambridge, Mass.: Harvard University Press, 1938), 48, 464–65; Sue Rainey, *Creating "Picturesque America": Monument to the Natural and Cultural Landscape* (Nashville: Vanderbilt University Press, 1994), chap. 3. *Leslie's* dispatched Joseph Becker on another tour of the southern states in the spring of 1869.

23. For engravings of freedpeople in *FLIN,* see, for example, May 19, 1866, 132; August 25, 1866, 361; March 9, 1867, 392; March 23, 1867, 9; August 3, 1867, 313. In contrast, poor whites appeared infrequently: "Georgia 'cracker' market carts," July 6, 1867, 249, was the only picture to appear during Taylor's tour. During the period under consideration, only four more engravings depicted

poor southern whites: March 26, 1870, 29; October 7, 1871, 61; August 17, 1872, 365; November 22, 1873, 181.

24. Taylor's other depictions of the Freedmen's Bureau in *FLIN* include August 25, 1866, cover (353); September 22, 1866, 5; October 27, 1866, 89; February 2, 1867, 314. A cartoon deriding the perspective of the Freedmen's Bureau cultivating black indolence, "The popular idea of the Freedmen's Bureau—Plenty to eat and nothing to do," appeared October 6, 1866, 48.

25. For a similar approach in the literary monthlies, see Scholnick, "*Scribner's Monthly* and the 'Pictorial Representation of Life and Truth,'" 61–62; Diffley, "Home on the Range." The antebellum sources of the paternalist portrayal are discussed in Lapansky, "Graphic Discord"; Reilly, "The Art of the Antislavery Movement."

26. *HW,* December 15, 1866, 797. "It is the peculiarity of this school," the description accompanying the engraving commented, "that it is entirely under the superintendence of colored teachers." This engraving is discussed in Wood and Dalton, *Winslow Homer's Images of Blacks,* 79; for other images of black education in the South by Waud and other *Harper's Weekly* artists, see ibid., 121 n. 179.

27. *FLIN,* January 19, 1867, 275. On the Black Codes, see Eric Foner, *Reconstruction: America's Unfinished Revolution, 1863–1877* (New York: Harper and Row, 1988), 199–201.

28. The distinction between the two engravings is particularly interesting because both cuts were based on sketches by the *same* special artist, William L. Sheppard (discussed later in this chapter and in n. 31); see Gregg D. Kimball, "'The South as It Was': Social Order, Slavery, and Illustrators in Virginia, 1830–1877," in *Graphic Arts and the South: Proceedings of the 1990 North American Print Conference,* ed. Judy L. Larson (Fayetteville: University of Arkansas Press, 1993), 146. For other comparisons, see "Virginia.—Characteristic scenes at the South—Negro voting in Richmond," *FLIN,* November 18, 1871, 152, and "The first vote," *HW,* November 16, 1867, cover (721): whereas both engravings depicted a range of African American types voting, the *Harper's* cut carefully posed, under a billowing American flag, a dignified old artisan, a more affluent city dweller, and a uniformed veteran casting ballots; *Leslie's* image presented a more slovenly and childlike line of prospective voters, headed by a bewildered-looking old man and all viewed by grim-faced whites and a slouching black official. In the *Leslie's* cut, some sort of illegal transaction was occurring in the rear of the line between a white man (a carpetbagger?) and a ragged black man.

29. *FLIN,* May 4, 1872, 125. Matt Morgan's cover cartoons proclaiming African American disillusionment with Grant and support of the Liberal Republicans include August 10, 1872, cover (337); August 24, 1872, 376–77; September 14, 1872, cover (1). See also the editorial "The Colored Vote," May 25, 1872, 162. Earlier in the development of the Liberal Republican movement, *Frank Leslie's* had expressed skepticism about its program: see the cartoon March 5, 1870, 424, depicting Greeley and Sumner desperately driving a sleigh and throwing a black infant to pursuing wolves.

30. For other images of black political activity, see *FLIN,* February 15, 1868, 345; April 30, 1870, 105; March 19, 1870, 8–9.

31. *FLIN*, April 27, 1872, cover (97). On William L. Sheppard (1833–1912), see Rainey, *Creating "Picturesque America,"* 66–68; Martin, "The Image of Black People in American Illustration," 382–83; Wood and Dalton, *Winslow Homer's Images of Blacks*, 90–92; Ulrich Troubetzkoy, "W. L. Sheppard: Artist of Action," *Virginia Cavalcade* 11.3 (winter 1961–62): 20–26; "The Artwork of William Ludwell Sheppard," *Virginia Cavalcade* 42.1 (summer 1992): 20–25. Sheppard's work was ubiquitous, appearing in *Harper's Weekly* and *Scribner's Monthly* as well (he redrew some of Champney's sketches for *Scribner's* "The Great South" engravings). Among *Leslie's* engravings attributed to Sheppard, see *FLIN*, September 11, 1869, 412; February 26, 1870, 400; December 31, 1870, 261–62; April 20, 1872, 93; July 5, 1873, 273; August 9, 1873, 352. For buffoon engravings not attributed to Sheppard (though in some cases the style suggests his work or his role in rendering other artists' sketches on the block), see December 11, 1869, 213; July 30, 1870, cover (305); June 3, 1871, 197; October 21, 1871, 93; February 8, 1873, 357 (attributed to Sheppard, based on a sketch by Becker); November 15, 1873, 169 (attributed to Becker).

32. "Art Gossip," *FLIN*, July 25, 1868, 291; see also "Art Gossip," September 7, 1867, 387. Wood and Dalton's dating of the watermelon stereotype in the depiction of southern African Americans to the 1880s (*Winslow Homer's Images of Blacks*, 122 n. 192) appears to be contradicted by Sheppard's engravings "A watermelon feast in Richmond," September 11, 1869, 412, and "The South.—The watermelon season—A scene on the Savannah docks," July 7, 1873, 273.

33. See also, along with the engravings of Hiram Revels previously noted, *FLIN*, December 26, 1868, cover (225); March 20, 1869, 13; January 14, 1871, 300; March 28, 1874, 45.

34. For other engravings of "exemplary" blacks, see *FLIN*, August 14, 1869, 341; January 28, 1871, 329 (and the editorial "Rowdyism in Colleges," March 11, 1871, 423, denouncing the court-martial of a black West Point cadet); June 24, 1871, 245; February 24, 1872, 380; December 13, 1873, 236.

35. *FLIN*, January 17, 1874, 312–13. Matt Morgan's rendering of African Americans in this and other cuts is noteworthy in the light of his Irish physiognomics (discussed in chapter 3, n. 65, above). Even in his 1872 pro–Liberal Republican cartoons, Morgan depicted African Americans without the telltale physical codes he lavished on other ethnicities and races, and this treatment was consistent through the 1880s (see, as an outstanding example, "Unrestricted immigration and its results.—A possible curiosity of the twentieth century. The last Yankee," *FLIN*, September 8, 1888, 56).

36. "The Ku Klux Klan at work—The assassination of the Hon. G. W. Ashburn, in Columbus, Georgia, on the 31st ult.," *FLIN*, April 25, 1868. The report of the incident included a reproduction of the death notice that the Klan posted around Columbus before the assassination.

37. In *FLIN*, see "A Ku-Klux outrage" (in the sensational "Home Incidents, Accidents, &c." section), April 18, 1868, 77; "Washington, D.C.—The Senate committee for the investigation of southern outrages—Scene in the Retrenchment Committee's room, Capitol.—Hearing the statement of a school-teacher

from New York, who had been 'run out' by the Ku Klux," April 8, 1871, 56. The description accompanying the latter engraving noted, "Our artist . . . succeeded in securing an accurate sketch of the Committee while in session, notwithstanding the privacy of the deliberations" (53–54). Such behind-the-scenes engravings, so common in *Leslie's* depictions of governmental process in the decade after the Civil War, illustrates another crucial aspect of the pictorial press's reform "mission": beginning with *Leslie's* early engravings of the swill milk scandal (which included cuts of the New York City Board of Health in session), these pictures provided readers with representations of critical events from which they were otherwise excluded, permitting them to evaluate the nature of "hidden" decision making (including, in some situations, corrupt political practices).

38. See *Leslie's* editorials "The New Orleans Outrage," September 1, 1866, 370; "The New Orleans Massacre," September 15, 1866, 402–3. *Harper's Weekly's* pictorial coverage of the New Orleans riot included seven engravings based on Theodore Davis sketches and two portraits (August 25, 1866, cover [529], 536, 537, 540); two more Davis cuts (September 1, 1866, 556); and Thomas Nast cartoons (September 1, 1866, 552–53; September 8, 1866, 569; March 30, 1867, 200–201). For other *Harper's Weekly* engravings of violence against blacks, see, for example, *HW*, May 26, 1866, cover (321); September 14, 1867, cover (577); November 21, 1868, 740; August 8, 1868, 512. On Alfred Waud's coverage of the Memphis Riots for *Harper's*, see Wood and Dalton, *Winslow Homer's Images of Blacks*, 79–80.

39. *FLIN*, May 9, 1868, 115. The "Red String League," better known as the Heroes of America, was a secret order of southern white Unionists dedicated to overthrowing the Confederacy during the Civil War. Mainly located in North Carolina, the order reappeared after the war as part of the state's Republican Party. If the scholarship on the Heroes of America is accurate, the only reliable information in *Leslie's* coverage was its reference to the red string, a biblically inspired symbol in the order's membership ritual and a secret identifying mark among its members. See William T. Auman and David D. Scarboro, "The Heroes of America in Civil War North Carolina," *North Carolina Historical Review* 58.4 (October 1981): 327–63; Foner, *Reconstruction*, 16, 284, 301.

40. *FLIN*, May 16, 1868, 139. A similar alternation of views characterized *Leslie's* coverage of violence and American Indians: "Enlightened and Christian warfare in the nineteenth century—Massacre of Indian women and children in Idaho, by white scouts and their red allies," August 22, 1868, cover (326), was (after a letter of protest) followed by "The capture of a freight train of the Union Pacific Railroad, by Sioux Indians—Antics of the savages after the capture," September 12, 1868, 408. See also "The Battle of Washita—The attack on Black Kettle's camp, Washita River, by the Seventh Regiment Cavalry under Major-General George A. Custar [*sic*], Nov. 27th," December 26, 1868, 233, versus " 'Vengeance on the trail,' " January 9, 1869, 265. On early coverage, see Patricia A. Curtin, "From Pity to Necessity: How National Events Shaped Coverage of the Plains Indian War," *American Journalism* 12.1 (winter 1995): 3–21. Until the 1873 Modoc War, *Leslie's* balanced denunciations of Indian "character" with admonishments to exercise fair treatment (e.g., "New York City.—The

Sioux chief, Red Cloud, in the Great Hall of the Cooper Institute, surrounded by the Indian delegation of braves and squaws, addressing a New York audience on the wrongs done to his people," *FLIN,* July 2, 1870, cover [241]). The murder of Special Artist Ridgeway (or Reginald) Glover by Arapahos in Dakota Territory in 1866 (see "The Fate of a Frank Leslie 'Special,'" *FLIN,* October 27, 1866, 94, and Elmo Scott Watson, "The Indian Wars and the Press, 1866–1867," *Journalism Quarterly* 17.4 [December 1940]: 301–12) seemed to have little impact on coverage, beyond a peculiarly lighthearted cartoon in the September 21, 1867, issue (16). The 1876 Battle of the Little Big Horn marked the demise of sympathetic coverage of "wild," as opposed to "reservation," Indians (and, conversely, the representational transformation of George A. Custer, presented in his previous appearances in *Leslie's* engravings as in turn savage, heroic, and absurd).

41. "The Philadelphia election fraud.—Policemen arresting citizens for challenging the votes of Negro repeaters," *FLIN,* October 26, 1872, cover (97), 102–3. See also 101, 109.

42. For *FLIN* engravings, see March 22, 1873, 24; May 3, 1873, 132; February 21, 1874, 396; October 3, 1874, 52, 61; November 28, 1874, 181; December 26, 1874, cover (257), 268; January 6, 1875, 320; January 23, 1875, cover (321), 328. Editorials include "Our 'Colored Brethren' in 1873," January 11, 1873, 282; "War of Races," May 3, 1873, 118; "South Carolina Legislative—Darkey Literature and Morals," May 17, 1873, 151; "The 'War of Races,'" September 12, 1874, 2–3; "Louisiana," October 3, 1874, 50; "Shall the Blacks Rule?" October 10, 1874, 66.

43. "The Ku Klux Klan Reports to Congress," *FLIN,* March 9, 1872, 402; for the illustration of the testifying schoolteacher, see April 8, 1871, 56; for the endorsement of the Ku Klux Klan Act, see May 13, 1871, 145. In a similar vein, see "Ku Klux Jack," August 14, 1875, 394–95, a short story about innocent North Carolina whites falsely accused by a crafty black.

44. "The 'war of races.'—The conflict in Tennessee.—The 'regulators' shooting blacks near Trenton, in Gibson County," *FLIN,* September 19, 1874, cover (17), 23. To confuse matters, an editorial in the same issue seemed to momentarily endorse the presence of federal troops to stop the violence: "The Southern Contest," 18.

45. *HW,* May 10, 1873, 396, 397; November 21, 1874, 958. See also Thomas Nast's cartoons in *HW,* October 17, 1874, 856–57; October 24, 1874, 878; February 6, 1875, 124; August 12, 1876, 652, 656–57; September 30, 1876, 801; October 14, 1876, 840; October 28, 1876, 880.

46. *FLIN,* December 2, 1876, 221. On the South Carolina legislature, see also December 23, 1876, 268. Depictions of black misrule, by this time, also had appeared in *Harper's Weekly:* see Thomas Nast's censorious "Colored rule in a reconstructed (?) state," *HW,* March 14, 1874, cover (229); Nast's physiognomic attack was immediately rebutted in a New York *Daily Graphic* cover cartoon by Thomas Wust, "Tu quoque!" (*DG,* March 11, 1874—but see "Black and White in the South," *DG,* August 24, 1874).

47. See, for example, *FLIN,* November 18, 1876, 176. An indication of *FLIN's* decline into the "picturesque" can be seen in two different cuts of the

Skidmore Guards, an 1870s New York marching club composed of barbers and servants. While "New York City.—First annual ball of the Skidmore Guard, a colored military organization, at the Seventh Avenue Germania Assembly Rooms" (February 24, 1872, 380) presented a handsome and dignified gathering of young African American men and women, "Our colored militia.—A 'Skid' dressing for the parade on the Fourth of July" (July 17, 1875, 333) settled comfortably into parody. The Skidmores themselves had, by 1875, become a feature of Charles Callender's minstrel show. On the Skidmore Guards and the *Leslie's* picture, see Wood and Dalton, *Winslow Homer's Images of Blacks,* 103; Toll, *Blacking Up,* 249. As for the corrupt black type, this political figure was usually depicted devoid of physiognomic signs. Rarely does one glimpse anything akin to the dangerous "coon" figure of the postbellum stage; an early and isolated exception is an engraving based on a Sheppard sketch of a Virginia black chain gang staring malevolently at the reader, their debased natures held in check by white authority (*FLIN,* March 1, 1873, 404). On the coon figure, see James H. Dormon, "Shaping the Popular Image of Post-Reconstruction American Blacks: The 'Coon Song' Phenomenon of the Gilded Age," *American Quarterly* 40.4 (December 1988): 450–71.

48. "Philadelphia, Pa.—The Centennial Exposition—The colored waiters at Mercer's 'Southern Restaurant' swearing in for the reform presidential candidates," *FLIN,* November 4, 1876, 137. In contrast, see "Louisiana—The presidential election—Colored citizens describing their wrongs to the northern commissioners in the St. Charles Hotel, New Orleans," December 2, 1876, 213; see also "Tennessee.—The colored national convention held at Nashville, April 5th, 6th and 7th," May 6, 1876, 145.

49. For *FLIN*'s images celebrating "reconciliation," see July 10, 1875, cover (309); June 9, 1877, cover (229).

50. Hugh Honour, *The Image of the Black in Western Art,* vol. 4, *From the American Revolution to World War I,* part 1, *Slaves and Liberators* (Cambridge, Mass.: Harvard University Press, 1989), 256–58. For castigation of the Pezzicar statue, see William Dean Howells, "A Sennight of the Centennial," *Atlantic Monthly* 38 (July 1876): 93; Edward C. Bruce, *The Century: Its Fruits and Its Festival* (Philadelphia: J. B. Lippincott, 1877), 174. Kirk Savage, *Standing Soldiers, Kneeling Slaves: Race, War, and Monument in Nineteenth-Century America* (Princeton: Princeton University Press, 1997), 52–88 and passim, compellingly demonstrates the racial and gendered limits of postbellum public commemorative sculpture that *The Freed Slave* transgressed. See also Michael Hatt, " 'Making a Man of Him': Masculinity and the Black Body in Mid-Nineteenth-Century American Sculpture," *Oxford Art Journal* 15.1 (1992): 21–35, for insight into the antipathy aroused by the subversive nature of the "heroic body" in public sculpture. On the exclusion of African Americans at the Centennial, see Robert W. Rydell, *All the World's a Fair: Visions of Empire at American International Expositions, 1876–1916* (Chicago: University of Chicago Press, 1984), 27–29.

51. For other images of equality in *FLIN,* see January 27, 1877, 341; February 3, 1877, 361; February 10, 1877, 376; April 7, 1877, 85; July 14, 1877, 328.

CHAPTER 5. RECONSTRUCTING REPRESENTATION, 1866–77

1. Joseph Becker, "An Artist's Interesting Recollections of *Leslie's Weekly*," *Leslie's Weekly*, December 14, 1905, 570.

2. Becker, who was born in 1841, began his career with *Leslie's* in 1859 when he was hired as an errand boy; in 1863, he became one of the publication's special artists covering the war. During 1869 and 1870, Becker traveled the West for *Leslie's;* his series of "Across the Continent" engravings presented readers with views of the West, including pictures of San Francisco's Chinese population and Utah's Mormons. His tenure as supervisor of *Leslie's* art department lasted until 1900. For Becker's career, see ibid.; Robert Taft, *Artists and Illustrators of the Old West, 1850–1900* (New York: Charles Scribner's Sons, 1953), 89–93, 312–14; idem, "Joseph Becker's Sketch of the Gettysburg Ceremony, November 19, 1863," *Kansas Historical Quarterly* 21.4 (winter 1954): 257–63.

3. *Frank Leslie's Illustrated Newspaper* (hereafter *FLIN*), March 25, 1871, cover (17); April 15, 1871, 76; April 22, 1871, 88; April 29, 1871, 108; May 6, 1871, cover (121); May 27, 1871, 177.

4. *FLIN*, June 17, 1871, cover (217; drawn by James E. Taylor); September 2, 1871, 420 (drawn by C. A. Keetels).

5. Strike coverage appeared in *FLIN*, July 6, 1867, 253; engravings of the 1869 Avondale, Pennsylvania, disaster appeared in September 25, 1869, cover (17), 21, 24–25, with additional cuts in an accompanying supplement; engravings of the Stockton, Pennsylvania, cave-in appeared in a supplement, January 8, 1870.

6. *FLIN*, July 19, 1873, 300 (drawn by John N. Hyde).

7. On the Long Strike, Gowen's plan to destroy the WBA, the organization of Irish miners' secret societies, and the prosecution of the Molly Maguires, see Kevin Kenny, *Making Sense of the Molly Maguires* (New York: Oxford University Press, 1997); Wayne G. Broehl Jr., *The Molly Maguires* (Cambridge, Mass.: Harvard University Press, 1964). Before Becker returned to Pennsylvania, Jonathan Lowe supplied one sketch for an engraving of a miners' faction fight, *FLIN*, October 24, 1874, 101 (see also Lowe's earlier cut of striking Ohio miners, September 5, 1874, 413).

8. *FLIN*, December 12, 1874, 232.

9. *FLIN*, February 6, 1875, 357, 364.

10. *FLIN*, March 13, 1875, 9, 11. It is instructive to compare Becker's depictions of striking miners with an earlier cut that has been attributed to him portraying an array of ethnic and regional types, "On the plains.—A station scene on the Union Pacific Railway," *FLIN*, December 11, 1869, 208–9. However, Taft's assertion of Becker's authorship (*Artists and Illustrators of the Old West*, 92, 314) ignores the name "Paul Frenzenl" labeling a trunk in the lower-right-hand corner of the engraving. Though misspelled, that name points to Paul Frenzeny as the artist. Frenzeny contributed illustrations of New York's poor to *Harper's Weekly* during the late 1860s, covered the West with fellow French-born artist Jules Tavernier for *Harper's* from 1873 to 1874, and contributed several illustrations to *Leslie's* during the 1880s. The only Long Strike image to appear in *Harper's Weekly* was credited to Frenzeny and Tavernier: "The strike in

the coal mines—Meeting of 'Molly M'Guire' men," *Harper's Weekly* (hereafter *HW*), January 31, 1874, 105, an unusually romantic image of the secret society that, according to several commentators, recalls Christ preaching to the Twelve Apostles: see Marianne Doezema, *American Realism and the Industrial Age* (Bloomington: Indiana University Press for the Cleveland Museum of Art, 1980), 38; John Gladstone, "Working-Class Imagery in *Harper's Weekly, 1865–1895*," *Labor's Heritage* 5.1 (spring 1993): 47–49. On Frenzeny, see Taft, *Artists and Illustrators of the Old West*, 94–116.

11. Becker, "An Artist's Interesting Recollections," 570. With the assistance of Kevin Kenny, author of the most recent and comprehensive study of the group, *Making Sense of the Molly Maguires,* I have ascertained that Becker's contribution to prosecuting the men accused of conspiracy has gone previously unrecorded in the annals of the case. If Becker's story is true, he joined forces with one of the five Pinkerton and Reading Railroad operatives who infiltrated the miners' ranks.

12. "Editorial Notes," *FLIN,* April 3, 1875, 51. I have been unable to locate more information about Hugh McGarvy. The standard histories of the Workingmen's Benevolent Association (officially known as the Miners' and Laborers' Benevolent Association after 1870)—including Andrew Roy, *A History of the Coal Miners of the United States . . .* (Columbus: J. L. Trauger Printing Company, 1907) and Chris Evans, *History of the United Mine Workers of America from the Year 1860 to 1890,* two volumes (Indianapolis: United Mine Workers of America, [1900])—do not mention McGarvy; Kevin Kenny graciously provided me with information from the WBA's newspaper, the *Anthracite Monitor,* for 1871 to 1872 (i.e., before the Long Strike), which did not name McGarvy but confirmed that the union's structure included a State General Council (composed of delegates from county-based district councils) with the office of president. The author of *Leslie's* editorial reply is equally difficult to determine (as discussed in chapter 3, n. 7, the editors have remained largely anonymous). The two editors known to have worked for *Leslie's* in the early 1870s, Ephraim G. Squier and J. C. Goldsmith, had left the publication by 1875. For possible authors, see "A Tribute of Respect," *FLIN,* January 31, 1880, 403.

13. "Editorial Notes," *FLIN,* April 3, 1875, 51.

14. "Pennsylvania.—'A marked man.'—Scene in the coal regions during the miners' strike," *FLIN,* April 10, 1875, 77; "Pennsylvania.—Pay-day in the mining regions," September 4, 1875, 449 (quotation, 450). Compare Becker's latter treatment with Frenzeny's more benign pictorial coverage in "The miners' payday," *HW,* February 22, 1873, 157. But see also the editorial titled "Coal Trade," *FLIN,* June 12, 1875, 215, essentially a critique of the Reading Railroad's monopoly control of Pennsylvania coal. The New York *Daily Graphic* (hereafter *DG*) covered the strike in the anthracite region in the issue of May 22, 1875, peppering its report with anti-Irish commentary.

15. The two-year hiatus in mining coverage was broken only by two engravings of coal region winter serenades and sledding in *FLIN,* March 25, 1876, 50, which were based on sketches Becker had made the year before.

16. *FLIN,* June 16, 1877, 253; June 30, 1877, 292; July 7, 1877, 305. An engraving showing four condemned prisoners, presumably also based on a

sketch by Becker, appeared in the June 30, 1877, issue (189) of Leslie's *New York Illustrated Times* (formerly *The Days' Doings*). Reports of the Molly Maguire trial and execution also appeared in the *Daily Graphic:* see *DG,* August 25, 1876; June 22, 1877.

17. Becker, "An Artist's Interesting Recollections," 570.

18. See, for example, engravings in *FLIN,* June 3, 1871, 196; June 10, 1871, 208, 213; June 24, 1871, 241. On the postwar monument campaign, see Kirk Savage, *Standing Soldiers, Kneeling Slaves: Race, War, and Monument in Nineteenth-Century America* (Princeton: Princeton University Press, 1997).

19. *Leslie's* also overtly positioned itself in opposition to *Harper's Weekly's* nativist stance. See, for example, "Editorial Notes," *FLIN,* May 8, 1875, 135, in which *Leslie's* criticized a Concord centennial oration by *Harper's Weekly* political editor George William Curtis: "[He] might have lauded the earlier immigrations to this country without flinging a superfluous slur upon the later immigrations which have swelled its population and incalculably added to its wealth and strength." See Curtis, "Centennial Celebration of Concord Fight," in *Orations and Addresses of George William Curtis,* ed. Charles Eliot Norton, vol. 3 (New York: Harper and Brothers, 1894), 85–121; see also Robert Charles Kennedy, "Crisis and Progress: The Rhetoric and Ideals of a Nineteenth Century Reformer, George William Curtis (1824–1892)" (Ph.D. diss., University of Illinois at Urbana-Champaign, 1993), 490–99.

20. See, for example, *FLIN,* April 7, 1866, 41; May 26, 1866, cover (145); June 2, 1866, 168; June 23, 1866, cover (209); June 11, 1870, cover (193).

21. See also the anticipatory cartoon "St. Patrick's Day in the morning," *FLIN,* March 30, 1867, 21, with its soused and riotous leprechauns. Characteristically, *Leslie's* concluded the text accompanying the riot engraving with what one might call a more catholic admonition: "While there is no possible justification for the treatment of the police by the rioters, yet it appears from the statements of some eye witnesses that the police were injudicious in their too prompt use of their clubs" (April 6, 1867, 35). On the general derogation of Irish Catholics in the pages of *Harper's Weekly,* exemplified in Thomas Nast's work, see Morton Keller, *The Art and Politics of Thomas Nast* (New York: Oxford University Press, 1968), 159–62; L. Perry Curtis Jr., *Apes and Angels: The Irishman in Victorian Caricature* (Washington, D.C.: Smithsonian Institution Press, 1971), 58–59; Roger A. Fischer, *Them Damned Pictures: Explorations in American Political Cartoon Art* (North Haven, Conn.: Archon Books, 1996), 17–23. For one cartoonist's recollections of Irish American antipathy toward *Harper's Weekly,* see William Allen Rogers, *A World Worth While: A Record of "Auld Acquaintance"* (New York: Harper and Brothers, 1922), 28–33.

22. On the Orange Riot and its press coverage, see Michael A. Gordon, *The Orange Riots: Irish Political Violence in New York City, 1870 and 1871* (Ithaca, N.Y.: Cornell University Press, 1993).

23. *FLIN,* July 29, 1871, 327. As indicated in its coverage of the 1867 St. Patrick's Day riot, *Leslie's* in earlier editorials had criticized the use of force by police who claimed to be seeking order: see "Another Hint for Policemen," November 3, 1866, 99; "Handcuffs versus Clubs," September 21, 1867, 2–3; "Indecent Reporting," October 19, 1867, 67. An altercation between police and

Special Artist Matt Morgan on the evening of September 14, 1872, led to two critical editorials: "Police Outrages," October 5, 1872, 50, and "Club Law," October 12, 1872, 66.

24. *FLIN*, July 29, 1871, 332. On the Orange Riot and the symbolism of women as participants (as well as avatars of order), see Mary P. Ryan, *Women in Public: Between Banners and Ballots, 1825–1880* (Baltimore: Johns Hopkins University Press, 1990), 158–60.

25. Roland Barthes proposes a similar "blockage of meaning" for the "traumatic photograph" of catastrophe: see "The Photographic Message," in his *Image, Music, Text*, ed. and trans. Stephen Heath (New York: Hill and Wang, 1977), 30–31. For engravings of Chicago Fire victims, see *FLIN*, October 28, 1871, cover (97); November 4, 1871, cover (113), 117, 120–21, 124 (including an illustrated supplement); November 11, 1871, 136, 140–41; November 18, 1871, 156–57. An indication of the change in representation may be gleaned from *Leslie's* engraving of the 1870 Orange Riot, in which physiognomy delineated the features of the male figures (editorially, *Leslie's* denounced Catholic aggression but then cast equal blame on the provocative Orange parade): July 30, 1870, 313.

26. For *Leslie's* recognition of the troops and its denunciation of disorder, see the editorial "Prohibition of Processions in Cities," August 5, 1871, 338, and the engravings in the same issue, cover (337), 344–45. In the August 5 issue, perhaps in deference to its wide German readership, *Leslie's* also published a picture of an orderly Turnverein ceremony that legitimated ethnic activities that its editorial seemingly dismissed: August 5, 1871, 348; see also August 26, 1871, 405.

27. "Bravo! Bravo!—New York, July 12, 1871," *HW*, July 29, 1871, cover (689); see also Thomas Nast's "Something that will not 'blow over'—July 11 and July 12, 1871," ibid., 696–97. *Leslie's* cartoons emphasized the barring of "foreign" sectarian disputes in the United States: *FLIN*, July 29, 1871, 325, 336. See the cartoon published in the August 12, 1871, issue of the *Irish World*—"Grand Turnout of the 'Apes' and 'Orang-outangs,' New York, July 12, 1871"—which denounced the overall press response but omitted *Leslie's* from the caricatured press band (including *Harper's*) depicted as leading the Boyne Day celebrants (Gordon, *The Orange Riots*, 183–84).

28. "The great financial panic.—Closing the doors of the Stock Exchange on its members, Saturday, Sept. 20th," *FLIN*, October 4, 1873, cover (65, supplement). See also ibid., 66, 67–68; October 9, 1869, 65; October 16, 1869, cover (73), 80, 81; April 13, 1872, cover (85); September 11, 1875, cover (1).

29. See *FLIN*, May 8, 1869, 120; September 25, 1869, cover (17), 21, 24–25 (and supplement); July 9, 1870, 268; June 17, 1871, cover (217); September 2, 1871, 420; May 3, 1873, cover (117); May 24, 1873, 173; October 3, 1874, cover (49); January 20, 1877, 325, 328. See also Julie Wosk, *Breaking Frame: Technology and the Visual Arts in the Nineteenth Century* (New Brunswick, N.J.: Rutgers University Press, 1992), 15–17, 52–54.

30. For the conditions of and responses to the depression, the most comprehensive work remains Herbert G. Gutman, "Social and Economic Structure and Depression: American Labor in 1873 and 1874" (Ph.D. diss., University of Wisconsin, 1959).

31. *FLIN*, February 13, 1875, 382.

32. Ibid. See also *FLIN*, February 21, 1874, 389. For *Frank Leslie's* reluctant editorial recognition of the depression's impact, see the arch comment and cartoon "Twelve Hundred a Year," November 1, 1873, 127 (comment), 132 (cartoon), expressing skepticism about a report in the *New York Sun* regarding a clerk's inability to support his family on his salary. Two weeks later, *Leslie's* presented a cover engraving showing an unemployed worker in front of a closed iron mill (see figure 5.14); but the title, "Out of work," reflected less the predicament of the unemployed than the publication's stance toward the future of the Grant administration, whose inflationary policies *Leslie's* blamed for the panic: "Out of work. Saturday night at the iron mills during the crisis" and "Out of Work" (editorial), November 15, 1873, cover (157), 158 (editorial). By 1875 *Leslie's* editorials no longer focused on the currency issue, but insisted that only companies already insolvent had succumbed after the 1873 panic. In the second year of the depression, *Leslie's* deemed the United States the one nation where the majority of the populace lay comfortably between labor and capitalists: see "The Money Power," July 31, 1875, 358.

33. "The Tramp Nuisance," *FLIN*, August 5, 1876, 354–55. See also *FLIN*, July 21, 1877, 341; "The value of a pistol.—A villainous tramp repulsed by a plucky woman," *The Days' Doings* (hereafter *DD*), June 12, 1875, 9. As Michael Davis has shown, *Leslie's* view coincided with the labor movement's denunciation of the tramp in the 1870s: see Davis, "Forced to Tramp: The Perspective of the Labor Press, 1870–1900," in *Walking to Work: Tramps in America, 1790–1935*, ed. Eric H. Monkkonen (Lincoln: University of Nebraska Press, 1984), 141–70.

34. *FLIN*, November 15, 1873, 164; March 7, 1874, 429. The presence of unattended children in the latter cut of the soup house carried a different message from earlier depictions of the poor, as noted in the accompanying text: "Families who did not wish to make their poverty public sent pails and kettles, which were filled. Scores of little girls came, saying that their mothers were sick, or starving, and unable to leave their garrets."

35. *FLIN*, February 10, 1877, 379. In keeping with its reform tradition, *Leslie's* also presented critical views of the conditions to which the poor were subjected: see, for example, "The Tombs prison.—Midnight scene—The matron going the rounds," May 16, 1874, cover (145). By 1876 *Leslie's* editorials had, however reluctantly, taken a decided turn: see "The Problem of a Crowd," July 15, 1876, 302–3, which in many ways attempted to counterbalance the publication's infatuation with the Philadelphia Centennial Exposition from 1875 through 1876. See also "Snow and the Poor," January 20, 1877, 323: while continuing to denounce those who willfully refused to work, the editorial nonetheless now recognized the extremity of destitution.

36. *FLIN*, September 4, 1875, 450.

37. Budd Leslie Gambee Jr., *Frank Leslie and His Illustrated Newspaper*, University of Michigan Department of Library Science Studies 8 (Ann Arbor: University of Michigan, 1964), 15, 18; "Frank Leslie," *FLIN*, January 24, 1880, 382; Richard B. Kimball, "Frank Leslie," *Frank Leslie's Popular Monthly* 9.3 (March 1880): 262. For one caricature, see Joseph Keppler's "A Stir in the

Roost" on the cover of the first English edition of *Puck*, March 14, 1877; reproduced in Richard Samuel West, *Satire on Stone: The Political Cartoons of Joseph Keppler* (Urbana: University of Illinois Press, 1988), 113.

38. Madeleine Bettina Stern, *Purple Passage: The Life of Mrs. Frank Leslie* (Norman: University of Oklahoma Press, 1953), 24–31, 33–71; Ishbel Ross, *Charmers and Cranks: Twelve Famous American Women Who Defied the Conventions* (New York: Harper and Row, 1965), 64–71; Brian W. Dippie, *Catlin and His Contemporaries: The Politics of Patronage* (Lincoln: University of Nebraska Press, 1990), 225–46, 251–58, 403–10; Gambee, *Frank Leslie*, 15–18; Lynne Vincent Cheney, "Mrs. Frank Leslie's Illustrated Newspaper," *American Heritage*, October 1975, 43–45. Leslie moved with the Squiers as they changed residences, from Tenth Street to Thirty-eighth Street to Thirty-ninth Street, each move fueling speculation about the nature of the sleeping arrangements.

39. See "The 'Interlaken' Cup presented by Mr. Frank Leslie to the Saratoga Racing Association for the international amateur regatta race on Lake Saratoga, August 28. Manufactured by Tiffany & Co.," *FLIN*, August 29, 1874, 389; "A Publisher's Summer Home," *New York Tribune*, August 25, 1877; Stern, *Purple Passage*, 73–77; Ross, *Charmers and Cranks*, 71–72; Gambee, *Frank Leslie*, 19; J. C. Derby, *Fifty Years among Authors, Books, and Publishers* (New York: G. W. Carleton, 1884), 693; Cheney, "Mrs. Frank Leslie's Illustrated Newspaper," 45–46. At the time of their marriage, Frank Leslie was fifty-four and Miriam Leslie was thirty-eight.

40. Mrs. Frank Leslie, *California: A Pleasure Trip from Gotham to the Golden Gate* (New York: G. W. Carleton, 1877). See Stern, *Purple Passage*, 77–88, 230–31, 234; Gambee, *Frank Leslie*, 18–21; "A Publisher's Summer Home"; Taft, *Artists and Illustrators of the Old West*, 149–61; Ross, *Charmers and Cranks*, 72–76; Cheney, "Mrs. Frank Leslie's Illustrated Newspaper," 46–47. See the notice, *FLIN*, May 3, 1879, 131, announcing the settlement of a libel suit requiring Leslie to publicly apologize for impugning the character of his partner in the centennial scheme.

41. Gambee, *Frank Leslie*, 21; Stern, *Purple Passage*, 89–90, 233–34; "A Well-Known Publisher's Failure," *New York Tribune*, September 10, 1877; "Assignment by Frank Leslie," *New York Evening Post*, September 10, 1877. While the idea of collecting a salary might have seemed demeaning to the former publisher, the amount was hardly insubstantial: Leslie received 20 percent of the firm's annual profits.

42. For a notice of the move to 53, 55 and 57 Park Place, see *FLIN*, April 13, 1878, 90.

43. Stern, *Purple Passage*, 93–96, 236 (see 1–24 for Miriam Follin's life up to her marriage to Squier); Gambee, *Frank Leslie*, 21, 24; Bruce Seymour, *Lola Montez: A Life* (New Haven: Yale University Press, 1996), 328, 350, 355–58.

44. Stern, *Purple Passage*, 97; Gambee, *Frank Leslie*, 24; "Pictorial Publishing," *Paper World* 4.2 (February 1882): 2–3.

45. On the Lynn procession, see *FLIN*, March 17, 1860, 242, 251. See also May 5, 1866, 101; February 20, 1869, 360; May 8, 1869, 125; September 4, 1869, 392. *Leslie's* editorials against the eight-hour day include "Eight Hour Labor Movement," May 5, 1866, 97–98; "Labor Conventions," October 6, 1866,

34–35; "Eight Hours' Labor Bill," May 4, 1867, 98; "Town Gossip," May 11, 1867, 114–15; "The Eight Hour Humbug," July 11, 1868, 258; "Labor and Wages. The Eight Hour Humbug," December 26, 1868, 225–26; "Matters and Things," January 23, 1869, 231; "Creation and Recreation," July 15, 1871, 286; and editorial comments, January 27, 1872, 307; February 17, 1872, 355.

46. *FLIN,* September 30, 1871, cover (33); quotation, 37. For *Leslie's* engravings of the 1871 Pennsylvania mine strikes, see n. 3 above.

47. On the eight-hour movement and its press coverage, see Iver Bernstein, *The New York City Draft Riots: Their Significance for American Society and Politics in the Age of the Civil War* (New York: Oxford University Press, 1990), 237–57; Stanley Nadel, "Those Who Would Be Free: The Eight-Hour Day Strikes of 1872," *Labor's Heritage* 2.2 (April 1990): 70–77.

48. *FLIN,* June 8, 1872, 199.

49. *FLIN,* June 29, 1872, 252. The theme of foreign infection, although usually associated with violence (including a cut of "Judith [*sic*] Marx" inciting strikers), also appeared in the coverage of Leslie's *The Days' Doings:* "The Great Strike—The Seed and Its Fruits," *DD,* June 29, 1872, 16.

50. On the "noble yeoman," see Sarah Burns, *Pastoral Inventions: Rural Life in Nineteenth-Century American Art and Culture* (Philadelphia: Temple University Press, 1989), 99–121. Thomas Nast's 1870s cartoons in *Harper's Weekly,* which were critical of the eight-hour movement and equated trade union organizing with communist agitation, tended to portray a nondescript, agrarian-like worker (usually encumbered by a dependent spouse and child): e.g., the anti-eight-hour "The workingman's mite," *HW,* May 20, 1871, 468 (supplement). Beginning in the 1870s, Nast began to articulate labor as an aproned and square-hatted artisan: e.g., "Inflation is 'as easy as lying,'" *HW,* May 23, 1874, 444. Ironically, the artisan symbol, purportedly Nast's invention, gained particular adherence during the 1880s (when Joseph Keppler borrowed the figure for cartoons in *Puck*).

51. On *Leslie's* coverage of the Long Strike and Molly Maguires, see the discussion in the beginning of this chapter. For an exception to *Leslie's* general treatment of labor, prefiguring its treatment of the 1877 railroad strike, see *FLIN,* April 18, 1874, cover (81), 85; see also January 2, 1875, 277.

52. *FLIN,* January 6, 1872, 264–65. See also *DD,* January 6, 1872, 16. For criticism of the police suppression of the Paris Commune memorial procession, see the editorial comment and cartoon, "Our municipal police bull becometh enraged at the display of the red flag," *FLIN,* December 30, 1871, 243 (comment), 256 (cartoon); see also January 6, 1872, 264–65. On de Rochefort's visit, see June 13, 1874, cover (209); June 20, 1874, 232. Other engravings in *FLIN* about the International Workingmen's Association include a number of portraits, such as those of Karl Marx in December 30, 1871, 245; June 22, 1872, 237; February 21, 1874, 397 (see also the accompanying description, "Champions of the Red Flag. Leaders of the 'Industrial Party' in New York," 397–98, which reprints a letter from the IWA leader Theodore H. Banks to *Leslie's*).

53. "'Bread or Blood,'" *FLIN,* January 31, 1874, 338. See also the more

panoramic and distinctively less sensational "Illinois.—The frustrated raid of Communists upon the Relief and Aid Society in Chicago," March 20, 1875, 21.

54. Leslie's *The Days' Doings* characteristically reveled in the violence of the Tompkins Square demonstration: "The police prevent a demonstration by working-men on Tompkins' [*sic*] Square, N.Y. City, January 13," *DD*, January 24, 1874, 9. Thomas Nast's treatment of the Tompkins Square Riot was similar to *Leslie's* in its message if more vituperative in its tone: "The emancipator of labor and the honest working-people," *HW*, February 7, 1874, cover (121). The New York *Daily Graphic*'s January 13 cover cartoon (by Frank Bellew), "The 'bread or blood' bugaboo," was consistent with its view of the Internationalists as a minor influence on workers; but though its typically sketchy graphics did not provide discernible signs for deciphering the "quality" of the participants, a cut of "weapons found on the rioters" effectively carried its message: *DG*, January 13, 1874; January 14, 1874; January 15, 1874. On the Tompkins Square Riot and its press coverage, see Herbert G. Gutman, "The Tompkins Square 'Riot' in New York City on January 13, 1874: A Re-examination of Its Causes and Its Aftermath," *Labor History* 6.1 (winter 1965): 44–70.

55. "The Farmers' Union," *FLIN*, February 21, 1874, 386. *Leslie's* devotion to representing agrarian protest received at least one plaudit from rural readers: see the reprinted comments from "a Western journal," August 15, 1874, 355, stating that *Leslie's* was the only New York publication "which seems to know that there is a West. 'Its articles are addressed *to* Western farmers, not leveled *at* them.'" For Granger cuts, see August 30, 1873, 397; September 13, 1873, 12; October 4, 1873, 56; October 18, 1873, 96; November 15, 1873, 168; January 31, 1874 , 341 (also depicting women); February 21, 1874, 389.

56. Burns, *Pastoral Inventions,* 99–121. One solution to *Leslie's* and the nation's dilemma lay in support for western migration: see "Eastern Labor and Western Lands," *FLIN*, July 21, 1877, 335; "Labor's Opportunity," August 11, 1877, 383.

57. See the following editorials: "The Great Labor Question," *FLIN*, March 15, 1873, 2; "The Labor Question," March 22, 1873, 18; "The Workingman," ibid.; "Lowell Mills," March 29, 1873, 37–38; "The Labor Question," April 26, 1873, 103; "American Labor," August 23, 1873, 375; "Wants of the Workingmen," February 14, 1874, 370; "Deterioration of Labor," May 2, 1874, 114; "Lessons 'Long Shore," December 26, 1874, 258; "Editorial Notices," March 27, 1875, 35 (an interesting contrast to earlier comments on the Tompkins Square Riot); "The Coal Trade," June 12, 1875, 215; "The Fall River Strikes," October 16, 1875, 83. See also the cartoon "Old King Coal—How his monopoly works," September 6, 1873, 420.

58. Robert V. Bruce, *1877: Year of Violence* (Indianapolis: Bobbs-Merrill, 1959), and Philip S. Foner, *The Great Labor Uprising of 1877* (New York: Monad Press, 1977), are the most comprehensive histories of the strike. In the last quarter century, numerous local studies have expanded our understanding of the Great Uprising's varied character and impact. For a useful historiographic overview, see David O. Stowell, *Streets, Railroads, and the Great Strike of 1877* (Chicago: University of Chicago Press, 1999), 1–11.

59. "The Railroad Strike and Insurrection," *FLIN*, August 11, 1877, 382. Subsequent editorials focused on recommendations for government regulation of the railroads (while defending the efficacy of previous subsidies) and, citing Indian resistance and contradicting its August 11 comments, expansion of the federal military: "A Lesson from the Riots," August 18, 1877, 398; "A Consideration for the Next Congress," August 25, 1877, 414; "The Strikes from an English Standpoint," September 29, 1877, 50.

60. *FLIN*, August 11, 1877, 385.

61. Ibid., cover (382).

62. Other engravings of the strike include *FLIN*, August 4, 1877, cover (365), 373, and supplement; August 11, 1877, 385, 388–89, 393; August 18, 1877, cover (397), 401, 409.

63. The change also registered in the strike coverage of the *New York Illustrated Times,* the new name applied to Leslie's *The Days' Doings* after October 1876: over three issues (August 4, August 11, and August 25, 1877), the paper presented twenty-seven engravings that departed from its previous pictures of labor violence. On the 1877 railroad strike as treated in the contemporary press, see Richard Slotkin, *The Fatal Environment: The Myth of the Frontier in the Age of Industrialization, 1800–1890* (New York: Atheneum, 1985), 475–98. Slotkin's interpretation that the militant worker was characterized as "savage" in the aftermath of the strike is not supported by *Leslie's* visual reportage.

64. See also, in *HW*, August 11, 1877, "The great strike—Blockade of engines at Martinsburg, West Virginia" (620), "The great strike—Burning of the Lebanon Valley railroad bridge by the rioters" (620), "The great strike—Destruction of the Union Depot and Hotel at Pittsburgh" (621), "The great strike—The work of destruction in Pittsburgh—The wall of fire and the scene of desolation" (624–25), "The great strike—Burning of the round-house at Pittsburgh" (628), "The great strike—A funeral among the ruins at Pittsburgh" (628), and "The great strike—Pittsburgh in the hands of the mob" (629); see also "The great strike—Scenes of riot in Chicago," *HW*, August 18, 1877, 640.

Michael L. Carlebach, in *The Origins of Photojournalism in America* ([Washington, D.C.: Smithsonian Institution Press, 1992], 159), cites the August 11 *Harper's Weekly* Baltimore engraving, based on a photograph by David Bendann, as an example of the broader range of news imagery that improvements in camera and film technology made accessible to the public by 1877. This claim seems questionable, as does Carlebach's statement that the Pittsburgh photographer S. V. Albee's celebrated stereograph series, "The Railroad War," "depicted clashes between railroad workers and the local police in Pittsburgh as well as the utter destruction of the railroad yards" (159). In fact, the series of forty-four pictures depicted *only* the inert aftermath of the violence: twisted tracks, smoldering buildings, wrecked locomotives. More likely than not, Bendann's Baltimore photograph recorded the place but not the event itself.

65. "The Laborers' Revolt," *DG*, July 21, 1877; "Scenes and incidents of the railroad riots at Pittsburg, Pa.," July 26, 1877. For other examples of the *Daily Graphic*'s coverage, see "Scenes of the railroad riots in Baltimore, Md., last Friday and Saturday," July 24, 1877; "Scenes of the railroad riot in Pittsburg, Pa., last Saturday and Sunday," "Scenes of the railroad riots at Pittsburg and Al-

toona, Pa., last Sunday," July 25, 1877; "Attack on the Philadelphia militia by the mob at Altoona," ibid.; "Endeavoring to move a train at the outer depot, Pittsburg," ibid.; "Scenes of the communistic demonstration in Tompkins Square last Wednesday evening," July 27, 1877. A useful comparison between the treatment in *Frank Leslie's* and in the *Daily Graphic* may be found in respective depictions of the vigilance committees set up by the Pittsburgh strikers: see "Pennsylvania.—Robert M. Ammon, the leader of the Pittsburgh and Fort Wayne railroad strike, at his post, directing the movements of the strikers," *FLIN,* August 11, 1877; "Forming a vigilance committee," *DG,* July 26, 1877 (the latter a vignette in the full page titled "Scenes and incidents of the railroad riots at Pittsburg, Pa.").

66. *Pittsburgh Leader,* July 31, 1877; quoted in "Notes and Comments: OUR RIOT PICTURES," *FLIN,* August 18, 1877, 399. On John Donaghy (1837–1931), see George C. Groce and David Wallace, *The New-York Historical Society's Dictionary of Artists in America, 1564–1860* (New Haven: Yale University Press, 1957), 183; Jean McCullough, ed., *Art in Nineteenth-Century Pittsburgh: An Exhibition* (Pittsburgh: McCullough Communications, 1977), 16–17; Paul A. Chew, ed., *Southwestern Pennsylvania Painters, 1800–1945* (Greensburg, Pa.: Westmoreland County Museum of Art, 1981), 34, 37–38; Virginia Lewis, "Paintings by John Donaghy" (photocopy of a pamphlet that accompanied a Pittsburgh exhibition of Donaghy's paintings, n.d., in the files of the American Social History Project, New York).

67. Realism here denotes not any coherent school of art but rather, in Alan Trachtenberg's phrase, "a tendency . . . to depict contemporary life without moralistic condescension" (*The Incorporation of America: Culture and Society in the Gilded Age* [New York: Hill and Wang, 1982], 182). A similar turn toward realism in British illustrated journalism can be seen in engravings published in the *Graphic* during the 1870s; see Julian Treuherz, *Hard Times: Social Realism and Victorian Art* (London: Lund Humphries, 1987), 53–64; see also Niamh O'Sullivan, "Through Irish Eyes: The Work of Aloysius O'Kelly in the *Illustrated London News,*" *History Ireland,* autumn 1995, 10–16. On photography and realism, see Estelle Jussim, *Visual Communication and the Graphic Arts: Photographic Technologies in the Nineteenth Century,* new ed. (New York: R .R. Bowker, 1983); cf. Miles Orvell, *The Real Thing: Imitation and Authenticity in American Culture, 1880–1940* (Chapel Hill: University of North Carolina Press, 1989), 73–102, which discusses nineteenth-century photographic realism's balancing of mimesis and artifice. See also Dan Schiller, "Realism, Photography, and Journalistic Objectivity in Nineteenth Century America," *Studies in the Anthropology of Visual Communication* 4.2 (winter 1977): 86–95; idem, *Objectivity and the News: The Public and the Rise of Commercial Journalism* (Philadelphia: University of Pennsylvania Press, 1981), 76–95. Although Schiller emphasizes the impact of photography on literary and journalistic realism, his critical evaluation of the culturally constructed limits of photographic representation suggests how *Leslie's* varied readership might undermine a unitary notion of "objectivity."

68. On the Beecher-Tilton scandal and its contemporary representations, see Richard Wightman Fox, "Intimacy on Trial: Cultural Meanings of the Beecher-

Tilton Affair," in *The Power of Culture: Critical Essays in American History*, ed. Richard Wightman Fox and T. J. Jackson Lears (Chicago: University of Chicago Press, 1993), 103–32; see also David Tatham, "Keppler versus Beecher: Prints of the Great Brooklyn Scandal," *Imprint* 23.1 (spring 1998): 2–8; on the scandal's relationship to social conflict, particularly in the volatile nature of a middle class in formation, see Altina L. Waller, *Reverend Beecher and Mrs. Tilton: Sex and Class in Victorian America* (Amherst: University of Massachusetts Press, 1982).

69. "Washington, D.C.—Character scenes of the Electoral Commission in session, February 6th," *FLIN*, February 24, 1877, 412. The change here may have been affected by photography, for after 1877, the process of photoxylography—perfected by *Scribner's Monthly* art superintendent Alexander W. Drake—permitted the direct transfer of an artist's sketch onto the wood block without the intervention of a mediating office artist. On photoxylography at *Leslie's*, see above, chapter 2, nn. 19, 62.

70. See "A Social Revival," *FLIN*, July 31, 1875, 358–59, and the discussion of this editorial in Fox, "Intimacy on Trial," 131–32.

CHAPTER 6. BALANCING THE UNBALANCEABLE, 1878–89

1. "Ultra-realism in Literature and Art," *Frank Leslie's Illustrated Newspaper* (hereafter *FLIN*), September 29, 1883, 82.

2. Madeleine Bettina Stern, *Purple Passage: The Life of Mrs. Frank Leslie* (Norman: University of Oklahoma Press, 1953), 97–99; Budd Leslie Gambee Jr., *Frank Leslie and His Illustrated Newspaper, 1855–1860*, University of Michigan Department of Library Science Studies 8 (Ann Arbor: University of Michigan, 1964), 24, 28–29; "Frank Leslie," *FLIN*, January 24, 1880, 382.

3. Dubbing herself the "Joan of Arc" of publishing, Miriam Leslie lived in comparatively straitened circumstances for the year following her husband's death. See the "Interlaken for Sale" advertisements that began in *FLIN*, March 27, 1880, and ended with the issue of October 15, 1881. When creditors attempted to foreclose on her unpaid debts, she was forced to borrow $50,000, putting up her famous diamonds as collateral. Her fight to retain ownership of the publishing house would become the stuff of legend in later years; the story of the diamonds, retold for the next thirty years, can be found, with a few variations, in Elizabeth Cady Stanton, Susan B. Anthony and Matilda Joslyn Gage, eds., *History of Woman Suffrage*, vol. 3, *1876–1885* (Rochester, N.Y.: Susan B. Anthony, 1886), 441; "The Home of Illustrated Literature," *Frank Leslie's Popular Monthly* 16.2 (August 1883): 435–36; "Pictorial Publishing," *Paper World* 4.2 (February 1882): 3–4; "Mrs. Frank Leslie," New York *Daily Graphic* (hereafter *DG*), May 14, 1886; "Lovely Frank Leslie," *DG*, March 17, 1888. See also Stern, *Purple Passage*, 100–102; Gambee, *Frank Leslie*, 29, 32; Frank Luther Mott, *A History of American Magazines, 1850–1865* (Cambridge, Mass.: Harvard University Press, 1938), 461–63. On her assumption of control, see "Mrs. Leslie in Possession," *New York Tribune*, June 5, 1881; in *FLIN*, see "Frank Leslie's Will Sustained," December 18, 1880, 246–47; "The Abuses of

Will Contests," December 25, 1880, 262; "A Caution and Legal Decision," March 26, 1881, 58; "A Business Statement," June 18, 1881, 262.

4. In 1880 the roster included the weekly *Frank Leslie's Illustrated Newspaper; Illustrirte Zeitung; Lady's Journal; Chimney Corner; Boy's and Girl's Weekly;* and the *New York Illustrated Times.* The monthlies were *Frank Leslie's Lady's Magazine; Budget of Wit, Humor, Anecdote, and Adventure; Popular Monthly; Pleasant Hours; Sunday Magazine;* and *Chatterbox.* By 1885 the weekly list was reduced to *Frank Leslie's Illustrated Newspaper, Illustrirte Zeitung,* and *Fact and Fiction for the Chimney Corner;* the monthly, to *Frank Leslie's Budget, Pleasant Hours, Popular Monthly,* and *Sunday Magazine.* See Stern, *Purple Passage,* 198; William E. Huntzicker, "Frank Leslie (Henry Carter)," in *American Magazine Journalists, 1850–1900,* ed. Sam G. Riley, vol. 79 of *Dictionary of Literary Biography* (Detroit: Gale Research, 1989), 216–19; George P. Rowell, ed., *Geo. P. Rowell and Co.'s American Newspaper Directory* (New York: G. P. Rowell, 1880), 259; idem, *Geo. P. Rowell and Co.'s American Newspaper Directory* (New York: G. P. Rowell, 1884), 326; see also *New York Illustrated Times* (hereafter *NYIT*), June 11, 1881, for the notice of new proprietorship held by William J. Ellis, 7 Frankfort Street.

5. "The Home of Illustrated Literature," 431, 435–36; "Pictorial Publishing," 3–4; J. C. Derby, *Fifty Years among Authors, Books, and Publishers* (New York: G. W. Carleton, 1884), 695–96; Stern, *Purple Passage,* 102–4, 109–10, 238–39; Gambee, *Frank Leslie,* 29, 32, 33; Mott, *American Magazines, 1850–1865,* 461–63; Ishbel Ross, *Charmers and Cranks: Twelve Famous American Women Who Defied the Conventions* (New York: Harper and Row, 1965), 78–80. "Our Holiday Number," *FLIN,* December 24, 1881, 274 (notice about the reorganization of the art department); see also *FLIN,* February 23, 1884, 2 (notice about design); the installation of a new $10,000 Web Perfecting Press was announced in *FLIN,* November 6, 1886, 179.

6. *Daily Graphic,* quoted in *FLIN,* October 6, 1883, 110. See Stern, *Purple Passage,* 122–34; Gambee, *Frank Leslie,* 33; Ross, *Charmers and Cranks,* 80–82; Lynne Vincent Cheney, "Mrs. Frank Leslie's Illustrated Newspaper," *American Heritage,* October 1975, 48, 90. For a critical evaluation of Mrs. Leslie, with insights into the world of her salon as well as her vulnerability to scheming suitors, see the memoirs of the sentimental poet Ella Wheeler Wilcox, *The Worlds and I* (New York: George H. Doran, 1918), 129–35.

7. On the maintenance of political independence, see "Our Position," *FLIN,* September 27, 1884, 82; "Impartial Journalism," November 15, 1884, 194–95. For feminist editorials and editorial comments, see the final section of this chapter and nn. 120–30 below. Mrs. Leslie was a dedicated member of the National Woman Suffrage Association. On Gilded Age feminism, see William Leach, *True Love and Perfect Union: The Feminist Reform of Sex and Society* (New York: Basic Books, 1980). On Mrs. Leslie's stature, see "'The Printer Girl' and the Leslie Club," *FLIN,* November 3, 1888, 194; see also the report on the Grand Rapids Ladies' Literary Club and the prominent display of Mrs. Leslie's portrait in its library, *FLIN,* December 29, 1888, 333, 334; Stern, *Purple Passage,* 135, 182, 266.

8. On the New School's rise and the debate it engendered among engravers, see Jo Ann Early Levin, "The Golden Age of Illustration: Popular Art in American Magazines, 1850–1925" (Ph.D. diss., University of Pennsylvania, 1980), 52–59; Estelle Jussim, *Visual Communication and the Graphic Arts: Photographic Technologies in the Nineteenth Century,* new ed. (New York: R. R. Bowker, 1983), 84–86; David Woodward, "The Decline of Commercial Wood-Engraving in Nineteenth-Century America," *Journal of the Printing Historical Society* 10 (1974–75), 58–65; James Watrous, *American Printmaking: A Century of American Printmaking, 1880–1980* (Madison: University of Wisconsin Press, 1984), 20–25; F. B. Smith, *Radical Artisan: William James Linton, 1812–97* (Manchester: Manchester University Press, 1973), 194–95, 204, 208; Frank Luther Mott, *A History of American Magazines, 1865–1885* (Cambridge, Mass.: Harvard University Press, 1938), 189–90.

9. Derby, *Fifty Years among Authors, Books, and Publishers,* 695–96. Interestingly, the labor reformer John Swinton, compelled by emotions that remain unrevealed, was among the former employees who gathered in a memorial to Frank Leslie on January 12, 1880. At that time Swinton was still a member of the editorial board of the *New York Sun;* he would leave in disgust in 1883 to start his own influential labor reform weekly. See "A Tribute of Respect," *FLIN,* January 31, 1880, 403.

10. *FLIN,* November 3, 1877, 144.

11. *FLIN,* February 2, 1878, 373. For descriptions of the Leslies' transcontinental excursion, see Robert Taft, *Artists and Illustrators of the Old West, 1850–1900* (New York: Charles Scribner's Sons, 1953), 149–61; Stern, *Purple Passage,* 79–88. Tramps would remain a consistent theme in *FLIN* throughout the 1880s in pictures that alternated between menace, confinement, pathos, and ridicule: April 19, 1879, 101; August 2, 1879, 364; Joaquin Miller, "The Tramp of Shiloh," January 3, 1880 (an illustrated poem in the Christmas supplement); September 2, 1882, 24; December 16, 1882, 268; January 5, 1884, cover (305); "The Tramp Nuisance," ibid., 306–7 (editorial); December 26, 1885, 316; April 13, 1889, 157. See also coverage in Leslie's *New York Illustrated Times:* e.g., September 22, 1877; September 4, 1880, 348.

12. *Harper's Weekly* (hereafter *HW*), September 14, 1878, cover. See also Thomas Nast's cartoon, "Riots are expensive luxuries," *HW,* March 8, 1879, cover (181), and Ph. G. Cusachs's "Waiting for the reduction of the Army," *DG,* June 14, 1878.

13. See also other engravings of the Consolidated Virginia Mines published in subsequent issues, especially *FLIN,* March 23, 1878, 37; March 30, 1878, 61. On Frank Leslie's interest in the Virginia City silver mines, see Taft, *Artists and Illustrators of the Old West,* 158–59, 340 n. 26. On the symbolic stability offered by the male worker body in late-nineteenth-century public art, see Melissa Dabakis, "Douglas Tilden's *Mechanics Fountain:* Labor and the 'Crisis of Masculinity' in the 1890s," *American Quarterly* 47.2 (June 1995): 204–35.

14. For scenes of Leadville, most likely rendered by Edward Jump, see *FLIN,* April 26, 1879, 120; May 3, 1879, 140; May 17, 1879, 169; May 31, 1979, 204; June 7, 1879, cover (217), 235 (supplement). In contrast, see "Pennsylvania.—Life among the miners—A pig peddler making the tour of the colliery re-

gion in Schuylkill County," April 26, 1879, 121. Beginning in 1882, *Leslie's* would periodically record, with no reference to its earlier celebrations, the decline of the boomtown. For a comparison between Jump's Leadville pictures for *Leslie's* and William Rogers's illustrations for *Harper's Magazine*, see Taft, *Artists and Illustrators of the Old West*, 169, 343–44 n. 18; see also William A. Rogers, *A World Worth While: A Record of "Auld Acquaintance"* (New York: Harper and Brothers, 1922), 183–88.

15. *FLIN*, March 20, 1880, 41. See also September 20, 1879, 48. On the Workingmen's Party, San Francisco politics, and anti-Chinese agitation, see Alexander Saxton, *The Indispensable Enemy: Labor and the Anti-Chinese Movement in California* (Berkeley: University of California Press, 1971); William Issel and Robert W. Cherny, *San Francisco, 1865–1932: Politics, Power, and Urban Development* (Berkeley: University of California Press, 1986), 125–30.

16. On the murder of Charles De Young, editor of the *San Francisco Chronicle*, by Mayor Isaac Kalloch's son (in revenge for De Young's earlier attempt on the elder Kalloch's life), see *FLIN*, September 13, 1879, cover (17); May 15, 1880, 184; May 22, 1880, 197; April 23, 1881, 137.

17. On the Greenback-Labor Party see, for example, *FLIN*, October 5, 1878, cover (64); July 3, 1880, 312; "The Greenback 'Side-show,'" August 7, 1880, 378 (editorial); cf. "A Free and Untrammeled Ballot," October 30, 1880, 148 (cartoon). On the Internationalists, see August 6, 1881, 384. See also *NYIT*, September 7, 1878, 341.

18. *Leslie's* published one labor image in 1880 to mark the brief return of prosperity: "New Jersey.—The revival of American industries—A little girl lighting up Furnace Number One, in the iron mills at Boonton, March 8th," *FLIN*, March 27, 1880, 56–57.

19. George E. McNeill, *The Labor Movement: The Problem of To-day* (Boston: A. M. Bridgman, 1887).

20. "A Great Labor Strike," *FLIN*, June 10, 1882, 242–43. See also "The Great Strike," June 24, 1882, 274 (an editorial juxtaposed, ironically, to another commentary, "The Perils of Overwork," 274–75, that deplored the burden of worry cutting short the lives of professionals and businessmen). The June 10 editorial ended with a departure from *Leslie's* usual espousal of laissez-faire principles: "Labor has its rights, which should be respected; but they can only be adequately protected by statute, and the extent to which law-making power may legitimately interfere to this end, is precisely the most difficult of all the questions which vex our highest statesmanship." This statement was no more than a gesture toward considering state intervention; characteristically, in an editorial that appeared after the Cumberland strikes had failed, *Leslie's* asserted that legislation would probably not work and denounced the victimization of workers by "unscrupulous" strike leaders. In closing, the editorial wondered how concerned citizens could guard against the oppression of workers while also warding off "conspiracies against employers" ("The Recent Strikes," September 2, 1882, 18).

21. *FLIN*, June 10, 1882, 248. On the 1882 Cumberland coal strike, see Katherine A. Harvey, *The Best-Dressed Miners: Life and Labor in the Maryland Coal Region, 1835–1910* (Ithaca, N.Y.: Cornell University Press, 1969), 228–52.

22. Harvey, *The Best-Dressed Miners*, 16–32.

23. *FLIN*, June 17, 1882, 267.

24. Harvey, *The Best-Dressed Miners*, 241. *Harper's Weekly* coverage of the strike was limited to Special Artist C. D. Weldon's Pittsburgh views: *HW*, June 17, 1882, 377, emphasized idle men; July 1, 1882, 409, showed a benign demonstration by workers.

25. *FLIN*, June 24, 1882, 275. On "emergent" and "residual" beliefs, see Raymond Williams, *Marxism and Literature* (New York: Oxford University Press, 1977), 121–27. On the Knights and "producing classes" ideology, see Leon Fink, *Workingmen's Democracy: The Knights of Labor and American Politics* (Urbana: University of Illinois Press, 1983), 3–17; idem, "The New Labor History and the Powers of Historical Pessimism: Consensus, Hegemony, and the Case of the Knights of Labor," *Journal of American History* 75.1 (June 1988): 115–36. See "The Knights at Richmond," *FLIN*, October 16, 1886, 130: "How many of our readers who are not Knights . . . ?" For a different interpretation of *Leslie's* coverage of the Knights, see Robert E. Weir, *Beyond Labor's Veil: The Culture of the Knights of Labor* (University Park: Pennsylvania State University Press, 1996), 260–67.

26. *FLIN*, September 13, 1884, 59, 60; see also September 16, 1882, 53. The New York *Daily Graphic* also covered the event: *DG*, September 7, 1882; September 2, 1884. *Harper's Weekly* did not cover the 1884 (or any other) Labor Day parade, but the preceding week offered a murky engraving of Thomas Anshutz's painting *The Ironworker's Noontime* (ca. 1881; *HW*, August 30, 1884, 570). From its inception in 1882, Labor Day itself represented an effort on the part of the labor movement to balance pride in class and craft with external legitimacy; see Michael Kazin and Steven J. Ross, "America's Labor Day: The Dilemma of a Workers' Celebration," *Journal of American History* 78.4 (March 1992): 1294–323.

27. "The Troubles of Labor," *FLIN*, September 13, 1884, 50. To be sure, *Leslie's* also acknowledged the malice of capital. Following the collapse of the 1884 miners' strike in Hocking Valley, Ohio, *Leslie's* commented: "It has been apparent for some time that the employing companies must in the end carry their point as against the starving workmen, but their success will not alter the fact that their policy has been harsh and oppressive, if not actually cruel"(February 28, 1885, 19). Offering sympathy, criticizing oppressive measures, *Leslie's* nevertheless insisted that the laws of trade must dominate.

28. See, for example, *FLIN*, October 25, 1884, 152; November 1, 1884, cover (161). Other engravings of strikes in *FLIN* also presented labor's transgressions: e.g., "New York City.—The telegraphers' strike and the cutting of the wires—The night patrol watching suspicious characters," August 25, 1883, cover (1) (although the textual description endeavored to distinguish between the criminal acts of workers and the policies of the Brotherhood of Telegraphers).

29. *FLIN*, November 15, 1884, 203, 204. The lower portion of the full-page engraving showed striking women leaving a "Commissary Building" with supplies contributed from "trades unions and workingmen's societies." *Harper's Weekly* covered the strike in its latter stages: *HW*, December 27, 1884, 863; January 3, 1885, 4; January 10, 1885, 29 (the latter juxtaposing a cut of strikers

about to ambush a guard with an inset showing children left alone in a miner's cabin).

30. *Frank Leslie's* offered sympathy to workers in other ways. Continuing a practice consistent with earlier coverage, *Leslie's* often presented readers with scenes of mining accidents. As a small sampling of a vast record of disasters, see *FLIN*, March 5, 1881, 12; April 29, 1882, 153; April 7, 1883, 109; March 22, 1884, cover (65), 72; January 2, 1886, cover (321), 329. Rendered at times in classical poses of grief and bereavement, miners and their families were blameless victims of "recklessness and avarice." An 1886 editorial, "The Slaughter in the Mine" (January 2, 1886, 322), recommended: "States, by legislative action, should lay down rules for the protection of life in mines, and the authorities should be compelled to obey and enforce those rules, rendering these shocking massacres impossible." Although this editorial blamed employers for failing to construct and the state for failing to mandate adequate escape routes, the weekly also denounced the miners' union for failing to demand such measures.

Leslie's sympathy was paternalistic in its general portrayal of worker apathy toward workplace dangers. A similar attitude characterized some of its criticism of Sabbatarian laws that barred working-class families from pursuing uplifting pursuits on Sundays. See, for example, "The sufferer—Always," December 16, 1882, 272 (cartoon); "Our Day of Rest," January 6, 1883, 322 (editorial).

31. *FLIN*, March 31, 1883, 86.

32. The series ran in *FLIN* from April 14, 1883, to October 20, 1883; the characterization of George's views appeared in "Henry George's Creed," October 16, 1886, 130. See Henry George Jr., *The Life of Henry George* (Garden City, N.Y.: Doubleday, Doran, 1930), 408–10; Charles Albro Barker, *Henry George* (New York: Oxford University Press, 1955), 425–29; see also Edward Thomas O'Donnell, "Henry George and the 'New Political Forces': Ethnic Nationalism, Labor Radicalism, and Politics in Gilded Age New York City" (Ph.D. diss., Columbia University, 1995). George's columns, with additional chapters, were subsequently published as *Social Problems* (Chicago: Belford, Clarke, 1883). Although *Leslie's* March 31 announcement mentioned a range of additional contributors, "The Problems of To-day" was dropped soon after George's series.

33. The series ran in *HW* from February 24, 1883, to May 5, 1883.

34. *FLIN*, March 21, 1885, 80.

35. Overt violence perpetrated by employers also received similar treatment: "Illinois.—The railroad strike in East St. Louis—Attempt of a deputy marshal to kill Mayor Joyce during the affair of April 9th," *FLIN*, April 24, 1886, cover (145). For other *Leslie's* cuts bearing multiple or indeterminate narratives, see July 11, 1885, cover (329); March 20, 1886, cover (65); April 10, 1886, 121; April 17, 1886, cover (129); October 30, 1886, cover (161).

36. My observations and my references to "multi-accentuality" and "systems of viewing" have been influenced by Michael Denning's work on nineteenth-century dime novels: see *Mechanic Accents: Dime Novels and Working-Class Culture in America* (London: Verso, 1987). Cf. the interpretation of *Leslie's* pictorial coverage of the Southwestern Railroad strikes in Weir, *Beyond Labor's Veil*, 263–64.

37. *FLIN*, August 5, 1882, 375.

38. *FLIN*, July 8, 1882, 309. On the freighthandlers' strike, see also "City Trade and Local Strikes," July 8, 1882, 306 (editorial), and the editorial comment in August 19, 1882, 403.

39. *FLIN*, October 14, 1882, 124; October 25, 1884, 149 (quotation, 151).

40. "Cheap Foreign Labor," *FLIN*, January 9, 1886, 338 (editorial). See also the cuts depicting the Hocking Valley, Ohio, strike cited in n. 28 above. The New York *Daily Graphic*'s coverage of the 1882 freighthandlers' strike also stressed the strikebreakers' foreignness: *DG*, June 21, 1882; July 21, 1882. Similarly, *Harper's Weekly*'s "The parade of the New York freight handlers," *HW*, July 8, 1882, 424, offered a celebratory view of a strikers' procession.

41. *FLIN*, February 6, 1886, 408.

42. "Imported Trouble," *FLIN*, February 13, 1886, 419; see John Higham, *Strangers in the Land: Patterns of American Nativism, 1860–1925*, 2d ed. (New York: Atheneum, 1974), 45–52. *Leslie's* viewed the consumer boycotts organized by the New York labor movement in a similar vein, decrying the importation of a foreign tactic to America: "Boycotting as an Element in Strikes," *FLIN*, November 21, 1885, 211 (editorial); "Strikes and Boycotts," May 1, 1886, 162 (editorial); "The American juggernaut," ibid. (cartoon). Similar denunciations appeared in the New York *Daily Graphic* and *Harper's Weekly*: see *DG*, April 2, 1886; April 16, 1886; April 30, 1886; and Thomas Nast's series of cartoons, *HW*, April 24, 1886, 271; May 8, 1886, 293, 303, 304. However, unlike the other papers, *Leslie's* also depicted boycotts in a more playful fashion: "Boycotted.—A scene on a business street in New York City," *FLIN*, January 23, 1886, 376. See Michael A. Gordon, "The Labor Boycott in New York City," *Labor History* 16.2 (spring 1975): 184–229.

43. *FLIN*, September 28, 1878, cover (49). See the editorial "The Lessons of Calamity," October 5, 1878, 66, which overtly celebrated unity in the face of crisis; the subtext for such emphasis was very likely the previous year's Great Uprising.

44. *FLIN*, November 18, 1882, 204; December 26, 1885, 309. See also November 8, 1884, 184. For an interesting exception in which groups do mingle, see "Winter sports in the metropolis.—A skating scene in Central Park," March 3, 1883, 24. On the "skating mania" and the mix of citizens on Central Park's frozen lakes, see Roy Rosenzweig and Elizabeth Blackmar, *The Park and the People: A History of Central Park* (Ithaca, N.Y.: Cornell University Press, 1992), 229–32. The 1883 engraving illustrates the transformation to the "polyglot" park that Rosenzweig and Blackmar discuss (307–39).

45. See, for examples, "New York City.—Contrasts in the courtesies of New Year's Day," *FLIN*, January 7, 1882, 325; "The restaurants of New York City.—From the patrician to the plebian," March 4, 1882, 28; "New York City.—The humors and contrasts of the recent political campaign," November 10, 1883, 181; "New York Restaurants," December 20, 1884, 282–83; "Night scenes in the metropolis.—Sketches of life and character from the platform of an elevated railway train," November 14, 1885, 198.

46. *FLIN*, April 22, 1882, 135. See also two full-page engravings juxtaposed across a page spread (*FLIN*, January 12, 1884, 328, 329): "Massachusetts.—

The humble patrons of Thespis in Boston—Scene at the entrance to a variety theatre" and "New York City.—The grand charity ball at the Metropolitan Opera House, January 3d—The spectacle as seen from one of the boxes."

47. "Christmas Merriment and Christian Kindness," *FLIN,* December 22, 1883, 274. The call to domesticate Christmas was hardly new, although by the 1880s the opportunities for *charivari*-esque revelry had diminished substantially; see Stephen Nissenbaum, *The Battle for Christmas* (New York: Alfred A. Knopf, 1996). For examples of *Leslie's* anti-Sabbatarian stance, see *FLIN,* December 16, 1882, 272; "Our Day of Rest," January 6, 1883, 322 (editorial). *Leslie's* continued allegiance to a broad "middle" readership while advocating that cultures and constituencies be split between "high" and "low" suggests the unevenness of the trends examined in Lawrence W. Levine, *Highbrow/Lowbrow: The Emergence of Cultural Hierarchy in America* (Cambridge, Mass.: Harvard University Press, 1988).

48. *FLIN,* December 5, 1885, 247. See also "Seeing the slums. The newest wrinkle of metropolitan society—How fashion finishes the night after the opera and the ball and enjoys a novel sensation at the expense of misery and vice," *National Police Gazette,* March 8, 1884. Mediated observation of "wretched quarters" was also espoused by William Dean Howells (in a manner that serves to define one function of an elite type of realism): "In a picture it would be most pleasingly effective, for then you could be in it and yet have the distance on it which it needs. But to be in it, and not have the distance, is to inhale the stenches of the neglected street, and to catch that yet fouler and dreadfuller poverty-smell which breathes from the open doorways" (Howells, "New York Streets," in *Impressions and Experiences* [New York: Harper and Brothers, 1896], 252–53).

49. On crime, see *FLIN,* December 2, 1882, 232. On political corruption, see November 19, 1881, 204 (and the editorial comment, November 26, 1881, 210, on the defeat of William Astor in the Eleventh Congressional District). On the poor and health, both as depictions of the "threat" and of methods to counteract it, see May 14, 1881, cover (177); November 19, 1881, 200; March 18, 1882, 56–57; December 30, 1882, 316; June 16, 1883, cover (261); August 18, 1883, cover (413); July 26, 1884, 364; "Cholera Alarm," ibid., 354 (editorial); August 2, 1884, cover (369); September 20, 1884, cover (65); October 16, 1886, 140. William Rogers recalled how he accompanied health inspectors when he went out to sketch the poor for the Harper's publications during the 1880s (*A World Worth While,* 148–51). See also Bert Hansen, "The Image and Advocacy of Public Health in American Caricature and Cartoons from 1860 to 1900," *American Journal of Public Health* 87.11 (November 1997): 1798–807.

50. "Italian Peasants," *FLIN,* August 22, 1885, 11. For engravings of Italian poverty, see September 11, 1880, 28, as well as the engravings cited in n. 40 above. For the more exceptional portrayal of poor Irish, see December 8, 1883, 245.

51. "Germany and the Jews," *FLIN,* January 29, 1881, 358. See also January 22, 1881, 356; March 4, 1882, 21. On physiognomy and Jewish pictorial representation, see John J. Appel, "Jews in American Caricature, 1820–1914," *American Jewish History* 71.1 (September 1981): 103–33; Shearer West, "The Construction of Racial Type: Caricature, Ethnography, and Jewish Physiog-

nomy in Fin-de-Siècle Melodrama," *Nineteenth Century Theatre* 21.1 (summer 1993): 5–40.

52. See "The Jewish Passover of 1858," *FLIN,* April 10, 1858, 296–97. On the series of nine articles published during 1857 to 1858 by Thompson and illustrated by either Eytinge or Nast (featured in the cuts as the characters "Doesticks," "Peleg Padlin," and "Little Waddley," respectively), see Budd Leslie Gambee Jr., *"Frank Leslie's Illustrated Newspaper, 1855–1860*: Artistic and Technical Operations of a Pioneer Pictorial News Weekly in America" (Ph.D. diss., University of Michigan, 1963), 254–58, 290–94. See also *FLIN,* November 1, 1884, 173.

53. *FLIN,* August 5, 1882, 375; "Repatriation of the Russian Jews," August 19, 1882, 402.

54. See also "A Polish trading post in New York," *HW,* May 3, 1884, 280, showing a crush of foreign faces filling Hester Street on Manhattan's Lower East Side, a foreign land the *Weekly*'s audience was unlikely to visit: "Very many of our readers probably will not be able to identify the locality, for it lies in that vast unexplored region bounded by the Bowery on the west and the East River on the east" (283).

55. For examples of the picturesque, see *FLIN,* June 10, 1882, 249; July 29, 1882, 364; May 9, 1885, 197. For urban disasters, see November 26, 1881, cover (209); April 26, 1884, 152–53; May 16, 1885, 208.

56. For sentimentalized contrasts of childhood poverty in the city, see *FLIN,* February 6, 1886, 409; December 8, 1888, 272. Images of children as dangerous classes in the making (posing a future threat, though in presentations that often merged with the picturesque) include November 13, 1880, 169; April 26, 1884, 156. These cuts often delineated youthful mayhem as the result of exposure to adult depravity; other cuts portrayed children as blameless victims, rescued by reformers: March 4, 1882, cover (17); June 17, 1882, 261; December 16, 1882, cover (257). Finally, many images portrayed the triumphant retrieval and transformation of the youthful poor: January 21, 1882, cover (361); August 7, 1886, 392.

57. The historiography of the imagery of urban poverty emphasizes the picturesque and sentimental (an arm's-length approach that inspired a detached sympathy on the part of viewers) over the malevolent, and tends to isolate the 1880s, assuming no earlier tradition of representation. See, for example, Robert H. Bremner, *From the Depths: The Discovery of Poverty in the United States* (New York: New York University Press, 1956), 113–18; Peter Bacon Hales, *Silver Cities: The Photography of American Urbanization, 1839–1915* (Philadelphia: Temple University Press, 1984), 183–90; Emily Bardeck Kies, "The City and the Machine: Urban and Industrial Illustration in America, 1880–1900" (Ph.D. diss., Columbia University, 1971).

58. For examples among a vast archive of Guiteau images, see *FLIN,* December 17, 1881, cover (257), 265; January 21, 1882, 384–85; February 4, 1882, 416–17; and esp. "Washington, D.C.—Clark Mills, the sculptor, taking a plaster-cast of Guiteau's head, in the jail, Dec. 18th," January 7, 1882, cover (321). On Guiteau and the meanings applied to his appearance and behavior, see Charles E. Rosenberg, *The Trial of the Assassin Guiteau: Psychiatry and*

Law in the Gilded Age (Chicago: University of Chicago Press, 1968). On physiognomy and insanity, see Aaron Sheon, "Caricature and the Physiognomy of the Insane," *Gazette des Beaux-Arts,* ser. 6, 88, no. 1293 (October 1976): 145–50; Sander L. Gilman, ed., *The Face of Madness: Hugh W. Diamond and the Origin of Psychiatric Photography* (New York: Brunner/Mazel, 1976).

59. See also *FLIN,* September 10, 1881, cover (17); October 8, 1881, 92. On the efforts of special artists to cover Garfield's lingering demise, see Rogers, *A World Worth While,* 20–25. On photojournalism and privacy, see Ulrich Keller, "Photojournalism around 1900: The Institutionalization of a Mass Medium," in *Shadow and Substance: Essays on the History of Photography in Honor of Heinz K. Henisch,* ed. Kathleen Collins (Bloomfield Hills, Mich.: Amorphous Institute Press, 1990), 293–94; Neil Harris, "Iconography and Intellectual History: The Half-Tone Effect," in *New Directions in American Intellectual History,* ed. John Higham and Paul K. Conkins (Baltimore: Johns Hopkins University Press, 1979), 206–8.

60. For *Leslie's* coverage of the Haymarket Square bombing, see the seven pages of engravings in *FLIN,* May 15, 1886, cover (193), 197, 200–201, 204, 205, 208. *Harper's Weekly's* depiction of the incident was limited to one dramatic cut by Thure de Thulstrup ("from sketches and photographs furnished by H. Jeanneret") that positioned a haranguing, bearded anarchist as the pivotal figure in a spectacularly violent nighttime tableau that included rioting demonstrators, charging police, and the exploding bomb: *HW,* May 15, 1886, 312–13. The rest of its coverage was assumed by a series of Thomas Nast cartoons: May 15, 1886, cover (305); May 22, 1886, 331, 333, 335; May 29, 1886, 351. The New York *Daily Graphic* covered the bombing in its May 8, 1886, issue, the culmination of the previous two days' presentation of characteristically rough and often crudely rendered drawings of rioting strikers and defending police outside the McCormick Reaper Works. See Carl Smith, *Urban Disorder and the Shape of Belief: The Great Chicago Fire, the Haymarket Bomb, and the Model Town of Pullman* (Chicago: University of Chicago Press, 1994), 148–55.

61. *FLIN,* May 22, 1886, 217, 218–19; Paul Avrich, *The Haymarket Tragedy* (Princeton: Princeton University Press, 1984), 222. Depictions of "nihilist" violence abroad earlier in the decade provided models for the coverage of the Haymarket conspirators. The assassination of Czar Alexander II in March 1881, an event that also provided context for Garfield's murder later in the year, engendered no pictorial imagery of the assassins (*FLIN,* March 26, 1881, cover [57]; April 2, 1881, cover [73], 77, 81); however, coverage of Irish nationalist violence, particularly the 1885 London dynamite campaign, included engravings whose imagery closely resembled that in the 1886 portrayals of foreign anarchists: "The new weapon of anarchists and conspirators.—A dynamitard manufacturing an explosive machine," *FLIN,* February 7, 1885, cover (401); see also "New York City.—The dynamite policy and its apostles—Samples of their explosives and 'infernal machines,'" March 15, 1884, 53.

62. In contrast, see the subdued "The trial of the Anarchists in Chicago," *HW,* July 31, 1886, 493; but see Thomas Nast's "Liberty is not Anarchy," September 4, 1886, 564, which energetically celebrated the conspirators' conviction.

63. For a deliberate contrast, see "The amateur photographer in the coun-

try—Preparing to 'take' the village store," *FLIN*, August 7, 1886, 393. The July 31, 1886, cut may have been inspired by the staged photograph "The Inspector's Model," which was published as a heliotype illustration in New York Chief of Detectives Thomas Byrnes's *Professional Criminals of America* (New York: Cassell, 1886); the photo was copyrighted in 1884. But see "Photography under difficulties. The rogues' gallery," *The Days' Doings*, February 20, 1869, 192. On the photograph as a device for the surveillance and control of the "criminal" and poor, see Allan Sekula, "The Body and the Archive," *October*, no. 39 (winter 1986): 3–64; Maren Stange, *Symbols of Ideal Life: Social Documentary Photography in America, 1890–1950* (New York: Cambridge University Press, 1989), 18–23. This theme would be repeated with a voyeuristic twist, featuring a struggling woman, in the 1904 film *A Subject for the Rogues Gallery;* see Linda Williams, *Hard Core: Power, Pleasure, and the "Frenzy of the Visible"* (Berkeley: University of California Press, 1989), 67.

Once the conspirators were convicted and sentenced to execution, *Leslie's* presented the anarchists in a more sympathetic light (repeating its earlier portrayal of the condemned Molly Maguires). See, for example, *FLIN*, October 1, 1887, cover (97); November 12, 1887, cover (193); November 19, 1887, 216–17; November 26, 1887, 232. *Harper's Weekly* presented three detached views: *HW*, November 19, 1887, 836 (including a view through prison bars), 839. The *Daily Graphic* marked the event with a cartoon: "Chicago profits by experience," *DG*, November 10, 1886.

64. "The Patience of the Poor," *FLIN*, July 10, 1886, 322.

65. *FLIN*, December 18, 1886, 274; "The Defense of New York," January 1, 1887, 338 (editorial).

66. "Illinois.—An anarchist Sunday-school in Chicago.—A teacher denouncing the existing system of law and government," *FLIN*, March 16, 1889, 93. This cut was part of a series of engravings demonstrating "abuses" of the Sabbath: see also ibid., 97; March 2, 1889, 44–45.

67. *FLIN*, July 14, 1888, cover (341); see also "Italian Immigration," ibid., 343 (editorial).

68. "The congressional investigation into the evils of immigration.—Scenes in 'Mulberry Bend,' the Italian quarter in Mulberry Street, New York City.—The padrone," *FLIN*, August 11, 1888, 412–13, 415.

69. See, for example, Matt Morgan's cartoon, "Unrestricted immigration and its results.—A possible curiosity of the twentieth century. The last Yankee," *FLIN*, September 8, 1888, 56; see also October 6, 1888, 128. For representative editorials, see "The Immigration Inquiry," August 4, 1888, 390; "A New Phase of the Immigration Question," August 18, 1888, 2; "The Immigration Evil," January 5, 1889, 346. Other images of the poor, while not always specifically focusing on the "immigrant evil," nevertheless portrayed evidence of its effects. For degraded pastimes, see March 5, 1887, cover (33); March 12, 1887, 57. For political corruption, see November 3, 1888, 193; November 10, 1888, 208. For children, both as victims and as potential threat, see February 26, 1887, 24; November 12, 1887, 197; January 28, 1888, 400; February 25, 1888, cover (17). For health hazards, see July 23, 1887, 373 (the description of which dis-

tinguished between the "prosperous working classes" and "paupers"); July 13, 1889, cover (381).

70. See, for example, "New York.—Welcome to the land of freedom—An ocean steamer passing the Statue of Liberty: Scene on the steerage deck," *FLIN*, July 2, 1887, 324–25; "New York City.—The celebration of the Jewish New Year's festival, Rash Hashana—Blowing the shofar, or ram's horn," September 15, 1888, 72; "An evening at a leading German social club in New York City," December 22, 1888, 321.

71. For Becker's 1870 "The Coming Man" series of engravings, see Taft, *Artists and Illustrators of the Old West*, 312 n. 18; see also Joseph Becker, "An Artist's Interesting Recollections of *Leslie's Weekly*," *Leslie's Weekly*, December 14, 1905, 570: "These people were then a novel addition to our population, and Mr. Leslie planned a 'scoop' on our competitors. My destination was kept a secret." For *Leslie's* coverage before 1877, see William E. Huntzicker, "Newspaper Representation of China and Chinese Americans," in *Outsiders in Nineteenth-Century Press History: Multicultural Perspectives,* ed. Frank Hutton and Barbara Straus Reed (Bowling Green, Ky.: Bowling Green State University Popular Press, 1995), 93–114. For Harry Ogden and Walter Yeager's 1878–79 engravings (which also served as illustrations in Mrs. Frank Leslie's *California*), see Taft, *Artists and Illustrators of the Old West*, 341 n. 33. Philip P. Choy, Lorraine Dong, and Marlon K. Hom, eds., *The Coming Man: Nineteenth Century American Perceptions of the Chinese* (1994; reprint, Seattle: University of Washington Press, 1995), surveys *Leslie's* and *Harper's Weekly* as well as the satirical weeklies *Puck, Judge,* and the San Francisco *Wasp.*

72. "Mob Rule in California," *FLIN*, May 13, 1882, 178. For 1870s images and commentary regarding Chinese strikebreakers, see July 9, 1870, cover (257), 264; "The Chinese among the Yankees," July 16, 1870, 285–86 (article); cf. "Cheap Labor, and Where to Get It," July 24, 1869, 289–90 (editorial); May 29, 1875, 189. Editorial expressions of *Leslie's* opposition to anti-Chinese agitation and legislation include "Chinese Immigration," February 15, 1879, 423; "Shall the Chinese Go?" March 29, 1879, 50; "Race Problems," May 1, 1880, 130; "The Chinese Must Be Protected," October 10, 1885, 114; "The Anti-Chinese Crusade," November 14, 1885, 194; "The Outrages on the Chinese," November 21, 1885, 211; "The Exclusion of the Chinese," September 15, 1888, 66–67. Relevant cartoons include March 15, 1879, 32; April 3, 1880, 80; April 15, 1882, 128.

73. "A growing metropolitan evil.—Scene in an opium den, in Pell Street, frequented by working-girls," *FLIN*, May 12, 1883, cover (181); "New York.—The Chinese Opium dens in Pell and Mott Streets—How the Opium habit is developed," May 19, 1883, 204; and "The Opium Traffic," June 9, 1883, 246 (editorial). See also December 17, 1887, 296; July 6, 1889, 373. *Leslie's* earliest depiction of Chinese immigrants was a comic report on a correspondent and special artist's experience in a New York gambling and opium den: see the five engravings (probably by Sol Eytinge Jr.) accompanying [Mortimer Neal Thompson], "Doesticks, P. B., among the Chinamen," February 6, 1858, 152–53.

74. "Sketches in the Chinese quarter of New York City," *FLIN,* June 30,

1888, 324 (supplement). See also March 27, 1880, 53, 64; April 3, 1880, 80; February 19, 1881, 409; October 6, 1883, 101; November 3, 1888, cover (181); January 5, 1889, 356; February 2, 1889, 433; June 29, 1889, 352.

75. "Fac-simile of the first Chinese newspaper published in New York," *FLIN*, February 17, 1883, 435. See also July 28, 1883, 367 (editorial comment on Wong Ching Foo's challenge to Denis Kearney); Wong Ching Foo, "A Local Chinese Poet," January 3, 1885, 331; October 29, 1887, 163 (editorial comment on Canadian customs' abuse of Wong Ching Foo). See John Kuo Wei Tchen, *New York before Chinatown: Orientalism and the Shaping of American Culture, 1776–1882* (Baltimore: Johns Hopkins University Press, 1999), 253–58, 268–69, 281–83; Karl Lo and H. M. Lai, comp., *Chinese Newspapers Published in North America, 1854–1875* (Washington, D.C.: Center for Chinese Research Materials, 1976), 5; William E. Huntzicker, "Chinese-American Newspapers," in Hutton and Reed, *Outsiders in Nineteenth-Century Press History*, 85–86.

76. For a similar disparity between illustration and text, compare *Leslie's* early pictorial and editorial coverage of labor reformer Father Edward McGlynn's conflict with the Catholic Church hierarchy: "New York City.—Rev. Edward M'Glynn, D.D., Rector of St. Stephen's Roman Catholic Church," *FLIN*, December 25, 1886, 325; "The Case of Dr. McGlynn," February 5, 1887, 418–19 (editorial). For the pictorial treatment of McGlynn in periodicals, see Samuel J. Thomas, "Portraits of a 'Rebel' Priest: Edward McGlynn in Caricature," *Journal of American Culture* 7.4 (winter 1984): 19–32.

77. *FLIN*, October 30, 1886, cover (161). In contrast, during the last days of the campaign the *Daily Graphic* devoted its front page to anti-George cartoons: *DG,* October 20, 1886; October 25, 1886; October 27, 1886; November 1, 1886. It is noteworthy that except for the George campaign, *Leslie's* ignored the array of local labor reform tickets during autumn 1886. After the fact, it made one acknowledgment: *FLIN*, December 18, 1886, 284.

78. *FLIN*, October 16, 1886, cover (129), 137. See also "The Knights at Richmond," October 23, 1886, 146 (editorial). *Leslie's* pictorial treatment of the Knights may have been influenced by the hasty denunciation of the accused Haymarket conspirators by Terence Powderly, Grand Master Workman of the Knights of Labor.

79. *FLIN*, December 10, 1887, 280–81.

80. *FLIN*, February 18, 1888, cover (1), 7, 2 (editorial), 12. *FLIN's* presentation of earlier stages of the Reading strike was decidedly less sensational: January 14, 1888, cover (361), 372; January 28, 1888, 397. *Harper's Weekly* limited its coverage to the violence: "The miners' riots at Shenandoah, Pennsylvania," *HW,* February 18, 1888, 121.

81. Stern, *Purple Passage,* 143–44; Elmer Ellis, *Mr. Dooley's America: A Life of Finley Peter Dunne* (New York: Alfred A. Knopf, 1941), 41.

82. *FLIN*, September 22, 1888, 91.

83. Ibid. For Becker's previous version, see "Anarchy in the coal regions of Pennsylvania.—Scenes about Pottsville among the 'Molly Maguires'—Master and slave," *FLIN*, February 6, 1875, 364.

84. See also "New York City.—The great strike of street-railway employes—

Burning of the transfer-house, on Forty-second Street, near Broadway—The police dispersing the mob," *FLIN*, February 9, 1889, cover (437), as well as cuts on 448 and 452. In characterizing the February 1889 strike, *Leslie's* observed that "public sympathy was uniformly on the side of the men" (443)

85. *FLIN*, April 7, 1888, cover (113).

86. O'Brien's decision to forgo the parade in the face of participation by radical opponents to Home Rule compromise no doubt also contributed to the nature of the representation. *Leslie's* commended O'Brien's action, interpreting his boycott as an attempt to distance himself from "George-McGlynn" calls for the nationalization of land. See the editorial comment in *FLIN*, June 18, 1887, 283. For other engravings of O'Brien's North American tour, see May 21, 1887, 220; May 28, 1887, cover (233).

87. *FLIN*, September 17, 1887, 76; September 15, 1888, 69.

88. "That Extra Holiday," *FLIN*, September 21, 1889, 103.

89. See also the Knights of Labor "boss" depicted in a cartoon titled "Turn about is fair play," *FLIN*, February 16, 1889, 16.

90. *FLIN*, June 4, 1887, 251. On criticisms of the monument generally, see Dale H. Freeman, "The Crispus Attucks Monument Dedication," *Historical Journal of Massachusetts* 25.2 (summer 1997): 134–36.

91. *FLIN*, October 1, 1887, 107.

92. Francis John Martin Jr., "The Image of Black People in American Illustration from 1825 to 1925" (Ph.D. diss., University of California, Los Angeles, 1986), 399–570. By the early 1880s, *Harper's Weekly* was featuring plantation reveries provided by William L. Sheppard and "Blacksville" buffoonery by Sol Eytinge Jr.

93. *FLIN*, March 3, 1883, 28, 29–30. *Leslie's* archive of southern imagery also included catastrophes in good measure, particularly extended coverage of the yellow fever epidemics of 1878 to 1879 and devastating floods in 1883.

94. See, for example, *FLIN*, August 17, 1878, 408; January 10, 1880, 348–49; September 10, 1881, 28; April 21, 1883, 141; December 22, 1883, 277; December 29, 1883, 300; September 12, 1885, 56; December 25, 1886, 304. Such treatment occasionally migrated northward: see August 9, 1884, 389.

95. Images of southern black politics include "North Carolina.—The political campaign—Colored voters from the interior journeying to the polling stations," *FLIN*, November 13, 1880, cover (165); "Politics in Virginia.—First appearance of a husband and father in the role of a plumed knight after a parade," October 4, 1884, 101; "The humors of the presidential canvass at the South—Rival political organizations countermarching," September 15, 1888, 73; "The political campaign in Kentucky.—A 'burgoo' feast," October 6, 1888, 117. For an example of the dismissive view of the southern black politician in *Harper's Weekly*, see "A distinguished guest.—'Come out to orate in de canvaas," *HW*, October 11, 1884, 674. An editorial, "Political 'Intimidation,'" *FLIN*, September 18, 1880, 34, endorsed charges made by the *Nation* of widespread intimidation of African American voters in the South during the 1880 election campaign, yet concluded by placing the blame in part on the "ancient habit" of submissiveness exhibited by black southerners; see also "The Ku-Klux Active," July 24, 1880, 360 (cartoon).

96. While *Leslie's* pictorial record for the most part glossed over racist violence, its textual columns occasionally disrupted the overall sense of a political status quo. "The Purity of the Ballot," *FLIN*, July 28, 1888, 374, an editorial that deplored reports of African Americans forcibly barred from voting elicited an angry protest from one southern white reader: "A Word of Protest," September 8, 1888, 55. Similarly, though *Leslie's* engravings of the 1888 election featured "The humors of the presidential canvass at the South" (see the cuts listed above), the less sanguine view enunciated in a later editorial ("The Southern Problem," December 22, 1888, 310) led to another protest letter by William M. Green of Nashville, Tennessee ("The Southern Problem," January 19, 1889, 383).

97. "The New Exodus," *FLIN,* April 12, 1879, 82; "The Negro Exodus," April 26, 1879, 114. See Nell Irvin Painter, *Exodusters: Black Migration to Kansas after Reconstruction* (New York: Alfred A. Knopf, 1976).

98. *FLIN,* May 10, 1879, 155.

99. For other engravings and editorials on the Exodusters, see *FLIN,* May 31, 1879, 205; "The Negro Exodus," July 5, 1879, 290 (editorial); "Political Anomalies," August 30, 1879, 422 (editorial); December 13, 1879, 257; "Talks on Timely Topics. Illustrated Interviews with Eminent Public Men. No. 7. Frederick Douglass on the Negro Exodus," ibid., 258–59 (article); "The Exodus into Indiana," January 17, 1880, 362 (editorial). *Leslie's* also covered African American emigration to Liberia: e.g., May 25, 1878, 208; April 24, 1880, 124. Thomas Nast's cartoons made up *Harper's Weekly* coverage of the Exodusters during 1879 to 1880, except for "The Negro Exodus—The old style and the new" (contrasting a fugitive slave and Exodusters), *HW,* May 1, 1880, 284; see also Ph. G. Cusachs's cartoon in the New York *Daily Graphic,* April 7, 1879.

100. *FLIN,* October 4, 1879, cover (65); March 13, 1880, 28; December 1, 1883, 237.

101. *FLIN,* May 26, 1883, 222 (description), 224, 225.

102. Other *FLIN* engravings based on Lewis's sketches include April 14, 1883, 129; April 21, 1883, 145; July 7, 1883, 325, 329. Lewis's work in *Harper's Weekly* appeared during 1879, including *HW,* January 11, 1879, 25; March 8, 1879, 184; August 16, 1879, 652 (reworked with predictable typification by Sol Eytinge Jr.). On Lewis (ca. 1837–1891), the mound surveys, and *The Freeman,* see Marvin D. Jeter, "The Palmer-Lewis 'Mound Survey' Forays into Tennessee, Mississippi, and Louisiana, 1881–1883," *Mississippi Archeology* 25.2 (December 1990): 1–37; idem, "Henry J. Lewis: A Researcher's Note," *Black History News and Notes* (Indiana Historical Society), no. 38 (November 1989): 3, 7–8; idem, "H. J. Lewis, Freeman Artist: A Working Paper," *Black History News and Notes,* no. 41 (August 1990): 3–8. For valuable comparisons between Lewis's original sketches and *Leslie's* engravings, see idem, ed., *Edward Palmer's Arkansaw Mounds* (Fayetteville: University of Arkansas Press, 1990). I am indebted to Marvin D. Jeter of the Arkansas Archeological Survey, University of Arkansas–Monticello, for sharing his research on Lewis's life.

103. *FLIN,* June 19, 1880, 264–65; December 3, 1881, cover (224). Other engravings portrayed black efforts at self-improvement, such as "Educational progress in Virginia.—The schools for colored children in Richmond," July 21, 1883, 353. Illustrations of black criminals proposed a sorrier inclusion in soci-

ety that nevertheless relinquished visual codes of racial typification, diminishing notions of innate immoral traits: see July 12, 1879, 312, 313; May 10, 1884, cover (177).

104. *FLIN,* May 1, 1880, 133, 144; April 24, 1880, 115 (editorial comment); "Shooting and Hazing," June 26, 1880, 278 (editorial).

105. *FLIN,* February 18, 1882, 445, 448. However, later engravings of the 1884 Hocking Valley, Ohio, strike depicted black (along with eastern European) strikebreakers fleeing the miners' fusillade (see n. 28 above).

106. *FLIN,* October 16, 1886, cover (129), 137; "The Knights at Richmond," ibid., 130; "A Perplexing Question," ibid.; "News of the Week," October 23, 1886, 158; "Mr. Powderly on Social Equality," ibid. As recent scholarship on the Knights has shown, the Order's commitment to the general principle of racial equality (which excluded Chinese workers) nonetheless accommodated racially segregated local assemblies in the South: Fink, *Workingmen's Democracy,* 149–77; Peter S. Rachleff, *Black Labor in the South: Richmond, Virginia, 1865–1890* (Philadelphia: Temple University Press, 1984), 109–78; Melton Alonza McLaurin, *The Knights of Labor in the South* (Westport, Conn.: Greenwood Press, 1978), 131–48. See also Weir, *Beyond Labor's Veil,* 265–66.

107. *FLIN,* February 23, 1889, 27.

108. *FLIN,* December 31, 1887, 335. On the American reception of Millet's work and the comparison of southern African Americans and European peasants, see Laura L. Meixner, *French Realist Painting and the Critique of American Society, 1865–1900* (New York: Cambridge University Press, 1995), 32–48.

109. *FLIN,* October 16, 1886, 134–35. See Susan Levine, *Labor's True Woman: Carpet Weavers, Industrialization, and Labor Reform in the Gilded Age* (Philadelphia: Temple University Press, 1984), 103–53; Paul Buhle, "The Knights of Labor in Rhode Island," *Radical History Review,* no. 17 (spring 1978): 39–74.

110. Other categorizations of women also held sway that were less defined by class. For example, some comparisons presented types whose physiognomies were predicated on the cruel aesthetics of physical beauty: see the "nymph" and "neglected" in *FLIN,* February 17, 1883, 433. See also August 28, 1886, cover (17).

111. *FLIN,* August 2, 1884, 373. Other images presented what one might call isolated points along the path of degraded "careers": see, for example, "New York City.—The merchants' police service in the harbor and along the docks.—A syren at work," June 5, 1880, 234 (supplement); "New York City.— A new juvenile vice—Children gambling for delicacies," April 26, 1884, 156.

112. "Connecticut.—The State Industrial School for Girls, at Middletown," *FLIN,* November 19, 1881, 197.

113. A significant aspect of *Leslie's* portrayal of women's victimization focused on Mormonism: see February 11, 1882, 432–33; March 11, 1882, 33; December 15, 1883, 264–65; May 8, 1886, 184.

114. Pictures of women pulled from the river appear in *FLIN,* November 25, 1882, 217; June 6, 1885, 257; August 4, 1888, 400; and depictions of women in opium dens, in May 12, 1883, cover (181); May 19, 1883, 204. For a contrast that suggests *Leslie's* effort to appeal more to middle tastes, see "The Mongo-

lian curse," *National Police Gazette*, June 2, 1883; "Slaves to a deadly infatuation," *National Police Gazette*, n.d. (reprinted in Edward Van Every, *Sins of New York, as "Exposed" by the "Police Gazette"* [New York: Frederick A. Stokes, 1930], 297).

115. See also *NYIT*, February 23, 1878, 320; April 13, 1878, cover. See Allan Keller, *Scandalous Lady: The Life and Times of Madame Restell: New York's Most Notorious Abortionist* (New York: Atheneum, 1981); Janet Farrell Brodie, *Contraception and Abortion in Nineteenth-Century America* (Ithaca, N.Y.: Cornell University Press, 1994), 229–31.

116. *FLIN*, November 3, 1888, 188–89, 191. Cf. "'Prisoners of Poverty,'" November 6, 1886, 178 (editorial). On the romanticization of nineteenth-century technology in popular imagery, see Marianne Doezema, "The Clean Machine: Technology in American Magazine Illustration," *Journal of American Culture* 11.4 (winter 1988): 73–92. On the sewing woman motif, see T. J. Edelstein, "They Sang 'The Song of the Shirt': The Visual Iconology of the Seamstress," *Victorian Studies* 23.2 (winter 1980): 183–210. For a more typical, sanitary rendition of women's industrial work, see "Leading American Industries.—The uses of 'coraline,' as illustrated at the manufactory of Warner Brothers, Bridgeport, Connecticut," *FLIN*, July 12, 1884, 332.

117. *FLIN*, September 21, 1878, 37 (engraving), 39 (description).

118. On "fashionable" women's benevolent work, see "Woman's Work for Woman," *FLIN*, July 31, 1886, 370 (editorial). On the Working Women's Protective Union, see Leach, *True Love and Perfect Union*, 164–65.

119. *FLIN*, February 7, 1885, 405; on the 1885 Philadelphia carpet weavers' strike, see Levine, *Labor's True Woman*, 63–83. See also "The strike of the feather-workers in New York City," *FLIN*, February 16, 1889, 5.

120. On the class-based nature of Gilded Age feminism's demand for women's "economic autonomy," see Leach, *True Love and Perfect Union*, 158–89; Ellen Carol DuBois, *Feminism and Suffrage: The Emergence of an Independent Women's Movement in America, 1848–1869* (Ithaca, N.Y.: Cornell University Press, 1978), 126–61. For *Leslie's* definition of "working woman," see the following editorials: "Women Helping Women," *FLIN*, February 10, 1883, 402; "Woman's Employment," August 4, 1883, 386; "The Occupations of Women," October 27, 1883, 146; "The American Working-woman," August 23, 1884, 2; "The Elevation of Workingwomen," November 22, 1884, 210; "Women's Work and Progress," February 21, 1885, 2; "Woman's Work for Woman," July 31, 1886, 370; "Occupations for Women," June 2, 1888, 242. See also "The Snobbery of Labor," September 15, 1888, 67, objecting to the "fashion" of ladies opening shops as a mere gesture toward employment. Engravings illustrating women's expanding participation in higher education include July 4, 1885, 320; June 23, 1888, cover (289). See also the following editorials: "Women and Scholarship," October 19, 1878, 106; "Female Education," July 9, 1881, 310–11; "Education for Women," July 22, 1882, 338; "Woman's Higher Education," February 17, 1883, 426; "Woman's Education," March 17, 1883, 50; "The Meeting of Extremes," June 2, 1883, 230; "Our Educated Women," September 5, 1885, 34; "Women as Educators," November 6, 1886, 178–79; "College-bred Women," December 25, 1886, 290. For portraits of ex-

emplary women figures, see April 5, 1879, cover (65); ibid., June 18, 1887, 293; March 3, 1888, 44. See also the following editorials: "What Career?" December 23, 1882, 290; "What a Woman Can Do," June 9, 1883, 246; "Why Not Captain Mary," February 2, 1884, 370; "No Man Should Say Her Nay," February 16, 1884, 402; "Shall Women Have a Chance?" March 22, 1884, 66; "May Women Practice Law?" May 17, 1884, 194; "Shall Women Be Preachers," June 7, 1884, 242; "More Woman Doctors," March 21, 1885, 74; "Women in the Right Place," November 27, 1886, 226. While some editorials scoffed at conventional wisdom about women's innate traits limiting equal participation in society (e.g., "The Witness Who Won't," May 31, 1884, 226–27; "Modern Grandmothers," July 5, 1884, 306–7; "Vigorous Girls," July 19, 1884, 338), other editorials registered skepticism about women's capabilities because they had been excluded from proper training (e.g., "Woman as Financier," July 9, 1881, 310). *Leslie's* occasionally criticized the cruel or frivolous nature of women's "fashionable" pursuits: e.g., "Murderers as Heroes—The latest feminine craze," May 10, 1884, cover (177); "Please Omit Flowers," 178 (editorial).

121. "Woman as a Risk," *FLIN*, March 10, 1883, 34; "Divorce Reform Wanted," June 23, 1883, 278; "The Question of Divorce," February 2, 1884, 370; "Marriage and Divorce Legislation," March 1, 1884, 18.

122. Engravings include *FLIN*, April 7, 1888, 120–21; October 27, 1888, 169; March 30, 1889, 121. See also the following editorials: "The Women's Congress," November 6, 1880, 150; "Expansion of Woman's Sphere," May 16, 1885, 202–3; "Woman's Enlarging Sphere," June 11, 1887, 266; "The Outcome of Sturdy Effort," April 14, 1888, 130; "The Woman Movement," January 5, 1889, 346.

123. *Quarterly Illustrator* (1894): 74, 454; Taft, *Artists and Illustrators of the Old West*, 151, 338; Peggy and Harold Samuels, *The Illustrated Biographical Encyclopedia of Artists of the American West* (Garden City, N.Y.: Doubleday, 1976), 126; Phyllis Peet, *American Women of the Etching Revival* (Atlanta: High Museum of Art, 1988), 54. Little is known about Davis; however, Barbara Balliet, associate director of Women's and Gender Studies at Rutgers University who is currently researching new occupations for middle-class women in mid-nineteenth-century New York, has located Davis as an art student in Cooper Union's Women's School of Art and Design in the early 1860s. The school provided training for women in the "feminizing" art trades, and may have also served as a source for *Leslie's* engravers. See "New York City.—The monument of a philanthropist: The Cooper Union and its Schools of Art," *FLIN*, April 14, 1883, 125. I am indebted to Barbara Balliet for sharing her research. Davis's first engraving for *Leslie's* ("New York.—A convict at Sing Sing holding an interview with his wife, in the detective's office, in the presence of a keeper") appeared in *FLIN*, April 13, 1878, 100. See also "A Charming Book," January 15, 1881, 338, a notice of an illustrated book by Davis, *Earth Scenes and Space Life* (I was unable to locate the book in the *National Union Catalog*). Davis also published poetry in *Leslie's* throughout the 1880s and contributed art to the Salvation Army's publication, *The American War Cry*. See Davis's series of articles "Under the Blood-Red Banner," published in *Leslie's Weekly* in November and December 1893, and Diane Winston, *Red-Hot and Righteous: The Urban Reli-*

gion of the Salvation Army (Cambridge, Mass.: Harvard University Press, 1999), 54–55, 73.

124. The description appears in *FLIN,* December 20, 1879, 279.

125. *FLIN,* November 24, 1888, cover (229); see also December 22, 1888, 320. For editorials on voting rights, see "Women as Voters," March 20, 1880, 34–35; "Woman's Suffrage Gaining Ground," May 24, 1884, 210; "Woman Suffrage in Dakota," April 4, 1885, 106; "Women as Voters," October 6, 1888, 115. Cf. Alice Sheppard, *Cartooning for Suffrage* (Albuquerque: University of New Mexico Press, 1993).

126. *FLIN,* September 20, 1884, 74; "The Woman's Nominee for President" (editorial), ibid., 66. See also September 5, 1879, cover (65), 71; "Which?—A timely question," July 21, 1888, cover (357).

127. *FLIN,* September 20, 1884, 74–75.

128. *FLIN,* April 16, 1887, 133. See, in contrast to this farcical image, the ebullient editorial comment in the same issue (131) and a follow-up editorial, "The Voting of Women in Kansas," April 30, 1887, 162. See also "A revolution in municipal government—A Kansas town governed by women. View of Oskaloosa, with portraits of the Mayor and Common Council," April 21, 1888, 149.

129. *FLIN,* January 5, 1884, 309. See also February 4, 1888, cover (409). While endorsing expansion of the suffrage, *Leslie's* editorials decried disruptive suffragist tactics: see "Women at the Polls," November 14, 1885, 195.

130. *FLIN,* November 1, 1884, 171.

EPILOGUE

1. Actual transfer of ownership occurred in May; see "Notice of New Management," *Frank Leslie's Illustrated Newspaper* (hereafter *FLIN*), May 11, 1889, 222.

2. Madeleine Bettina Stern, *Purple Passage: The Life of Mrs. Frank Leslie* (Norman: University of Oklahoma Press, 1953), 139–52 (esp. 143), 166–68, 170–75, 181–82, 259–61, 265–66; Ishbel Ross, *Charmers and Cranks: Twelve Famous American Women Who Defied the Conventions* (New York: Harper and Row, 1965), 84–88; Lynne Vincent Cheney, "Mrs. Frank Leslie's Illustrated Newspaper," *American Heritage,* October 1975, 90–91; Agnes Hooper Gottlieb, "Networking in the Nineteenth Century: Founding of the Woman's Press Club of New York City," *Journalism History* 21.4 (winter 1995): 159; Ida Husted Harper, ed., *History of Woman Suffrage,* vol. 5, *1900–1920* (New York: National American Woman Suffrage Association, 1922), 755. The will was contested for three years, after which Catt formed the Leslie Woman Suffrage Committee. On the *American Magazine,* see Frank Luther Mott, *A History of American Magazines, 1865–1885* (Cambridge, Mass.: Harvard University Press, 1938), 510–16.

3. On *Leslie's* new ownership and format, see "The New Leslie's" and "'Judge's' New Home," *FLIN,* May 11, 1889, 222, 234; "The New Frank Leslie's," May 18, 1889, 254; "Free Discussion Desirable," August 2, 1890, 547 (on the editorial switch to the Republican position). See also Stern, *Purple Passage,* 136–37, 247–48; Budd Leslie Gambee Jr., *Frank Leslie and His Illustrated*

Newspaper, 1855–1860, University of Michigan Department of Library Science Studies 8 (Ann Arbor: University of Michigan, 1964), 32–33; Frank Luther Mott, *A History of American Magazines, 1850–1865* (Cambridge, Mass.: Harvard University Press, 1938), 463–65. On *Judge,* see Richard Samuel West, *Satire on Stone: The Political Cartoons of Joseph Keppler* (Urbana: University of Illinois Press, 1988), 199, 281–82, 320, 323; Mott, *American Magazines, 1865–1885,* 552–56.

4. Mott, *American Magazines, 1850–1865,* 482–86; Eugene Exman, *The House of Harper: One Hundred and Fifty Years of Publishing* (New York: Harper and Row, 1967), 180–81.

5. Neil Harris, "Iconography and Intellectual History: The Half-Tone Effect," in *New Directions in American Intellectual History,* ed. John Higham and Paul K. Conkins (Baltimore: Johns Hopkins University Press, 1979), 196–211; quotation, 199. A slightly expanded version of this essay appears in Harris, *Cultural Excursions: Marketing Appetites and Cultural Tastes in Modern America* (Chicago: University of Chicago Press, 1990), 304–17.

6. Valerian Gribayedoff, "Pictorial Journalism," *Cosmopolitan* 11.4 (August 1891): 471–81; Will Jenkins, "Illustration of the Daily Press in America," *International Studio* 16 (June 1902): 254–62; Everett Shinn, "Life on the Press," *Philadelphia Museum Bulletin* 41.207 (November 1945): 9–12; Frank Luther Mott, *American Journalism: A History of Newspapers in the United States through 250 Years, 1690 to 1940* (New York: Macmillan, 1941), 501–3; George Juergens, *Joseph Pulitzer and the New York World* (Princeton: Princeton University Press, 1966), 93–117; Rebecca Zurier, "Picturing the City: New York in the Press and the Art of the Ashcan School, 1890–1917" (Ph.D. diss., Yale University, 1988), 109–26, 131–61; Rebecca Zurier, Robert W. Snyder, and Virginia M. Mecklenburg, *Metropolitan Lives: The Ashcan Artists and Their New York* (New York: W. W. Norton, 1995), 59–62; David Woodward, "The Decline of Commercial Wood-Engraving in Nineteenth-Century America," *Journal of the Printing Historical Society* 10 (1974–75): 67–69; Jo Ann Early Levin, "The Golden Age of Illustration: Popular Art in American Magazines, 1850–1925" (Ph.D. diss., University of Pennsylvania, 1980), 61–63.

7. Frank Luther Mott, *A History of American Magazines, 1885–1905* (Cambridge, Mass.: Harvard University Press, 1957), 2–14 and passim; idem, "The Magazine Revolution and Popular Ideas in the Nineties," *Proceedings of the American Antiquarian Society,* n.s., 64.1 (April 1954): 195–214; John Tebbel and Mary Ellen Zuckerman, *The Magazine in America, 1740–1990* (New York: Oxford University Press, 1991), 66–130, 140–46. In recent years a substantial body of scholarship has tackled the magazine "revolution," with particular emphasis on the gendered nature of the consumer culture and consciousness promulgated by the new magazines: Helen Damon-Moore, *Magazines for the Millions: Gender and Commerce in the "Ladies' Home Journal" and the "Saturday Evening Post": 1880–1910* (Albany: State University of New York Press, 1994); Jennifer Scanlon, *Inarticulate Longings: The "Ladies' Home Journal," Gender, and the Promises of Consumer Culture* (New York: Routledge, 1995); Ellen Garvey, *The Adman and the Parlor: Magazines and the Gendering of Consumer Culture, 1880s to 1910s* (New York: Oxford University Press,

1996). While these works focus on a middle-class readership, they also propose ways in which the magazines' consumerist vision appealed to a more varied audience. Matthew Schneirov, in *The Dream of a New Social Order: Popular Magazines in America, 1893–1914* (New York: Columbia University Press, 1994), perceives greater diversity among both the magazines and their readerships, while Richard Ohmann, in *Selling Culture: Magazines, Markets, and Class at the Turn of the Century* (London: Verso, 1996), specifies the magazines' purpose as a new medium for a new managerial class. On the managed reading process in the new magazines and its promotion of an illusory sense of participation by the reader, see in particular Christopher P. Wilson, "The Rhetoric of Consumption: Mass-Market Magazines and the Demise of the Gentle Reader, 1880–1920," in *The Culture of Consumption: Critical Essays in American History, 1880–1980,* ed. Richard Wightman Fox and T. J. Jackson Lears (New York: Pantheon, 1983), 39–64, and idem, *The Labor of Words: Literary Professionalism in the Progressive Era* (Athens: University of Georgia Press, 1985); see also Susan M. Ryan, "Acquiring Minds: Commodified Knowledge and the Positioning of the Reader in *McClure's Magazine,* 1893–1903," *Prospects* 22 (1997): 211–38.

8. Robert Taft, *Photography and the American Scene: A Social History, 1839–1889* (New York: Macmillan, 1938), 419–50; Robert Sidney Kahan, "The Antecedents of American Photojournalism" (Ph.D. diss., University of Wisconsin, 1969), 3–16; Woodward, "The Decline of Commercial Wood-Engraving," 65–69; Levin, "The Golden Age of Illustration," 64–66; Estelle Jussim, *Visual Communication and the Graphic Arts: Photographic Technologies in the Nineteenth Century,* new ed. (New York: R. R. Bowker, 1983); Michael L. Carlebach, *The Origins of Photojournalism in America* (Washington, D.C.: Smithsonian Institution Press, 1992), 160–65; David Clayton Phillips, "Art for Industry's Sake: Halftone Technology, Mass Photography, and the Social Transformation of American Print Culture, 1880–1920" (Ph.D. diss., Yale University, 1996), chap. 1.

9. Clement Shorter, "Illustrated Journalism: Its Past and Its Future," *Contemporary Review* 75 (April 1899): 491; see also Woodward, "The Decline of Commercial Wood-Engraving," 75. Estimates vary, but by the 1880s a full-page wood engraving could cost as much as $300.

10. On the decline of the engraving trade, see William Allen Rogers, *A World Worth While: A Record of "Auld Acquaintance"* (New York: Harper and Brothers, 1922), 164–66; Kahan, "The Antecedents of American Photojournalism," 171–84; Woodward, "The Decline of Commercial Wood-Engraving," 69–78: Woodward notes Cooper Union's 1890 announcement of the discontinuation of its wood-engraving classes, which were replaced with courses in pen and ink drawing for process-line work. On the genteel resistance to photomechanical reproduction and critique of resulting cultural decline (reiterating many of the arguments against "chromo-civilization" expressed in the 1870s), see Michael Leja, "The Illustrated Magazines and Print Connoisseurship in the Late 19th Century," *Block Points* 1 (1993): 54–73; Neil Harris, "Pictorial Perils: The Rise of American Illustration," in his *Cultural Excursions,* 337–48; see also Schneirov, *The Dream of a New Social Order,* 48–72. The unsuccessful efforts of com-

mercial artists to escape invidious comparisons are explored in Michele H. Bogart, *Artists, Advertising, and the Borders of Art* (Chicago: University of Chicago Press, 1995), 15–78.

11. Gribayedoff, "Pictorial Journalism," 472.

12. Rogers, *A World Worth While*, 167. See also Levin, "The Golden Age of Illustration," 66–75; Jussim, *Visual Communication and the Graphic Arts*, 285–91; Kahan, "The Antecedents of American Photojournalism," 157–71; idem, "Magazine Photographs Begin: An Editorial Negative," *Journalism Quarterly* 42.1 (winter 1965): 53–59. On the lag in employing half-tone photography in newspapers, see R. Smith Schuneman, "Art or Photography: A Question for Newspaper Editors of the 1890s," ibid., 43–52; Carlebach, *The Origins of Photojournalism*, 162; Jenkins, "Illustration of the Daily Press in America," 254–62.

13. *Frank Leslie's Popular Monthly*, which was still under Mrs. Leslie's aegis, emulated the mixed presentation of mass-market magazines. An 1894 article asserted that the *Popular Monthly* "affords an admirable object lesson in the progress and varieties of illustration up to date." The current issue included "contrasted styles of pen drawing," "process from etchings," "wood engravings in the art pictures," "half-tone process reproductions of untouched photographs," "retouched photographs," and "half-tone facsimiles of wash drawings in India ink" ("Modern Magazine Making," *Frank Leslie's Popular Monthly* 38.4 [October 1894]: 393).

14. The first unambiguous example of process engraving published in *Leslie's* was Georgina A. Davis's sketch "The Easter Festival.—Some of the quaint, old-time methods of its observance illustrated," *FLIN*, April 20, 1889, 172. In fact, zincography may have been used to reproduce some *Leslie's* illustrations that have been ascribed to wood engravings during the latter half of the 1880s; see Jussim, *Visual Communication and the Graphic Arts*, 63.

15. See also "White Ghost, the most progressive chief of the Sioux nation," *FLIN*, September 27, 1890, 135 (photo); "Progress among the Sioux Indians.—House of an advanced Sioux," ibid. (photo); "Sitting Bull, the so-called High Priest of the Indian Messiah craze," November 22, 1890, 280 (engraving); "The Indian craze over the 'New Messiah.'—Sitting Bull seeks to foment disaffection among the Sioux bucks," ibid. (engraving); "The recent Indian excitement in the Northwest," December 13, 1890, 354 (four engravings); "The Indian excitement in the Northwest," December 20, 1890, 389 (three photos); "The Indian excitement in the Northwest—An Indian policeman warning the settlers of a probable uprising," December 27, 1890, cover (386) (engraving); "The Indian excitement in the Northwest.—Scenes and incidents in Indian life," ibid., 395 (four photos); "The Indian troubles.—Grand River crossing to Sitting Bull's camp—Scene of the capture and death of the Sioux Chief," January 3, 1891, 408 (photo); "The Sioux Ghost-Dance," January 10, 1891, 437 (engraving); "The Indian troubles in the Northwest," January 17, 1891, 464 (two engravings, one half-tone); "The Indian troubles—A body of nineteen teamsters repel an attack on a wagon-train near Wounded Knee Creek, South Dakota," ibid., 461 (engraving); "Sketches in the Indian country," January 24, 1891, 476 (two photos, one half-tone); "The recent fight between United States troops and Big

Foot's band of hostile Sioux at Wounded Knee Creek," ibid., 484 (four engravings, one photo); "The relief corps searching for the dead and wounded after the fight with the hostile Sioux at Wounded Knee—Discovery of a live papoose," January 31, 1891, cover (493) (half-tone).

16. Phillips, "Art for Industry's Sake," chap. 4.

17. "An American section of the Paris Exposition.—View of the Gorham exhibit," *FLIN*, September 28, 1889, 125; October 5, 1889, 149; November 30, 1889, 293, 297. On the imperfection of the half-tone translation of the photograph, see Estelle Jussim's remarks in "The Syntax of Reality: Photography's Transformation of Nineteenth-Century Wood Engraving into an Art of Illusionism," in *The Eternal Moment: Essays on the Photographic Image* (New York: Aperture, 1989), 35.

18. "A Chance for Amateur Photographers," *FLIN*, March 22, 1890, 146; "Prizes for Amateur Photographers," April 19, 1890, 230. For a typical full-page display of contributions, see "Our amateur photographic contest.—Examples of the work, submitted in competition for the prizes," April 26, 1890, 261. The winner of the contest was " 'He Cometh Not, She Said.'—Photo by John E. Dumont, Rochester, N.Y.," August 16, 1890, cover (21) (published along with a double-page spread of runners-up, 38–39). A second contest was announced in the following issue, subsequently followed by more weekly displays of photographs: see "Our Amateur Contest," August 23, 1890, 42, and November 29, 1890, 302, announcing the postponement of the second contest due to "unpropitious weather." One interesting contribution to the second competition was " 'At Low Tide' " by "Alfred Stieglitz, New York," December 27, 1890, 389.

19. See "A Suggestion.—'The Leslie Circle,' " *FLIN*, August 30, 1890, 62, a proposal by one contestant for the exchange of photos by *Leslie's* readers.

20. Shorter, "Illustrated Journalism," 489. In Shorter's survey, during the same week in March 1899 the *Illustrated London News* carried twenty-eight photographs and nineteen drawings, while *Harper's Weekly* published thirty-five photographs and eight drawings.

21. On the residual presence of earlier narrative and pictorial conventions in strike coverage, see Larry Peterson, "Pullman Strike Pictures: Remolding Public Perceptions of Labor Conflict by New Visual Communication," in *The Pullman Strike and the Crisis of the 1890s: Essays on Labor and Politics,* ed. Richard Schneirov, Shelton Stromquist, and Nick Salvatore (Urbana: University of Illinois Press, 1999), 87–129; Ulrich Keller, "Photojournalism around 1900: The Institutionalization of a Mass Medium," in *Shadow and Substance: Essays in the History of Photography,* ed. Kathleen Collins (Bloomfield Hills, Mich.: Amorphous Institute Press, 1990), 289. Michael L. Carlebach, in *American Photojournalism Comes of Age* ([Washington, D.C.: Smithsonian Institution Press, 1997], 11–56), demonstrates the sweep of photographic news coverage at the turn of the century as it also displays the limits of representation; on photography of the Spanish-American War, see 57–75 (esp. 63–64, on recording battles).

22. Miles Orvell, *The Real Thing: Imitation and Authenticity in American Culture, 1880–1940* (Chapel Hill: University of North Carolina Press, 1989). Cf. Ralph F. Bogardus, "Tea Wars: Advertising Photography and Ideology in the

Ladies' Home Journal in the 1890s," *Prospects* 16 (1991): 297–322, which underestimates the importance of hybrid forms as well as earlier representational precedents. On the lag in the use of photography in magazine advertising, see Bogart, *Artists, Advertising, and the Borders of Art* , 171–78.

23. "ANPA Meeting News," *Editor and Publisher,* April 27, 1929; quoted in Bob Stepno, "Staged, Faked and Mostly Naked: Photographic Innovation at the *Evening Graphic* (1924–1932)," paper presented at the Association for Education in Journalism and Mass Communication conference, Chicago, August 1997, 15. See Phillips, "Art for Industry's Sake," chap. 4.

24. See Mott, *American Journalism,* 669–72; Carlebach, *American Photojournalism Comes of Age,* 153–55; Lester Cohen, *The "New York Graphic": The World's Zaniest Newspaper* (Philadelphia: Chilton Books, 1964).

25. Orvell, *The Real Thing,* 88; more generally, see 73–102. On Riis and his contemporaries and their maintenance of narrative and typing strategies, see Maren Stange, *Symbols of Ideal Life: Social Documentary Photography in America, 1890–1950* (New York: Cambridge University Press, 1989), 1–26; Sally Stein, "Making Connections with the Camera: Photography and Social Mobility in the Career of Jacob Riis," *Afterimage,* May 1983, 9–16. Such representations, sparing the viewer the necessity of firsthand experience, maintained the purposes of earlier wood-engraved imagery of the poor: "The beauty of looking into these places without actually being present there," Riis explained in an 1888 interview, "is that the excursionist is spared the vulgar sounds and odious scents and repulsive exhibitions attendant upon such a personal examination" (quoted in Stange, *Symbols of Ideal Life,* 16). As recent studies have delineated, later documentary photography, exemplified in the vast archive created by the Farm Security Administration photographers during the Great Depression, framed and composed subjects to conform to enduring popular beliefs about the poor: see, for example, James Curtis, *Mind's Eye, Mind's Truth: FSA Photography Reconsidered* (Philadelphia: Temple University Press, 1989); Carl Fleischhauer and Beverly W. Brannan, eds., *Documenting America, 1935–1943* (Berkeley: University of California Press, 1988). See also Kevin G. Barnhurst, *Seeing the Newspaper* (New York: St. Martin's Press, 1994), 43–44, 53, on the persistence of typification in twentieth-century photojournalism.

26. Ian Gordon, *Comic Strips and Consumer Culture, 1890–1945* (Washington, D.C.: Smithsonian Institution Press, 1998), chap. 3. Gordon demonstrates that while comic strips trafficked in ethnic and racial stereotypes, their reliance on "polysemic" characters appealing to a wide audience led to only the occasional appearance of identifiably black or ethnic lead characters. See also Francis John Martin Jr., "The Image of Black People in American Illustration from 1825 to 1925" (Ph.D. diss., University of California, Los Angeles, 1986); *Ethnic Images in the Comics,* issue title of *Nemo,* no. 28 (December 1987); John Canemaker, *Felix: The Twisted Tale of the World's Most Famous Cat* (New York: Pantheon, 1991), 75–76.

27. On the Wilmington riot, see Edward L. Ayers, *The Promise of the New South: Life after Reconstruction* (New York: Oxford University Press, 1992), 301–4.

28. Robert W. Rydell, *All the World's a Fair: Visions of Empire at American*

International Expositions, 1876–1916 (Chicago: University of Chicago Press, 1984); Stephen Jay Gould, *The Mismeasure of Man* (New York: W. W. Norton, 1981).

29. However, as Zurier, Snyder, and Mecklenburg cogently argued in *Metropolitan Lives,* the liminal space of the American city continued to provoke significant departures in the use of social typing, notably in some works of the artists in the Ashcan School. In illustrations, prints, and paintings of the immigrant working class, these artists, who were for the most part trained in pictorial reporting, transcended the limitations of the device to create images that offered multiple narratives and—particularly in the works of John Sloan and other members of the group who engaged in radical politics—relinquished the standard moral subtext. See also Joshua Brown, "'A Spectator of Life—A Reverential, Enthusiastic, Emotional Spectator,'" *American Quarterly* 49.2 (June 1997): 356–84.

30. Wilson, "The Rhetoric of Consumption"; Keller, "Photojournalism around 1900," 295–96. To be sure, as the historiography of commercial culture has demonstrated, audiences' artful consumption altered the meanings of some commercial forms: see, for example, Kathy Peiss, *Cheap Amusements: Working Women and Leisure in Turn-of-the-Century New York* (Philadelphia: Temple University Press, 1986); Miriam Hansen, *Babel and Babylon: Spectatorship in American Silent Film* (Cambridge, Mass.: Harvard University Press, 1991). Indeed, in the early twentieth century, the comparative cheapness of the half-tone process and growing flexibility of the camera enabled the immigrant working-class and radical press to create an alternative pictorial record—though its presentation was rarely as compelling as that of the commercial press.

Bibliography

PRIMARY SOURCES: NEWSPAPERS AND JOURNALS

Daily Graphic (New York), 1873–89. [*DG*]
The Days' Doings [*New York Illustrated Times* after 1876] (New York), 1868–84. [*DD*]
Frank Leslie's Illustrated Newspaper (New York), 1866–91. [*FLIN*]
Gleason's Pictorial Drawing-Room Companion (Boston), 1851–52. [*GP*]
Harper's Weekly (New York), 1866–91. [*HW*]
Illustrated News (New York), 1859.
Vanity Fair (New York), 1861–63.

OTHER PRIMARY SOURCES

"Assignment by Frank Leslie." *New York Evening Post,* September 10, 1877.
Barnum, Phineas T. *Struggles and Triumphs; or, Forty Years' Recollections of P. T. Barnum Written by Himself.* 1871. Reprint, Harmondsworth: Penguin, 1981.
Barnum's American Museum Illustrated. New York: William Van Norden and Frank Leslie, 1850.
Becker, Joseph. "An Artist's Interesting Recollections of *Leslie's Weekly.*" *Leslie's Weekly,* December 14, 1905, 570.
Brace, Charles Loring. *The Dangerous Classes of New York and Twenty Years' among Them.* 3d ed. New York: Wynkoop and Hallenbeck, 1880.
Browne, Junius Henri. *The Great Metropolis; A Mirror of New York.* Hartford, Conn.: American Publishing Company, 1868.
Bruce, Edward C. *The Century: Its Fruits and Its Festival.* Philadelphia: J. B. Lippincott, 1877.
Byrnes, Thomas. *Professional Criminals of America.* New York: Cassell, 1886.

Curtis, George William. *Orations and Addresses of George William Curtis*. Edited by Charles Eliot Norton. 3 vols. New York: Harper and Brothers, 1894.

Davis, John Parker. [Letters written to Albert Bigelow Paine.] *Life in Letters: American Autograph Journal* 4.2 (May 1940): 284–303.

Davis, Theodore R. "How a Battle Is Sketched." *St. Nicholas* 16 (July 1889): 661–68.

———. "Grant under Fire." *Cosmopolitan* 14 (January 1893): 333–40.

Derby, J. C. *Fifty Years among Authors, Books, and Publishers*. New York: G. W. Carleton, 1884.

Dickens, Charles. *American Notes*. 1842. Reprint, Oxford: Oxford University Press, 1966.

———. *Bleak House*. 1853. Reprint, Harmondsworth: Penguin, 1971.

Douglass, Frederick. *The Frederick Douglass Papers*. Series 1, *Speeches, Debates, and Interviews*. Edited by John W. Blassingame. Vol. 3. New Haven: Yale University Press, 1985.

George, Henry. *Social Problems*. Chicago: Belford, Clarke, 1883.

Goldsmith, James C. *Himself Again; A Novel*. New York: Funk and Wagnalls, 1884.

Gribayedoff, Valerian. "Pictorial Journalism." *Cosmopolitan* 11 (August 1891): 471–81.

Harper, Joseph Henry. *The House of Harper: A Century of Publishing in Franklin Square*. New York: Harper and Brothers, 1912.

Higginson, Thomas Wentworth. *Army Life in a Black Regiment*. 1870. Reprint, East Lansing: Michigan State University Press, 1961.

"The Home of Illustrated Literature." *Frank Leslie's Popular Monthly* 16.2 (August 1883): 129–38.

Howells, William Dean. *Impressions and Experiences*. New York: Harper and Brothers, 1896.

———. "A Sennight of the Centennial." *Atlantic Monthly* 38 (July 1876): 92–107.

Hudson, Frederic. *Journalism in the United States, from 1690 to 1872*. New York: Harper and Brothers, 1873.

Jackson, Mason. *The Pictorial Press; Its Origins and Progress*. London: Hurst and Blackett, 1885.

Jenkins, Williams. "Illustration of the Daily Press in America." *International Studio* 16 (June 1902): 254–62.

Kimball, Richard B. "Frank Leslie." *Frank Leslie's Popular Monthly* 9.3 (March 1880): 258–63.

King, Edward. *The Great South: A Record of Journeys in Louisiana, Texas, the Indian Territories, Missouri, Arkansas, Mississippi, Alabama, Georgia, Florida, South Carolina, North Carolina, Kentucky, Tennessee, Virginia, West Virginia, and Maryland*. Hartford, Conn.: American Publishing Company, 1875.

Ladies of the Mission. *The Old Brewery, and the New Mission House at the Five Points*. New York: Stringer and Townsend, 1854.

Leslie, Mrs. Frank. *California: A Pleasure Trip from Gotham to the Golden Gate*. New York: G. W. Carleton, 1877.

Leslie's Illustrated Civil War. With introduction by John E. Stanchak. Jackson: University Press of Mississippi, 1992. [Facsimile edition of *The Soldier in Our Civil War* (New York: Stanley-Bradley Publishing Company, 1894).]

Linton, William James. *Memories.* London: Lawrence and Bullon, 1895.

McCabe, James D., Jr. *Lights and Shadows of New York Life; or, the Sights and Sensations of the Great City.* Philadelphia: National Publishing Company, 1872.

McNeill, George E. *The Labor Movement: The Problem of To-day.* Boston: A. M. Bridgman, 1887.

"Making the Magazine." *Harper's New Monthly Magazine* 32 (December 1865): 31.

"Modern Magazine Making." *Frank Leslie's Popular Monthly* 38.4 (October 1894): 385–96.

"Pictorial Publishing." *Paper World* 4.2 (February 1882): 1–6.

Quarterly Illustrator (1894): 74, 454.

Quimby, Harriet. "How Frank Leslie Started the First Illustrated Weekly." *Leslie's Weekly,* December 14, 1905, 568.

Rogers, William Allen. *A World Worth While: A Record of "Auld Acquaintance."* New York: Harper and Brothers, 1922.

Rowell, George P., ed. *Geo. P. Rowell and Co.'s American Newspaper Directory.* New York: G. P. Rowell, 1869.

———. *Geo. P. Rowell and Co.'s American Newspaper Directory.* New York: G. P. Rowell, 1874.

———. *Geo. P. Rowell and Co.'s American Newspaper Directory.* New York: G. P. Rowell, 1880.

———. *Geo. P. Rowell and Co.'s American Newspaper Directory.* New York: G. P. Rowell, 1884.

"A Sabbath with the Children at the Five Points House of Industry." *Monthly Record,* May 1857, 19–20.

Schell, Francis H. "Recollections of a Leslie's Special Artist in the Civil War: No. 1 Baltimore in 1861; Generals Butler and Banks and the Baffled Insurrectionists." *Imprint: Journal of the American Historical Print Collectors Society* 23.1 (spring 1998): 18–26.

———. "Sketching under Fire at Antietam." *McClure's Magazine* 22 (February 1904): 418–29.

Shinn, Everett. "Life on the Press." *Philadelphia Museum Bulletin* 41.207 (November 1945): 9–12.

Shorter, Clement. "Illustrated Journalism: Its Past and Its Future." *Contemporary Review* 75 (April 1899): 485–86.

Splitstone, F. J. "Our Sixtieth Birthday," *Leslie's Weekly,* December 16, 1915, 661.

Stanton, Elizabeth Cady, Susan B. Anthony, and Matilda Joslyn Gage, eds. *History of Woman Suffrage.* Vol. 3, *1876–1885.* Rochester, N.Y.: Susan B. Anthony, 1886.

U.S. Congress, House of Representatives. *Report of the Joint Committee on Reconstruction.* 39th Cong., 1st sess., 1866. H. Doc. 30.

Wilcox, Ella Wheeler. *The Worlds and I.* New York: George H. Doran, 1918.

Wingate, Charles F., ed. *Views and Interviews on Journalism.* New York: F. B. Patterson, 1875.

Wordsworth, William. *The Poetical Works of William Wordsworth.* Edited by William Knight. Vol. 8. Edinburgh: William Paterson, 1886.

SECONDARY SOURCES

Adams, Bluford. *E Pluribus Barnum: The Great Showman and the Making of U.S. Popular Culture.* Minneapolis: University of Minnesota Press, 1997.

Altick, Richard D. *"Punch": The Lively Youth of a British Institution, 1841–51.* Columbus: Ohio State University Press, 1997.

American Social History Project. *Who Built America? Working People and the Nation's Economy, Politics, Culture, and Society.* Vol. 2, *From the Gilded Age to the Present.* New York: Pantheon, 1992.

Anbinder, Tyler. *Five Points: The 19th-century New York City Neighborhood That Invented Tap Dance, Stole Elections, and Became the World's Most Notorious Slum.* New York: Free Press, 2001.

Anderson, Patricia. *The Printed Image and the Transformation of Popular Culture, 1790–1860.* Oxford: Clarendon Press, 1991.

Appel, John J. "From Shanties to Lace Curtains: The Irish Image in *Puck,* 1876–1910." *Comparative Studies in Society and History* 13.4 (October 1971): 365–75.

———. "Jews in American Caricature, 1820–1914." *American Jewish History* 71.1 (September 1981): 103–33.

Arnheim, Rudolf. "The Rationale of Deformation." *Art Journal* 43.4 (winter 1983): 319–24.

Arslott, Caroline, Griselda Pollock, and Janet Wolff. "The Partial View: The Visual Representation of the Early Nineteenth-Century City." In *The Culture of Capital: Art, Power, and the Nineteenth-Century Middle Class,* edited by Janet Wolff and John Seed, 191–233. Manchester: University of Manchester Press, 1988.

"The Artwork of William Ludwell Sheppard." *Virginia Cavalcade* 42.1 (summer 1992): 20–25.

Auman, William T., and David D. Scarboro. "The Heroes of America in Civil War North Carolina." *North Carolina Historical Review* 58.4 (October 1981): 327–63.

Avedon, Richard. "Borrowed Dogs." *Grand Street* 7.1 (autumn 1987): 52–64.

Avrich, Paul. *The Haymarket Tragedy.* Princeton: Princeton University Press, 1984.

Ayers, Edward L. *The Promise of the New South: Life after Reconstruction.* New York: Oxford University Press, 1992.

Baker, Nicholson. *Double Fold: Libraries and the Assault on Paper.* New York: Random House, 2001.

Banta, Martha. *Imaging American Women: Idea and Ideals in Cultural History.* New York: Columbia University Press, 1987.

Barker, Charles Albro. *Henry George.* New York: Oxford University Press, 1955.

Barnhurst, Kevin G. *Seeing the Newspaper.* New York: St. Martin's Press, 1994.

Barthes, Roland. *Image, Music, Text.* Edited and translated by Stephen Heath. New York: Hill and Wang, 1977.

Bates, Anna Louise. *Weeder in the Garden of the Lord: Anthony Comstock's Life and Career.* New York: University Press of America, 1995.

Becker, Stuart William. "*Frank Leslie's Illustrated Newspaper* from 1860 to the Battle of Gettysburg." M.A. thesis, University of Missouri, Columbia, 1960.

Benjamin, Walter. "Paris, Capital of the Nineteenth Century." In *Reflections: Essays, Aphorisms, Autobiographical Writings,* 146–62. Edited by Peter Demetz. Translated by Edmund Jephcott. 1978. Reprint, New York: Schocken Books, 1986.

———. "The Work of Art in the Age of Mechanical Reproduction." In *Illuminations,* 217–51. Edited by Hannah Arendt. Translated by Harry Zohn. New York: Schocken Books, 1969.

Berger, John, Sven Blomberg, Chris Fox, and Michael Dibb. *Ways of Seeing.* New York: Viking, 1973.

Bernstein, Iver. *The New York City Draft Riots: Their Significance for American Society and Politics in the Age of the Civil War.* New York: Oxford University Press, 1990.

Blackmar, Elizabeth. *Manhattan for Rent, 1785–1850.* Ithaca, N.Y.: Cornell University Press, 1989.

Blumin, Stuart M. "Explaining the New Metropolis: Perception, Depiction, and Analysis in Mid-Nineteenth-Century New York City." *Journal of Urban History* 11.1 (November 1984): 9–38.

———. "The Hypothesis of Middle-Class Formation in Nineteenth-Century America: A Critique and Some Proposals." *American Historical Review* 90.2 (April 1985): 299–338.

———. "Introduction: George G. Foster and the Emerging Metropolis." In *New York by Gas-Light and Other Urban Sketches,* by George G. Foster, 1–61. Berkeley: University of California Press, 1990.

Bogardus, Ralph F. "Tea Wars: Advertising Photography and Ideology in the *Ladies' Home Journal* in the 1890s." *Prospects* 16 (1991): 297–322.

Bogart, Michele H. *Artists, Advertising, and the Borders of Art.* Chicago: University of Chicago Press, 1995.

———. *Public Sculpture and the Civic Ideal in New York City, 1890–1930.* Chicago: University of Chicago Press, 1989.

Boime, Albert. *The Art of Exclusion: Representing Blacks in the Nineteenth Century.* Washington, D.C.: Smithsonian Institution Press, 1990.

Boyer, Paul. *Urban Masses and Moral Order in America: 1820–1920.* Cambridge, Mass.: Harvard University Press, 1978.

Bremner, Robert H. *From the Depths: The Discovery of Poverty in the United States.* New York: New York University Press, 1956.

Brewer, John. *The Pleasures of the Imagination: English Culture in the Eighteenth Century.* New York: Farrar, Straus, and Giroux, 1997.

Brigham, Clarence S. *Paul Revere's Engravings.* Rev. ed. New York: Atheneum, 1969.

Brilliant, Richard. *Portraiture.* Cambridge, Mass.: Harvard University Press, 1991.

Brodie, Janet Farrell. *Contraception and Abortion in Nineteenth-Century America*. Ithaca, N.Y.: Cornell University Press, 1994.

Broehl, Wayne G., Jr. *The Molly Maguires*. Cambridge, Mass.: Harvard University Press, 1964.

Brooks, Peter. *The Melodramatic Imagination: Balzac, Henry James, Melodrama, and the Mode of Excess*. New Haven: Yale University Press, 1976.

Broun, Heywood, and Margaret Leech. *Anthony Comstock: Roundsman of the Lord*. New York: Albert and Charles Boni, 1927.

Brown, Joshua. "The 'Dead Rabbit'–Bowery Boy Riot: An Analysis of the Antebellum New York Gang." M.A. thesis, Columbia University, 1976.

———. "'A Spectator of Life—A Reverential, Enthusiastic, Emotional Spectator.'" *American Quarterly* 49.2 (June 1997): 356–84.

———. "Visualizing the Nineteenth Century: Notes on Making a Social History Documentary Film." *Radical History Review*, no. 38 (April 1987): 114–25.

Bruce, Robert V. *1877: Year of Violence*. Indianapolis: Bobbs-Merrill, 1959.

Buchanan, Lamont. *A Pictorial History of the Confederacy*. New York: Crown, 1951.

Buckley, Peter G. "The Case against Ned Buntline: The 'Words, Signs, and Gestures' of Popular Authorship." *Prospects* 13 (1988): 249–72.

———. "Comic and Social Types: From Egan to Mayhew." Paper presented at the American Historical Association Annual Meeting, New York, December 1990.

———. "Mose Revisited: The Audience and Local Drama in New York, 1840–1860." Paper presented at the American Studies Biennial Conference, Philadelphia, November 1983.

———. "To the Opera House: Culture and Society in New York City, 1820–1860." Ph.D. diss., State University of New York at Stony Brook, 1984.

Buhle, Paul. "The Knights of Labor in Rhode Island." *Radical History Review*, no. 17 (spring 1978): 39–74.

Bumgardner, Georgia Brady. "George and William Endicott: Commercial Lithography in New York, 1831–51." In *Prints and Printmakers of New York State, 1825–1940*, edited by David Tatham, 43–65. Syracuse, N.Y.: Syracuse University Press, 1986.

Bunker, Gary L. "Antebellum Caricature and Woman's Sphere." *Journal of Women's History* 3.3 (winter 1992): 6–43.

Burns, Sarah. "Modernizing Winslow Homer," *American Quarterly* 49.3 (September 1997): 615–39.

———. *Pastoral Inventions: Rural Life in Nineteenth-Century American Art and Culture*. Philadelphia: Temple University Press, 1989.

Butterfield, Roger. "Pictures in the Papers." *American Heritage*, June 1962, 32–55, 96–100.

Campbell, William P. *The Civil War: A Centennial Exhibition of Eyewitness Drawings*. Washington, D.C.: National Gallery of Art, 1961.

Canemaker, John. *Felix: The Twisted Tale of the World's Most Famous Cat*. New York: Pantheon, 1991.

Carlebach, Michael L. *American Photojournalism Comes of Age*. Washington, D.C.: Smithsonian Institution Press, 1997.

———. *The Origins of Photojournalism in America.* Washington, D.C.: Smithsonian Institution Press, 1992.

Cheney, Lynne Vincent. "Mrs. Frank Leslie's Illustrated Newspaper." *American Heritage,* October 1975, 42–48, 90–91.

Chew, Paul A., ed. *Southwestern Pennsylvania Painters, 1800–1945.* Greensburg, Pa.: Westmoreland County Museum of Art, 1981.

Choy, Philip P., Lorraine Dong, and Marlon K. Hom, eds. *The Coming Man: Nineteenth Century American Perceptions of the Chinese.* 1994. Reprint, Seattle: University of Washington Press, 1995.

Clark, T. J. "Preliminaries to a Possible Treatment of 'Olympia' in 1865." *Screen* 21.1 (spring 1980): 18–41.

Cohen, Lester. *The "New York Graphic": The World's Zaniest Newspaper.* Philadelphia: Chilton Books, 1964.

Colbert, Charles. *A Measure of Perfection: Phrenology and the Fine Arts in America.* Chapel Hill: University of North Carolina Press, 1997.

Comolli, Jean-Louis. "Machines of the Visible." In *The Cinematic Apparatus,* edited by Teresa de Lauretis and Stephen Heath, 121–42. New York: St. Martin's Press, 1980.

Couvares, Francis G. *The Remaking of Pittsburgh: Class and Culture in an Industrializing City, 1877–1919.* Albany: State University of New York Press, 1984.

Cowling, Mary. *The Artist as Anthropologist: The Representation of Type and Character in Victorian Art.* Cambridge: Cambridge University Press, 1989.

Cresswell, Donald, comp. *The American Revolution in Drawings and Prints: A Checklist of 1765–1790 Graphics in the Library of Congress.* Washington, D.C.: Library of Congress, 1975.

Curtin, Patricia A. "From Pity to Necessity: How National Events Shaped Coverage of the Plains Indian War." *American Journalism* 12.1 (winter 1995): 3–21.

Curtis, James. *Mind's Eye, Mind's Truth: FSA Photography Reconsidered.* Philadelphia: Temple University Press, 1989.

Curtis, L. Perry, Jr. *Apes and Angels: The Irishman in Victorian Caricature.* Washington, D.C.: Smithsonian Institution Press, 1971.

Cutrer, Emily Fourmy. "Visualizing Nineteenth-Century American Culture." *American Quarterly* 51.4 (December 1999): 895–909.

Czitrom, Daniel. "Wickedest Ward in New York." *Seaport* 20.3 (winter 1986–87): 20–26.

Dabakis, Melissa. "Douglas Tilden's *Mechanics Fountain:* Labor and the 'Crisis of Masculinity' in the 1890s." *American Quarterly* 47.2 (June 1995): 204–35.

Da Costa Nunes, Jadviga M. "The Naughty Child in Nineteenth-Century American Art." *Journal of American Studies* 21.2 (1987): 225–47.

Damon-Moore, Helen. *Magazines for the Millions: Gender and Commerce in the "Ladies' Home Journal" and the "Saturday Evening Post": 1880–1910.* Albany: State University of New York Press, 1994.

Davis, Michael. "Forced to Tramp: The Perspective of the Labor Press, 1870–1900." In *Walking to Work: Tramps in America, 1790–1935,* edited by Eric H. Monkkonen, 141–70. Lincoln: University of Nebraska Press, 1984.

Davis, Susan G. "'All-me-knack'; or, a Working Paper on Popular Culture." University of Pennsylvania. Typescript, 1980.

Davis, Susan G., and Dan Schiller. "Street Literature and the Delineation of Deviance in the United States, 1830–1860." University of Pennsylvania. Typescript, n.d.

Davison, Nancy R. "E. W. Clay and the American Political Caricature Business." In *Prints and Printmakers of New York State, 1825–1940,* edited by David Tatham, 91–110. Syracuse, N.Y.: Syracuse University Press, 1986.

Dawley, Alan. *Class and Community: The Industrial Revolution in Lynn.* Cambridge, Mass.: Harvard University Press, 1976.

Denning, Michael. *Mechanic Accents: Dime Novels and Working-Class Culture in America.* London: Verso, 1987.

Diffley, Kathleen. "Home on the Range: Turner, Slavery, and the Landscape Illustrations in *Harper's New Monthly Magazine,* 1861–1876." *Prospects* 14 (1989): 175–202.

DiGirolamo, Vincent. "The Negro Newsboy: Black Child in a White Myth." *Columbia Journal of American Studies* 4.1 (2000): 57–80.

Dippie, Brian W. *Catlin and His Contemporaries: The Politics of Patronage.* Lincoln: University of Nebraska Press, 1990.

Doezema, Marianne. *American Realism and the Industrial Age.* Bloomington: Indiana University Press for the Cleveland Museum of Art, 1980.

———. "The Clean Machine: Technology in American Magazine Illustration." *Journal of American Culture* 11.4 (winter 1988): 73–92.

Dormon, James H. "Ethnic Stereotyping in American Popular Culture: The Depiction of American Ethnics in the Cartoon Periodicals of the Gilded Age." *Amerikastudien* 30.4 (1985): 489–507.

———. "Shaping the Popular Image of Post-Reconstruction American Blacks: The 'Coon Song' Phenomenon of the Gilded Age." *American Quarterly* 40.4 (December 1988): 450–71.

DuBois, Ellen Carol. *Feminism and Suffrage: The Emergence of an Independent Women's Movement in America, 1848–1869.* Ithaca, N.Y.: Cornell University Press, 1978.

Dudden, Faye E. *Serving Women: Household Service in Nineteenth-Century America.* Middletown, Conn.: Wesleyan University Press, 1983.

Eby, Cecil D., Jr. *"Porte Crayon": The Life of David Hunter Strother.* Chapel Hill: University of North Carolina Press, 1960.

Edelstein, T. J. "They Sang 'The Song of the Shirt': The Visual Iconology of the Seamstress." *Victorian Studies* 23.2 (winter 1980): 183–210.

Edwards, Lee M. *Domestic Bliss: Family Life in American Painting, 1840–1910.* Yonkers, N.Y.: Hudson River Museum, 1986.

Ellis, Elmer. *Mr. Dooley's America: A Life of Finley Peter Dunne.* New York: Alfred A. Knopf, 1941.

Ethnic Images in the Comics. Issue title of *Nemo,* no. 28 (December 1987).

Evans, Chris. *History of the United Mine Workers of America from the Year 1860 to 1890.* 2 vols. Indianapolis: United Mine Workers of America, 1900.

Exman, Eugene. *The House of Harper: One Hundred and Fifty Years of Publishing.* New York: Harper and Row, 1967.

Fabian, Ann. *Card Sharps, Dream Books, and Bucket Shops: Gambling in Nineteenth-Century America*. Ithaca, N.Y.: Cornell University Press, 1990.

Fairbrother, Trevor. Review of *American Impressionism and Realism: The Painting of Modern Life, 1885–1915* [Metropolitan Museum of Art exhibition and catalog], *Archives of American Art Journal* 33.4 (1993): 15–21.

Faler, Paul G. *Mechanics and Manufacturers in the Early Industrial Revolution: Lynn, Massachusetts, 1780–1860*. Albany: State University of New York Press, 1981.

Farwell, Beatrice. *The Cult of Images (Le Culte des Images): Baudelaire and the Nineteenth-Century Media Explosion*. Santa Barbara: University of California, Santa Barbara Art Museum, 1977.

Fink, Leon. "The New Labor History and the Powers of Historical Pessimism: Consensus, Hegemony, and the Case of the Knights of Labor." *Journal of American History* 75.1 (June 1988): 115–36.

———. *Workingmen's Democracy: The Knights of Labor and American Politics*. Urbana: University of Illinois Press, 1983.

Fischer, Roger A. *Them Damned Pictures: Explorations in American Political Cartoon Art*. North Haven, Conn.: Archon Books, 1996.

Fleischhauer, Carl, and Beverly W. Brannan, eds. *Documenting America, 1935–1943*. Berkeley: University of California Press, 1988.

Foner, Eric. *Reconstruction: America's Unfinished Revolution, 1863–1877*. New York: Harper and Row, 1988.

Foner, Philip S. *The Great Labor Uprising of 1877*. New York: Monad Press, 1977.

Fox, Celina. "The Development of Social Reportage in English Periodical Illustration during the 1840s and Early 1850s." *Past and Present*, no. 74 (February 1977): 90–111.

———. *Graphic Journalism in England during the 1830s and 1840s*. New York: Garland, 1988.

Fox, Richard Wightman. "Intimacy on Trial: Cultural Meanings of the Beecher-Tilton Affair." In *The Power of Culture: Critical Essays in American History*, edited by Richard Wightman Fox and T. J. Jackson Lears, 103–32. Chicago: University of Chicago Press, 1993.

Frassanito, William. *Gettysburg: A Journey in Time*. New York: Charles Scribner's Sons, 1975.

Freeman, Dale H. "The Crispus Attucks Monument Dedication." *Historical Journal of Massachusetts* 25.2 (summer 1997): 125–38.

Frisken, Amanda. "Tabloid Representations of Victoria Woodhull: *The Days' Doings*, 1870–72." Paper presented at the Bowery Seminar, Cooper Union, New York, March 1997.

Gambee, Budd Leslie, Jr. *Frank Leslie and His Illustrated Newspaper, 1855–1860*. University of Michigan Department of Library Science Studies 8. Ann Arbor: University of Michigan, 1964.

———. "Frank Leslie and His Illustrated Newspaper, 1855–1860: Artistic and Technical Operations of a Pioneer Pictorial News Weekly in America." Ph.D. diss., University of Michigan, 1963.

Garvey, Ellen. *The Adman and the Parlor: Magazines and the Gendering of*

Consumer Culture, 1880s to 1910s. New York: Oxford University Press, 1996.

Gates, Henry Louis, Jr. "The Face and Voice of Blackness." In *Facing History: The Black Image in American Art, 1710–1940,* by Guy C. McElroy, xxviii–xlvi. Washington, D.C.: Corcoran Gallery of Art, 1990.

George, Henry, Jr. *The Life of Henry George.* Garden City, N.Y.: Doubleday, Doran, 1930.

Gerdts, William H., and Mark Thistlewaite. *Grand Illusions: History Painting in America.* Fort Worth: Amon Carter Museum, 1988.

Gilfoyle, Timothy. *City of Eros: New York City, Prostitution, and the Commercialization of Sex, 1790–1920.* New York: W. W. Norton, 1992.

Gilman, Sander L., ed. *The Face of Madness: Hugh W. Diamond and the Origin of Psychiatric Photography.* New York: Brunner/Mazel, 1976.

Gladstone, John. "Working-Class Imagery in *Harper's Weekly,* 1865–1895." *Labor's Heritage* 5.1 (spring 1993): 42–61.

Gombrich, E. H. *Art and Illusion: A Study of the Psychology of Pictorial Representation.* 2d ed. Princeton: Princeton University Press, 1969.

Gombrich, E. H., and Ernst Kris. *Caricature.* Harmondsworth: Penguin, 1940.

Gordon, Ian. *Comic Strips and Consumer Culture, 1890–1945.* Washington, D.C.: Smithsonian Institution Press, 1998.

Gordon, Michael A. "The Labor Boycott in New York City." *Labor History* 16.2 (spring 1975): 184–229.

———. *The Orange Riots: Irish Political Violence in New York City, 1870 and 1871.* Ithaca, N.Y.: Cornell University Press, 1993.

Gorn, Elliott J. "'Good-Bye Boys, I Die a True American': Homicide, Nativism, and Working-Class Culture in Antebellum New York City." *Journal of American History* 74.2 (September 1987): 388–410.

———. *The Manly Art: Bare-Knuckle Prize Fighting in America.* Ithaca, N.Y.: Cornell University Press, 1986.

———. "The Wicked World: The *National Police Gazette* and Gilded Age America." *Media Studies Journal* 6.1 (winter 1992): 1–15.

Gottlieb, Agnes Hooper. "Networking in the Nineteenth Century: Founding of the Woman's Press Club of New York City." *Journalism History* 21.4 (winter 1995): 156–63.

Gould, Stephen Jay. *The Mismeasure of Man.* New York: W. W. Norton, 1981.

Grafton, John. *New York in the Nineteenth Century.* New York: Dover, 1977.

Groce, George C., and David H. Wallace. *The New-York Historical Society's Dictionary of Artists in America, 1564–1860.* New Haven: Yale University Press, 1957.

Grover, Jan Zita. "The First Living-Room War: The Civil War in the Illustrated Press." *Afterimage,* February 1984, 8–11.

Gruesz, Kirsten Silva. "Brave *Mundo Nuevo:* Spheres of Influence in Martí's New York." Paper delivered at the American Literature Association Conference, Baltimore, May 23, 1997.

Gutman, Herbert G. "Social and Economic Structure and Depression: American Labor in 1873 and 1874." Ph.D. diss., University of Wisconsin, 1959.

———. "The Tompkins Square 'Riot' in New York City on January 13, 1874:

A Re-examination of Its Causes and Its Aftermath." *Labor History* 6.1 (winter 1965): 44–70.

Hales, Peter Bacon. *Silver Cities: The Photography of American Urbanization, 1839–1915*. Philadelphia: Temple University Press, 1984.

Hall, David D. "Introduction: The Uses of Literacy in New England, 1600–1850." In *Printing and Society in Early America*, edited by William L. Joyce et al., 1–47. Worcester, Mass.: American Antiquarian Society, 1983.

Halttunen, Karen. *Confidence Men and Painted Women: A Study of Middle-Class Culture in America, 1830–1870*. New Haven: Yale University Press, 1982.

Hansen, Bert. "The Image and Advocacy of Public Health in American Caricature and Cartoons from 1860 to 1900." *American Journal of Public Health* 87.11 (November 1997): 1798–807.

Hansen, Miriam. *Babel and Babylon: Spectatorship in American Silent Film*. Cambridge, Mass.: Harvard University Press, 1991.

Harper, Ida Husted, ed. *History of Woman Suffrage*. Vol. 5, *1900–1920*. New York: National American Woman Suffrage Association, 1922.

Harris, Neil. *Cultural Excursions: Marketing Appetites and Cultural Tastes in Modern America*. Chicago: University of Chicago Press, 1990.

———. *Humbug: The Art of P. T. Barnum*. Boston: Little, Brown, 1973.

———. "Iconography and Intellectual History: The Half-Tone Effect." In *New Directions in American Intellectual History*, edited by John Higham and Paul K. Conkins, 196–211. Baltimore: Johns Hopkins University Press, 1979.

Harvey, Katherine A. *The Best-Dressed Miners: Life and Labor in the Maryland Coal Region, 1835–1910*. Ithaca, N.Y.: Cornell University Press, 1969.

Hatt, Michael. "'Making a Man of Him': Masculinity and the Black Body in Mid-Nineteenth-Century American Sculpture." *Oxford Art Journal* 15.1 (1992): 21–35.

Hatton, Edward. "Domestic Assassins: Gender, Murder, and the Middle Class in Antebellum America." Ph.D. diss., Temple University, 1997.

Henkin, David. *City Reading: Written Words and Public Spaces in Antebellum New York*. New York: Columbia University Press, 1999.

Hess, Stephen, and Milton Kaplan. *The Ungentlemanly Art: A History of American Political Cartoons*. Rev. ed. New York: Macmillan, 1975.

Hibbert, Christopher. *The Illustrated London News: Social History of Victorian Britain*. London: Angus and Robertson, 1975.

Higham, John. *Strangers in the Land: Patterns of American Nativism, 1860–1925*. 2d ed. New York: Atheneum, 1974.

Hill, Marilynn Wood. *Their Sisters' Keepers: Prostitution in New York City, 1830–1870*. Berkeley: University of California Press, 1993.

Holzer, Harold, Gabor S. Borritt, and Mark E. Neely Jr. *The Lincoln Image: Abraham Lincoln and the Popular Print*. New York: Charles Scribner's Sons, 1984.

Honour, Hugh. *The Image of the Black in Western Art*. Vol. 4, *From the American Revolution to World War I*. Part 1, *Slaves and Liberators*. Cambridge, Mass.: Harvard University Press, 1989.

Hoole, W. Stanley. *Vizetelly Covers the Confederacy*. Tuscaloosa, Ala.: Confederate Publishing, 1957.

Horgan, Stephen Henry. "The World's First Illustrated Newspaper." *Penrose Annual* 35 (1933): 23–24.

Horowitz, Helen Lefkowitz. "Victoria Woodhull, Anthony Comstock, and Conflict over Sex in the United States in the 1870s." *Journal of American History* 87.2 (September 2000): 403–34.

Huntzicker, William E. "Chinese-American Newspapers." In *Outsiders in Nineteenth-Century Press History: Multicultural Perspectives,* edited by Frank Hutton and Barbara Straus Reed, 71–92. Bowling Green, Ky.: Bowling Green State University Popular Press, 1995.

———. "Frank Leslie (Henry Carter)." In *American Magazine Journalists,* edited by Sam G. Riley, 209–22. Vol. 79 of *Dictionary of Literary Biography.* Detroit: Gale Research, 1989.

———. "Newspaper Representation of China and Chinese Americans." In *Outsiders in Nineteenth-Century Press History: Multicultural Perspectives,* edited by Frank Hutton and Barbara Straus Reed, 93–114. Bowling Green, Ky.: Bowling Green State University Popular Press, 1995.

Issel, William, and Robert W. Cherny. *San Francisco, 1865–1932: Politics, Power, and Urban Development.* Berkeley: University of California Press, 1986.

Ivins, William M., Jr. *How Prints Look.* Rev. ed. Boston: Beacon Press, 1987.

———. *Prints and Visual Communication.* Reprint, Cambridge, Mass.: MIT Press, 1969.

Jacobson, Matthew Frye. *Whiteness of a Different Color: European Immigrants and the Alchemy of Race.* Cambridge, Mass.: Harvard University Press, 1998.

Jaffee, David P. "An Artisan-Entrepreneur's Portrait of the Industrializing North, 1790–1860." In *Essays from the Lowell Conference on Industrial History, 1982 and 1983,* edited by Robert Weible, 165–84. North Andover, Mass.: Museum of American Textile History, 1985.

———. "Peddlers of Progress and the Transformation of the Rural North, 1760–1860." *Journal of American History* 78.2 (September 1991): 511–35.

Jameson, Fredric. *The Political Unconscious: Narrative as a Socially Symbolic Act.* Ithaca, N.Y.: Cornell University Press, 1981.

Jensen, Oliver. "War Correspondent: 1864: The Sketchbooks of James E. Taylor." *American Heritage,* August–September 1980, 48–64.

Jeter, Marvin D. "Henry J. Lewis: A Researcher's Note." *Black History News and Notes* (Indiana Historical Society), no. 38 (November 1989): 3, 7–8.

———. "H. J. Lewis, Freeman Artist: A Working Paper." *Black History News and Notes* (Indiana Historical Society), no. 41 (August 1990): 3–8.

———. "The Palmer-Lewis 'Mound Survey' Forays into Tennessee, Mississippi, and Louisiana, 1881–1883." *Mississippi Archeology* 25.2 (December 1990): 1–37.

———, ed. *Edward Palmer's Arkansaw Mounds.* Fayetteville: University of Arkansas Press, 1990.

Johannsen, Robert W. *To the Halls of Montezuma: The Mexican War in the American Imagination.* New York: Oxford University Press, 1985.

John, Arthur. *The Best Years of the "Century": Richard Watson Gilder, "Scribner's Monthly," and the "Century Magazine," 1870–1909.* Urbana: University of Illinois Press, 1981.

Johns, Elizabeth. *American Genre Painting: The Politics of Everyday Life.* New Haven: Yale University Press, 1991.

Johnson, Malcolm. *David Claypool Johnston: American Graphic Humorist, 1798–1865.* Exhib. cat., American Antiquarian Society et al. Lunenberg, Vt.: Stinehour Press, 1970.

Jordanova, Ludmilla. "Reading Faces in the Nineteenth Century." *Art History* 13.4 (December 1990): 570–75.

Juergens, George. *Joseph Pulitzer and the New York World.* Princeton: Princeton University Press, 1966.

Jussim, Estelle. *The Eternal Moment: Essays on the Photographic Image.* New York: Aperture, 1989.

———. *Visual Communication and the Graphic Arts: Photographic Technologies in the Nineteenth Century.* New ed. New York: R. R. Bowker, 1983.

Kahan, Robert Sidney. "The Antecedents of American Photojournalism." Ph.D. diss., University of Wisconsin, 1969.

———. "Magazine Photographs Begin: An Editorial Negative." *Journalism Quarterly* 42.1 (winter 1965): 53–59.

Kaplan, Sidney. "The Black Soldier of the Civil War in Literature and Art." In *The Chancellor's Lecture Series, 1979–1980,* 1–39. Amherst: University of Massachusetts, 1981.

Kaser, David. *Books and Libraries in Camp and Battle: The Civil War Experience.* Westport, Conn.: Greenwood Press, 1984.

Kasson, John F. *Rudeness and Civility: Manners in Nineteenth-Century Urban America.* New York: Hill and Wang, 1990.

Katzman, David M. *Seven Days a Week: Women and Domestic Service in Industrializing America.* Urbana: University of Illinois Press, 1978.

Kazin, Michael, and Steven J. Ross. "America's Labor Day: The Dilemma of a Workers' Celebration." *Journal of American History* 78.4 (March 1992): 1294–323.

Keller, Allan. *Scandalous Lady: The Life and Times of Madame Restell: New York's Most Notorious Abortionist.* New York: Atheneum, 1981.

Keller, Morton. *The Art and Politics of Thomas Nast.* New York: Oxford University Press, 1968.

Keller, Ulrich. "Photojournalism around 1900: The Institutionalization of a Mass Medium." In *Shadow and Substance: Essays in the History of Photography,* edited by Kathleen Collins, 283–303. Bloomfield Hills, Mich.: Amorphous Institute Press, 1990.

Kelley, Mary. *Private Woman, Public Stage: Literary Domesticity in Nineteenth-Century America.* New York: Oxford University Press, 1984.

Kemnitz, Thomas Milton. "The Cartoon as a Historical Source." *Journal of Interdisciplinary History* 4.1 (summer 1973): 81–93.

———. "Matt Morgan of 'Tomahawk' and English Cartooning, 1867–1870." *Victorian Studies* 19.1 (September 1975): 5–34.

Kennedy, Robert Charles. "Crisis and Progress: The Rhetoric and Ideals of a Nineteenth Century Reformer, George William Curtis (1824–1892)." Ph.D. diss., University of Illinois at Urbana-Champaign, 1993.

Kenny, Kevin. *Making Sense of the Molly Maguires*. New York: Oxford University Press, 1997.

Kies, Emily Bardeck. "The City and the Machine: Urban and Industrial Illustration in America, 1880–1900." Ph.D. diss., Columbia University, 1971.

Kimball, Gregg D. "'The South as It Was': Social Order, Slavery, and Illustrators in Virginia, 1830–1877." In *Graphic Arts and the South: Proceedings of the 1990 North American Print Conference,* edited by Judy L. Larson, 1298–57. Fayetteville: University of Arkansas Press, 1993.

Knobel, Dale T. *Paddy and the Republic: Ethnicity and Nationality in Antebellum America*. Middletown, Conn.: Wesleyan University Press, 1986.

Kunzle, David. *The History of the Comic Strip: The Nineteenth Century*. Berkeley: University of California Press, 1990.

Lapansky, Phillip. "Graphic Discord: Abolitionist and Antiabolitionist Images." In *The Abolitionist Sisterhood: Women's Political Culture in Antebellum America,* edited by Jean Fagan Yellin and John C. Van Horne, 201–30. Ithaca, N.Y.: Cornell University Press, 1994.

Laurie, Bruce G. *Artisans into Workers: Labor in Nineteenth-Century America*. New York: Hill and Wang, 1989.

———. *Working People of Philadelphia, 1800–1850*. Philadelphia: Temple University Press, 1980.

Leach, William. *True Love and Perfect Union: The Feminist Reform of Sex and Society*. 1980. Reprint, Middletown: Wesleyan University Press, 1989.

Leja, Michael. "The Illustrated Magazines and Print Connoisseurship in the Late Nineteenth Century." *Block Points* 1 (1993): 54–73.

Leonard, Thomas C. *The Power of the Press: The Birth of American Political Reporting*. New York: Oxford University Press, 1986.

Levin, Jo Ann Early. "The Golden Age of Illustration: Popular Art in American Magazines, 1850–1925." Ph.D. diss., University of Pennsylvania, 1980.

Levine, Lawrence W. *Highbrow/Lowbrow: The Emergence of Cultural Hierarchy in America*. Cambridge, Mass.: Harvard University Press, 1988.

Levine, Susan. *Labor's True Woman: Carpet Weavers, Industrialization, and Labor Reform in the Gilded Age*. Philadelphia: Temple University Press, 1984.

Lo, Karl, and H. M. Lai, comps. *Chinese Newspapers Published in North America, 1854–1875*. Washington, D.C.: Center for Chinese Research Materials, 1976.

Lott, Eric. *Love and Theft: Blackface Minstrelsy and the American Working Class*. New York: Oxford University Press, 1993.

McClinton, Katharine Morrison. *The Chromolithographs of Louis Prang*. New York: Clarkson N. Potter, 1973.

McCullough, Jean, ed. *Art in Nineteenth-Century Pittsburgh: An Exhibition*. Pittsburgh: McCullough Communications, 1977.

McElroy, Guy C. *Facing History: The Black Image in American Art, 1710–1940*. Washington, D.C.: Corcoran Gallery of Art, 1990.

McKerns, Joseph P., ed. *Biographical Dictionary of American Journalism.* Westport, Conn.: Greenwood Press, 1989.

McLaurin, Melton Alonza. *The Knights of Labor in the South.* Westport, Conn.: Greenwood Press, 1978.

Maidment, B. E. *Reading Popular Prints, 1790–1870.* Manchester: Manchester University Press, 1996.

Martin, Francis J., Jr. "The Image of Black People in American Illustration from 1825 to 1925." Ph.D. diss., University of California, Los Angeles, 1986.

Marzio, Peter C. *The Democratic Art: Pictures for a Nineteenth-Century America.* London: Scolar Press, 1980.

———. *The Men and Machines of American Journalism.* Washington, D.C.: National Museum of History and Technology, Smithsonian Institution, 1973.

Mayor, A. Hyatt. *Prints and People: A Social History of Printed Pictures.* New York: Metropolitan Museum of Art, 1971.

Meixner, Laura L. *French Realist Painting and the Critique of American Society, 1865–1900.* New York: Cambridge University Press, 1995.

Mirzoeff, Nicholas. *An Introduction to Visual Culture.* New York: Routledge, 1999.

Moretti, Franco. "Homo Palpitans: Balzac's Novels and Urban Personality." In *Signs Taken for Wonders: Essays in the Sociology of Literary Forms,* 109–29. Translated by Susan Fischer, David Forgacs, and David Miller. Rev. ed. London: Verso, 1988.

Morrison, Toni. *Beloved.* New York: Alfred A. Knopf, 1987.

Mosse, George L. *Toward the Final Solution: A History of European Racism.* 1978, Reprint, Madison: University of Wisconsin Press, 1985.

Mott, Frank Luther. *American Journalism: A History of Newspapers in the United States through 250 Years, 1690–1940.* New York: Macmillan, 1941.

———. *A History of American Magazines, 1850–1865.* Cambridge, Mass.: Harvard University Press, 1938.

———. *A History of American Magazines, 1865–1885.* Cambridge, Mass.: Harvard University Press, 1938.

———. *A History of American Magazines, 1885–1905.* Cambridge, Mass.: Harvard University Press, 1957.

———. "The Magazine Revolution and Popular Ideas in the Nineties." *Proceedings of the American Antiquarian Society,* n.s., 64.1 (April 1954): 195–214.

Museum of Graphic Art. *American Printmaking: The First 150 Years.* Washington, D.C.: Smithsonian Institution Press, 1969.

Nadel, Stanley. "Those Who Would Be Free: The Eight-Hour Day Strikes of 1872." *Labor's Heritage* 2.2 (April 1990): 70–77.

Nissenbaum, Stephen. *The Battle for Christmas.* New York: Alfred A. Knopf, 1996.

Nord, David Paul. "Working-Class Readers: Family, Community, and Reading in Late Nineteenth-Century America." *Communication Research* 13.2 (April 1986): 156–81.

O'Brien, Frank M. *The Story of "The Sun."* New York: D. Appleton, 1928.

O'Donnell, Edward Thomas. "Henry George and the 'New Political Forces':

Ethnic Nationalism, Labor Radicalism, and Politics in Gilded Age New York City." Ph.D. diss., Columbia University, 1995.

Ohmann, Richard. *Selling Culture: Magazines, Markets, and Class at the Turn of the Century.* London: Verso, 1996.

O'Leary, Elizabeth L. *At Beck and Call: The Representation of Domestic Servants in Nineteenth-Century American Painting.* Washington, D.C.: Smithsonian Institution Press, 1996.

Orvell, Miles. *The Real Thing: Imitation and Authenticity in American Culture, 1880–1940.* Chapel Hill: University of North Carolina Press, 1989.

O'Sullivan, Niamh. "Through Irish Eyes: The Work of Aloysius O'Kelly in the *Illustrated London News.*" *History Ireland,* autumn 1995, 10–16.

Oursler, Fulton. "Frank Leslie." *American Mercury,* May 1930, 98–99.

Paine, Albert Bigelow. *Th. Nast: His Period and His Pictures.* New York: Macmillan, 1904.

Painter, Nell Irvin. *Exodusters: Black Migration to Kansas after Reconstruction.* New York: Alfred A. Knopf, 1976.

Pearson, Andrea G. "*Frank Leslie's Illustrated Newspaper* and *Harper's Weekly:* Innovation and Imitation in Nineteenth-Century American Pictorial Reporting." *Journal of Popular Culture* 23.4 (spring 1990): 81–111.

Peet, Phyllis. *American Women of the Etching Revival.* Atlanta: High Museum of Art, 1988.

Peiss, Kathy. *Cheap Amusements: Working Women and Leisure in Turn-of-the-Century New York.* Philadelphia: Temple University Press, 1986.

Pernicone, Carol Groneman. "The 'Bloody Ould Sixth': A Social Analysis of a New York City Working-Class Community in the Mid–Nineteenth Century." Ph.D. diss., University of Rochester, 1973.

Peters, Lisa N. "Images of the Homeless in American Art, 1860–1910." In *On Being Homeless: Historical Perspectives,* edited by Rick Beard, 44–53. New York: Museum of the City of New York, 1987.

Peterson, Larry. "Pullman Strike Pictures: Remolding Public Perceptions of Labor Conflict by New Visual Communication." In *The Pullman Strike and the Crisis of the 1890s: Essays on Labor and Politics,* edited by Richard Schneirov, Shelton Stromquist, and Nick Salvatore, 87–129. Urbana: University of Illinois Press, 1999.

Philippe, Robert. *Political Graphics: Art as Weapon.* New York: Abbeville Press, 1980.

Phillips, David Clayton. "Art for Industry's Sake: Halftone Technology, Mass Photography, and the Social Transformation of American Print Culture, 1880–1920." Ph.D. diss., Yale University, 1996.

Porter, Roy. "Prinney, Boney, Boot." *London Review of Books,* March 20, 1986, 19–20.

———. "Seeing the Past." *Past and Present,* no. 118 (February 1988): 186–205.

Potts, Alex. "Picturing the Modern Metropolis: Images of London in the Nineteenth Century." *History Workshop,* no. 26 (autumn 1988): 28–56.

Price, Kenneth M., and Susan Belasco Smith, eds. *Periodical Literature in Nineteenth-Century America.* Charlottesville: University Press of Virginia, 1995.

Rachleff, Peter S. *Black Labor in the South: Richmond, Virginia, 1865–1890.* Philadelphia: Temple University Press, 1984.

Rainey, Sue. *Creating "Picturesque America": Monument to the Natural and Cultural Landscape.* Nashville: Vanderbilt University Press, 1994.

Ray, Frederic. *Alfred R. Waud: Civil War Artist.* New York: Viking, 1974.

Reaves, Wendy Wick. "Portraits in Every Parlor." In *American Portrait Prints: Proceedings of the Tenth Annual Print Conference,* 83–134. Charlottesville: University Press of Virginia, 1984.

Reilly, Bernard, Jr. "The Art of the Antislavery Movement." In *Courage and Conscience: Black and White Abolitionists in Boston,* edited by Donald M. Jacobs, 47–73. Bloomington: Indiana University Press, 1993.

———. "Comic Drawing in New York in the 1850s." In *Prints and Printmakers of New York State, 1825–1940,* edited by David Tatham, 147–62. Syracuse, N.Y.: Syracuse University Press, 1986.

Reps, John W. *Views and Viewmakers of Urban America: Lithographs of Towns and Cities in the United States and Canada, Notes on the Artists and Publishers, and a Union Catalog of Their Work, 1825–1925.* Columbia: University of Missouri Press, 1984.

Reynolds, David S. *Beneath the American Renaissance: The Subversive Imagination in the Age of Emerson and Melville.* Cambridge, Mass.: Harvard University Press, 1989.

Roediger, David R. *The Wages of Whiteness: Race and the Making of the American Working Class.* London: Verso, 1991.

Rosenberg, Charles E. *The Cholera Years: The United States in 1832, 1849, and 1866.* Chicago: University of Chicago Press, 1962.

———. *The Trial of the Assassin Guiteau: Psychiatry and Law in the Gilded Age.* Chicago: University of Chicago Press, 1968.

Rosenzweig, Roy, and Elizabeth Blackmar. *The Park and the People: A History of Central Park.* Ithaca, N.Y.: Cornell University Press, 1992.

Ross, Ishbel. *Charmers and Cranks: Twelve Famous American Women Who Defied the Conventions.* New York: Harper and Row, 1965.

Rotskoff, Lori E. "Decorating the Dining-Room: Still-Life Chromolithographs and Domestic Ideology in Nineteenth-Century America." *Journal of American Studies* 31.1 (April 1997): 19–42.

Rourke, Constance. *American Humor: A Study of the National Character.* New York: Harcourt, Brace, 1931.

Roy, Andrew. *A History of the Coal Miners of the United States from the Development of the Mines to the Close of the Anthracite Strike of 1902, Including a Brief Sketch of Early British Miners.* Columbus: J. L. Trauger Printing Company, 1907.

Ryan, Mary P. *Women in Public: Between Banners and Ballots, 1825–1880.* Baltimore: Johns Hopkins University Press, 1990.

Ryan, Susan M. "Acquiring Minds: Commodified Knowledge and the Positioning of the Reader in *McClure's Magazine,* 1893–1903." *Prospects* 22 (1997): 211–38.

Rydell, Robert W. *All the World's a Fair: Visions of Empire at American International Expositions, 1876–1916.* Chicago: University of Chicago Press, 1984.

Salvatore, Nick. *We All Got History: The Memory Books of Amos Webber.* New York: New York Times/Random House, 1996.

Samuels, Peggy, and Harold Samuels. *The Illustrated Biographical Encyclopedia of Artists of the American West.* Garden City, N.Y.: Doubleday, 1976.

Sandweiss, Martha A., Rick Stewart, and Ben W. Huseman. *Eyewitness to War: Prints and Daguerreotypes of the Mexican War, 1846–48.* Washington, D.C.: Smithsonian Institution Press, 1989.

Savage, Kirk. *Standing Soldiers, Kneeling Slaves: Race, War, and Monument in Nineteenth-Century America.* Princeton: Princeton University Press, 1997.

Saxon, A. H. P. T. *Barnum: The Legend and the Man.* New York: Columbia University Press, 1989.

Saxton, Alexander. *The Indispensable Enemy: Labor and the Anti-Chinese Movement in California.* Berkeley: University of California Press, 1971.

————. *The Rise and Fall of the White Republic: Class Politics and Mass Culture in Nineteenth-Century America.* London: Verso, 1990.

Scanlon, Jennifer. *Inarticulate Longings: The "Ladies' Home Journal," Gender, and the Promises of Consumer Culture.* New York: Routledge, 1995.

Schiller, Dan. *Objectivity and the News: The Public and the Rise of Commercial Journalism.* Philadelphia: University of Pennsylvania Press, 1981.

————. "Realism, Photography, and Journalistic Objectivity in Nineteenth Century America." *Studies in the Anthropology of Visual Communication* 4.2 (winter 1977): 86–98.

Schneirov, Matthew. *The Dream of a New Social Order: Popular Magazines in America, 1893–1914.* New York: Columbia University Press, 1994.

Scholnick, Robert J. "*Scribner's Monthly* and the 'Pictorial Representation of Life and Truth' in Post–Civil War America." *American Periodicals* 1.1 (fall 1991): 46–69.

Schudson, Michael. *Discovering the News: A Social History of American Newspapers.* New York: Basic Books, 1978.

Schuneman, R. Smith. "Art or Photography: A Question for Newspaper Editors of the 1890s." *Journalism Quarterly* 42.1 (winter 1965): 43–52.

Scobey, David. "Anatomy of the Promenade: The Politics of Bourgeois Sociability in Nineteenth-Century New York." *Social History* 17.2 (May 1992): 203–27.

————. "Empire City: Politics, Culture, and Urbanism in Gilded-Age New York." Ph.D. diss., Yale University, 1989.

Sekula, Allan. "The Body and the Archive." *October*, no. 39 (winter 1986): 3–64.

Seymour, Bruce. *Lola Montez: A Life.* New Haven: Yale University Press, 1996.

Shenton, James P., ed. *Free Enterprise Forever! "Scientific American" in the Nineteenth Century.* New York: Images Graphiques, 1977.

Sheon, Aaron. "Caricature and the Physiognomy of the Insane." *Gazette des Beaux-Arts*, ser. 6, 88, no. 1293 (October 1976): 145–50.

Sheppard, Alice. *Cartooning for Suffrage.* Albuquerque: University of New Mexico Press, 1993.

Slotkin, Richard. *The Fatal Environment: The Myth of the Frontier in the Age of Industrialization, 1800–1890.* New York: Atheneum, 1985.

Smith, Carl. *Urban Disorder and the Shape of Belief: The Great Chicago Fire, the Haymarket Bomb, and the Model Town of Pullman.* Chicago: University of Chicago Press, 1994.

Smith, F. B. *Radical Artisan: William James Linton, 1812–97.* Manchester: Manchester University Press, 1973.

Smith, Gene, and Jane Barry Smith, eds. *The Police Gazette.* New York: Simon and Schuster, 1972.

Smith-Rosenberg, Carroll. *Religion and the Rise of the American City: The New York City Mission Movement, 1812–1870.* Ithaca, N.Y.: Cornell University Press, 1971.

Spann, Edward K. *The New Metropolis: New York City, 1840–1857.* New York: Columbia University Press, 1981.

Stange, Maren. *Symbols of Ideal Life: Social Documentary Photography in America, 1890–1950.* New York: Cambridge University Press, 1989.

Stansell, Christine. *City of Women: Sex and Class in New York, 1789–1860.* 1986. Reprint, Urbana: University of Illinois Press, 1987.

Starr, Louis M. *Bohemian Brigade: Civil War Newsmen in Action.* 1954. Reprint, Madison: University of Wisconsin Press, 1987.

Stein, Roger B. "Picture and Text: The Literary World of Winslow Homer." In *Winslow Homer: A Symposium,* edited by Nicolai Cikovsky Jr., 33–59. Studies in the History of Art 26. Washington, D.C.: National Gallery of Art, 1990.

Stein, Sally. "Making Connections with the Camera: Photography and Social Mobility in the Career of Jacob Riis." *Afterimage,* May 1983, 9–16.

Stepno, Bob. "Staged, Faked, and Mostly Naked: Photographic Innovation at the *Evening Graphic* (1924–1932)." Paper presented at the Association for Education in Journalism and Mass Communication Conference, Chicago, August 1997.

Stern, Madeleine Bettina. *Imprints on History: Book Publishers and American Frontiers.* Bloomington: Indiana University Press, 1956.

———. *Purple Passage: The Life of Mrs. Frank Leslie.* Norman: University of Oklahoma Press, 1953.

———. *We the Women: Career Firsts in Nineteenth-Century America.* New York: Schulte, 1963.

———, ed. *Publishers for Mass Entertainment in Nineteenth Century America.* Boston: G. K. Hall, 1980.

Stern, Philip Van Doren. *They Were There: The Civil War in Action as Seen by Its Combat Artists.* New York: Crown, 1959.

Stowell, David O. *Streets, Railroads, and the Great Strike of 1877.* Chicago: University of Chicago Press, 1999.

Stutler, Boyd B. "An Eyewitness Describes the Hanging of John Brown." *American Heritage,* February 1955, 4–9.

Szuberla, Guy. "Ladies, Gentlemen, Flirts, Mashers, Snoozers, and the Breaking of Etiquette's Code." *Prospects* 15 (1990): 169–96.

Taft, Robert. *Artists and Illustrators of the Old West, 1850–1900.* New York: Charles Scribner's Sons, 1953.

———. "Joseph Becker's Sketch of the Gettysburg Ceremony, November 19, 1863." *Kansas Historical Quarterly* 21.4 (winter 1954): 257–63.

———. *Photography and the American Scene: A Social History, 1839–1889.* New York: Macmillan, 1938.

Tatham, David. "David Claypoole Johnston's Theatrical Portraits." In *American Portrait Prints: Proceedings of the Tenth Annual Print Conference,* 162–93. Charlottesville: University Press of Virginia, 1984.

———. "Keppler versus Beecher: Prints of the Great Brooklyn Scandal." *Imprint* 23.1 (spring 1998): 2–8.

Taylor, Joshua C. *America as Art.* Washington, D.C.: Smithsonian Institution Press, 1976.

Taylor, William R. *Cavalier and Yankee: The Old South and American National Character.* New York: George Braziller, 1961.

Tchen, John Kuo Wei. *New York before Chinatown: Orientalism and the Shaping of American Culture, 1776–1882.* Baltimore: Johns Hopkins University Press, 1999.

Tebbel, John, and Mary Ellen Zuckerman. *The Magazine in America, 1740–1990.* New York: Oxford University Press, 1991.

Thistlewaite, Mark. "The Most Important Themes: History Painting and Its Place in American Art." In *Grand Illusions: History Painting in America,* edited by William H. Gerdts and Mark Thistlewaite, 7–58. Fort Worth: Amon Carter Museum, 1988.

Thomas, Samuel J. "Portraits of a 'Rebel' Priest: Edward McGlynn in Caricature." *Journal of American Culture* 7.4 (winter 1984): 19–32.

Thompson, William Fletcher, Jr. "Illustrating the Civil War." *Wisconsin Magazine of History* 45.1 (autumn 1961): 10–20.

———. *The Image of War: The Pictorial Reporting of the American Civil War.* New York: Thomas Yoseloff, 1959.

Toll, Robert C. *Blacking Up: The Minstrel Show in Nineteenth-Century America.* New York: Oxford University Press, 1974.

Trachtenberg, Alan. *The Incorporation of America: Culture and Society in the Gilded Age.* New York: Hill and Wang, 1982.

———. *Reading American Photographs: Images as History: Mathew Brady to Walker Evans.* New York: Hill and Wang, 1989.

Treuherz, Julian. *Hard Times: Social Realism and Victorian Art.* London: Lund Humphries, 1987.

Troubetzkoy, Ulrich. "W. L. Sheppard: Artist of Action." *Virginia Cavalcade* 11.3 (winter 1961–62): 20–26.

Tucher, Andie. *Froth and Scum: Beauty, Goodness, and the Ax Murder in America's First Mass Medium.* Chapel Hill: University of North Carolina Press, 1994.

Tytler, Graeme. *Physiognomy in the European Novel: Faces and Fortunes.* Princeton: Princeton University Press, 1982.

Van Every, Edward. *Sins of New York, as "Exposed" by the "National Police Gazette."* New York: Frederick A. Stokes, 1930.

Wagner, Ann Prentice. "The Graver, the Brush, and the Ruling Machine: The Training of Late-Nineteenth-Century Wood Engravers." *Proceedings of the American Antiquarian Society* 105, pt. 1 (1995): 167–91.

Waller, Altina L. *Reverend Beecher and Mrs. Tilton: Sex and Class in Victorian America.* Amherst: University of Massachusetts Press, 1982.

Walters, Ronald G. *American Reformers, 1815–1860.* New York: Hill and Wang, 1978.

Watrous, James. *American Printmaking: A Century of American Printmaking, 1880–1980.* Madison: University of Wisconsin Press, 1984.

Watson, Elmo Scott. "The Indian Wars and the Press, 1866–1867." *Journalism Quarterly* 17.4 (December 1940): 301–12.

Wechsler, Judith. *A Human Comedy: Physiognomy and Caricature in Nineteenth Century Paris.* Chicago: University of Chicago Press, 1982.

———, ed. *The Issue of Caricature.* Special issue of *Art Journal* (43.4 [winter 1983]).

Weinbaum, Paul O. "Temperance, Politics, and the New York City Riots of 1857." *New-York Historical Society Quarterly* 59 (July 1975): 246–70.

Weir, Robert E. *Beyond Labor's Veil: The Culture of the Knights of Labor.* University Park: Pennsylvania State University Press, 1996.

Welsh, Peter C. "Henry R. Robinson: Printmaker to the Whig Party." *New York History* 53.1 (January 1972): 25–53.

West, Richard Samuel. *Satire on Stone: The Political Cartoons of Joseph Keppler.* Urbana: University of Illinois Press, 1988.

West, Shearer. "The Construction of Racial Type: Caricature, Ethnography, and Jewish Physiognomy in Fin-de-Siècle Melodrama." *Nineteenth Century Theatre* 21.1 (summer 1993): 5–40.

Weymouth, Lally. *America in 1876: The Way We Were.* New York: Vintage, 1976.

Wiegand, Wayne A. "Introduction: Theoretical Foundations for Analyzing Print Culture as Agency and Practice in a Diverse Modern America." In *Print Culture in a Diverse America,* edited by James P. Danky and Wayne A. Wiegand, 1–13. Urbana: University of Illinois Press, 1998.

Wilentz, Sean. *Chants Democratic: New York City and the Rise of the American Working Class, 1788–1850.* New York: Oxford University Press, 1984.

Williams, Linda. *Hard Core: Power, Pleasure, and the "Frenzy of the Visible."* Berkeley: University of California Press, 1989.

Williams, Raymond. *Culture.* Glasgow: Fontana, 1981.

———. *Marxism and Literature.* New York: Oxford University Press, 1977.

Wilson, Christopher P. *The Labor of Words: Literary Professionalism in the Progressive Era.* Athens: University of Georgia Press, 1985.

———. "The Rhetoric of Consumption: Mass-Market Magazines and the Demise of the Gentle Reader, 1880–1920." In *The Culture of Consumption: Critical Essays in American History, 1880–1980,* edited by Richard Wightman Fox and T. J. Jackson Lears, 39–64. New York: Pantheon, 1983.

Wilson, R. Jackson. *Figures of Speech: American Writers and the Literary Marketplace, from Benjamin Franklin to Emily Dickinson.* New York: Alfred A. Knopf, 1989.

Winston, Diane H. *Red-Hot and Righteous: The Urban Religion of the Salvation Army.* Cambridge, Mass.: Harvard University Press, 1999.

Wolff, Michael, and Celina Fox. "Pictures from the Magazines." In *The Victorian City: Images and Reality*, edited by H. J. Dyos and Michael Wolff, 559–82. London: Routledge and Kegan Paul, 1973.

Wood, Peter H., and Karen C. C. Dalton. *Winslow Homer's Images of Blacks: The Civil War and Reconstruction Years*. Austin: University of Texas Press, 1988.

Woodward, David. "The Decline of Commercial Wood-Engraving in Nineteenth-Century America." *Journal of the Printing Historical Society* 10 (1974–75): 57–83.

Wosk, Julie. *Breaking Frame: Technology and the Visual Arts in the Nineteenth Century*. New Brunswick, N.J.: Rutgers University Press, 1992.

Wright, Helena E. *With Pen and Graver: Women Graphic Artists before 1900*. Washington, D.C.: National Museum of American History, Smithsonian Institution, 1995.

Zboray, Ronald J. "Antebellum Reading and the Ironies of Technological Innovation." *American Quarterly* 40.1 (March 1988): 65–82.

Zucchi, John E. *The Little Slaves of the Harp: Italian Child Musicians in Nineteenth-Century Paris, London, and New York*. Montreal: McGill-Queen's University Press, 1992.

Zurier, Rebecca. "Picturing the City: New York in the Press and the Art of the Ashcan School, 1890–1917." Ph.D. diss., Yale University, 1988.

Zurier, Rebecca, Robert W. Snyder, and Virginia M. Mecklenburg. *Metropolitan Lives: The Ashcan Artists and Their New York*. New York: W. W. Norton, 1995.

Index

Text:	10/13 Sabon
Display:	Sabon
Compositor:	G & S Typesetters, Inc.
Printer/Binder:	Thomson-Shore, Inc.